An American Lens

An American Lens

Scenes from Alfred Stieglitz's New York Secession

Jay Bochner

The MIT Press Cambridge, Massachusetts London, England

MIT Press books may be purchased at special quantity discounts for business or sales promotional use. For information, please email special_sales@mitpress.mit.edu or write to Special Sales Department, The MIT Press, 55 Hayward Street, Cambridge, MA 02142.

This book was set in Garamond 3 and Din by Graphic Composition and The MIT Press and was printed and bound in the United States of America.

Library of Congress Cataloging-in-Publication Data

Bochner, Jay, 1940–
 An American lens : scenes from Alfred Stieglitz's New York Secession / Jay Bochner.
 p. cm.
 Includes bibliographical references and index.
 ISBN 0-262-02580-9 (alk. paper)
 1. Photography, Artistic—Philosophy. 2. Photography—United States—History—20th century. 3. Arts, American—20th century. 4. Modernism (Art) 5. Art and photography—United States. 6. Stieglitz, Alfred, 1864–1946. 7. Photo-Secession (Association) 8. Armory Show (1913 : New York, N.Y.) I. Title.

TR642.B6267 2005
700'.9747'109041—dc22 2005043347

*Something for
Sally's
faith and love,
trust and care*

Contents

Preface

An American Lens offers a version of the history of modern artistic movements in America that looks at relatively short moments along its development. That is the sense of the word "scenes" in my subtitle: highly focused moments that ought to provide a tighter sense of historical relevance in the arts than a more continuous storyline evenly distributed through the years. The premise is that if we are to understand, at some useful depth, the import of what an artist or writer was accomplishing, we must excavate more thoroughly the moments of creation and initial exposure to the public. This is not to say the scene does not call for wider contexts; numerous contexts loom here, and I expect them to fill out the scene's meaning and its implications. But it is an intense and expanded moment I wish to observe first and last, one which I think offers us a pointed relevance that the more usual long view tends to dilute.

At one point in Carl Schorske's introduction to his well-known *Fin-de-Siècle Vienna,* he calls his chapters on various artistic aspects of his subject "a kind of postholing." He explains that he was drawn to his technique by a realization that, even if he is still searching for the historian's diachronic view, because of a kind of "fraying" of the historical thread by modernism's need to fragment he can reconstruct sensibly only on the synchronic canvas, at least in the first instance.[1] Despite Schorske's acute

sense of historical discontinuity, rare are the chapters in *Fin-de-Siècle Vienna* that make as astringent a demand on synchronicity as I will in most of what follows. He has full chapters on Klimt or, say, Kokoschka where he follows their careers over ten or fifteen years; I am progressing much more slowly, with the perhaps simpler task of giving over much of this book to a single actor, Alfred Stieglitz. My first posthole is dug at the site of a single photograph and a short verbal sketch of a few hours one snowy night. If the dig is not too tedious to watch, it should have the merit of bringing a crucial series of scenes to life for the reader, who may find the historical thread not so irretrievably frayed after all.

This is, then, a version of reception criticism, but of a double sort. Certainly it aims to weigh the present-day responses of critics to old images and texts; but more importantly it is an attempt to steer past these loaded viewpoints in order to penetrate the responses of readers and viewers, as well as artists and writers, of the time, when modernism was born in its various guises in the new worlds of American modernity. When what I am doing works well, I am recreating the conditions for being an audience *then,* regenerating my own readers as the contemporaneous audience (and witness) for art in the social and historical conditions of the time. I am as historical as I can manage, and hoping to fly below the ideological projections we make today, but of course I am also dealing in subjectivities—mine, ours, and "theirs." Despite the strongly felt, material presence of my scenes, I cannot claim that my interpretations and intuitions have greater truth beyond what I can understand, but I hope I have opened up enough room for my readers to bring their own subjectivities into play upon a large collection of facts arranged to complement one another in illuminating ways.

Many of the viewers and readers of the time were themselves aspiring modernists, or people otherwise engaged in the debate about the modern. Was one a postimpressionist, a futurist, a modernist, a Secessionist, or an avant-gardist, or merely doing one's best to confront a new cultural dispensation in artistic terms that would be honest about the values of the new? I prefer to leave in abeyance any tight definition of modernism here, mimicking the floating situation of the time. Stieglitz's term, when he used a term at all, was "the Secession," taken from the Viennese resistance to its own bourgeois culture; he had no precise definition, and in fact pretended that anyone doing good work could be a Secessionist upon deciding so. That was before he tired definitively of "isms." Arguably, such a wholesale rejection would have made him an anarchist, artistically speaking, and that may be one of the best definitions of early modernism because of how much freedom it permits, or demands. I myself am fond of the term "avant-garde" because it is meant to group all those doing new

work without specifying a more directed agenda, except for being in front. In any case, the most usual term of "modernism" carries a great deal of freight; it entails strictures which, in the English-speaking world, were primarily about writing, and were evolved by and for authors like T. S. Eliot, Ezra Pound, James Joyce, and Virginia Woolf. These authors are now associated with quite conservative social politics, despite the technical innovations that, for the most part, came out of a revolutionary avant-garde. I try to sort some of this out in chapter 5. In painting in America, the term is often used to describe the movements around abstract expressionism, thus a much later period after World War II; but it seems especially odd not to call Marin or Dove modern, not to mention "les peintres modernes," Picasso, Braque, Léger, and others. The term "modernism" never existed for these painters and poets of the cubist epoch in France until much later, in the writings of critics looking back, nor did it have much to do with politics then. For the French, Picasso and Apollinaire were "nouveaux," partaking of the new spirit, or "L'esprit nouveau," the title of a posthumously published essay by Apollinaire that Le Corbusier went on to use for his own periodical of the arts and culture. Also, still in the same period, the term "modernism" was a matter of no interest to the likes of Picabia, Duchamp, and Arthur Cravan, all three of whom play large roles in this book. They are avant-gardists, then. They also serve to show the degree of flux in the period, a very attractive flux I might add, when "isms" were attempts to label and then profit from what was otherwise happening quite freely, anarchically. Many aspects of what is now called postmodernism come out of this avant-garde; in part that contemporary reaction is a return to the roots of modernisms before modernism recuperated out of the avant-garde what it wanted for its own idea of a right-thinking culture.

Schorske's concentrated digging into his period of budding secessions is not the only progenitor of this book. For many years I have admired Roger Shattuck's *The Banquet Years* for its detailed account of the avant-garde in France at a similar period, and, closer yet to my topic, Dickran Tashjian's *Skyscraper Primitives,* a blow-by-blow history of the periodicals that played such a crucial role in the evolution of the arts in the American avant-garde. Peter Stansky's *On or about December 1910* would appear to narrow the historical focus down even more, though in fact he ranges far afield into the family histories and interrelations of Bloomsbury.[2] But my impulse is similar to his, in that I try to tease out all the details that may contribute to our understanding of a turning point in artistic consciousness. In a number of graduate seminars over the years, I had the opportunity to isolate one year or another of extraordinary production in American literature and culture, 1925 for example,

and to have us examine, as a group, both the causes for such a concentrated splurge of creative energy and the feel of that energy as it emerged before a curious or baffled public. This study plays out as a sequence of such examinations into the progress of the avant-garde.

One may well wonder about the relative invisibility of the Secession in New York in the histories of modernisms. Eliot's poetic modernism had obscured, when it did not co-opt, the earlier work in New York and Paris, as he tamed an exuberant avant-garde into a more solemn performance of new techniques. The revolution of cubism in Paris entirely eclipsed Marin or Dove, whose work in New York remained without apparent influence upon other artists, and it took the rediscovery of Dada in the 1950s to remind us of the multifarious manifestations of that antimovement in New York before Tzara plucked the word out of a dictionary in Zurich.[3] If not for Roger Conover's devotedly researched edition of the striking work of Mina Loy, a poignantly modern poet would not be known to us at all.[4] Finally, the sustained indifference of the art communities to photography served to split the work of Stieglitz into two: his galleries were important for art, his photography was important only for photography. More recently much has changed: our distaste at the conservatism, in so many areas, of Pound and Eliot's modernism has taken much of the glow off that word, and the work on Dada in New York by Francis Naumann, along with work instigated by him, has amply demonstrated the remarkable vitality of the anticonventional arts in New York about the time of the famous Armory Show.[5] The important double role of Stieglitz is now celebrated, notably in the monumental works coming out of the National Gallery in Washington under the guidance of Sarah Greenough.

Indeed, why then Stieglitz at this juncture, when his work and influence are now a terrain secured twice over? In his own time, many of his contemporaries worked to praise him as the embattled impresario of European and then of American avant-garde painting—"a real creator of creators," wrote Hartley—as well as to exalt his virtually one-man creation of photography as an art form—one thinks of Paul Rosenfeld's personal summa, *Port of New York* of 1924, which remains a sensitive and intelligent piece of admittedly impressionistic criticism.[6] Stieglitz was both gadfly to American provincialism and renegade promoter of American art. Defended by a small coterie, he acquired the status of a myth. Somewhat neglected or taken for granted into the sixties, he thereafter gained his own chapter in histories of American art as the guiding spirit behind a little gallery that exhibited new work before the Armory Show. William Innes Homer reasserted the photographer's central importance for American art; a bit earlier Bram Dijkstra's *The*

Hieroglyphics of a New Speech made Stieglitz's work relevant to innovations in poetic language.[7] But most recently criticism has found it important to demolish the "myth" in the name of at least two academic agendas. To defend Georgia O'Keeffe as an early feminist—a role she had little interest in—some critics have found it useful to portray Stieglitz as an unregenerate Victorian (admittedly, he was thirty-six and already famous in 1900). Worse than merely underevaluating the abilities of women artists, for a number of critics he played Svengali to O'Keeffe's Trilby, and it has been argued that she would have done better without him. In the name of a more rigorous, gendered appraisal, we are being asked to trade an old Stieglitz myth for a new O'Keeffe one. Also, in a number of gay studies Stieglitz is considered verging on homophobic: he is faulted for not supporting Marsden Hartley as much as he did his heterosexual male artists; and the wily photographer is deemed bent on sabotaging the career of F. Holland Day. Curiously, Stieglitz went on to offer this Boston colleague lead billing in the inaugural issue of *Camera Work,* the keystone of the Secession. I find it telling that, Day having turned down the honor, Stieglitz featured a woman photographer, Gertrude Käsebier. As for Hartley, his recently published correspondence with Stieglitz ought to put to rest any idea he was neglected by his "dealer." To deflate the myth, critics require a less remarkable man, one who could not have performed principled, selfless deeds in support of O'Keeffe or Hartley, not to mention Marin, Dove, Strand, de Zayas, Steichen, and photography in general, but instead took advantage of these artists for his vainglorious self-advancement as leader of American modernist art.

It is a natural and productive reflex for the academy to put old myths to rest, but it makes weak sense to argue that a single, and singular, person working against the grain conforms to a period stereotype, one we have constructed to assuage the social ills of today. Rather than revive a crippled myth, my goal is to see what truth resides in it that was impressive enough to set it into place. Between the myth and its debunking there is a space for history; not a history independent of our desiring, but one that is the product of a sustained effort to move toward it rather than indulge in either idolatry or demolition. My postholes excavate a version of Stieglitz's biography, his lives in art presented in fragments but, in its essence, not at all frayed. It is a voyage through the "isms" of the early third of the century, when the photographer and his friends worked past isms altogether. There is little doubt left in my mind that Stieglitz was an exceptional personality, and I propose to prompt the record to show that, if it will. He was certainly thoroughly human, for example overbearing enough in his convictions to alienate many who disagreed with him. But that does not mean he did not behave in various ways and in

many areas far better, more brilliantly, or far more interestingly than most of us. And in particular, more generously. For him, generosity of spirit was an American ideal, the reflection of a spirit-saving indifference to personal profit. It would be natural for such generosity of spirit to lead to a myth of a man; but it is a personal quality, one which any agenda based on conflictual models of behavior among social groups is ill prepared to encompass. A politicized agenda is inclined to see Stieglitz as the scheming architect of his own myth. I am leery of assuming the myth is entirely hollow merely because any myth deserves cutting down to size. I wish my own close-ups to bring to light his well thought out and focused determination to keep artwork faithful to modern, personal experience, in his own work and in that of a number of others. It should not cloud our view of him that, in comparison, our own unexceptional failures tend to make his principled commitments appear mythical.

As to what other biases run this study, it will have to be for others to point them out to their satisfaction.

Acknowledgments

I gratefully acknowledge permission to reprint or quote from the following publishers: to The University of Illinois Press for "New York Secession," in *Modernism: Challenges and Perspectives,* edited by Monique Chefdor, Ricardo Quinones, and Albert Wachtel, 1986, which was a shorter version of my chapter 5, "Mechanics of the New York Secession"; to Peter Lang for "The Coming Storm of Modernism," in *American Modernism across the Arts,* edited by Jay Bochner and Justin D. Edwards, 1999, a shorter version of my chapter 1 of the same title; to New Directions Publishing Corporation for "Overture to a Dance of Locomotives" (excerpts), "Drink" (excerpts), "The Great Figure" (excerpts) by William Carlos Williams, from *Collected Poems: 1909–1939,* volume I, © 1938 New Directions Publishing Corp., and for "Improvisations" (excerpts) by William Carlos Williams, from *Imaginations,* © 1970 Florence H. Williams, used by permission of New Directions Publishing Corporation; and to Farrar, Straus and Giroux for excerpts from *The Lost Lunar Baedecker* by Mina Loy, works of Mina Loy © 1996 the Estate of Mina Loy, introduction and edition © 1996 Roger L. Conover, reprinted by permission of Farrar, Straus and Giroux, LLC.

My thanks for perceptive and constructive readings of portions of this book to Carol Kahn, and to my longtime friend and colleague John

O'Neill, who has followed the development of this study over many years. *Un grand merci* to Maryline Leducq for her toils at the Jacques Doucet Library (Paris); and to Roz Hain, Carla Schultz-Hoffmann, and Anthony Montoya for their kind generosity. My deep appreciation to the Faculty of Arts and Sciences of the Université de Montréal for their substantial financial support of this project. Further generous support was provided by the Society for the Protection of American Modernists, which I hope will find its confidence was well placed in this defense of the Secessionists.

Finally, my grateful thanks to my editor, Roger Conover, for his commitment and patience during a long wait which never fazed him.

An American Lens

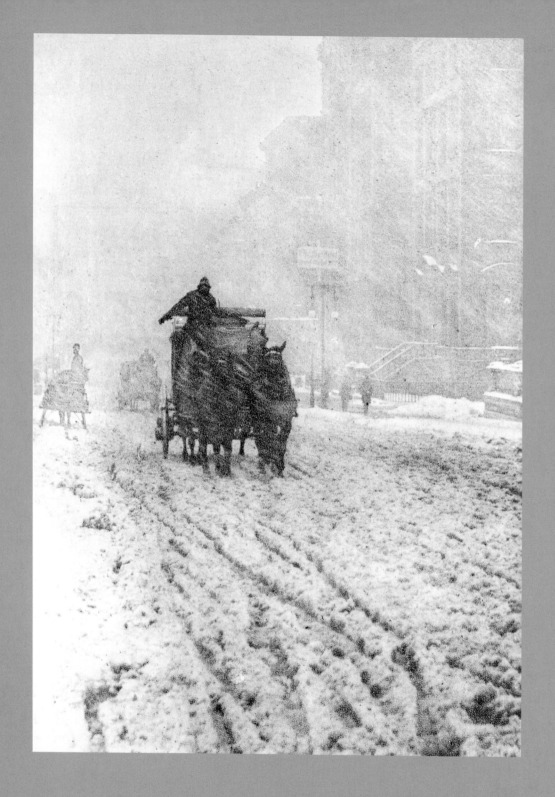

1 The Coming Storm of Modernism (1893)

When does modernism start?

Early and late, apologists convinced us that modernism arrived with a single shudder, breaking suddenly with the past on all fronts. Many cultural changes come down to us in this shape of a single determinate birth, but in truth this one, no doubt like many of the others, has many markers rather than one. Generated by our enthusiasm for this artist or that, one writer's performance or declaration, a critic's lucky or exasperated coinage, such markers are easy to multiply: an early *Mont Sainte-Victoire* by Cézanne, or Virginia Woolf's famous though enigmatic "On or about December 1910 human nature changed," or Louis Vauxcelles's reference to paintings by Braque at the 1908 Salon d'Automne as "bizarreries cubiques."[1] With those three—a breach with the painter's brushstroke, a breach with self-consciousness, a breach with representation—we are yet ten years short of Joyce's *Ulysses* and Eliot's *The Waste Land,* and almost twenty years too late to credit Rimbaud. I am now about to add yet another marker, an early sign of modernism working out its radical premises, somewhere in the middle of all these, and proper to photography but with implications for modernism in the other arts as well. The ability of this photograph to radiate its meanings toward the other arts is precisely what gives it its special importance.

Early photography was, arguably, modern without yet knowing it. Its modern quality was due to its absolutely new means of representation, not its content, though the distinction is already blurred in what is frequently accepted to be the very first photograph, Nicéphore Niépce's 1826 view of buildings, which strikes viewers of today as having an extraordinary resemblance to the minimalist planes of Picasso's Horta de Ebro cubist paintings of 1909. Photography, in 1826 as sixty years later, was a long way from a medium for making art, whether ancient or modern. This industrial "art" evolved in two directions: at first it was refined technically to produce a traveler's documentary record, such as large-format, perfectly detailed photographs of Egyptian ruins; then, in what may have seemed a further if different sort of refinement, photographers attempted to make art pictures, an operation that entailed going backward, or at very least sideways to the knee-jerk codes and content of later-nineteenth-century academic painting. The special technique of this artiness was to focus fuzzily, in order to romanticize the image for the viewer's musing and remove the sense of the mechanical in the camera lens's just-about-perfect rendering. Neither of these two main directions for photography near the turn of the last century used the camera as a new medium for making modern artwork; quite the contrary, the camera's ability to produce an image that was either "mere" document or a dreamy copy of another art helped, as a counterexample, in formulating and confirming the value of painting as it stood at the time. It was largely by his ability to move beyond these distinctive categories of document and imitation that Alfred Stieglitz came to make and promote authentically modern pictures.

Surprising, then, to see the eminent scholar of photography Van Deren Coke open an important discussion of modernism in photography by removing Alfred Stieglitz from the list of contributors.[2] Coke is working from a very specific idea of what starts modernism, and he does feel the necessity of explaining the exclusion, which he makes on the grounds that Stieglitz curtailed his own work in a crucial period, 1915 to 1920, in order to promote modern painting in his 291 gallery. Tying modernism so precisely to these dates permits the critic to promote Paul Strand, Stieglitz's protégé, and to emphasize the very powerful formalism that became, at about that moment, the most striking aspect of the modernist revolution in the production of camera work. Strand's abstracted forms, which must have seemed inconceivable for a purely recording medium, embody well modernism's breach with the past; nevertheless, I hope the reader will follow me in seeing important earlier stirrings in work being done by Stieglitz, the younger man's mentor and the person who first showed his work to the public.

I take my cue from a remarkable coincidence, or synchronicity, underscored by Richard Whelan in his recent biography of Stieglitz: during the blizzard of 1893, when Stieglitz took his famous early picture *Winter—Fifth Avenue,* the writer Stephen Crane may also have been in the New York streets, keeping company with the out-of-work men who came to people his newspaper sketch "The Men in the Storm" (probably written about another blizzard in 1894). The sketch includes a description of a horse-drawn omnibus of just the sort we see in Stieglitz's photograph: "The street-cars, bound uptown, went slowly, the horses slipping, straining. . . . The drivers, muffled to the eyes, stood erect and facing the wind, models of grim philosophy."[3] Whelan credits Walt Whitman with generating interest in the omnibus driver, certainly a New York fixture, but I am more interested in the artists' response to their own times, in a difference in their readings of the environment as a place significantly changed, and as a place somehow calling upon them to change their work. I am arguing, in short, that this shared topic is no coincidence. Dreiser was to write about the photograph in 1899, and then used it, transmogrified into a painting by his hero, in *The "Genius"* in 1915. And Dreiser was also to use Crane's sketch, in one instance copying some of it out as his own, and most famously as a model for Hurstwood's last days trudging through the snow in the streets of New York near the end of *Sister Carrie.* So we are dealing with at least one turning point in consciousness, as American naturalism latches onto this weather front to assert its power against the dominant Victorian self-satisfaction of the period. As Michael Robertson has written, Stieglitz's photograph "served to establish the blizzard as a defining trope of urban experience in the 1890's."[4] But I see something significantly different from an obvious subject for social Darwinism in this urban experience: this photograph and Crane's sketch mark the beginning of a subtle modernism right in the bodies of Victorian propriety and its late-nineteenth-century antagonist, a heavy-handed naturalism, with its blunt portrayal of the demise of the individual in the face of natural and social forces. For what common purposes might we imagine the new men out in this extreme weather?

To begin with, just what are those social forces in 1893, as they might impinge on work that means to be creative? The main event of 1893 in America, which would have affected American artists merely because it affected everyone in every sphere of life, was the stock market crash and major depression that began early that year, to last through 1897. It was the most severe depression to date for the young nation and is somewhat forgotten today only because of the even greater depression after 1929. While accounts of the failure of Stieglitz's Photochrome

Engraving Company usually blame normal problems of business competition, matters could only have been made worse by the depression, which also made it increasingly difficult for his father to continue Alfred's stipend of $3,000 a year, this in the same year the young man married. The company's difficulties had already confirmed the photographer's growing feeling that it was impossible to offer the public any high degree of quality in a commercial product.

The first events on Wall Street that signaled the crash took place mere days after the formidable blizzard in which Stieglitz hazarded out onto Fifth Avenue with his shaky—that is, hand-held—camera to wait some three hours for the scene to compose itself. The Philadelphia and Reading Railroad declared bankruptcy on February 26, four days after Stieglitz stood guard in his storm, and on May 4, after a month of wild fluctuation in the stock market, the National Cordage Company collapsed for want of working capital.[5] Transportation was a key, sore issue of the times, and so it may be no accident that this epoch-making photograph should be of a much-awaited streetcar.

One may imagine the young, already famous photographer walking out of his father's house, despairing of commerce no doubt but even more of a lack of direction in his personal as well as his photographer's life.[6] He appears not to be looking for something in particular, but rather for anything different from his fate indoors, where he has just left his unwieldy, large-format camera on its stolid, may I say Victorian, three feet. The dullness of a hazy pictorialism, all softened focus and forest nymph-ridden, has driven him into the streets looking for a new experience, something suddenly real in the street. Although we cannot see him responding to the crash directly, we do see his discontent as premonitory in its heightened sensitivity to an idle culture. His challenge in the street is, in fact, to demonstrate a higher sensitivity for the photograph.

There were plenty of signs to imply rents in the social fabric and make people wonder how well it was holding, or whether it should be permitted to hold at all. We know the Gilded Age was a time of immense change in American life: a time of slowly growing, often threatened prosperity for the middle class; of powerful concentration of wealth, first in the hands of a very few well-known entrepreneurs, then in the offices of trusts and corporations that consolidated innumerable holdings into quasi-illegal monopolies; finally, immense change for a large working class, created by industrial growth but now under continual pressure for lower wages and longer working hours, as businesses went head to head for control of markets and industrial inventiveness eliminated jobs, particularly skilled ones. The market crisis was itself an epiphenomenon, a crisis in confidence on the part of investors produced,

in large part, by extraordinary labor strife before this year of 1893 and, once the crisis became a depression, worsened by yet more frequent and serious strikes. In 1877, a mere twelve years after the end of the War between the States, and eight years after the Union Pacific and the Central Pacific railroads linked Atlantic and Pacific coasts, the first national strike in America was declared, "after four years of repeatedly reduced wages."[7] This point should be stressed; invariably strikes were called not because owners refused demands for salary increases, but in response to the companies' cutting wages, even in periods of formidable expansion and profit. The number of strikes in this period is so shocking that its very reporting seems out of control: Fay Blake gives the official report of the Government Printing Office for 1886 as 15,000 strikes between 1880 and 1887; Tony Tanner writes that William Dean Howells was aware of the "more than 10,000 strikes that had disrupted the economy in 1886," including a "prolonged traction strike in New York while he was finishing his novel [*A Hazard of New Fortunes*]"; and Jay Martin reports an average of 6,000 strikes annually for the years 1886 to 1894.[8] Whatever the exact numbers might be, the results of this plethora are, for my purposes, double: unlike the invisible stock market, striking men were a startling and ubiquitous reality, reverberating in the reflecting mind even if the full implications for the economic system as a whole might remain somewhat obscure; and, at any crossroads in one's daily life in an American city, one might chance upon a strike in progress, perhaps even be caught up in its violence, as both Howells and Dreiser (and later Dos Passos) were to dramatize it.

Without straying far afield from 1893, it is not difficult to find three strikes that left their deep mark on history and that reflect upon the market panic of that year, as well as on the mindset of the artist in the storm. In May 1886 a strike at the Chicago factories of the McCormick Harvester Company resulted in six dead strikers. A protest meeting was organized, mainly by anarchists, in Haymarket Square. Even though the mayor himself visited the rally and reported to his office that the crowd was orderly, police descended upon the gathering. Someone, to this day unidentified, threw a bomb, and a number of policemen were killed (along with a smaller number of citizens). The authorities rounded up eight well-known anarchists and tried them successfully without any evidence. Anarchism had now become a threatening presence on the American scene, as fearsome as witches in Salem, and for hardly better reason. One of the convicted anarchists committed suicide, and four were hanged; the others were jailed. Howells wrote his father: "it's all been an atrocious piece of frenzy and cruelty, for which we must stand ashamed forever before history."[9] It was clear to Howells that

the illegality of the proceedings undermined the moral stance and pretensions of the genteel society he belonged to. Haymarket prompted him to write *A Hazard of New Fortunes,* which for much of its length does not seem to be overly concerned with social issues; but these sneak up on the reader, in the figures of both Conrad, son of Dreyfoos the new capitalist, who is killed by a policeman's bullet during the streetcar strike that ends the narrative, and Landau, the impoverished old socialist who lives by posing for biblical paintings and reviewing foreign books. He will die as well, after a clubbing from police in the same scene. Exclaims Basil March, Howells's narrator and stand-in (he also appears in other novels): "It's the policeman's business, I suppose, to club the ideal when he finds it inciting a riot."[10] I read less irony here than resignation. Basil observes and sympathizes, but, like Howells himself, who was courageous enough to protest the Haymarket affair in public, he cannot effect any important change. Howells is a witness, and writes a novel of witness, which is not nothing; but there is pessimism for the future of American society in his rhetoric. Thirty years later a writer with as little special concern for politics as Willa Cather has a working-class man distressfully rank Haymarket with the Dreyfus affair: "He brooded on the great injustices of our time: the hanging of the Anarchists in Chicago. . . ."[11]

The Haymarket trial had another remarkable witness, whose life was changed by it. She was a slight girl of seventeen, and had been in America for only five months, living in Rochester, New York. If the authorities had known what intellectual fire they were to set blazing for the next twenty-five years, they might have conducted themselves with more circumspection in Chicago. By her own admission, the Haymarket made Emma Goldman into "an active anarchist."[12] By 1889 Emma had moved to New York, to apprentice herself in political thought to the most influential anarchist still at large in the United States, Johann Most. By 1892, the year of the Homestead strike, she was twenty-three and strong enough to part with the dictatorial Most, to share her future with the ill-fated Alexander Berkman.

My second instructive strike, Homestead, was a bitterly fought industrial dispute that became emblematic of the disastrous relations of high capital with working men six months before the 1893 crash. A union of highly skilled workers was at the table negotiating the company's demand to lower wages by some 22 percent, to match lower prices in the market for steel. Henry Clay Frick, who had made his first fortune out of the panic of 1873, managed Andrew Carnegie's steelworks with such an iron fist that his tactics embarrassed his own employer. In July 1892 he broke off negotiations and, after evicting the employees' families from company housing, brought in three hundred Pinkertons to

remove the striking workers and protect his scabs. An armed battle ensued with dead on both sides. The conflict had all the appearance of a small war, with the already infamous Pinkertons arriving on river barges to outflank the strikers, who had been warned and managed to fight off the landing. Eventually, the outcome was decided by government militia, who entered on the company's side.

On the occasion of this bloody and well-reported strike, Berkman, Emma Goldman's lover, decided the moment was right in the history of American labor for a desperate or "direct" act. On July 23, 1892, he attempted to assassinate Frick in his office. Emma, while always (at least later) resistant to the *attentat* version of anarchism, nevertheless sought to raise the five dollars necessary to purchase her friend's gun by prostituting herself on Fourteenth Street; an elderly gentleman recognized how miscast she was, gave her the money, and admonished her to go home.[13] Having failed to do better than merely wound Frick, Berkman and two accomplices were jailed; their convictions were a running concern of the *New York Times* in February 1893 (the month Stieglitz took his photograph), with articles on February 10 (2.4), February 11 (5.2), February 12 (11.7), and February 26 (13.3). It is important to sense the fatal quality in the outcome of this strike, as in almost all the strikes of the period. Although with hindsight we may see labor just beginning to flex its organizing muscles, workers always lost, and in defeats that were bloody, debilitating, and apparently fruitless. The government was clearly on the side of employers, as was entirely logical within the context of industry and nation stretching imperially westward together. The striking worker appeared un-American, even to himself, since his protest against what was already termed wage slavery conflicted with his own general a priori approval of the "free" market. Further, labor strife was taking on more and more of an ethnic polarization, nowhere more so than in New York, and the *Times* was already calling for a suspension of immigration, largely in response to socialist and anarchist demonstrations meant to organize workers. In the habit of denouncing anti-Semitism at home and abroad, the *Times* was nevertheless capable of the following disgraceful language about Emma Goldman: "On this base and poisonous diet [radical literature] the hatchet-faced, pimply, sallow-cheeked, rat-eyed young men of the Russian-Jew colony feed full. . . . On these depraved, diseased, diabolical natures the appalling nonsense of creatures like Goldman falls like alcohol on a kindling flame."[14] In jail, Berkman was chagrined to learn that workers he met there believed he must have acted for some personal profit or out of a personal vendetta against Frick.

There is no evidence of Stieglitz's being concerned, in any specific way, with these two famous strikes or with the sorry plight of the

American industrial workforce, with which he had little personal contact. As a well-established Jew of German background, he had yet to develop a rapport with the newer waves of immigrant Jews. His background was decidedly bourgeois and, until 1890, quite European. But his understanding of the financial nexus, of an America beholden to commercial success, was acute when he returned to New York in that year, and it produced in him disgust and depression: "Everything seemed crass, greedy, filthy, abrasive, selfish. Instead of life he found a diseased and directionless kinetic, in which the only energizing force was money."[15] He could hardly have felt differently from many Americans who saw well enough the complex, incestuous, and inexorable world of "king bank" and "robber barons" buying up the country, as Frick's coke mines fed Carnegie's steel mills, which in turn fed Pullman's luxury train cars and supplied the rails that tied the West Coast to eastern trusts. Henry Adams, another American despondent over the commercial betrayal of American ideals, wrote: "A banker's Olympus . . . became more and more despotic over Esope's frog-empire." With the extreme concentration of wealth and the collusion of public authority, there seemed little possibility for action. Alfred Kazin later summed up the sense of oppression: "the image of a closed frontier, of a corporation economy, of a city proletariat oppressed and rebellious, darkened the mind."[16]

Stieglitz's mind was not darkened on the picket lines or even, yet, in the streets, but by the production line's assault on the quality of work. At his Photochrome company he insisted on a high level of craftsmanship, and he paid his employees accordingly, but the number of clients willing to pay the higher prices for good work was quickly dwindling, even before the crash. This was the period of Frederick Winslow Taylor's early successes in rationalizing production, based in large part on increasing the efficiency of the most ordinary common worker. Taylor no doubt completed the alienation of workers, making their skills and workmanship antithetical to good production. Although he himself went bust in the 1893 crash, he nevertheless went on to teach a "plain handyman" at Bethlehem Steel to handle forty-seven instead of twelve and a half tons of pig iron in a single day: "The skilled mechanics were too stubborn for him, what he wanted was a plain handyman who'd do what he was told," wrote John Dos Passos.[17] Cheap, mass-produced products called for a benumbed worker. But from the beginning, and from within a technology-generated "art," Stieglitz advocated serious workmanship; photography required craft on the way to producing art, and this craft entailed expertise with mechanics, chemistry, and optics, all areas of skilled industrial work. And so even as a champion of photography as an art, he continued to refer to himself as a worker. His own adversary of choice,

rather than Carnegie, was George Eastman, who introduced his first Kodak box camera in 1888: "You press the button, we do the rest" went the famous slogan, which Stieglitz duly choked on. Writing in 1897, and after alluding to the new popularity of photography brought on by the hand-held camera ("This is what the public wanted—no work and lots of fun"), he indicts Eastman: "The climax was reached when an enterprising firm flooded the market with a very ingenious hand camera and the announcement, 'You press the button, and we do the rest.' This was the beginning of the 'photography-by-the-yard era.'"[18]

1.2 The Folding Montauk. Advertisement in *American Amateur Photography,* edited by Alfred Stieglitz and F. C. Beach, July 1895.

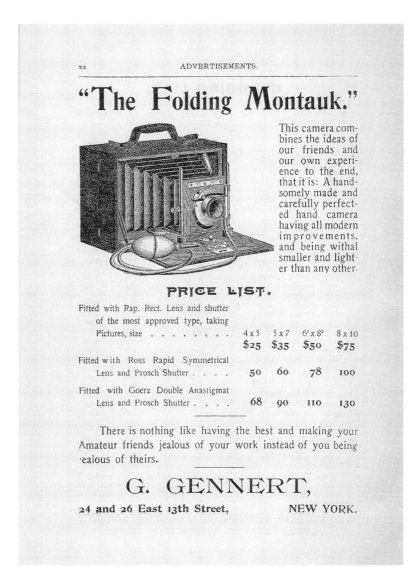

By the yard, indeed; this preloaded Kodak took 100 little round snaps, you mailed the camera back to Eastman, and he returned it loaded with a fresh roll, along with your more or less successful 100 mounted in cardboard frames. This convenience sold a remarkable 15,000 little boxes in 1889,[19] and by 1892 it permitted Eastman to become one of the first in the United States to produce a standardized product on a large scale.[20] Further, and more ominous, it set Eastman on the path to controlling virtually the whole of American camera image-making, from the fabrication of the popular Kodak through to photo-finishing, the picture "taker" now reduced to only a marginally significant contribution in the process of visualizing his own world.[21]

So, although Stieglitz went into the snowy street on February 22, 1893, with a hand-held camera, he in no way meant to become a cog in this photographic process. It is difficult to agree with Richard Whelan when he opines that Stieglitz was carrying a Kodak, even if it was not the little box model but another that had been modified to take four-by-five-inch plates.[22] While one part of Stieglitz's goal was to secede from the stodginess of his father's interior, another was to challenge the restrictions that the new Kodak immediately imposed. He was on his own craftsman's strike: he would not relinquish control of the frame or of the specific sensitivity of a single plate chosen for the job; he refused Eastman's fixed focus (a lens in any case inferior to what was easily available, from Goerz for example); and he especially refused the sunny picture, which was the only sort Eastman's little miracle could record. (One may well wonder about the determined influence upon the American consciousness, as Eastman took more and more of the market, of the American family's being recorded solely under sunny conditions.) Stieglitz was, in fact, challenging even better cameras, since it was considered impossible to shoot in blowing snow.

Along with technique, he was changing the subject, from thoughtful portraiture or pastoral repose to a working man under duress, confronting, like himself, a new technology. The strikes Howells and Dreiser portrayed were against companies running motorized, horseless streetcars. Although we have no direct evidence that Stieglitz was brooding over such conflicts, it is not difficult to read *Winter—Fifth Avenue* as a naturalist, politicized picture: the forces of irresistible technological change blanket the city (and the country) as one man, not heroically brave but doing his job with both stoicism and grace, urges his condemned animals up the avenue past his masters on "millionaires' row."[23] (A photograph by Brown Bros., taken about the same year, frames the same buildings in a different season, and even includes an identical carriage.) At the same time, it is not necessary to give over all of one's read-

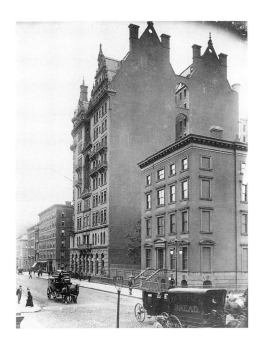

1.3 Brown Bros., 5th Avenue and 34th Street, between 1893 and 1898. Brown Brothers, Sterling, Pa.

ing to this naturalist one of distress at the victory of an aggressive, modernizing industrial America. There is independent, resistant life here; that is what has attracted Stieglitz into the street in the first place. Gentility has, for him, severed the relation of culture to work, and the photographer is working to revive the subject's vitality for a different sort of art. That vitality, for both the driver and the image, feeds on the storm, which is, after all, a natural phenomenon, like the horses; storm and team together show their muscle against the city, or at least against that sense of the city which we imagine represents the successes of industry and of money. The storm can all but immobilize this city, with this horse-driven exception which Stieglitz has awaited for some three hours at the corner of 35th Street and Fifth Avenue. Then he, too, immobilizes the city, the storm, and the team, asserting his power to give direction to "this New York of boundless misdirected energy and to capture a portion of that wasteful flow," as Lewis Mumford put it.[24] Capturing that gritty flow, in the 1890s, was in large part a work of documentary, even if future estimate has ranked Stieglitz on the side of art in a "camera work/social work" dichotomy.[25]

The first element of this document's modernism resides in the delicate balancing of the various vitalities of technology, modern city, triumphant storm, stoic man, and team, a balancing act that is clearly *performed*. If I appear to be seceding from the usual position that modernism chose to separate from high capitalist culture by a full retreat into art for art's sake and ivory tower formalism devoid of social import, it is precisely because Stieglitz has managed to give social value and signification to formal, balancing choices. Form here is eloquent about the social. Granted, this image retains a romanticism in its grace and gentle definition of forms that removes us from naturalism's protesting, sharp definition of oppressed toiler. But a comparative look at the final print we know and a print from the full negative tells us more. The image has been cropped to remove a number of distractions, including men shoveling snow, and to concentrate our attention on the driver and his team, which consequently have become individualized and, no doubt, more universal. That would be the first appraisal of critic and fellow photographer alike. However, another effect of the cropping is to turn the horizontal emphasis into a vertical one. The original, in its traditionally proportioned frame of greater width, expands outward to form a peopled landscape, with wide expanse of snow. The street is wide, and there is ample space to rest one's mind, as if one were in an open field. There is a sense of a wide horizon in the two almost aligned sidewalks. In contrast, the famous, cropped photograph brings us into the vertical city, almost bereft of people. The team and driver are no longer on the horizon but in

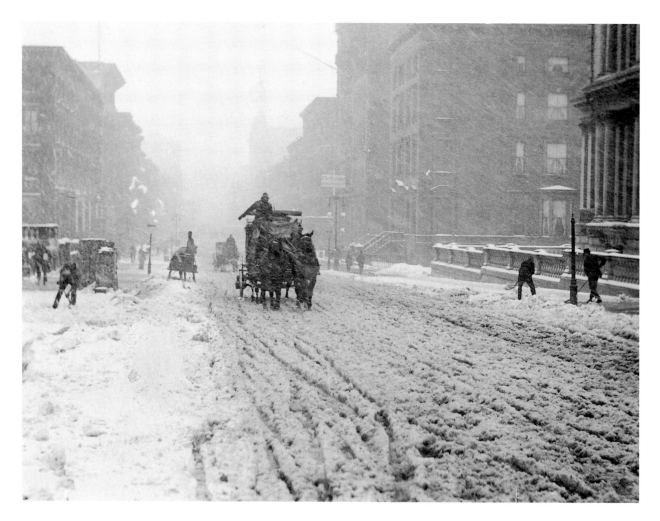

1.4 Alfred Stieglitz, *Winter—Fifth Avenue,*
1893 (uncropped). Courtesy George Eastman
House. Gift of Georgia O'Keeffe. © 2004 The
Georgia O'Keeffe Foundation/Artists Rights
Society (ARS), New York.

the shadow of the buildings. And the second streetcar has emerged from
its virtual insignificance in the "original"; it brings up the rear and sug-
gests a file of cars behind, each toiling alone but faithful to schedule. This
manipulation of form is not innocent of social comment or import. The
loneliness of the modern temper has taken the place of the communal
relatedness of people that naturalism had inherited from earlier culture;
but this man and team are not crushed, and may yet have their story.

I said the photograph, like the storm, has largely immobilized the
world of the industrious city. The camera has performed that stoppage
which permits us, now, to appreciate that the team will not be stopped.
With his older, view camera Stieglitz would not have attempted to inter-
vene in all this movement in the street. This is a candid "snapshot,"
made with what was then termed a "detective" camera, which permitted

a secret intrusion upon its subject. The subject has not posed, has not already been for some time in the attitude that will be the image; it is one of the first times an exposure has been devoted so clearly to conveying the flow of changing event, the stilled moment culled from change in order to convey the change. The anecdote, true or false, of waiting in the storm for three hours for this image to compose itself, reminds us that, for Stieglitz, only one special twenty-fifth of a second in particular would tell the story of the flow as he knew he saw it.

Beyond that, in a different game with time, he challenges the poor light and the stream of snowflakes speeding across his frame to give up their resistance to his recording machine. His fellow photographers had insisted that the image was beyond the capacity of their and his optics and chemistry, and so the image is a challenge to his community of would-be artists. He will wrest a moving reality from the worst of city and nature, and he can bend the modern machine to his will to do so; otherwise, of what value would modernity be? With his hand-held camera he enters modern time, and ushers man, horses, and weather of any time into modern times, on a more or less equal footing with the modern city. He is reinventing the camera for its own proper historical moment; as Ellen Moers has it: "If anyone can be said to have seen the urban winter as it had never been seen before, it was Stieglitz, for no such photograph had ever been made. . . . This photograph seems to have opened the eyes of New York to its own particular wintry quality."[26]

My third and last exemplary labor dispute is the Pullman Car Company strike, in the summer of 1894. Its outcome and ramifications were even more debilitating for working men and well-intentioned observers alike than the previous two discussed here. Obviously the strike could not have directly affected *Winter—Fifth Avenue,* taken a year and a half earlier, nor even the writing of Crane's sketch, but it does precede the latter's publication as "The Men in the Storm" in *The Arena,* a rare leftist journal, for October 1894, only days after Clarence Darrow rested his defense of Eugene Debs in the aftermath of Haymarket. Crane's foray into the mean streets of poverty took place that preceding winter, on February 26, 1894, thus almost a year to the day later than Stieglitz's sortie. Though not witnesses to the same blizzard, Crane and Stieglitz tramped through extreme weather that seemed to carry the same message for the Gilded Age, storms that expressed the savaged illusions about any American streets paved with gold for all. By the time of Crane's 1894 storm, the market panic had produced its full-blown depression, preparing his reading public for the sorry Bowery scenes he lived and portrayed (but even before the crash, Jacob Riis had reported that 14,000 homeless men looked for a bed around the Bowery every

night).[27] The Pullman confrontation may go just a bit further than some of the other strikes to show why Stieglitz and Crane were, already, responding to a state of affairs that went beyond the ken of naturalism.

The situation at Pullman was remarkable in the land of the free in that George Pullman owned the town of Pullman, Illinois, its factories, housing, stores, churches, and trees. His taxes were frozen at farmland rates, while some of his more modest "shanties," which could be built for about $100, rented to workers for $98 a year. My source, the Reverend William Carwardine, reports that as many as five families shared a single faucet; it delivered at ten cents water Pullman bought at four cents.[28] But not to live in Pullman meant not to be hired, or to be hired last and fired first in his factories. As one worker was reported to say, after being born, fed, taught, and catechized in rooms Pullman owned, "when we die we shall be buried in the Pullman cemetery and go to the Pullman hell."[29] It would be difficult to distinguish these workers' lives from those of sharecroppers, except for the scale of the operation and the fact that Pullman was a suburb of Chicago, a modern industrial city. The situation was quite simply feudalism, presumably benevolent. Pullman called his workers his "children." Indeed, his workforce included many women, who worked on upholstery, curtains, table linens, and so forth.

From 1893 through 1894 Pullman reduced wages by an average of 33 percent on the grounds that, because of the deepening depression, he was obliged to underbid to keep his "family" in work (whom he had to underbid is never clear; he ran a monopoly).[30] Actually, most of his work was on repairing and refurbishing the many sleeping cars he had put on the rails to get well-to-do Americans to the World's Columbian Exposition of 1893 in Chicago, and he did not have to bid on this work. Meanwhile, he refused to reduce rents in his town, but deducted them (illegally) from pay envelopes. After the workers struck in May 1894, Eugene Debs, fresh from some successes for his American Railroad Union, agreed to a sympathy boycott of all trains that included Pullman cars, and this boycott closed down service across the country, most thoroughly west of Chicago. By July Debs felt that the Pullman workers had just about won, when President Cleveland intervened with some 4,000 U.S. deputy marshals who served on the trains (and were paid by the railroad companies).[31] Later that month a federal injunction was issued; this was a historic intervention and especially biased since it was invoked in the name of the Sherman Anti-Trust Act, a law recently passed and intended for curtailing monopolies. Troops were sent to Chicago and the West ("over 12,000, or about half of the entire standing army of the U.S. at that time"),[32] and Debs was arrested, defended through to the Supreme Court, and jailed for six months, during which

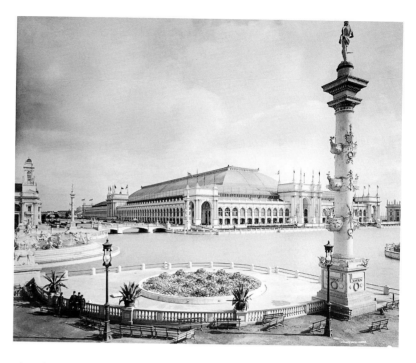

1.5 D. Arnold, *Chicago, Manufactures and Arts Building,* 1893. Platinum print. The Avery Architecture Library, Columbia University.

time his union was broken. Pullman rehired any of the strikers who tore up their union cards.

In such a manner the federal government had intervened, over the objections of Governor Altgeld of Illinois,[33] to safeguard a feudal monopoly and further "darken the mind," paralyzing democracy for a large segment of the population and appearing to freeze it out of the history of America. A far more acceptable official history was being written only a few miles away, in the construction of an immaculate "white city," the prototype for urban planners' dreams of a City Beautiful, though its function in 1893 was to be witnessed by an audience, and not lived in. The buildings of the Columbian world's fair utilized modern steel framing that was cloaked in "staff," a plaster imitation of stone facing meant to eulogize American industriousness with classical reference. The simulacrum was successful, memorialized by the fair's most famous tourist: "Thine alabaster cities gleam / Undimmed by human tears," wrote Katherine Lee Bates in her poem "America the Beautiful." Worker protest was stopped at the gates of what Trachtenberg calls an "incorporated society of Capitalism," and Pullman's fief, a predictor of this planned city, was represented in replica inside Sullivan's Transportation Building, which also housed two tracks of Pullman cars.[34]

But it is not the mere existence of such a utopian blueprint for a gated community that produces the official history of urban life; it must

be recorded and the record must be imposed. As part of their effort at public relations, the organizing committee for the fair gave over full control of the photographic rendering and the dissemination of its images to a single person, a minor but well-connected professional photographer named Charles Dudley Arnold, who produced spectacular platinum contact prints from negatives as large as twenty by twenty-four inches for the benefit of the architects, engineers, officials, and patrons who could afford his magnificent portfolios. These images were all in the "grand style" of architectural representation, combining fine vistas of Beaux-Arts facades with little or no attention to people; in fact, his photographs of the buildings while under construction manage to include no workers at all. Blithely innocent of any reference to the urban problems posed by the city beyond the pale of this one, "Arnold's photographs must be seen as an apologia for laissez-faire capitalism and a confirmation of the elitism of its beneficiaries," writes Peter Bacon Hales; his "visual documents would lock the symbolic language of the Exposition's forms into a timeless Rosetta stone," setting the model, for example, of the plan for Washington, D.C.[35]

Hales has determined that the resistance to Arnold's monopoly on the image of the fair came from two sources: the popular press, clamoring for independent access to the site, and Stieglitz, acting through his influence on, then his editorship of, the *American Amateur Photographer.* In particular, number 5, for May 1893, "bristled with attacks," often in the shape of reprints from the press, minutes from official meetings, and letters to government and fair commissions—a technique of exposure he was to practice later in *Camera Work,* as we shall see in chapter 3. Hales's description of Stieglitz's position underscores the importance the photographer gave to promoting democratic representation through an assault on old forms: "He saw the prevailing photographical style as sterile and conservative, and its linkage to undemocratic forces as fundamentally unhealthy to artistic progress in the medium. Change would have to come from outsiders free of the compositional formulae and the marketplace orientation inherent to the training system and the economics of grand-style photography."[36] Bowing to the gathered protest, Burnham and his committees took away Arnold's monopoly by midsummer of 1894, but the record that has come down to us is still that of Arnold and his single successor, William Henry Jackson.

To speak in terms of a "Rosetta stone" is to recognize that, if it is successful, no other stories of the city will be readable. Indeed, "America the Beautiful" does not vaunt one alabaster city but an American future full of such cities.[37] Theodore Dreiser's *Sister Carrie* was soon to permit Chicagoans another view. But, staying with 1893 and 1894, it is pre-

cisely the loss of an ordinary man's modest narrative that strikes us when we look at Crane's "The Men in the Storm" in the context of Pullman's and Burnham's utopias. Crane goes to the Bowery to "live" the empty evening of these out-of-work men on February 26, 1894, and he writes up his sketch the next day in his lodgings at the Art Students' League.[38] Crane has little story to tell, the men none. Crane criticism generally agrees on this point, that he successfully refrains from moralizing or sentimentalizing, from turning his "sketch" into a "tale." More than anything, it resembles a photograph, in the derogatory sense that term had for any writing (or painting) that seemed without point but merely stated the facts of the case.[39] The men's dialogue is almost meaningless, almost nothing happens with them, and they do not even show enough anguish or consciousness of suffering to qualify them for a dramatic role as victim. These men are being frozen out of their history, are merely specters in waiting. They show already, as if announcing Pullman's victory, that someone else owns history, and that they expect to make no claim for a story of their own.

Crane's novel *Maggie,* published a year earlier under a pseudonym, also strikes us with the inanity of its relentlessly repeated dialogue, indicating, even through Crane's exaggeration, the heroine's lack of resources in thought and expression in handling her world. When Maggie falls to prostitution, she cannot utter a word to entice prospective clients but can only wait for them to speak. How far this is from Emma Goldman's act, which, despite its failure, was part of a plan; she took charge of the story she wanted her body to inhabit, even if she bungled it.

But compared to "The Men in the Storm," even *Maggie* has a story, as the short novel winds down the streets relentlessly toward her suicide (an act that at least declares her protest at history). The "photograph" of "The Men in the Storm" begs not to move. Though Crane does provide a touch of closure as a door lets the men off the street and closes behind them, rather than treating the successful arrival at sanctuary as his ending, Crane prefers to finish his sketch in the street. The stage of the blizzard empties of men, while the snow continues to fall and swirl, at times in the same terms as those of the sketch's opening paragraph ("up from the pavements": page 66 and repeated on page 73). In this manner the static (and poetic) quality of the photographed document is underlined; the stormy street remains, while the men pass out of relevance, society doing no better than to get them out of our sight one night at a time. Crane's treatment of these men without names or value is markedly different from Dreiser's use of Crane's sketch and from Dreiser's own sketches on similar topics. Ellen Moers has detailed the subtle shifts as Crane's narrating "one" becomes Dreiser's sketched character as "one," finally to

be transformed into a named person, Hurstwood.[40] Hurstwood has a story; the sad narrative he embodies is so strong as to challenge that of the titular hero of the book, Carrie. This is where Crane's little work is almost untenable, too shorn of meaning for the Gilded Age: it dares to remain a fragment, defies social commentary as well as sympathetic involvement. These men, though neglected, do not suffer in the ways that Hurstwood does, full of emotion about his fate. They do suffer, deprived of all but their coats, yet they are so deprived that they seem not to know it; poverty and hunger actually pale before the consciousness of being cold. That cold, then, remains on stage, after they are dismissed without their stories. The cold is the only thing left to tell any sort of tale.

Having freed his stage of narrative and character, Crane has been credited with a poetic, "impressionistic" technique, or eye. Indeed, it is the description of swirling snow, falling snow, snow-covered coats, sidewalks, and buildings that dictates the meaning of the text, as Crane distances himself from the fate or nonfate of his men, writing, as Alan Trachtenberg has it, "from a curiously asocial perspective."[41] After the snowy stage is first set, "The Men in the Storm" opens with characters who have access to comfortable lives: "There was an absolute expression of hot dinners in the pace of the people." These hot dinners are "a matter of tradition," "from tales of childhood," and further connect with a sort of pastoral on the opening page: the men shoveling the white drifts "created new recollections of rural experiences which every man manages to have in a measure" (we recall Stieglitz has shoveling men in his negative, cropped out for the final print). But when we shift to the West Side, "there was a collection of men to whom these things were as if they were not." It is an odd turn of phrase, searching awkwardly. It is not that the men have forgotten hot dinners, or that they have been excluded from the table, or now pine hopelessly for them; they appear to have been removed to another world, one in which hot dinners do not even exist to consciousness. They have no will to dine, as the snow "acted as drivers, as men with whips" to bring them to this charitable house. The storm drives the mass of unnamed, unindividualized men to this small door as if they were less than powerless, inanimate: "the crowd was like a turbulent water forcing itself through one tiny outlet."[42] It is this work with imagery that made Crane remarkable among the naturalists or realists, as he endows the dull human scene with movement (and usually color; but this is snow, at night) in the viewer's perception. At the same time, however, he has displaced the human qualities of people and turned them into objects.

Michael Robertson, most recently, has examined how Crane's figures of speech "fracture the men into outerwear or body parts," "calling into

question not only class hierarchy but stable human identity."[43] Though such a conclusion, in which postidentity politics is granted higher value than class distinctions, is attractive to us today, I do not think it fits Crane's operation better than an older discourse on reification. The sketch's well-known example in this text is: "The snow came upon this compressed group of men until, directly from above, it might have appeared like a heap of snow-covered merchandise." Not only have the men been compressed out of individual existence and then alienated into things, but those objects that now stand in for them are a product for market. A page later they acquire some "grim" humor: "one doesn't expect to find the quality of humor in a heap of old clothes under a snow-drift."[44] While the men have been rendered into objects, they may yet retain a touch of the human, a faint memory thanks perhaps to becoming less than marketable, as inaccessible rags (in a way, they are coerced into being bohemians, people subtracted from the marketplace). The thorough alienation of these men threatens to remove them entirely from a world of social conflict, one which is necessary to feed even naturalism. Meanwhile, and in some opposition, Crane's images raise the language that sustains them to a brighter place in the reader's mind; even this short sketch exhibits some of the luminosity of his more colorful though ironic situations. What signals a move into modernism here is how Crane's language permits him to rescue the situation of reified people and to impart a sensuality, limited as it may be, to a bleak scene that was tailor-made for the naturalist's freighted pen. Crane has doubled the moment, playing man as product or object against man with "American" humor. This is certainly one operation in which we discern his irony. A scene which in 1894 was otherwise destined to be ideologically driven, whether from morality or politics, and thus to run thin for later readers, has been thickened with a fleshy body of language. Without screaming, it still indicts gentility while it seduces the genteel with tactile language. The reader is brought to touch these humans who have been dematerialized of their eventfulness, to poke into the lost bodies his society has inured him to. The humor, their irony about themselves, lasts only a moment within the hardly large moment of the eight-page text, but it translates Crane's own attitude, his ironic distance from the lost and useless men and his ironic substitution of poetic weather for his subject. As readers, we approach the dynamics of modernism's imagism, while we remain embedded in the social.

A similar poetizing transformation, while it cannot be put into words, can be seen in *Winter—Fifth Avenue*. The city appears stark, but not so forbidding that it cannot somehow be dealt with. The man and team are very much alone among the snow-bleached buildings, not so

much in terms of other people lacking in the scene, for there are a few, but in terms of their separate and heightened tonal presence. Stieglitz has given them more body than any other element, noticeably the buildings, which could easily have stood more heavily, oppressively. Within that strong and controlling presence, car, horses, and man's body are compressed into a vigorous boxed mass where the separate parts are further bound together as the snow hatches across their joined forms; but with this main exception to the box, that the driver's right arm swings out from his body and from this shape held in common by car, team, and man, and in counterweight the rest of his upper body leans ever so slightly back over the top of the box. That arm's grace is made crucial in the photograph's moment, for that moment at least, set at a determined right angle to the blowing snow, as if finding grace and strength from the city street and storm it is working against.[45]

As compared to Crane's language, which can fairly declare its desire to be tactile, the picture merely shows itself to an audience that may or may not choose to feel what it sees. But there is enough here, in slush, arm, horses' breath, stone of vacant building, and evanescent streaks of snow, for the whole effect of the scene to be, in 1893, emphatically felt as compared to so much work in painting as in photography that supplied the "picturesque," which is a sugared idea about the physical in the place of the thing itself. Dispensing with comment, Crane and Stieglitz have found, for a moment, American places without American myths: the writer will not tell us why these men are poor or how they will turn their rags to riches tomorrow; the photographer has shown neither the quaintness of horse-driven carriages nor the elegance of prosperous Fifth Avenue. They both refuse a transforming Victorian narrative or lesson, while still working short of a revolutionary one. They accept the fragment as their modern lot and claim some comforting beauty for it, lifting it out of while not entirely disentangling it from the "darkening of the mind" that is the fate of a freewheeling acquisitive life. These fragments are small enough pauses of concrete experience in the growing abstraction of American materialism; but they are early signs of the modernist poet's desire to recapture a lost or suppressed world of the senses.

The difference for naturalism was that, very much like Victorian culture, it too called for a long narrative, but in its case to detail the long grinding down of the well-polished surfaces of gentility. Dreiser is, of course, the prime case in point. Howells can present a somewhat different but related attack. Embracing the "photographic" commonplace in *A Hazard of New Fortunes,* he initiates a search for a New York apartment that preoccupies the protagonists for the remarkable length of some sixty pages, in a bizarre form of realism that looks more like Italian postwar

neorealist filmmaking. Addresses, porters, steam heat, elevators, decisions, and indecisions are all too real, and full of bourgeois concern tantamount to anxiety. It is as if the genteel had its own tail in its mouth, swallowing blithely with no consciousness that its consuming self was disappearing into its own process. In the place of a modernist extraction of the sensual fragment from a desensitized and desensitizing age, Howells's attack spins an *ad absurdum* narrative in which acquisition beats itself softly senseless. For both Dreiser and Howells boredom is important, a long, drawn-out narrative that denies fun or success. Crane and Stieglitz prefer the difficulty of the storiless but palpable moment, which may function as an evocative fly in the industrial ointment. As compared to the work of these two early modernists, naturalism is capitalist in its way, as it accumulates mountains of detail, fills its pages with coveted products, to wage a quantitative war: naturalism was still about money. The modernists' relation to high capitalism is more akin to that of the anarchist, at odds with an alienating market system altogether. Rather than change politics, Crane and Stieglitz try to change hearts and minds by personalizing a piece of New York quotidian neglected by the age and making it radiate *as experience* in the reader or viewer.

One last important aspect of this modernism. Neither Crane nor Stieglitz are rejecting modernity, but both read very well the capabilities and meanings of changed technologies—newspaper and camera, in their cases—infusing these rapidly debased mediums with the force of their sensitivity to pry loose an authenticity not yet bought and paid for. Their fragments are in a way pirated; if the consumer was willing to let Eastman hijack his personal experience, Stieglitz, for one, would take some back, with a better negative, a better lens, and greater virtuosity in the darkroom. It is the *quality* of his image that is a sanctuary, and that sanctuary is not from modernity, which has after all produced the medium he is using and perfecting. Crane, for his part, is laying the groundwork for a prose initiated by the popular press but rendered in his hands capable of undercutting stock response. Both are trying to keep democratization free of a cheapening of means in mass production.

How precisely modernist was all this, before twentieth-century modernism? Photographer and writer, both in their twenties, did not have a "modernist" program but only wanted to do good, presumably new, serious and independent work. To see anew is a job for every generation. The naturalist and the realist were already seeing anew in the Gilded Age, with a counterideology. The modernism of Crane's and Stieglitz's two works lay in emphasizing the seeing alone, in being able to convey the importance of nothing more than an intense, unjudging gaze that clearly emanated out of sympathetic rather than presumably

scientific sensitivity. More recently, criticism has preferred to find any such powerful gaze to be suspect; Susan Sontag, for one, has seen in Stieglitz's new seeing, as in photography as a whole, an appropriation, a translation of a previously "innocent" reality into image, at once consumer product and new master of the real.[46] But in the contexts I have provided, I am sure it is apparent that there was little "innocence" in the reality behind the works. If we want to think of Crane or Stieglitz as appropriating those men's lives, they would more likely be doing so in order to rescue their bodies, for a sympathetic moment, from the darkness of such innocence as might have been granted by McCormick, Frick, Eastman, Pullman, Burnham, and Arnold when they refused to look at them as any sort of reality at all.

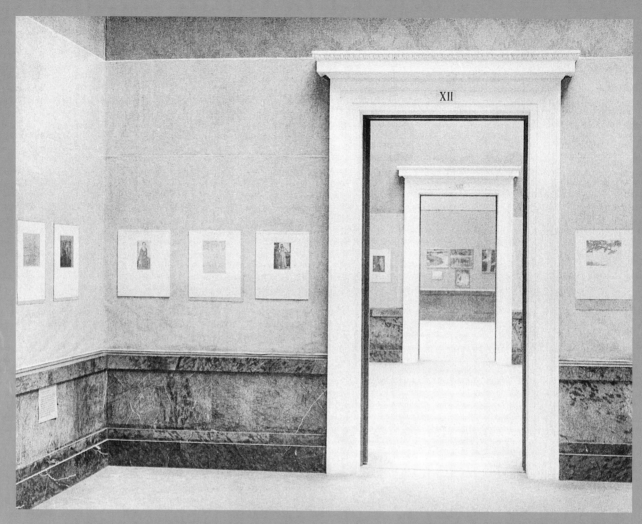

2.1 Karl Struss, *Interior View, International Exhibition of Pictorial Photography.* Albright Art Gallery, Buffalo, N.Y., 1910. Platinum print. © 1983 Amon Carter Museum, Fort Worth, Texas. The photograph is taken in the gallery devoted to Clarence H. White.

2 Conservation Frames (1910)

When Stieglitz took up the proposal of a major American museum to stage a decisive photographic exhibition, one that would finally admit photography into the family of the fine arts, he faced a number of tangled issues around the meanings and value of art and about its public display. The issues have grown more complex today because of our own much revised views of a museum's function.

In 1910, when he struck this his last major blow on behalf of photography, Stieglitz was hoping for the respect for his mechanical medium that would be conveyed by a museum's acceptance and endorsement. By show's end, he thought he had attained it. Since he was clearly looking for the museum's approval, he may not have seemed to be questioning its status as guardian of valuable, "high" art, nor the assumption that some artifacts are art while others are not special enough to be called by that name. But, in fact, he certainly was undermining these premises. He was not asking for one artist's admission to the canon, but seeking to compel acceptance of a whole new and "low" medium, a medium already well engaged in the very different business of documentary recording. He might not have been challenging the idea of canonicity, but his mechanical medium itself performed that job, as we shall see; it couldn't help but do so, and Stieglitz had to be conscious at times of this revolution in the

very foundations of the club of art. In 1910 we were yet many years from any other, similarly profound questioning of what an art museum should be collecting and assigning high value to.

Today we have become much more conscious, and critical, of a museum's exercise of cultural power, of its ideological assumptions when it chooses some works as high art at the expense of others, or imposes an institutionalized morality, politics, or social agenda through the narrative of art history it presents to the public. And there are layers to this revision, so that it is not enough to offer a new, postcolonial resistance narrative, for example, to cleanse the museum's lily-white hands and have done with it, as demonstrated by the events around the *Sensation* show at the Brooklyn Museum in the fall of 1999. There, an African Madonna bespattered with elephant dung (not even the most interesting nor the most outrageous work in the show) became the symbol of the "new" museum's freedom from the Western cultural narrative, a freedom defended, at least at first, by other museums, in opposition to Mayor Giuliani's old-fashioned stand for morality in art. The progressive public took its stand, only to be undermined by the revelation that most of the show belonged to the same London art dealer and was funded in part by a famous auction house.[1] All sides old and new being contaminated, we may prefer to fall back on a simpler determination: Is the painting any good?

But that question also has been contaminated when "good" is determined to be an ideologically driven concept, and we are forced to wonder further, to wonder what sort of thing art might be altogether. This is an inquiry for which we know few rules of conduct, except that we see it answered, ultimately, by the museum itself when it rationalizes its choices. Here photography stands in a special and especially ambiguous position, a document encroaching upon art, making the same image both artless and artful. By producing an image that may be either, or both, the photograph becomes a crucial test in the debate about what art is. Further, the two questions of the definition of art and of the quality of a given work merge and become more acute in the body of the photograph because it was easier, at least in 1910, to say any photo was not art than to say the same thing of an indifferent painting. While Stieglitz harbored no doubts that a photograph could be good art, he had to face the general opinion that even a very good photograph was not art as much as a very bad painting was.

Ironically, while Stieglitz found himself outside looking in, in 1910, because photographs couldn't be art, we find him put outside again, in 1996, when the museum decides that photography-as-art is too narrow a view of photography for a museum of art. I'm thinking of the National Museum of American Art's exhibition *American Photographs: The First*

Century. The freestanding art object is out, the contextualized archival record is in. Stieglitz is deemed to have instilled "a prejudice against images that did not fit modern aesthetic expectations," writes the curator. The "stuff of Stieglitz and Newhall" is the lightning rod for a critique that aims to justify turning the museum over to the "facsimile of the world": "For some photographs—likewise for folk materials, tribal goods, and decoration—the question of art is so perplexing it may have outlived its usefulness."[2] We have become tired of art, or at least of the question. Yet I wonder if the 1996 rhetoric of *American Photographs* has not mistakenly polarized the argument around Stieglitz, who was not, himself, keeping the archive out of the museum but only poor "art" photographs.[3] Leaving the more fundamental dilemma of what art is to Dada and a later chapter, I would like to pursue here the questions of whether a photograph can be art, even good art, and what one could do about it in 1910, in an art museum.

The Cost of Aura

To a large degree the debate about high art evolves around Walter Benjamin's concept of the "aura" and his prediction, and even hope, that the entry of photography into the world of art would destroy aura as the prime, defining quality of a work of art. For Benjamin, in his famous essay "The Work of Art in the Age of Mechanical Reproduction,"[4] the singleness of each work guaranteed for it (and its owner, its audience, . . .) a powerful presence, a quasi-mystical if not religious quality of unique value. The photograph, on the other hand, was one of a multiple, one in a series of identical, reproduced images. Could the art museum maintain its relatively newly forged role of arbiter and sanctifier of radiant art objects, yet permit photographs on its exhibition walls, not to mention into its collections? If photography was to become art, then probably aura could no longer be invoked as a necessary, ennobling attribute. Worse, photography in the museum might play something of the role of fox in the henhouse, discreetly despoiling other artworks of elite aura. Isn't Stieglitz just an elitist, demanding a place in the world of auras for his photographs? For Christopher Phillips he is, though it is the fox he decides to cite in an epigraph, to match a facing quotation from Benjamin that declares there is no sense to the idea of an "authentic" print: "My ideal is to achieve the ability to produce numberless prints from each negative, prints all significantly alive, yet indistinguishably alike, and to be able to circulate them at a price no higher than that of a popular magazine or even a daily paper."[5] This seemingly uncharacteristic and definitely democratic statement has to be reconciled, somehow,

with Stieglitz's lifelong commitment to the fine individual print, product of many attempts (as many as 100 in some cases) to find and balance the effects he wanted from his negative. Note that, above, he still requires "prints all significantly alive." Although aura will be severely undermined by the multiplication of prints, he still demands important contributions of craft and sensitivity to each. This is why Stieglitz, in this catalogue quotation, does not suggest that the ideal is easily attained; on the contrary he throws down a challenge to produce "numberless" prints of value. The aura of the good photograph would then be comparable to that of the fine, limited-series lithograph. A lithograph by Pierre Alichinsky, numbered 57th of a run of 99, is less unique, and probably less vibrant or "present," than one of his paintings, but it shows the attention of the maker's hand, mind, craft, and discrimination. The photographer can give that much attention to each print; thus, work with some degree of aura might still be attainable, as well as affordable.

Because we should not forget the monetary implications of Benjamin's aura. The uniqueness or singleness of the work makes it desirable and rare (or, speaking from the point of view of a market, scarce). The museum embodies authoritative verification of high value, since it is presumed to acquire and exhibit only a work it considers of value. At the turn of the century this term, in connection with art, still carried moral, spiritual, and aesthetic baggage—or at very least pretended to—but of course today critics and public alike are more cynical, or realistic. No matter the exorbitant prices already commanded by Picassos, a one-man show at MoMA will increase them, just as they increase audience attendance. This phenomenon even has a name, "exhibition effect." If I lend a piece to a prominent show, I thereby increase its value on the market or as an eventual gift for a tax break, unless of course its new spotlight reveals it to be a fake, which has no aura. (However, recently a copy could gain a perverse value, signed by its new "artist.") The work, even as it hangs on the museum wall, generates within its frame a moneyed aura, especially if it is an item the museum has recently acquired with due media attention to the disbursement. Though Benjamin saw an iconic aura in uniqueness, it is also in the maker's name, the owner's name, the dealer's and the museum's renown, and all the attendant buzz. Finally, it may not be possible to separate the financial component in a work's aura from any of its other presumably more laudable components: reflections of vision, craft, aesthetics, history, morality, expression, or emotion. This is naturally very distressing for our sense of the fine work of art, the object of our journeys to museums in quest of the authentic and the accomplished, qualities we hoped could be enshrined away from the marketplace and branding.

Obviously, the photograph can be expected to tarnish aura by virtue of the means of its making and its reproducibility, and this holds for the aura attached to beauty as well as for the aura of unique marketability. The entry of photography into the museum could undermine both high art and expensive art, regardless of how these were combined. That is, unless photography could be kept in its proper place. While the Buffalo show may have marked a turning point in the photograph's acceptance, the market hardly changed; thirty years later MoMA was selling Stieglitz, Weston, and Ansel Adams prints for $10, because the market would not pay more.[6] That provided a fine opportunity for some to obtain beautiful works of art stripped of virtually all their monetary aura: just beautiful work, and that is what Stieglitz called for, in his exceptional combination of patrician printmaker and democratic salesman. Today, however, fine photographic prints are worth a great deal of money, have perfectly respectable aura, and have failed to diminish the selling prices of rare paintings.

Stieglitz's approach to the monetary evaluation of either a photograph or a painting was quite radical. On the one hand, we must imagine both Stieglitz and the Albright Art Gallery in Buffalo (the venue of his 1910 photographic exhibition) functioning on the same understanding of an uncontaminated aura for real artwork. It was precisely because of his absolute insistence on photographic prints of the highest possible caliber that he had gained such authority as to be the person the director called upon to organize the museum's proposed exhibit. The museum was less interested in photography per se than in what Stieglitz guaranteed could be done with it. For him, not only should the composition of the image be powerful, emphatic, and constructive, but every print must demonstrate all the qualities of tone, depth, contrast, and so on that might be extracted from the negative to produce individual conception and insight. The print should be artistically unique, even if the negative remained capable of supplying, in the right hands, any number of other prints of equal quality. On the other hand, he functioned, in his view, quite outside the marketplace, in secession from it, even though money continued to change hands. Much of his peculiar, perhaps partially apocryphal behavior attests to his disdain for the marketplace of art, all the while showing that he was not ignorant of it or its terrible power. There are the stories of his refusing to sell paintings to wealthy would-be patrons, who clearly seemed to him to be looking to invest or show off acquisitions, and then virtually giving away a Marin painting to a penniless art student.[7] The painting and the viewer were first matched in a relationship, with financing to follow. Or he would have potential buyers "give" Marin enough money to retire to his Maine

island to paint for a year, and then let them take their pick of what had been produced by year's end. It is not, in this last case for example, that the paintings have cost nothing, but that the product of the artist's vision has been disassociated from speculative purchasing. By paying the artist for food, paint, and work, one has contributed to and even participated in the production of paintings which have become, by this process, more than possessed, coveted objects; the investment has been made to permit a person of genius to follow through in his or her work.

A revealing example of Stieglitz's attitude toward the cost of aura is the incident, in the late twenties, involving Duncan Phillips, a wealthy and well-known collector who amassed a very fine collection of American paintings, in particular by painters showing at Stieglitz's various galleries (these may be seen at the Washington, D.C., gallery of his name). This story is complicated by numerous moves by all parties, and the sequence and secession of moves is crucial for grasping what Stieglitz has to say about value and cost, a message Phillips cannot quite fathom.

To take but the central narrative of this comedy of misunderstanding. Phillips wants a particular painting by Marin, a large watercolor which Stieglitz says costs $6,000 (Stieglitz worked for free and did not take a dealer's commission, but the artists paid for the upkeep of the gallery if sales were made). Phillips protests he cannot pay that amount for a Marin, especially not for a watercolor. Why, asks Stieglitz, since he would gladly pay twice that for a Matisse or another well-known European, and this Marin has been judged, by viewers and the press, as one of his finest? But Phillips can't be swayed, especially because, if word ever got around to dealers, he would be sorely disadvantaged in subsequent dealings. The next day Phillips returns with his wife, Marjorie, and reiterates his interest in the same picture, but his wife and he decide upon others they like and which they purchase, in a "deal" where they save $1,500 on the catalogue listing. This transaction is nullified by what then follows. Encouraged by his wife to buy his original first choice, since he loves it so, and reassured by Stieglitz that no outsiders will find out what he will pay for it, Duncan finally takes it, whereupon Stieglitz writes: "A miracle had happened. For me it had nothing to do with money." He then turns to Mrs. Phillips: "One miracle begets another. Mrs. Phillips, let me present to you in commemoration of this act of sportsmanship of Mr. Phillips, that Marin,"[8] and he gives her one of the three earlier choices, this one listed in the catalogue at $1,800. Thereafter, Duncan continually refers to these works as "our" paintings, while Stieglitz keeps reminding him that one is a gift to Mrs. Phillips for her fine intervention.

It is worth pausing to examine this exchange. One of the paintings is free. It is better than free, as it gives more than itself as a mere object

of consumption. It embodies a social and personal exchange, a sign of mutual esteem between Stieglitz and Marin on the one side and Marjorie Phillips on the other. It is probably not even intended for the Phillips Museum, but more appropriately for a private space of her own. But Duncan sees it in terms of the financial bargain, product and cost, despite his moment of illumination when he actually followed through on his personal desiring. For him, the "free" Marin continues to have a market price on it, though that price as it has been combined with the price of the first purchase has merely gone down, to move inventory. Possibly he thinks he has outsmarted Stieglitz in a "deal." Marjorie Phillips, on the other hand, has received a gift that she had had no reason to expect, as she spontaneously prodded her husband to recognize his own connection to the Marin, a value he was the first to see but which he was unwilling to pay a decent price for. Finally, there is Stieglitz, probably looking a bit idiotic in his idealism. No matter, that was the job he assigned himself: the quixotic task of decontaminating aura of lucre. The aura of *this* Marin, at least, has engaged a free circulation of desires to please among three people, putting such desires above value in coin. Speaking realistically, we may feel aura cannot be decontaminated, cannot be shorn of the excitement of exchange value. And yet what else do we desire from art in the first place, what good does it do for viewer, owner, or the culture at large, if these hopefuls cannot, to some degree, take something from a work more satisfying for their own minds than awe about its marketability?

The Seat of Judgment

At its best, the aura has many facets. It is a quality of unique authenticity to which contribute sensuality in content and treatment, fine labor (which is to say, craft), emotion from many sources, transcendence, composure, the cultures and histories of society and individuals (including owners), cachet, and nostalgia. Other qualities could easily be added to this list, and might even force the removal of some I've just affirmed as more or less essential; market inflation or indifference play their parts, but at best the museum ought to sidestep or transcend the market, and in this sense, for as long as the museum failed to value photography at all, Stieglitz constituted a sort of virtual museum in himself, as both a judge and a collector. All through these years he collected the work of innumerable photographers, and when this collection was given to the Metropolitan Museum of New York, it was as large as the Buffalo show.[9]

If the Albright was to take the plunge and dare to put photography on its walls, the display had to be the very best. Since there were no

persons on staff in any great museum anywhere who specialized in art photography, Stieglitz's assistance would be invaluable to the museum, his vaunted intransigence guaranteeing high quality in an area where the directors had little ability or resources to judge for themselves. The head of the Albright, Charles M. Kurtz, had served as a judge at one of the Philadelphia salons and, after hosting a show of the Photo-Pictorialists of Buffalo, had visited Stieglitz and Edward Steichen in New York to enlist their help in a much more ambitious project. While Stieglitz promised help and contributions from the Secession, he did not want the exhibition to emanate, or be seen to emanate, from his group; in a letter dated February 6, 1909, he writes Kurtz that the Photo-Secession is now withholding its support because of "the introduction of petty politics," whereas he had originally called for letting "the exhibition come from the art gallery authorities direct."[10] Stieglitz is probably referring to meetings Kurtz held with H. Snowden Ward, editor of two British photography publications, and the Buffalo Photo-Pictorialists, already trying to set favorable rules of inclusion. Later in March Kurtz met again with Stieglitz, after which Stieglitz wrote to Kurtz's assistant, Cornelia Sage, that "everything had been thoroughly discussed, & everything virtually arranged to assure Buffalo of a really wonderfully fine & thoroughly representative exhibition."[11] Unfortunately, the reason this letter was addressed to Sage was that Kurtz had suddenly died at his desk; Stieglitz now assumed the show was off, for the present.

He was quite mistaken, as Sage was already pursuing the idea, quite carefully. Two letters of hers in April, one to Ward and one to Stieglitz, show her to be polite but noncommittal to the former about the project but already requesting help from Stieglitz: "In case that we do have the exhibition . . . I should ask you to give me a great deal of important advice and to help me or anyone who might be here in the selection of works."[12] By October, now acting director, she can write Stieglitz more confidently: the show, "my personal idea," will go on, but as "an exhibition of the Photo-Secessionists alone." She hopes Stieglitz will oblige, and she expects to leave the selection "almost exclusively to your artistic judgment."[13] The need, then, of Stieglitz's collaboration was far greater than any concern she might have had about his personal preferences or any complaints from other parties. Still, when the gallery's official announcement was circulated, it no longer proposed "Photo-Secessionists alone" but rather called for submissions from Photo-Secessionists on the one hand and all comers for an open section. As Stieglitz had already proposed such an open section in his first meeting with Kurtz, it is more than likely that the photographer was the one who had insisted on this wider representation. But this call for submissions

generated a good deal of outrage in the "pictorial" community, with various groups objecting, then preferring to withdraw rather than be juried by the Secessionists.[14]

Yet Stieglitz did want a "thoroughly representative exhibition," as long as all the work was of high quality. I'm convinced that despite his peremptoriness and obstinacy he was a great deal more open-minded, generous, and disinterested than we realize from our distance. His relationship with F. Holland Day, to the degree that we can make out its contours, is instructive on this point. Day, probably the only other person between 1896 and 1910 to attempt to organize exhibits on a large scale and with the intention of establishing the importance of photography (and of American photography in particular) as a serious art form, had occasion to write to Stieglitz in 1899: "I would sooner think of flying than undertake a photographic movement which you would refuse to head in the fullest possible way."[15] But Day was about to attempt just that, since Stieglitz refused to move to Boston, where Day felt more comfortable centering his movement and where he had contacts at the Boston Museum of Fine Arts.

Stieglitz's refusal to abandon his own territory, a modernizing New York, for Brahmin but provincial Boston was the beginning of his difficult relations with Day. But organizing important exhibits in the photo salons had already been an endeavor fraught with aggravation for him for quite some time, with infighting among local camera clubs (in Philadelphia in 1899, 1900, 1901, and in Buffalo in 1910) that demanded preferential exposure, or that pressed to be so all-inclusive that the "pictorial" would be swamped by commercial work and technical demonstrations. Organizing aside, it does seem that Stieglitz was a supporter of Day's work, since he bought his prints for his own collection, and he thought highly of his judgment, writing to him a propos of a jury for the 1899 second Philadelphia Photographic Salon: "I like you as a juror. . . . Why not Day to represent the East."[16] This put Day in a position to judge Stieglitz himself. Stieglitz was on the jury the following year, helping to produce the exhibit of only 112 prints out of about a thousand submissions.[17] Such discrimination provoked a reaction from conservatives and led to the unjuried shows of the following Philadelphia salon. In turn the unjuried shows caused sufficient disgruntlement that the salons were discontinued. Stieglitz went on to form the "Photo-Secession" group for the purpose of defining "modern" photography for an exhibit at the National Arts Club in New York in 1902, and he duly included Day in this exhibit on more or less equal terms with Käsebier, Steichen, Joseph Keiley, Frank Eugene, himself, and others,[18] even though by this time Day was certainly angry with him about the 1900 London show, which I would like to take a closer look at.

Estelle Jussim, who has saved Day from relative obscurity in her *Slave to Beauty,* has cast Stieglitz as the major villain in Day's eclipse. She says Gertrude Käsebier, one of the foremost photographers of the period, found Stieglitz "unpredictable, irascible, and imperial" (Jussim's words), even though Käsebier had earlier written to Day that she found Stieglitz "one of the fairest, broadest, finest men I ever knew."[19] No doubt Stieg-litz could be all of these; for example, he would be open to new work even while exercising the "imperial" role of impatience with inferior work. Stieglitz came to his position of judgment as a photographer; that was how he saw himself primarily and that is how he had gained the respect of his peers. Why then spend so much time—for long periods even all of his time—in the thankless task of supporting and promoting the work of others? It is on this point mainly that I see the most telling difference with Day as an impresario for photography. It was usual for Stieglitz to have his photographs appear on the walls in roughly equal numbers with other prominent workers such as Käsebier or Day himself. On the other hand, in the exhibit that Day organized in London at the Royal Photographic Society in 1900, he planned to show about 100 prints of his own, out of a total of about 400 by 16 different artists. This exhibit was his *New School of American Photography,* in which Stieglitz had chosen not to participate because he felt that many of the prints were of poor quality and would be doing American photography a disservice. To show his criticism of Day's exhibit, Jussim cites an editorial comment of Stieglitz that many of the prints were "unfinished" or "seconds." If one reads on in the original, however, one finds that Stieglitz pointedly excludes Day's prints from this criticism, calling them "all carefully selected" (as are those by Steichen). Further, his complaint about "seconds" is not that various artists are weak, but that the prints, as chosen, are "an injustice to [the] maker." Stieglitz was, as we have said, relentless in requiring museum quality in every show, and here the fault no doubt lies with the organizer. And yet he tries to be conciliatory, ending his comment: "Mr. Day certainly deserves the thanks of all the photographic world for the good service he has done in exhibiting American pictures, whether truly representative or not, in London and Paris."[20]

How much he did actively to prevent this London show of American photographers we cannot know very precisely. Various critics, including Jussim most crucially, follow the lead of Weston Naef who, in *The Collection of Alfred Stieglitz,* describes a letter of September 16, 1900, in which Stieglitz warns A. H. Hinton of the London "Links" not to host Day's collection. But this letter can no longer be located, nor does any critic ever quote from it. Jussim refers to an attack by Stieglitz "from the

rear," but it would help us to form our own opinion if the text of the letter could be seen.[21] As early as July 21 of the same year, Hinton, requesting Stieglitz's opinion about the collection, had already voiced some misgivings: "he [Day] will not however submit them to a Selection Committee, so that I anticipate our people over here will refuse to accept them en masse. . . . I gather that . . . more than half the names are of people all unknown to us." Day's proposal certainly seems imperial enough to get the show derailed without the intervention of Stieglitz. He seems to have gone even a bit further than denying the Links their right to jury a show on their premises; a week after this letter another Link, Reginald Craigie, called a general meeting to discuss Day's proposal, which "he offers to us as an alternative to his taking a special gallery himself in the West End in the early autumn which might prove an inconvenient contemporary attraction."[22] We don't know Mr. Craigie, but he is to be commended for his refined recasting of the term "blackmail." Day did move his exhibition, his "ambition . . . whetted by his fury at Stieglitz's deceit."[23]

Less than two years later, when Stieglitz decided to publish *Camera Work,* he wanted to feature Day in the opening issue (for January 1903). *Camera Work* was intended to be the finest, most serious, and most beautifully produced photographic periodical, and it fulfilled its intention. And it is remarkable how little Stieglitz put himself forward as a photographer in it. Jussim speaks of his "never-failing nerve," his "audacity to ask Day for permission,"[24] but the evidence does not support such a systematic demonization. Day refused, for reasons which, I think, remain his own, though it was clear from the start that the reproductions, photogravures, would vie with original prints in quality, and Day's position in history would have been secured as the first artist to be showcased in the most famous photographic journal in the world. Käsebier was featured for the inaugural issue, Steichen had the second, Clarence White the third, then Frederick Evans, Robert Demachy from France, then Alvin Langdon Coburn. In these six issues altogether, only three photographs by Stieglitz appeared (always singly, in the first, third, and fourth issues), and an issue did not feature the director of the Photo-Secession until number 12, three years after publication began and after White and Käsebier had already seen repeat feature appearances. From this record it is clear that Stieglitz was not working at promoting himself as a photographer, but working at promoting photography. Perhaps he thought himself to be well enough established not to require further illustration, and probably he did impress others as stubborn and overly idealistic when he argued tactics and choices; but he does not behave at all like a person out to destroy a colleague's career.

Finally, for the Buffalo show of 1910, which Stieglitz saw as an opportunity to bring together *all* the good work done so far even if the Photo-Secession specifically had been invited to construct the exhibit, he again saw the desirability if not the necessity of including Day, even though the two men were clearly quite estranged at this point; Stieglitz wrote a colleague: "It would be a scandal to have an exhibit without Day."[25] Stieglitz "had even swallowed his pride," says Jussim, and written Day for prints, but Day was adamant.[26] Stieglitz then proceeded to hang prints by Day from his own collection, and most certainly against Day's wishes (unless he knew Stieglitz would hang them anyway, which is certainly a possibility, and one which gives him both his cake and its consumption). This act was certainly out of order, imperial indeed, and yet a favor, it seems to me, both for the photographer and for the potential audience of the Buffalo exhibit, which served as the early coronation of photography as an art form in America. We might imagine Stieglitz weighing relative scandals, his own uncollegial behavior versus neglectful history-making.

Art History Lesson in Buffalo

Buffalo's art institute was not the first to accept photography; William Innes Homer grants that honor to Philadelphia, for the first of the salons there in 1898, and he traces other similar shows back as far as 1886.[27] However, these shows were smaller, the one in 1898 for example hanging 259 images—certainly extensive, but less than half of what would go up in Buffalo. They did not have the scope, in breadth or in depth, that would have convincingly anointed photography, and they usually ignored Europeans completely. The years around 1900 were not ready for the exalted claims of the likes of Stieglitz. At various times already, he had boycotted or withdrawn from organizations like the New York Camera Club or exhibits like the Philadelphia salon of 1901 because they were, in his view, too indiscriminate or catered to special interests. After the victories of conservatives, or "rationalists," in Philadelphia and of local clubs at the second Chicago exhibition, and after Stieglitz's more successful but tightly controlled show at the New York National Arts Club in 1902, the photographer seceded from the wider community of photographers to form his Photo-Secession, that is, to pursue photography as art and ideal within the confines of a small, self-appointing group and its magazine, *Camera Work*. Despite some successes abroad in those years, at Glasgow, Paris, and London salons, and in Munich alongside the Secession painters,[28] he had decided to pull back for a while and leave be the wide audiences of big exhibitions.

By 1908 the atmosphere had already begun to change, though Stieglitz was by then striking out in an entirely new direction. At the very same moment that the National Arts Club had decided to exhibit the Eight or Ashcan School of painters, together with the Secessionist photographers, Stieglitz was hanging his January show of Rodin sketches at his Little Galleries of the Photo-Secession (known as "291" from its address on Fifth Avenue). A month later the *New York Times* announced "Camera Club Ousts Alfred Stieglitz," but, as if to tell the clubs they were already too late to touch him, 291 showed Matisse, followed by the gallery's first exhibitions of Mauer, Marin, and Hartley. In 1909 the Little Galleries' exhibits of painters far outnumbered those for photographers. Stieglitz had discovered a new battlefield for photography: painting from France which was in the process of forsaking representation.

Still, there was a sense of growing momentum for photography, even with what seemed a lost opportunity in Buffalo: 1909 saw an important show at the National Arts Club again, an international *Exhibition of Pictorial Photography* that Naef calls "a curtain raiser for Stieglitz's swan song at Buffalo";[29] and there was a huge exposition at Dresden in May, which "meant hours of work, cajoling photographers." Robert Doty continues, "When they refused, or reneged on their promises, Stieglitz sent examples of their work from his own collection."[30] (It seems this practice, which had presumably terminated his good relations with Day, was not so unusual for him, nor unknown to his fellow workers.) This new momentum stands in contrast to a general sense that, in the various quarters of photography, among pictorialists, British Links, Secessionists, and others, there was fatigue, stagnation, and a lack of new direction. When Cornelia Sage offered him full control of the proposed exhibition at the Albright, he was not unhappy to be back in the fray, and a letter of his to Alvin Langdon Coburn predicts the exhilaration and exhaustion of a great, final effort: "The show at Buffalo will knock the spots out of anything yet done, if I remain alive until it is up on the walls."[31] The stage was thus set for an apotheosis of sorts, a "swan song" to a degree, or a "phoenix song" more likely, as he turned to another cause, modernism itself. Indeed, during the Buffalo show, which ran from November 4 to December 1, the Little Galleries showed Manet, Cézanne, Renoir, Toulouse-Lautrec, Rodin, and Henri Rousseau, a willfully counter cornucopia. Full of color and abandon, and disdainful of slavish representation, such a show at 291 critiqued both imitative art and photography that strived to copy imitative art.

Sage, for her part, had already scored a success in betting on photography, as she had been promoted to director, a post she was to hold for fifteen years. She had at that moment put all her eggs into the one

basket, giving over almost all of the museum to photography, including the main floor and newly opened rooms. Her enlightened appointment, by a board of trustees entirely made up of men, made her the first female director in the United States and perhaps, opined commentators, the world. In October of 1910, with preparations for the show under way, Stieglitz wrote: "My Dear Miss Sage: First of all my heartiest congratulations. Bully for the wisdom of the Trustees." He reiterates his salute to both her and the "institution," and ends: "this show must and will be a real smasher, for your sake and mine, if for no other reason. Photography is to gain a signal triumph."[32] It is interesting to see Stieglitz tie these three successes together and give credit to the old boys' club for openness. Sage was only the second director for the museum, and it sorely lacked works of its own to hang; this, her first show, inaugurated a long series of annual exhibitions of contemporary American work from which to make acquisitions.[33] An extensive, if quaint, interview for the *Buffalo Illustrated Sunday Times,* while highlighting Miss Sage's Victorian femininity ("Her brown eyes have the hue of ripe chestnuts after the frost has glossed them with richness . . . "), also permits us to perceive a strong determination to put the Albright on the cultural map. She wants funds and bequests to bring important works into the collection. She is concerned that it lacks a Whistler or a Homer (the latter had just died); there is no work by either artist on the open market. She considers Monet, Degas, and Rodin the greatest living painters (along with one Manchini), and the upcoming photographic show "will be great," comprising "the fathers of artistic photography just as Manet was the father of Impressionism."[34] Two of the artists just mentioned, Manet and Rodin, figured in the exhibit Stieglitz was preparing to run at 291 concurrently with the Buffalo exhibition, and Sage had visited Stieglitz in New York before deciding to put the Secession in charge in Buffalo. Sue Davidson Lowe goes so far as to speak of an "unspecific seduction" of Sage, a not uncommon occurrence for the photographer, which puts a special light on a letter she wrote him after their meeting: she had found "a friend . . . in tune with my innermost thoughts."[35] Her taste in art was not revolutionary, but for 1910 America it was certainly quite advanced, and it is amusing to think that she was at very least encouraged to acquire it by a photographer who was challenging the fine arts in her museum. Stieglitz for his part had already gone further at 291, showing, along with the above-mentioned, Rousseau and Cézanne, two steps toward modern art that Miss Sage did not yet choose to take. However, she reserved funds to purchase a dozen or so prints from the exhibition, thus affirming that photography also had a role to play in her acquisition policy.

It was clear to her that, through her, the museum was investing in art, "artistic" photography for a museum of art. The title of the show, *The International Exhibition of Pictorial Photography,* sounds ambiguous, if not downright duplicitous to the ears of critics writing today, since we know that the term "pictorial," by 1910, no longer represented an earlier idea of photography as art: that is to say, it referred to pictures, not snaps. By 1910 it more likely described what we might call artsy, slavish, or fawning attempts to recreate the surface effects of the day's conventional painting. This was the sort of derivative work the Secession was seceding from as it explored the meaning of a photographic picture, but it was also the dominant aesthetic of photo clubs across the nation. Wasn't Stieglitz, with that title, trying to pretend the exhibit represented *all* schools of photography that intended to do artwork?[36] A more honest title would have referred to the Secessionist group explicitly, since it occupied some three-quarters of the show space, with the same Secessionist judges going on to choose the entries in the "open" section.[37] This was, then, something of a palace coup. And yet the survival of the Secessionists in our histories of photography, their acknowledged position in our history of the medium to the almost complete exclusion of those practicing "pictorialists," is a vindication of Stieglitz's stringencies. At any rate, there seems to have been no misunderstanding at all in the press at the time, and we should not think that the public was being deceived. Headlines read: "Photo Secession Opened Exhibition at Albright," or "Photography a Fine Art: Exhibition of Secessionists at Buffalo Museum," or "Opening of the Photo-Secession Exhibition on Thursday."[38] It is reasonably clear that the term "pictorial," which does appear at times, refers, through the exhibition title, to the larger idea of making photography into artwork, and it seems to me Stieglitz was attempting to reclaim this usage, even while he consigned the practicing pictorialists to the wrong side of history. In fact, Stieglitz was not the first to make this move; the previous year's exhibition at the National Arts Club of New York, organized by John Nilson Laurvik, sported the same title (but Laurvik was himself a Secessionist, and Stieglitz was on the hanging committee). Obviously, the word "picture" was crucial, and to both sides it meant no less than "art." In the Secessionists' view, pictorialism partook of Victorian sentimentality, even what we would today call kitsch. Given our own changing views about its quaint charms, it would be no surprise to see a revival of the pictorialists, but the Secessionists wanted a serious and nonderivative art, having not yet seen much of it in their time. The cause of photography would not be advanced by making pictures that encouraged viewers to appreciate the same qualities shared by the most common of contemporary paintings.

In fact the public was being presented with two competing itineraries toward the art in museums: the Secession in Buffalo was taking the more difficult road, searching for an authenticity intrinsic to their machinery of lens and film, and allying themselves with a modernism that had yet to reveal much of its face.

The show in Buffalo, grouping some 605 prints in all, was principally divided into two unequal sections, the much larger invitational section where the Secessionists could spread out, and a smaller open section where, arguably, a much finer and more strenuous job of judging had to be performed with unknowns. The Buffalo Photo Club had been offered a room to itself but declined the venue as being too small a concession and, in any case, not sufficient enticement to have them defect from the pictorialist anti-Stieglitz front.[39] For the most part, the invitational did not contain surprises, but rather confirmation of quality and demonstrations of achievement. However, the invitational also contained a completely separate section unto itself, forty prints by David Octavius Hill (working with John Adamson, not acknowledged then), who had died in 1870. The Hill corpus, more than half a century old in 1910, and the only work in the show by an artist no longer living, thus represented an attempt at historical perspective and origins, as Hill was the founder. Daguerre, Talbot, and Emerson did not figure in this demonstration, though they could have, or should have. In the National Arts Club exhibition of 1909, Hill had been joined by Julia Margaret Cameron in a similar historical component and demonstration, thus giving photography both a paternity and a maternity. What probably distinguished Hill for Stieglitz was that Hill was first to be, well, pictorial. Even the elision of Adamson's name confirms this decision to look into the past not for a photographer working out the technical discoveries but for one becoming an artist in photography. Thus also, in the wake of the Hill opener, the whole design of the show was to provide a framework of historical depth and validity.

Hill and Adamson had worked in calotype, Talbot's improvement over the daguerreotype in that it produced a negative and thus set the stage for multiple prints, the revolution Benjamin was going to respond to. Calotype means "beautiful picture," and Talbot's famous six-part book of calotypes was called *The Pencil of Nature* (1844–46); thus terms signifying aesthetically contrived objects were already at work to promote the idea of the maker's intervention into the camera obscura's recording. But Hill went somewhat further and, in a famous quotation, admitted the calotype's relative failure at rendering complete detailing, even though this was presumed to be the essential, intrinsic quality of the photographic process, the quality that was creating such anxiety for

the world of painting. To Hill, this "failure" became the photographic artist's gain: "this is the very life of it. They look like the imperfect work of a man—and not the much diminished perfect work of God."[40] Extraordinary statement! This God-fearing Scot shied away from the photograph's built-in precision because it might vie with God's own perfection and be defective for that arrogance, even quite dead for its pretension. On the other hand, a print from the calotype negative, on paper of "rough surface and unequal texture throughout," was closer to man, full of the life of striving imperfections. In this cautiously sustained imperfection we could remain human, and alive. I doubt if Stieglitz was much preoccupied with such justification, but what it produced for Hill was photographs with heavy, even brooding shadows arrayed in dramatic massings of darkness and light, in figures variously emerging from or mixing with dark backgrounds and even darknesses in their own postures. Details could be dismissed if they were not deemed suggestive, and whole areas of the framed image could be made to recede, as dramatic foregrounding and selective concentration produced a symbolic, and an especially moral, art form. Gone, the camera eye's promiscuous exposure of everything in view. Hill's is an exclusionary tale, a concentrated art of exclusion and thus precisely the job the photograph was not designed to perform. He becomes, in the Buffalo demonstration, the founder of artistic statement, of willful meaning in the use of a medium otherwise slated for total, and consequently meaningless, recall.

At its source, Hill's sense of drama was religious, and that fact produced a curious irony for the use Stieglitz was making of him. He had been a painter, and had undertaken the herculean project of painting some 450 people together in a group portrait to celebrate the founding of the Free Church of Scotland. He became a photographer in order to record the members of this worthy gathering, to better paint them at his leisure. Thus, a purely documentary function was originally being served in his mind; and yet he and Adamson managed to dramatize these records so forcefully that they surpass his artistic achievement in the finished painting.

The rest of the invitational section does not contain surprises for historians of the Secession, as far as the names of the participants are concerned. These photographers were now well established, as Secessionists but in their own right as well, and their reputations have endured. They had shown in exhibitions in America and western Europe and had been featured in Stieglitz's *Camera Work*. Edward Steichen's work was always well received, though he himself had vacillated for a long time between painting and photography and was to go into commercial work after the war for *Vogue* and *Vanity Fair,* where he made fashion photography into

an art. He was to become one of the best-known photographers in the world, and was the first photographer to show at the Museum of Modern Art (he became director of photography there in 1947). Clarence White, who like Käsebier and Day would make Buffalo the last of his collaborations with Stieglitz, would teach in a number of institutions and found his own schools. He had time to train at least one generation of students, Paul Outerbridge and Margaret Bourke-White for two famous examples, the undeservedly neglected Margaret Watkins for another.[41] Unfortunately, he died suddenly in 1925, while on a photo trip with students in Mexico. Coburn, Day's brilliant protégé, had already been commissioned to photograph frontispieces for Henry James's twenty-six volumes of collected novels and tales, and was now, in 1910, publishing one of the first photographic essays devoted to individual cities, in this case, New York. Day, as we have seen, was in the invitational, perhaps against his will. Stieglitz had had access only to prints he himself owned, all dating to before 1904 when Day had lost all his prints and negatives in a fire. Stieglitz managed to get hold of one post-1904 print, but that was not enough to present an artist in the full historical light he wanted for the show. J. Craig Annan, Frank Eugene, Baron A. de Meyer, and Käsebier were other names familiar to readers of *Camera Work* and gallery goers; some fifteen American and European artists including these spoke for about 400 pictures in the 605-print show. But the point was not merely to overwhelm the museum space with well-known Secessionists; as with Hill, history was the serious focus for this crucial lesson in photography as an art.

Indeed, biographical entries for these artists were presented in the catalogue, a novelty for the time, and the number of works included by each artist encouraged an examination of their evolution. Steichen and White, for example, were represented by thirty-one and thirty works, respectively, each artist alone in his alcove and with a significant representation of his career on exhibit. The evolution of the single artist was unveiled, an individual lesson within the larger one of the whole show of communal progression and development. This was, in large part, similar to the idea of the gallery as laboratory that Stieglitz would impose on exhibits at 291, a concept which was to be the very idea of the place. The artist's production was exhibited as a testing of the artist and a demonstration of his perception, his work was repeatedly measured against itself, and the evolution of creation was put before the viewer, who was called upon to read a career in history rather than isolated achievements. Such full review would be fascinating and useful for fellow and would-be artists, but the invited public would also gain, since here it could educate its own taste. The sense of a progression, of a development was

further enhanced by the photographers' work being hung "on the line," that is to say in a single row (more on the single line below). This placement created something of a narrative or lifeline effect, but also, with various groupings or emphases on, say, three images grouped together, the effect of a before and an after, of contrasts and associations of past with present within the linear narrative. Contrasts of treatment, of scale, of dark and well-lit places, and so on brought the viewer into the artist's own moments of discovery, then embedded these moments back into his history. Variations, perhaps even hesitations in style contributed to the sense of a single, recognizable style in the alcove; it became clear, through this extensive exposure, that Käsebier was not to be mistaken for de Meyer. And, of course, if a photographer could have her own style, the myth of the objective, inexpressive camera was neatly exploded. Both the number of prints for each artist and the opportunity to stretch out a line for her grappling with the objectifying lens produced a picture, even a photographic essay on one subjectivity's voyage through the world. Finally, each of these invited artists, so well represented, became a world unto herself for the time viewers spent with her; individualism had its time of triumph, rather than dissolving into the general movement of this massive show. Each alcove was a strong statement, and these statements probably had the effect of reducing dispersal, of promoting fine artists more emphatically than fine photographs. With Hill photography had a father, with the invitational it had its accomplished masters.

The open section, much smaller at about 120 prints, looked to the future, tentatively. It was perhaps a place to placate some who had not been chosen; indeed, Lowe refers to photographers there as "outside the pale," "indifferent or openly antagonistic" to the Secession.[42] But if this was the case, it showed the organizers to be liberal enough. This section performed an important function in the design of the overall lesson. As judges were Secessionists, acceptance in the open was, in its way, an invitation into the ranks. Indeed one, Paul Haviland, was already a Secessionist, as well as a judge and a hanger of the show, so his presence in the open section amounted to a declaration of his apprenticeship. William B. Post, also a Secessionist, was hardly such a beginner, but he had done little or no work in some ten years. The important distinction, then, between invitational and open was that for the former there should be a significant body of work over time, a lesson in itself for the open section. The sense of historical achievement was not present in the open, which could have the feel of guesswork, of promised forays into unknown territories. Pierre Dubreuil, Arnold Genthe, and, to my mind, the very fine and delicate modernist Karl Struss were in the open, to be discovered in the first instance by the Secession itself. Here viewers were invited not to

2.2 Arnold Genthe, *San Francisco Fire,* 1906
(or *After the Earthquake—San Francisco, 1906).*
Photograph, The Library of Congress.

appreciate a presanctioned evolution but, after their initiation in the invitational, to test their own taste and determine for themselves if these works might have aura. History, that is to say the specific history of photography as taught by the invitational, did not yet underwrite the signatures on these photographs, and I expect the judges would have been the first to be happily surprised as they sifted through relatively unknown submissions. Stieglitz bought six of the prints shown by Genthe, and even he might have seen new lessons in something like Genthe's *After the Earthquake—San Francisco, 1906,* on at least two scores: the image is dependent on an overwhelming event, its mere recording representing so much power that the effect has to be that of a documentary, beyond the control of manipulations; but the almost aggressive symmetry of the shot, the unlikely classical perspective right down the middle of the street into the chaos, seems like a very unsophisticated artistic decision. Does the document not admit of enhancement? The symmetry, with houses on each side fleeing into perfect and balanced perspective as the camera stares over the shoulders of staring

citizens (but their faces all turned away from us), follows their own trans-
fixed yet unseen gaze, so that the tripod's stance is a mocked position of
order-making. Yet at the same time it imposes a sense of retrospection,
of shared awe at the quake's effect rather than terror or victimization. It
is not an image of balanced contents but rather a magical balance
between content and perception.

This is only one example, and of course I only guess at the judges'
appraisal. Still, the open section would have to have been, for them, the
site of discoveries. For the public, the Buffalo show was also a discovery,
or rather an organization of discoveries subsumed into the overarching
one of the seriousness of photography, and portioned out into these main
three stages: the discovery of an already sixty-year-old imposition of
artistic statement upon the new medium, the discovery of masterly
careers still in progress, and the uncovering, in the close present, of
newer, edgy possibilities. Depth of lineage, depth of character, the com-
petition of new talent.

On the Line

Because the classical museum was not made for photographs, one could
not just hang this threefold demonstration up on the wall. Of course
there is some paradox here, because photography, to enter the museum,
had to modify the site it aspired to. Even paintings, most often much
larger and full of colors, framed as they were in heavy gilt, were not often
shown in one line, but invariably stacked some three high, or "skied."[43]
A wall that today might show some ten paintings could then be enlisted
to show thirty or more. As a viewer, one did not so much concentrate on
a single work and then move on to the next, but moved in and back to
see above, and then higher, and while taking in the uppermost picture,
also see a profusion, perhaps nine paintings at a time simultaneously, or
art as environment, decoration, or, frankly, acquisition. To contemplate a
painting hanging some twenty feet high was, also, to see it assaulted from
all directions, and to wonder less at the life of the painting than at the
life of the collector or the life of the museum. On the other hand, to be
hung "on the line" meant to be singled out for praise, something Cornelia
Sage was well aware of, having been once honored herself in that manner.
To hang the whole exhibit democratically on the line was to concentrate
a larger responsibility for evaluation in the viewing public.

But to hang photographs only on the line required countermanding
the stated grandeur of the room, permitting the rows of small, black-and-
white apparitions to breathe in these acquisitive vaults. Credit for
redesigning the galleries usually goes to Max Weber, a young avant-garde

painter Steichen had introduced to Stieglitz and who had recently returned from Paris. There, he had befriended Rousseau and convinced Matisse to give a studio course at a time when few would have studied with him.[44] In Paris, Weber admired and collected African art about the same time Apollinaire and Picasso were doing so. Back in New York, he would soon show himself to be one of the most advanced painters in America, if not the most advanced, integrating into an independent and original expression Matisse's color and composition, the Iberian primitivism of Picasso, the kaleidoscope of futurism, and even aspects of what looked like the Brücke group before he saw them, to produce such fine, complex work as *Chinese Restaurant* (1915) and the saturated minimalism of *Fleeing Mother and Child* (1913).[45] Weber was not a photographer, but he would teach composition in White's school of photography during World War I, a valuable crossover that furthered Stieglitz's overall modernist project. Unfortunately, by then the two men had broken off relations, and Weber had further damaged his career by refusing to give anything to the Armory Show in 1913 when they rejected his demand that he be allowed eight works.

In Buffalo, Weber stuck an eye-level band of background cloth around the room, dismissing half of the wall's height—everything above one's head—and setting the photographs more into the room toward the viewer, sometimes on yet another band of material. A photograph by Struss of the Stieglitz alcove shows that the linear order was not always chronological, that small groupings were formed to break up the line, and that the occasional picture was not on the line but interrupted it, forcing one to stop and reflect on the advancing narrative.[46] This narrative, with its interruptions, was a far cry from the skied pile-up, in which even the lateral part of the development preferred an overall symmetry on the wall space—larger canvases at the ends and in the middle, for example—in lieu of any sequence based on style or period. MoMA's Alfred Barr is conventionally credited with abandoning skying and symmetry in his museum's 1929 inaugural show, but here we see that Weber, White, and Stieglitz anticipated Barr's aesthetics by almost twenty years.[47]

Frames were radically plain and slender; this was a rather new practice, probably inaugurated by Day for his own collection. The frame itself was entirely minimal and unobstrusive, aesthetically almost absent, and all the frames were the same. More attention was drawn, then, to the wide mats, which provided exceptional spaces. Photographs of very different sizes could be hung next to each other in frames of the same dimensions, thus offering a strong sense of uniform importance to the exhibit as a whole. With the help of the near-absent frame, the large

expanses of white around each black-and-white image enhanced a sense of nakedness, of unaccustomed frankness in the presentation. This minimal frame and its vast mat, which often matched or surpassed the image in area, is one of the first harbingers of the modernism of photography, one of its early dismissals of Victorian elaborateness. Older frames proclaimed the arrogance of possession, turned pictures into furniture, and through sheer weight declared aura would emerge from being well fed. Arguably, the heavy frame was an enforcer of aura, with or without the painting. Such an image hung in a plane behind the frame, which was an elaboration in reliefs to draw the eye into a privacy, as if a beach could be tamed into a room. Paintings would be imaginary beaches transported into weatherproofed, tufted comfort. But photographs, hung with less artifice, imagined the viewer at the beach, something more raw, immune to coloring, immune to gilt and couches.

Weber later wrote that he "treated the geometric rectangles and features of the prints as windows in the walls of a building."[48] He meant that he was organizing the pictures as if wall and prints together were a composition. But I see something further in Weber's statement: it is the sense that these pictures do not look inward, with an artist's thickly brushed colors and mythical characters staring back at the viewer, but rather seem to hope to look outward, and thus invite the viewer to think of looking outward as well, not so much at the images as somehow through them. To think of windows instead of pictures is to think of areas that do not bring attention to themselves but bring light and naturally lighted scenes in to us. Despite the relatively small scale, as well as the distance or sobriety a black-and-white world imposes, the photograph must still appeal to the viewer's sense of the real beyond its paper surface, and beyond the museum's wall, at least as a fundamental starting point. As Roland Barthes has insisted, we know that "ça a été," or "that has existed." The photographs in Buffalo were, in themselves, a peering outside of the room. As a new importation into the world of the museum, which holds relics safe, they embodied a breath of fresh air from outside of the walls, something still resistant to the collector. To the extent that the framed print was a window, it returned, to some degree at least, to its documentary function—which was clearly purposeful on the part of the exhibitors. These images may have had claims to be art, but they nonetheless recognized their ambiguous medium, stood against artifice, and bet a good deal on reframing the art viewer's stare to have it carry a share in the creation of the new art. The style of hanging refused to toady to the stuffier, more hierarchal prejudices about art, and based its claim to be admitted into the inner circle on the grounds of forthrightness and simplicity.

Phantom of the Galleries

These small, precise, cool, open images called for a new manner of exhibition, one to which the museum, despite the efforts of Stieglitz and company and others since, is naturally recalcitrant. In an article for the Centre Pompidou's *Cahiers du Musée National d'Art Moderne* on Stieglitz as a "phantom in the museum," Alain Sayag discusses both the presence and the exhibition of photography in a museum setting, and concludes on the great difficulty of showing photographs well. He amusingly avoids all mention of Stieglitz in his article, outside of the title and the photographer's name in another article being cited in a footnote, and in such manner he sustains his conceit of a phantom, or a ghost in the museum machinery, the old director of 291 haunting museum practices that try to ignore him. Sayag speaks of a photograph's "fragilité visuelle," and wonders if the solution to the "espace banalisé et morne" of the permanent rooms at MoMA, for example, might not be a return to the format of the rooms at 291, "le lieu où s'inventa la photographie 'moderne.'"[49]

Many have written about the small rooms of the Little Galleries, and a few photographs of installations survive. Of course, an exhibit at 291 would always have the advantage of any small site: fewer works on which to concentrate one's attention, to take the images seriously, for all they are worth. The museum, on the other hand, while it can consecrate with its own enveloping presence and with sheer quantity, can hardly reduce its shows to the fifteen by fifteen feet or so of each of the two 291 rooms and expect record crowds to pay the rent, along with salaries, insurance, and what have you. In any case, do those crowds desire only the pictures, as much as they want the spectacle, the excitement of being there *with* the pictures? 291 was a better place to muse about artwork; in that spirit one might propose the experiment of setting a few replicas of the rooms at 291 into the middle of the museum's far more vast halls. Each would replicate one of the exhibits at 291; on the actual walls of the museum galleries might hang other arts and cultural or even political work of the period. For example, a December 1910 room, where the lithographs by Cézanne, Renoir, Manet, Rousseau, and Rodin formed an island of deconstructed line and liberated color, would be tucked inside this Buffalo show of black-and-white photography on the museum walls. Or, to reverse the contrast, Stieglitz's own photographs at 291 in February and March of 1913 go in the little room, and the works of the Armory Show on the institution's walls. In this 1913 example, on the outside walls of the little room, a third and intermediary surface, we might hang Weber, who excluded himself from the Armory, along with other photographers working then, and the adverse or favorable reviews

2.3 Alfred Stieglitz, installation photograph of the Little Galleries of the Photo-Secession, 1906, in *Camera Work,* no. 14, 1906. Yale Collection of American Literature, Beinecke Rare Book and Manuscript Library.

of Stieglitz's work, as well as his newspaper interview in advance of the Armory Show. In this manner, while the inner room provides moments of concentration on the artists Stieglitz chose, the outside walls of 291 and the encompassing walls of the museum itself would feature the arts and the cultural life of the city at large. The viewpoint of the wandering spectator would be constantly readjusted, from the cramped quarters of the Secession to the long or wide New York view; it would always be comparing and reevaluating, in fact rewriting cultural history for itself.

Only the number of museum rooms we chose to use would limit the number of moments in the history of the Little Galleries one might wish

to replicate and to test against other work being done in the arts: 1908, first Matisse show; 1909, Steichen, with his Rodin prints; 1910, new American artists (Dove, Marin, Hartley, Weber); 1910, first Rodin show; 1911, Cézanne, then Picasso's first one-man show anywhere; 1912, the art of children aged two to eleven; 1914, African sculpture; 1915, Picasso and Braque together with "primitive" art; 1915, Picabia; 1916, Marin alone; 1916, O'Keeffe's first show, then Strand's first show. Outside these revolutionary walls the historical record of culture and social change might keep pace, fall behind, might isolate the little rooms, feed or feed off them. If artwork outside the hallowed walls is more appealing to us, fresher, worthy of reevaluation, so be it; the seat of judgment will circulate and do its own work (a museum director might gamble on separate curators for the 291 and the museum wall installations). An invaluable interplay would take place, one time a restfully contemplative inner room when the outside is too raucous; alternately, a gritty outer room when the inner becomes too ethereal; a brash 291 of exploding colors and lines when the city is brown and convention-bound. Crucial shows would mark off moments in cultural innovation. Secessionists confronting pictorialists might stand on show together, each putting their best works forward. Modern painting would burst out in the little room first, matching the Ashcan School and Prendergast on the outer walls, then proceed to take over these outer walls in 1913 when Stieglitz counters, inside, with his own photographs, to see if they hold their own. Such a double exhibition could permit today's public to make the judgment call once again. The museum where such a show took place would become something of the laboratory Stieglitz saw in 291, setting aside for a while both conservation and the determination of markets. It would be a salutary exploration for a museum, putting the phantom presence back in its proper place—which is not to take over all of the museum, nor to reside in a little room disconnected from the histories it reflected upon. The isolation of the 291 rooms, their relatively lonely search for the "ideal," had to be part of a dialectic for its director, and it does not give a fair or useful picture to either aggrandize an isolated Stieglitz or to dismiss him on the grounds of his devotions.

Conserving the Photograph

Whether or not Stieglitz intended the Buffalo exhibition to be his swan song, it did just about terminate his efforts on behalf of photography, that is to say, on behalf of other photographers as a group. It is hard to say if he felt photography had won its place in the world of the arts, for though he said so then, he had also said so earlier and was to say so again.

Most likely he only felt there was not much more he could do, after some twenty years of working at it, on behalf of such a large, divided, and jealous constituency. He had seceded from the photo clubs; now many of the Secessionists left him. There had never been any clear definition of the Secession, which had been a willful omission on his part. Stieglitz famously said to Käsebier, when she asked if she was a Secessionist, "Do you feel you are?" When she replied she did, she became one. And of course, on those terms, she could as easily undo the connection. If you believed you were looking for quality and authentically photographic treatment, you fit the definition, and there was nothing to it, in the two opposed senses one can give to such a phrase. Only for Stieglitz were heart and mind so far engaged in this ideal that all other more practical demands could be dismissed. When the Albright set aside $300 to purchase prints from the exhibition, Stieglitz had to plead with his friends to reduce their prices, in order to put more works into the gallery's collection. Käsebier balked, though she gave in, but that was enough of Stieglitz's ideal for her; she joined White and Day in their defection from the Secession, although it was shortsighted on her part, even financially.

Two prints by Stieglitz were among those the Albright bought, this collection of a dozen or so being probably the first photographs to enter an art museum's holdings. It was not until 1923 that another occasion arose for Stieglitz, this time with the Boston Museum of Fine Arts, an institution with such a conservative reputation that the opportunity was not to be missed. A friend of the Stieglitz circle, Ananda K. Coomaraswamy, curator of oriental prints, with fellow curator John Lodge, proposed the acquisition of a dozen or so Stieglitz prints to the doubting trustees. The term "acquisition" is misleading; the trustees were eventually convinced to be receptive to a gift from the photographer (the same thing happened in 1928 with the Metropolitan Museum of Art in New York). Stieglitz proceeded to make new, painstakingly fine prints from both early and more recent negatives. He labored at this representative collection of his work for some fourteen months, rejecting innumerable prints from each negative and mounting all of the prints himself at his own expense (at a cost of some $300, a serious expenditure that matched the Albright's budget to *buy* prints); the images were exactly as he wished to have them shown.[50] In his bequest, he insisted that the prints always be shown as he had mounted them, a condition the museum wanted to ignore in order to standardize the mounts and frame sizes. But they would not get them under such conditions: "Unless the prints are in the museum *right* they are worse than wrong," Stieglitz wrote Coomaraswamy.[51] The collection would not only be the first of a single photographer in a museum, but it would set a standard and not enter as a poor relation.

These twenty-seven prints in the collection of the Boston Museum of Fine Arts hold a special value that is easily overlooked, quite separate and beyond the historical one of anointing both photography in general and Stieglitz in particular. Doris Bry, in her record of this collection, is conscious of it when she notes that several of the prints "were finer than those he kept for himself; this was the first time he had ever parted with his best print for anyone."[52] The prints are essentially perfect, in the sense that each one is the very finest expression the artist felt he could produce. Rarely has the itinerary from artist's hand to museum been so uncontaminated by artistic compromise, finances, tortuous provenance, or happenstance. Regardless of one's opinion of Stieglitz's photographs, there is no doubt that these represent perfectly what Stieglitz wanted from them; they are the absolute real things, closer to the photographer's intention, at every stage of their production and then their transmission to the museum visitor than even other prints clearly from his hand, at least as good and better preserved and presented as the select few, marked by him as "AA-1," dispersed in museums and private hands around the country. These twenty-seven are an invitation into the precise meaning and full expression of the artist; if there can be aura in his work, this is where it should be tested.

Viewing these photographs, one could be carrying Doris Bry's *Alfred Stieglitz: Photographer,* preferably the first edition. This book reproduces the complete Boston collection of prints (it includes a second bequest from O'Keeffe in 1950), to scale in every case, on fine, natural cream-colored paper, "using a warm brown ink or a neutral grey with black in order to suggest the tonality of the original print."[53] Indeed the paladium and platinum prints especially retain some depths of tone in Bry's reproductions. However, this is at the cost of some degree of brown muddiness, which is also increased by the flat finish of the paper. Further, the print is, perforce, on the same paper as the book's page itself, which makes for a very different background from the expansive white mats Stieglitz was so insistent upon, usually five by seven inches (this can put a four-by-five-inch print into a fourteen-by-eighteen-inch frame). Still, the Bry reproductions have the advantage of being far removed from the brilliant, shiny black-and-white ones the modern book owner is used to, prints that shine on a very thin surface with little hint of the depths the originals call upon us to plunge into, to abide with for a while; those are playing to the glitz and slickness that Stieglitz was hoping to forestall in photography.

Thus armed, one might have attended the 1996 exhibition at the Boston Museum of Fine Arts entitled *Alfred Stieglitz and Early Modern Photography,* for example (one of Stieglitz's stipulations was that the

prints be shown at least once every five years), and noted differences of the sort that follow, reactions I had in the case of three well-known and quite different sorts of images in the Stieglitz canon.

The Hand of Man, 1902.[54] I am first surprised by the great clarity of the print, right within the grime which is its central statement. The reproduction in Bry's book, actually quite strong (though in this case, since the original is a silver print, the cream paper may be a drawback), is almost filthy-looking in comparison, especially in the top half of smoke, gray buildings, and sky. The famously symbolic rails leading into and around the viewer's own space are actually less shiny, yet better defined. The print's blacks are not the inevitable gray of the reproduction, a process that must lump together some eight to ten tones of a photograph's dark gray-to-black range; one of the strong pleasures of real prints becomes the appreciation of profound black. Here, the range of darknesses offers more definition and variation in details, or tonal depth—something to peer into. It is a poetic image of train and industry, realism with a dark, personal vision rather than a dingy one, such as the reproduction encourages. The print projects both admiration and despair about modern man's handiwork, a clear vision in the process of

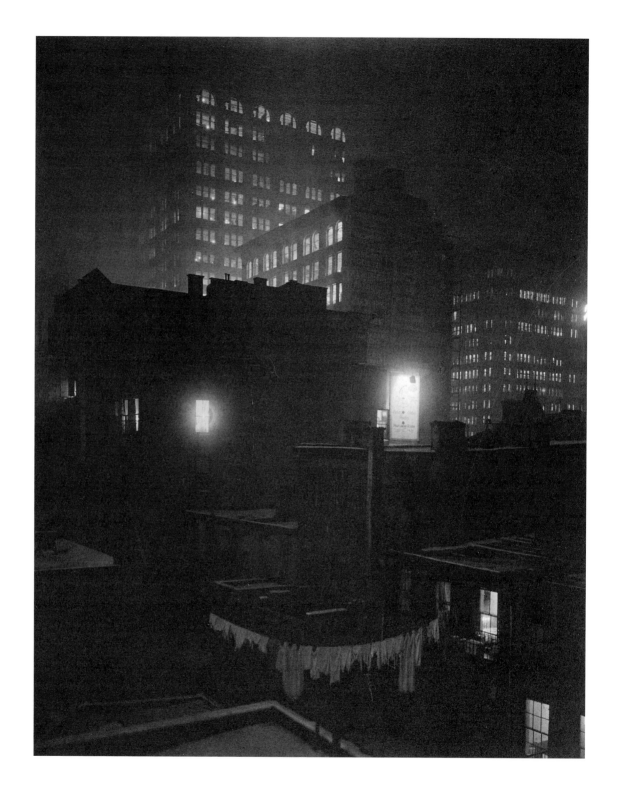

CHAPTER 2

conceiving its idea rather than a cloudy-minded dismissal. The National Gallery reproduction is even filmier, completely grimy;[55] however, the comparison is unfair, as the latter is made from a photogravure (as is my own reproduction), a process which, though superior, was still meant to produce multiples, for *Camera Work* in this case. As we look at the print, our gaze is clear-eyed and far-reaching, whereas in the reproductions the grime of the scene has been transferred into a grimy viewing of it, making us see poorly.

From the Back Window—"291" (1), 1915.[56] This is a platinum print, full of thick depths in the vast dark areas that, by contrast, produce a greater sense of penetration into the various dispersed windows, as if into the lives abiding there (or potential for life, as no people are visible). Again, everything seems to hinge on the power of blacks in the original print. Even though the reproduction has the same details of objects and lines in the central area, the print feels blacker, more full of night, and supports a deeper loneliness and sense of lurking individuals with desires quieted in their modest rooms, behind the small well-lit windows. In the print the line of laundry seems to take up this desire, with cold humor and some pathos; in the reproduction the laundry is flattened and isolated from its source (here the National Gallery version is stronger, perhaps largely because of the paper, which provides the depth that leads to a weightier meaning). Moving from reproductions to original print, we are suddenly aware of a strong sense of privacy in the slivers of windows on the left, as compared to our gaze's invasion of the windows lower right, where lives seem the more exposed and naked as the rooms are empty. Finally, the ever-lit office buildings fade more spectrally into the sky. They are distant, floating, yet hover, owning the landscape of the city's light, even while the photographer has pushed them back from the huge darkness of the living; this is a balance Stieglitz much have worked hard to obtain, dodging overstatement.

"A Portrait," 1922.[57] This is one of over 300 images of Georgia O'Keeffe, the term "portrait" often serving as title for a majority of the images and thus applying, in fact, not to one image but to the whole project, extending over some fifteen to twenty years. The first, quite shocking difference is the extreme darkness of the whole face in the print. An idea of this value can be found in another reproduction in O'Keeffe's own choices for a volume to accompany an exhibit at the Met in 1978.[58] Here the face could be that of an African-American; bright areas look like highlights off deeply colored surfaces. The somewhat pockmarked cheeks of the Bry, still apparent in the Met reproduction, are hardly visible in the print; not only does O'Keeffe appear to be a different age, but the expression, or rather the whole intention and intensity of her looking,

seems quite different. This face, filling almost the whole image, contrasts more strongly with the lighter background, and has been rendered statuesque (though we are dealing only with the head), more confident and soaring out of the image space. In the Bry reproduction, where the increased light has brought down O'Keeffe's imperiousness at least a few notches from that of the print, we realize even before much reflection that we are looking at a piece of paper. In the print the light of ordinary day is behind O'Keeffe, and the skin and structure of her neck, which is at eye level for us, has none of it, whereas the book printer's screening process has speckled her blanched, daytime skin. The smoothness of the print's rendering has permitted the skin to retain texture, the sensuality of its sculpturing, whereas much of the texture of the reproduction seems to be dictated by the process. Perhaps the reproduction was made lighter in order to search out detail, in lieu of the feel of a body it had no means of reproducing.

These are but three examples, of industrial America, of buildings set out in planes for living and business, of a beloved face. They stand, here, for a general principle. The Boston prints do not necessarily tell each of us the same thing, as dictated by Alfred Stieglitz, but they give us the confidence to say we are looking at his vision, whatever you make of it. In the face of huge doubts about the ability of his medium to be artful at all, an artist has managed to impose precise expression and to convey that work of expression into a place of serious conservation. We may here be sure of seeing what Stieglitz saw and hoped to have us see, know for sure that the infinity of our various responses all refer back to prints that perform their very best intentions. They went to Boston for free (how shocking, really, and worse, at his own expense); his conditions were all aesthetic, with the exception that they be shown periodically; they are unencumbered by remounting or other extraneous decisions; and they are unique and uniquely fine. When they are exhibited, the rooms of the Boston Museum of Fine Arts will be a magical place, well worth the voyage. As they are perfectly preserved and saved for us, we may see the value of Stieglitz's intransigence, if not arrogance, and gain a certain nonmonetary profit from it; for in this preservation, the ideal of the museum itself is also preserved.

International Exhibition Modern Art
New York

To our
Friends and Enemies
of the Press

The Association of
American Painters and
Sculptors, Inc.

March 8th **BEEFSTEAK DINNER** **1913**
Healy's—66th St. and Columbus Ave.

MENU

ALL YOU CAN EAT AND DRINK

3 Before the Armory (1913)

Stieglitz had very little to do with the Armory Show directly, and nothing at all to do with organizing it. His name appeared as honorary vice-president, a fact which, if anything, would confirm an entirely passive role, though an important symbolic one; other honorary vice-presidents included Monet, Renoir, and Odilon Redon.[1] But his presence was continually felt, as I would like to show. Most publicly, at the outset, he volunteered (or found himself enlisted for) an interview to preview the show for the *New York American.* This article, ambiguously identified as "by Alfred Stieglitz" but in small print said to be "contributed to this newspaper in the form of an interview," appeared on January 26, 1913, some three weeks before the Armory opened its doors on February 17. As this seems to be the only advance text to prime a potential audience before the opening, it stands as witness to the authority invested in Stieglitz by the press. The editor announces that Stieglitz is the "Distinguished American Leader of the Movement" of "Revolutionists," his gallery on Fifth Avenue being famous as the "headquarters of 'Futurists.'"[2] Explicit in this interview or article is the idea that the Photo-Secession gallery at 291 Fifth Avenue had already provided the public with innumerable opportunities to see what was going to be considered revolutionary at the Armory Show. At that moment in 1913 Stieglitz was exhibiting oils and

watercolors by John Marin at 291, which explains why most of a full column of the article is devoted to quoting the American painter; while advertising the other exhibition, Stieglitz was telling his readers to come up to the "little rooms" for a foretaste (Marin had ten watercolors at the Armory Show, and no doubt some if not all of these were the same ones taken down two days earlier from the walls of 291). But it was not only a matter of Marin's work, for since 1908, some five years earlier, 291 had shown more and more artwork, mainly American and French, and less photography. Since 1910 only two photographers had been exhibited, Steichen and de Meyer, each once, whereas there had been over twenty exhibitions of paintings and sculpture. Were it not for exhibiting his own work during the Armory Show, one would have guessed Stieglitz had given up on photography altogether, very close to the very moment he had gained the victory of Buffalo. With hindsight we can see that he was marking time, waiting to be offered something really new and strong—and that was to be Strand. Meanwhile, he was enlisting painting in this "clinic to revitalize art," as he put it, to revitalize the photographic or any other arts, and he had been putting onto his little stage in New York the most radically nonphotographic work of the time.

The *New York American* knew this in 1913, and the point is no longer in dispute. But because of the irresistible impact of the big public bash, the Armory event will no doubt continue to reap most of the credit for the introduction of modern art into America. The standard histories now give Stieglitz and his circle a chapter before the one on the Armory,[3] but the sheer size of the show, with its well-publicized effect on a popular audience, will continue to hold its power over our imagination, the power of a revolution in art, even a revolution in perception, which was managed so as to take the shape of a spectacle. As the recent National Gallery of Art exhibition *Modernism in America* amply illustrates, 291 deserves the credit not only for promoting the new young Americans who came to be thought of as Stieglitz's "stable" of artists, but for introducing the more fundamentally rejuvenating so-called "School of Paris" to New York, in a well-elaborated and considered demonstration, a true clinic in the exploration of expression.[4] In contrast, there is good reason to wonder if the organizers of the Armory Show had much of a clue about what they were doing, not to mention the time in which to do it. One of the most fascinating, hardly believable aspects of the show, as described in great detail by Milton Brown in his *Story of the Armory Show,* is the spectacle of the two or three main organizers virtually stumbling onto modern art in toto, with almost no previous exposure to it, and ordering it all from Europe in the space of only a few weeks. Meanwhile, Stieglitz and his collaborators had been methodically

exhibiting choice segments of modern production over a five-year period, with very small funds and no sales to speak of. But that was in the nature of a carefully examined evolution, not a theatrical revolution for mass consumption.

I won't recite the whole history, which Brown elaborates in marvelous detail; a sketch of the organizers' progress in 1912 shows them veritably consuming art. Imagine this early modernist itinerary: Walt Kuhn, alone, arrives in Cologne on September 30, the last day of the 1912 Sonderbund show, to see 125 Van Goghs, 26 Cézannes, 25 Gauguins, and 16 Picassos, as they were being taken off the walls. Then, rushing from Cologne to The Hague, Munich, and Berlin, he quickly makes his way to Paris where he can foresee being so overwhelmed that he cables Arthur Davies, the chief organizer and financier, to join him. Guided by Walter Pach, who knows the dealers, many of the artists, and the Steins, Kuhn and Davies build the whole French connection of the Armory Show, from impressionism through fauvists to cubists, in the space of less than ten days, Davies having arrived on November 6 and he and Kuhn already in London on November 16 to see Roger Fry's second Grafton Galleries exhibit.[5] The Armory was the product of this whirlwind tour and crash course, and obviously dependent on whatever was going to be available on the spot from dealers, shows, and artists. It is its own parody, but on a gigantic if not mythological scale, of the rich American buying culture in Europe, although, of course, they were not yet buying. Dealers like Vollard and Kahnweiler must have looked askance, all the while ecstatic to have artists to whom they had been committed for so long with so little return find a large, possibly vast, moneyed audience in that faraway dreamland of the new: *l'Amérique*. Over four hundred paintings, sculptures, and drawings were brought to New York from Europe, ordered by two men after a few weeks' acquaintance. One wonders how many of the works they actually had a chance to inspect more than once, or for more than a few moments, to confirm or question first impressions. More likely they listened to a good deal of only partially disinterested advice.

From this brash excursion was the revolution formulated, a bare three months before the show was hung. Of all the members of the Association of American Painters and Sculptors, only Davies, Brown surmises, knew even a little about Paris art. He got his idea for the show after seeing the Sonderbund catalogue in August 1912 (and we should consider the poor quality of reproductions at that time).[6] Before that exposure, Davies had bought a Cézanne watercolor he had seen at 291, in March 1911, but his own taste was not otherwise auspicious if we look at his own painting as an indicator of what he would suddenly be

promoting at the Armory. To the show he loaned three drawings by Serret; from the show he acquired Cézanne, Villon, Duchamp-Villon, Gauguin, and Picasso, along with Manolo and Redon.[7] Throughout, his own style remained uninfluenced by the new art to which he was, manifestly, willing to open America's doors, as well as the doors to his own home. So we might take that first Cézanne purchased via 291 as the true beginning of the show.[8] It was also, perhaps unwittingly, the salesman's foot in America's door.

The most revealing demonstration of Stieglitz's huge yet half-forgotten role in the fostering of the Armory Show is the roll call of European artists, and even of specific paintings, shown first at 291. It begins as early as January 1908, with the first exhibition of drawings by Rodin. He showed fifty-eight drawings, which in their looseness, spontaneity, and evanescence were more contemporary than Rodin's more finished sculptures. The seven hung at the Armory were lent by Gertrude Käsebier, the Secessionist photographer who was a regular exhibitor at 291 and a contributor to *Camera Work;* it is likely, therefore, that she acquired her seven from Stieglitz, or at very least her taste for them, whether at this show or from one of the subsequent exhibits at 291 before 1913, as there was no place else to see them in America. "These drawings should never have been shown anywhere," wrote one critic.[9] Thus began a series of shows almost universally condemned by reviewers, whose columns Stieglitz regularly and accurately reproduced in the pages of his *Camera Work* to record the early history of the art community's reception of modernism. Here is the roster of those of his radical exhibits that led to the Armory Show, along with a sampling of their reception in the papers.

April 1908, first American exhibition of Matisse. Apparently only one work by Matisse was to be found in New York before this exhibit, where it was shown.[10] It was owned by George Of, who did framing for 291 artists, and it was shown again at the Armory Show.[11] Stieglitz himself lent six drawings by Matisse to the Armory (Michael Stein lent three, and the artist nine, of twenty-two in all). "Female figures . . . of an ugliness that is most appalling and haunting, and that seems to condemn this man's brain to the limbo of artistic degeneration," wrote the critic for the *New York Evening Mail,* while the well-known James Huneker wrote in the *Sun:* "With three furious scratches he can give you a female animal in all her shame and horror. Compared to these memoranda of the gutter and brothel the sketches of Rodin (once exhibited in this gallery) are academic."[12]

December 1909, Toulouse-Lautrec lithographs; the artist's first introduction in America. These prints were not for sale, nor did they find

their way to the Armory, as far as we can tell, where only one lithograph was hung. Though Stieglitz showed Lautrec "more as a protest than anything else against that commercialism which has led so many of our men,"[13] the French artist was not a special focal point in 1913 at the Armory, for either antagonists or supporters of the new painting. And yet, in 1909, Hoeber of the *Globe* complained, "One leaves this room with a bad taste in the mouth," and Chamberlin in the *Mail* felt, "Most of them are indescribable; and a description would not be edifying if it were possible."[14]

February 1910, second Matisse exhibition. Drawings, of which the usually advanced critic J. B. Kerfoot wrote amusingly: "I had been spending an hour with Henri Matisse in the 'Little Galleries,' inviting my soul—and having the invitation refused."[15] By invoking Whitman, at least Kerfoot was getting into the right spirit. Two of these drawings were reproduced in *Camera Work* for October 1910.

April 1910, a second exhibit of drawings by Rodin.

November 1910, small paintings by Henri Rousseau, along with lithographs by Cézanne, Renoir, Manet, and Toulouse-Lautrec. This show represents the introduction of both Rousseau and Cézanne to America.[16] The work by Rousseau belonged to Max Weber, who was thus instrumental in arranging this, the artist's first one-man show anywhere.[17] Two months later Stieglitz gave Weber his own first comprehensive show. Of ten works by Rousseau at the Armory, seven were lent by Weber, and so most of what was seen at the Armory had already been hung at 291 over two years earlier. The influential James Huneker dismissed Rousseau in the New York *Sun:* "As an artist he is a joke. To deify his ignorance smacks of the silly or the hysterical."[18]

March 1911, Cézanne watercolors. It is from this show that Davies bought his Cézanne. Later, he and Stieglitz each bought a lithograph of *Les Baigneuses* from the Armory Show, as did John Quinn and Walter Conrad Arensberg (Davies actually bought two). Hoeber of the New York *Globe* wrote: "As it stands the work is meaningless. . . . There are other drawings in front of which the present writer was unable to make out the intention, mistaking a landscape for a branch of blossoms until corrected by the ever cheerful cicerone, Mr. Stieglitz."[19]

April 1911, Picasso drawings and watercolors. First one-man show anywhere, as well as the first public display of a thoroughly cubist work, *Drawing* or *Female Nude,* a charcoal that Stieglitz bought and later lent to the Armory Show, along with a 1909 bronze, *Bust* (now called *Woman's Head*). The charcoal was reproduced in *Camera Work* for October 1911, following sixteen photographs by Stieglitz, thus inviting comparison between painter and photographer; I will return to this subject in the

next chapter. The drawing was called a glorified fire escape and a wire fence, responses that anticipate the language soon to be used for Duchamp's *Nude Descending a Staircase.* Hoeber in the *Globe* quite lost control of himself: "The display is the most extraordinary combination of extravagance and absurdity that New York has yet been afflicted with. . . . Any sane criticism is entirely out of the question; any serious analysis would be in vain. The results suggest the most violent wards of an asylum for maniacs, the craziest emanations of a disordered mind, the gibberings of a lunatic."[20] I expect Hoeber was hardly to be brought around by Gertrude Stein's essay on Picasso in the special August 1912 issue of *Camera Work* (her first public appearance in print, preceded only by the privately printed *Three Lives*): "One whom some were certainly following was one having something coming out of him something having meaning, and this one was certainly working then." I shall have more to say about this deconstructed and minimalist picture of Picasso in the next chapter.

March 1912, first Matisse sculpture exhibit anywhere. Hoeber's response was rendered tortuous, even tortured, by his subject. His aesthetics became sexual, an interesting issue which will come up later in connection with a closer look at Matisse. Hoeber described the Matisse pieces as "impossible travesties of the human form. There are attenuated figures representing woman seriously offered here which makes [sic] one grieve that men should be found who can by any chance regard them with other than feelings of horrible revulsion."[21]

Sometime in 1912, introduction in America of Manolo, a pleasing but not disturbing sculptor who was handled by Kahnweiler. Three were lent to the Armory Show by Paul Haviland, a friend and strong supporter of 291. Of the other works by Manolo at the Armory, Stieglitz, Quinn, and Davies each bought one.

Certainly this list of Europeans shown at 291 before February 1913 is extraordinary. It goes straight to the heart of the revolution the Armory Show was designed to effect. Almost every important artist was shown at 291 first, in many cases represented by the very works to go on to the Armory. I have not included the Americans shown at 291 who were also hung in the Armory Show: Marin, Hartley, Abraham Walkowitz, Alfred Maurer; there is no doubt at all that their exposure anywhere was largely Stieglitz's doing. He had also shown Dove and Weber, who were the most advanced and, in my opinion, the strongest of the artists at 291 at that moment. Neither of these two made it to the Armory. Dove was yet to reach his stride, and had in fact interrupted painting in 1912, though clearly he became within a few years the best American abstractionist before abstract expressionism. Weber was miffed

that the Armory committee would take only two of his works; he felt he was worth at least eight, and though that may appear arrogant on his part, he was probably right (and he was an arrogant and difficult person to deal with). Many artists who were weaker and, especially, who were far less innovative were represented with more than three or four works.

Admittedly some notable foreigners failed to make it to 291 before the revolutionary month: Braque, Brancusi, Picabia, Duchamp. But the gallery would soon show these others as well. Picabia, for one, was shown beginning two days after the Armory closed, and Brancusi and Braque (he and Picasso together with African art) in 1914. The February through April 1913 showing at 291 of what we might call a triple threat—Marin, Stieglitz, and Picabia—served as a counterstatement to the profusion and hype of the Armory Show; it was Stieglitz's assertion that he was well prepared to be much more coherently modern, even if he hadn't gone before in every respect.

It is not difficult to see, then, that Stieglitz's efforts not only anticipated the Armory but also supplied it with direction and specific works of art to hang. It is within this context of his grasp of the event to come that we can understand the implications of the January 1913 interview for the *New York American* that I opened this chapter with. Stieglitz was not sure he had made himself clear, and in a letter to a friend he disclaimed responsibility for much of the contents of the article: "Did you see the so-called interview with me published in yesterday's American? It contains some things I said but a great deal which I did not say and is virtually the reverse of what I did say."[22] From everything we know about Stieglitz's thought, it is hardly likely that many of the ideas in the *American* are fully the reverse of what he wanted to express, but perhaps he had second thoughts about interviews when he was confronted with a text over which he had not exerted more control. Further, we may guess that he was uneasy with finding himself caught up in the Armory Show's exploitation of the popular press, with all that entailed in the way of advertising the artists in a most commercial manner.[23] The article asserts Stieglitz's position as an authority and trailblazer (and Stieglitz was not prone to this style of self-advertisement except in self-defense, even though he knew he was performing the roles), since he and only he, in the article's view, can prepare the public for the terrifying and incomprehensible event to come, and at the same time ally himself selflessly with the enterprise. This enhancement of the promoter, as a means to enhance the excitement of the event, is probably the newspaper editor at work. Stieglitz, for his part, only asks the reader to go without prejudices, to apply no labels (these make artists "froth at the mouth"), to see what is there as well as the meaning behind what is there, as expressed

on the canvases and nowhere else. This tactic of an appeal to open-mindedness was a common one for Stieglitz; he had just used it to introduce his April 1912 exhibit of children's drawings and paintings. His is a completely antiauthoritarian call to clear the table of traditional expectations.[24] He expects readers to be disgusted and calls upon them not even to reject their disgust. They don't have to like the work but they should be open-minded enough to look at themselves honestly afterward and recognize the possibility that their discontent has a value, for which the exposition may come to take the credit: "When the smoke has cleared away you will go back to your habitual worship of eternal repetitions of mere externals of people and things that cram all the museums and galleries—but you won't feel happy. The mere outside of things won't satisfy you as it used to."[25] While the header for this article claims that Stieglitz is the leader of those insisting that "the old Masters should be destroyed and that true art cannot even imitate Nature," the article itself never says any such thing; but it does roundly condemn "copyists" and deems that imitation has died as a viable enterprise. What is largely at issue here, then, is representation. As Stieglitz makes clear at some length in connection with the Marin show that had just opened at 291 (January 20 to February 15), art begins where imitation ends. Marin is seeing into things, behind and into representation, he might say. In this sense, representation is a red herring, while, to go to the core, to the truth or the ideal, the painter—and his viewer, not to be forgotten—must delve into the abstract. In this manner of argument we can see Stieglitz espouse, in advance, the meaning of the most radical exhibits of the Armory Show and propose their special lesson of freedom with representation, as well as freedom from it, as the norm for the whole demonstration. It is interesting to wonder just how much the show actually measured up to Stieglitz's prediction of the truly new, to see where the actual emphases were, and what in fact was missing.

Missing, most noticeably since their presence had been so noisily announced, were the Italian futurists, who had demanded to be shown as a group and who withdrew when the demand was not met. And yet the press was ready to seize upon this ism to stand for the whole gist of what was revolutionary in the show; as we have seen in the *American* article, Stieglitz at 291 was already a futurist. What fine, telling wish fulfillment! There were in fact a few works that appeared to be or actually were futurist in some degree. The American Joseph Stella may, or then again may not, have exhibited his *Battle of Light, Coney Island*.[26] This painting was not mentioned in the press, though it was a scandal in a show the following year. In any case, there is some debate as to just how properly futurist it is, though there can be no doubt it would have passed as such

in the eyes of the public in 1913. Stella's other entry, *Still Life,* would never have been taken for futurist. The main "futurist" exhibit, then, would have been Duchamp's *Nude Descending a Staircase.* Certainly it is more futurist than it is any other sort of thing in the way of isms, and already had its iconoclastic way prepared for it by being excluded from a Paris show the previous year by Duchamp's cubist colleagues. Movement is duly decomposed into its constituent elements. But rather than a truly futurist rush of movement, an appeal to multiplying the viewers' excitement by multiplying discernable body parts as they change through time exposures, this painting might better be termed an anatomy of pure, dematerialized movement, an almost colorless analysis in which the importance of the body recedes, along with the importance of sensuous color. As in futurism, there is a crisis of representation, but not because representation is absent. The painting's prominence in the scandal of the show is due to the fact that the body has not disappeared sufficiently, but has been transformed into malleable blocks which still suggest the real body at the same time that it is being dismissed. No specific elements of a real body subsist, only the schematic elements of escaping movement as we might produce it by manipulating an artist's wooden manikin. The painting is the site of a discernible insult to the Female Form Divine, probably the most important victim of the Armory Show's attack.

Beyond these two paintings (or one painting, if Stella's wasn't shown), there is no actual futurism at the Armory; we might try to draw in Delaunay's *Fenêtres sur la ville,* and those would fill the poor ranks of the scandalous yet absent movement. It is as if the city had braced itself for futurism and in its eagerness to take up the imagined challenge was not to be denied. The American public did want futurism, whether they were going to like it or hate it, because, as its very name claimed—relevant or not—it marched under the same banner as America itself. Progress was what made America young and new, as well as strong and optimistic. Why then should not art itself progress, be modern, be optimistically bright-colored? This question raises a truly American dilemma: cultured conservatism may be instinctively more comfortable and even sound, yet how can such an American preserve remain safe from invasion by the very essentials of American ideology: progress, change, the new, along with related and felt concepts like individuality, democracy, and freedom? How to hold on to anything of value if all and anything new is, in an ideological a priori, supposed to be better? Theodore Roosevelt, recently released from the presidency, spoke as a perfect example of someone in this dilemma, wedded as he had been for years to the national dream of progress, yet embarrassingly unable to accept the new:

It is true, as the champions of these extremists say, that there can be no life without change, no development without change, and that to be afraid of what is different or unfamiliar is to be afraid of life. It is no less true, however, that change may mean death. . . . It is vitally necessary to move forward and to shake off the dead hand, often the fossilized dead hand, of the reactionaries; and yet we have to face the fact that there is apt to be a lunatic fringe among the votaries of any forward movement. In this recent art exhibition the lunatic fringe was fully in evidence, especially in the rooms devoted to the Cubists and the Futurists, or Near-Impressionists.[27]

The bully American has cornered himself between two manners of dying: the death of an immovable past with no tolerance for change and, more terrifying, that death contained in the very idea of change. That progress beyond himself is unacceptable to Teddy, whose own taste does not permit a happy ending for him, in that position where he has stopped changing. What makes his review so touching is that we sense he knows he isn't really on safe ground, that he knows he is dying.

Graciously, Roosevelt does not stoop to saying that such "lunatic" futurism is especially distasteful for not being of purely American origin. One critic who saw a parallel between "futurist" or modern art coming to these shores and the threat of massive foreign immigration poisoning a coherent, purebred American spirit was Royal Cortissoz: "The United States is invaded by aliens, thousands of whom constitute so many perils to the health of the body politic. Modernism is of precisely the same heterogeneous alien origin and is imperiling the republic of art in the same way."[28] New life and blood, then, is a new death, in place of a merely old one. The principle of a futurist America, that is to say, of an America of the future, would always have to prevail as an idea, but as a fact it would have to be fought aggressively all the way; otherwise it would be hard to imagine the famous label of "Ellis Island art" as anything but praise, which it manifestly was not (of course in retrospect the official historian would record that the immigrant had been welcomed with open arms, so at least the myth of the land of the future would be sustained). Another critic, F. J. Gregg, could make reverse use of the biological metaphor, writing that the Frenchmen showed the seeds of a "growth into fulness," while the American work was "deadly dull and suggests decay."[29] Trying to sort out Cortissoz and Gregg when read together, we might say that American academic art looked into the mirror of futurism and saw its own death, but then blamed the carrier of the news. Futurism, in its mistaken guise of harbinger and representative of all of the new art, was flaunting freedom and youth in the face of a stale art community that claimed freedom and youth as its exclusive, national birthright.

That the new art was as much a mirror as an alien otherness framed on the walls was exactly Stieglitz's point, or at least his hope. Certainly he was interested in visitors seeing the paintings; but he continually returns to the hunger in the viewer, a hunger created not by representation in the paintings but by what freedom the paintings represent: "The mere outside of things won't satisfy you as it used to." The emancipation of the artist was terrifying because, mirrorlike, it called out to the viewer to emancipate himself or herself as well, and this call was such an assault on the viewer's sensibilities that it was impossible to remain indifferent, quite precisely because the American viewer was primed to applaud change. As Meyer Shapiro has pointed out, while modern art in 1913 had to fight for acceptance, its audience already "shares the artist's freedom and feeling of isolation (in both their agreeable and negative aspects), but has not discovered the sense of its new experience."[30]

Whereas Stieglitz was always concerned with the experiencing of art, calling 291 a laboratory and not a gallery, the American audience, desirous of futurity without death—or call it progress without change!—was unlikely to truly experience anything very deeply, certainly not its own contradictory emotions. A cultural escape was, however, conveniently provided, and that was sensation: a roaring scandal, a world of headlines and publicity, and, ultimately, the world of consumption. One did not need to think of acquiring a work for its aesthetic relationship to oneself but for the scandal and publicity it aroused, which is to say, for fame and investment.

From Brown's exhaustive account it is clear that the organizers wanted a big bash of a show, American-style boosterism. While Davies was more discreet (discretion was a most powerful aspect of his personality, as he maintained two separate households without raising suspicion in either and was able to raise huge amounts of money almost magically from rich society women to fund the show), Kuhn was perfectly clear and frank in his letters: "It will be like a bombshell," he wrote Walter Pach in December of 1912:

> I have planned a press campaign to run from now right through the Show and then some. . . .
>
> We are going to feature Redon big (BIG!). You see, the fact that he is so little known will mean a still bigger success in publicity.
>
> John Quinn, our lawyer and biggest booster, is strong for plenty of publicity. He says the New Yorkers are worse than rubes, and must be told.
>
> The ball is on.[31]

Roosevelt invoked P. T. Barnum in connection with the show, while at least one newspaper referred to it as "sensational"; the commentators got the idea. After all, it was not an exhibition but a show, like a horse spectacle at the Hippodrome.

Certainly Duchamp's nude had a great role to play here, but a role that was largely given to it by the promoters and the press. It figured in reproduction on the menu for the beefsteak dinner organized for "Our Friends and Enemies of the Press," directly under the words "All you can eat and drink"[32]—as if to say, Consume this painting, if your digestion can take it. Everyone had a new title for *Nude Descending a Staircase.* "Rude Descending a Staircase" recalls the remark attributed to Quinn about New Yorkers being worse than rubes. "Explosion in a Shingle Factory" is the most famous description, but not better than "Staircase Descending a Nude." One writer may have smelled more cubism than futurism when he or she called it an "academic painting of an artichoke" (one wonders what was meant by "academic" here). The winner of a newspaper contest to explain the painting opined the nude "isn't a lady but only a man."[33] But no problem in interpretation is solved by that determination. In any case, there is no way to guess the sex of the figure, and the French title of *Nu* right on the canvas, although in the masculine form, is general and neutral, for the portrayal of either sex. Was there some anxiety that this might, indeed, be a woman, the Female Form Divine? In the painting it is *forms* that are denuded, not bodies, and to that degree the shapes we see are not naked, for the prurient. The unclothing is very much for the mind's eye: naked art principles. For comparison, of picture and title both, the audience might have strolled over to Robert Henri's *Figure in Motion,* which William Zorach remembered as the "nudest nude I ever saw."[34] The scandal, as far as Duchamp held any responsibility for it, was in his combination of a painting of misrepresentation from which the nude is not convincingly banished and a title displayed right on the image itself which does not appear to coincide with it. Even in Paris the year before, the title in the painting was what had irked fellow painters. It is only one absurdist step to Magritte's *Ceci n'est pas une pipe,* the title inscribed on the painting of what is, so obviously, a pipe. Michel Foucault, in his *This Is Not a Pipe,* has discussed the peculiar interplay of language and paint in Magritte's painting, where he sees a greater assault on the necessity of language to represent objects than on the image's necessity to do so (though both are assaulted). A dozen years before Magritte, Duchamp had already set up the profound ambiguity of these interrelated representations. We note that the title can describe what the painting *should* imitate, evolving in a reality outside of its frame, or it can describe the work of painting itself; how-

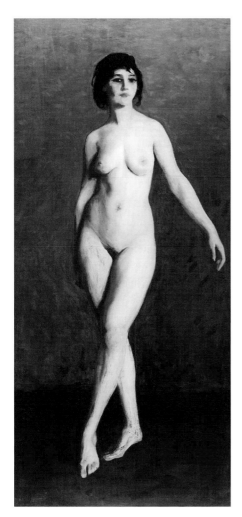

3.2 Robert Henri, *Figure in Motion,* 1913. Oil on canvas, 77 1/4 × 37 1/4 in. Terra Foundation for the Arts, Daniel J. Terra collection, 1999.69. Photograph courtesy of the Terra Foundation for the Arts.

ever, this latter is a lot trickier to do since the title is part of it, internal to the painting it means to label. Another way of describing the *Nu:* a still painting of the flow of futurity that absorbs its stabilizing metatext, making what describes it flow with it.

It stands to reason that the title got so much of the attention, and provided the source of ridicule. Certainly the nude has disappeared in terms of sensuousness, leaving only its form as it has been deconstructed, as if into formulas about its subject. One is not offended morally, only intellectually. The steps of the staircase no longer function as elements in a steady series of pedestals; form, whether academic or realistic, of both pedestal setting and nude has been slighted in favor of motion, descent into the field of the title, which combines description and challenge, and the challenge can be taken up there with some humor. It is this painting's relatively high clarity, in each of two separate yet insistently interpenetrating fields of perception, image and text, that gave the promoters and the press their hook. One wonders why they did not latch onto the more obscure though certainly similar *King and Queen Surrounded by Swift Nudes,* a painting that also had its title in the picture (and the "nus vites" of the French title is more odd a phrasing than its English version admits, unlike the "nus en vitesse" of an earlier version). Duchamp had arrived on the scene with just that combination of representations and destruction of representations which the press and the public could absorb and thus be willing to try to identify.

Whether *Nude Descending a Staircase* was cubist or futurist, or something else, no one knew; Duchamp later described it as the passage, for him, from the painterly to the nonretinal.[35] It was difficult to convincingly revile it for what *sort* of thing it was, for there was no category to take it in. It appeared to be an eccentricity, a form of artistic anarchy; in the revolution it stood apart and alone, and was actually less aggressive than, say, the fauvist or the abstractionist work. Indeed, what was burned in effigy in Chicago when the show traveled west was not a Duchamp but a Matisse, that "apostle of ugliness."[36] Whereas the show had elicited complaints of tomfoolery in New York, in the Midwestern city it raised questions of morality. A Sunday school teacher turned his pupils away as soon as he glimpsed Paris "degeneracies" from the door, and the superintendent of schools considered declaring the show off-limits;[37] ironically, one of the major complaints, leveled at Matisse in particular, was that many of the artists drew like children. Though such paintings were deemed to be poorly drawn, they nevertheless managed to be sufficiently "obscene," "vile," and "profanely suggestive" that they could not even be hung in saloons (interesting to wonder what special guidelines about obscenity or suggestivity licensed images designated for such

places). The investigator for a senatorial "white slave" commission promised a thorough investigation, and duly came to the conclusions that futurist art was immoral and that a woman in Matisse's *Luxury* had four toes.[38] These accusations, in which incompetent technique is allied to the accomplished portrayal of lewdness, are oddly revealing; the goal of technique and training would be, then, to dissimulate a ubiquitous vileness ever ready to leap out. Extraordinarily, adroit representation is recognized as a mask, and a necessary one, the proper form of accomplished and civilized lying, while mere children and madmen are accidentally endowed with the ability to see the underside, or rather with the inability to mask it. The most violent of the attacks were led by art teachers and their students, who hung Matisse, Brancusi, and Walter Pach in effigy and burned imitations of Matisse's *Luxury* and *The Blue Lady* (now known as *The Blue Nude*). As compared to most critics and the general audience, those trained to draw may have seen that Matisse was not so incompetent; this realization could only make him more perverse, if not perfidious.[39]

In reacting to Matisse with horror, Chicago was not especially more provincial than any other city; Paris viewers had behaved as violently toward him since the fauves had burst upon the Salon d'Automne in 1905. Another term for the beasties was the "Invertebrates"; indeed, when a friend of Gertrude Stein was introduced to the painter in front of his nude at 27 rue de Fleurus, she could do no better than to blurt out that she did not think she could assume that particular pose, to which the artist responded "Et moi non plus."[40] So, while we may presume the primary assault of the fauves was in the realm of color, drawing and the line as representation were also being called into question. In *The Blue Nude* the contortions of the body force it into a more patterned relationship to the other elements of the painting, and tend to both float it off its ground and make it two-dimensional on it. But I see no need to claim that representation is completely swamped in design; while the rump is unduly emphasized by a heavy dark-blue swath of "ground" around it, and then by another above that in the curving palms, such patterning does not obscure the solidity of this highlighted posterior. Its simple outline along with the lines of various other parts of the body—underarm, belly, ankle, and the place where the buttock joins the thigh—are quite true; these successes must have seemed accidental in what was an otherwise erratic rendering of the body's form. But the painter was faithful to a sensuousness that is overripe, a maturity that is the more voluptuous by virtue of its proximity to collapse, that last call before death which the public recoiled from, calling it ugliness. The schematic drawing of the face is not, for example, what horrified viewers, but those areas

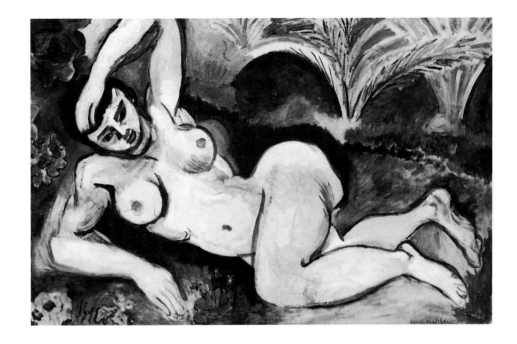

3.3 Henri Matisse, *Blue Nude (Souvenir de Biskra),* 1907. Baltimore Museum of Art: The Cone Collection, formed by Dr. Claribel Cone and Miss Etta Cone of Baltimore, Maryland. BMA 1950.228. © 2004 Succession H. Matisse, Paris/Artists Rights Society (ARS), New York.

where the reality of the sexual but declining body violated the perfect, sanitized, and eternally young body of the academy. Nudity, if sufficiently idealized, would pass, including the extremely sexual, life-sized nude by Robert Henri mentioned above, the painting whose sensuality William Zorach remembered so well fifty years later. In that *Figure in Motion,* while the body's unidealized maturity fairly advances—in fact, like Duchamp's, this nude is descending—out of the frame to step up to the viewer, it presents what must have passed for a sufficiently idealized gesture, as underscored by the word "motion" in the title, permitting a well-trained audience to idealize its remarkably frank eroticism. In its way, Henri's *Figure* is the more subtly subversive, in America, for its sensual push against the norms. Matisse conceded nothing to this classical and Victorian necessity contained within the academic, the tradition of the Female Form Divine that solved the problem of representing bodies without requiring their actual, overly physical presence. And paradoxically, Matisse could draw an insufficiently representational picture that rudely awakened ideas of real bodies by failing to sufficiently invoke mythical, unreal ones. The artist was damned for drawing too well and too poorly at the same time. The body was not the Body: "The body is the temple of God and the cubists have profaned the temple," spoke one lecturer. "It is not possible to accept such offensive representations of the

human form divine as those which appear in 'La Coiffeuse' and the 'Panneau rouge' and the 'Portrait of Marguerite,'" wrote a critic in Boston. "Just who is responsible for this showing of dishonor to sensitive great art that finds expression in the chaste and beautiful painting of the human figure of the nude?" demanded a Chicago correspondent.[41]

Naturally Matisse's use of color did nothing to temper his violations of form. If what the public was protecting was the idea of an imitation that would not age, it could hardly be seduced by a body that appeared to be losing its blood. Here in the *Blue Nude,* as in other cases, the wording of the title is not merely for identification but raises a red flag. One might have found this much blue in an early stage of an oil portrait, to become undertone in the finished version of a pale, sickly ethereal body; so part of the insult is to declare the unfinished painting to be a finished one. Blue it is, without a doubt, though Leo Stein, who owned it while it was shown at the Armory, wrote (much later, granted) that it was really "a pink woman in blue scenery."[42] I don't know whether this is poor memory or provocation. It is true that the blue in the body is in part a reflection of its blue environment, which in any case is only partially blue. There is a curious effect where the left breast seems to have cast a shadow of its own hue and shape onto the darker green and blue background. Finally, while the very ripe nude is cooled by its blue shading, the roseate nipples are shocking in their contrast with pale flesh and in their playful way of finding their color from small flowers in the grass below. Certainly Matisse's indifference to muted, drawing-room tones combined with his perilously emotional line—as much as to say the demise of, on the one hand, anemic and powdered flesh and on the other of idealized and anesthetized form—were reasons enough to compel the art students to fight fire with fire. Duchamp evoked concern that the schematicized image of the wooden body was not solid and fixed, but fluid and variable, impossible to seize and exciting for that very reason; Matisse returned the image as both less real, in pattern, and more real in the portrayal of the aggressively sensual body on the way to its death. In both artists, a hierarchical distinction between subject and background was being dismissed: in Duchamp the staircase moved with the nude— or the nude was obliged to get into step with the floating stairs—and in Matisse body and plants flowered together.

At the same time that nudes by Duchamp and Matisse raised havoc with reviewers and the public, the even more revolutionary tendencies to abstraction, so beyond the pale as even to resist parody, were noticed only by a happy few. Only in their skirting of abstraction did Duchamp, Braque, and the other cubists become such great fun for the newspapers, which could run cartoons and contests about finding the subject in the

painting; the scandal absolutely depended on representation in the act of its violation. But true abstraction was already in evidence at the Armory Show, to provide a battleground where only the knowledgeable and very committed would choose to fight. It should come as no surprise to find Stieglitz implicated in almost all of the radical work in abstraction: he owned the *Female Nude* by Picasso, called merely *Drawing* at the time, a charcoal study which comes as close to abstraction as the painter ever ventured (this drawing was reproduced in the August 1912 *Camera Work,* along with the Matisse painting); he bought from the show the lone Kandinsky, *Improvision No. 27,* arguably the sole example of a purposely, programmatically abstract painting in the whole exhibit of over 1,200 works (and excerpts of Kandinsky's *The Spiritual in Art* had appeared in *Camera Work* for July 1912); Picabia would be featured at 291 in a matter of weeks; and Stieglitz had already given Marsden Hartley three shows at 291, the most recent being of his drawings in February 1912, shortly before Hartley went to Paris. Only *Fenêtres sur la ville* by Robert Delaunay, of works which had abandoned or seemed to have abandoned subject matter, escapes close association with the photographer.

The Hartley drawings are hardly remembered in a class with the work of the Europeans, and may even have disappeared completely. They may have been the drawings Stieglitz had shown a year earlier at 291, or just as easily not. It is known that Hartley absorbed a good deal about cubism and abstraction in his Paris trip in 1912–1913.[43] However, the closest we may come to seeing one of these drawings is the sketch Carl Zigrosser made in the margin of his copy of the catalogue.[44] By any account, Hartley had strayed the furthest from representation, as the very perceptive conservative critic, Kenyon Cox, recognized:

> Some of it is silly, but little of it is dangerous. There is one American, however, who must be spoken of because he has pushed the new doctrines to a conclusion in some respects more logical and complete than have any of the foreigners. In the wildest productions of Picabia or Picasso there is usually discernable, upon sufficiently painstaking investigation, some faint trace of the natural objects which are supposed to have inspired them; and even when this disappears the title remains to show that such objects have existed. It has remained for Mr. Marsden Hartley to take the final step and to arrange his lines and spots purely for their own sake, abandoning all pretense of representation or even of suggestions. . . .
>
> This, I say, is the logical end.[45]

BRAQUE, GEORGES
205 Le Violon *and fixed by Mozart & Rubens*
206 Anvers *Signac in oil*
207 La Forêt
 Lent by M. Henry Kahnweiller

KIRCHNER, T. L.
208 Wirtsgarten
 Lent by M. Hans Goltz

BOURDELLE, E. A.
209 Portrait
210 Observatoire de Meudon *child with grass observed*

GUERIN, CHARLES
211 Viole d'Amour
212 Dame à la Robe
 Lent by M. E. Druet

KANDINSKY, WASSILY
213 Improvisation
 Lent by M. Hans Goltz

CEZANNE, PAUL
214 Femme au chapelet *character*
 Lent by M. E. Druet
215 Portrait de Cezanne
216 Baigneuses
217 Colline des pauvres
218 Anvers
219 Portrait
220 Melun
 Lent by M. A. Vollard

HARTLEY, MARSDEN
221 Still Life, No. 1
222 Still Life, No. 2
223 Drawings, No. 1 *The Old Man with long ...*
224 Drawings, No. 2
225 Drawings, No. 3
226 Drawings, No. 4

28

HARTLEY, MARSDEN (Continued)
227 Drawings, No. 5
228 Drawings, No. 6

CROSS, HENRI, EDMOND
229 Amandiers en fleurs
230 La Clairiere *lurid pointillism woman in a tree*
231 Aquarelle
232 Aquarelle
 Lent by M. E. Druet

ZAK, EUG.
233 Le Berger.
234 En Eté

CAMOIN, CHARLES
235 Liseuse
236 Seville *tropical color*
237 Collioure
 Lent by M. E. Druet
238 Moulin Rouge *back out line school*
 Lent by M. Heinrich Thannhauser

DUCHAMP, MARCEL *The Shingle artist*
239 Le roi et la Reine entoures de Nus Vites
240 Portrait de joueurs d'echeque
241 Nu descendant un escalier
242 Nu (sketch)

HESS, JULIUS
243 Dame mit grünem Schirm
 Lent by M. Heinrich Thannhauser

MUNCH, EDWARD
244 Woodcuts, Nos. 1—4
245 Lithographs, Nos. 1—4

DUNOYER de SEGONZAC, ANDRÉ
246 Paysage No. 1
247 Scene de Paturage *cows*
248 Paysage No. III.
249 Paysage, (Drawing)

29

3.4 Carl Zigrosser, sketch of one of six drawings by Marsden Hartley shown at the Armory Show, as drawn in his copy of the catalogue. Annenberg Rare Book and Manuscript Library, University of Pennsylvania.

Further into his article Cox distinguishes Hartley from the Europeans; his drawings are "purely nugatory," thus not so offensive morally, while the French work is "in some strange way . . . revolting and defiling. . . . One feels that one has seen not an exhibition, but an exposure." Hartley, then, has even seceded from the field of scandal, attacking neither sex nor representation, as far as anyone else could see. As yet no name was attached to the position the abstractionists had reached, just as there were no titles for their productions. Their work disappeared from view at the show as if a failure to render them into language, whether representational or supplementary, gave permission to drop them from the discussion altogether. In contrast, the cubists, who had initiated the same processes, nevertheless maintained their dependence on both image and descriptive or disruptive language, to give the public grounds and a medium for outrage.

The Picasso drawing was called only that, *Drawing,* a permissible nonnaming for a mere sketch. If it had borne its subsequent title of *Female Nude,* no doubt that label would have forced the issue of representation, as with the Duchamp and Matisse nudes. As it stood, it gave no indication of its representing a figure except by the relation of width to height and the viewer's expectation that it must be of something. Two years earlier Edward Steichen, assembling the show of Picasso's work to be shown at 291 in April 1911, wrote to Stieglitz of his own bafflement at "this latest," certainly "abstract" work: "nothing but angles and lines that has got the wildest thing you ever saw laid out for fair. . . . I admire him but he is worse than greek to me. . . . There is one late picture that represents a nude woman. If you can make it out you are as good as I am. It's something like this [Steichen draws a copy of *Drawing*]. Please don't mention any of my opinions to the fellows so as not to prejudice them in any way—let them all see and judge for themselves—P may be a great man but it would be rank snobbery for me to say I see it *now.*"[46]

Nor was it necessary that Stieglitz himself, responsible for showing Picasso to America, understand the drawing much better; no matter what one thought of it, it had its place in an evolution, a spectacularly rapid one for any artist. 291 must truly have appeared a laboratory, by showing an exhibit that included blue, pink, fauvist, Cézanne-like, Iberian, and African periods before arriving at cubism and this cubelike abstraction—a veritable history of modern art compressed by Picasso into a dozen years of work, then further compressed into the two minuscule rooms of the Little Galleries. There the drawing made sense, as part of an individual exploration and progression. At the Armory, though, abstraction was beyond discussion and other connections had to be made, to *Nude Descending a Staircase* for example or, even more clearly, to Braque's *Le Violon,* which was saved for the parodists by the presence of

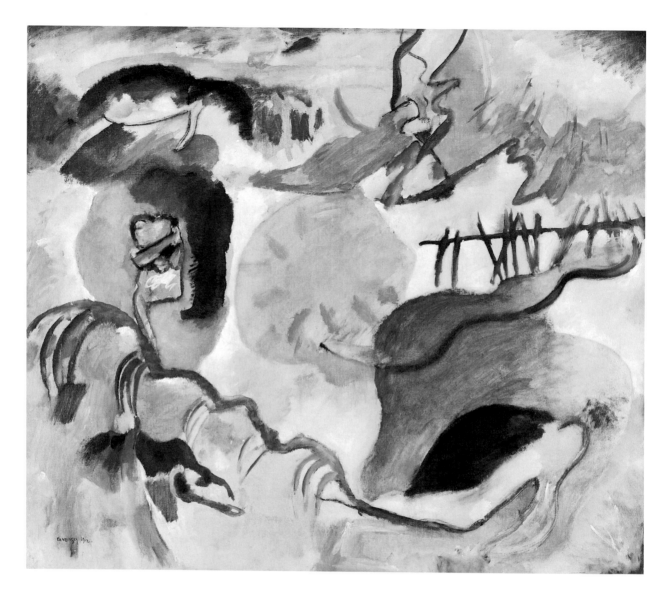

3.5 Wassily Kandinsky, *Improvisation no. 27 (The Garden of Love)*, 1912. Alfred Stieglitz Collection, Metropolitan Museum of Art, New York. © 2004 Artists Rights Society (ARS), New York/ADAGP, Paris.

pieces of the musical instrument and, even more helpfully, the words "Mozart" and "Kubelick" written into the painting. So *Drawing* would pass for cubist, even if it represented nothing. We might search for affinities with a figure, finding one of unknown sex, more likely clothed, perhaps with epaulettes; but then what violence these sharp angles make, all elbows, compared to Duchamp's swerves, his nude's swivel hips. Here the attack upon imitation is led by a rigid geometry. If, in cubist fashion, the artist may have once considered reducing the figure to its basic volumes, eventually he went beyond that operation to give full force to

the emerging logic of geometric schematization. In that extreme we can see *Drawing* as truly abstract, though it may actually bear witness to a Picasso sitting on the fence, unwilling to take the last leap.

Any geometry at all would have been, I feel, more comforting to the public of 1913 than the free strokes of Kandinsky. At least Picasso's drawing could be visually grafted onto the simple art class exercises that blocked out basic structures before "real" drawing began. But Kandinsky's *Improvisation no. 27* looked much less destined for control or organization. As faithfully announced in its nontitle, it was childish, emotional, formless, splotchy, random, ragged, indecisive, perhaps even made of parts from different works or intentions; and yet, as a finished and richly colorful oil painting of forty-seven by fifty-five inches, it forthrightly declared itself to be of consequence. In nonmedical circles in 1913 Freud's work was almost completely unknown in America, so no one was in a position to mount a defense for the meanderings of free association.

In May Stieglitz wrote Kandinsky to say he had bought the *Improvisation* mainly because he was incensed at the attitude of viewers, "and also more than incensed at the stupidity of most of the people in charge of the Exhibition, in not realizing the importance of your picture."[47] To another correspondent he wrote that he had felt the need to save it for New York because, as reported by Dorothy Norman, "from a certain point of view—that is considering the future development of a certain phase of painting—the Kandinsky was possibly the most important feature in the whole Armory exhibition."[48] It was certainly the most radical. In his search for the antiphotographic in painting, Stieglitz could find no better example, especially when we consider that Duchamp's nude had its origins in Marey's "chronophotography" (closely related to Muybridge's stop-motion photography), and thus was not very convincingly antiphotographic at all. The cubists were yet rearranging exterior reality which, even when drastically deconstructed, was hardly as disturbing as Kandinsky's almost entirely interiorized landscapes. There do seem to be recognizable items in the painting, arguably more recognizable than the objects in some of Picabia's work at the Armory, but they are such fluid and partial or indistinct forms that we question our own perception rather than the artist's mimetic abilities. We feel as if we are finding faces and animals in cloud formations. This difference is essential. The cubists presented a maze in which it appeared the object was hiding, so that a game was proposed, whether the artist desired this effect or not, and an object of some sort or other could usually be ferreted out or deciphered. Kandinsky's illusions of lurking realities are more hallucinatory, formless, and fading; anarchy is invasive, form conveys the fluidity of dreaming. Part of the difference lies in the

cubists' straight, rationalizing lines as compared to Kandinsky's wavering, shaken ones of this period; another contributing aspect is their preference for monochromes as compared to his screaming, raw colors, far worse than those of Matisse which are rather lush but cool. Matisse has a beautiful palette, Kandinsky's is garish or lurid; the artist can project the feeling that he may have no sense of color at all. And while Matisse's body is heavily outlined, massive against strong patterning, Kandinsky's bodies are so dispersed and approximate they appear ghostlike and convey perhaps only accidental resemblances, as we might dream of ourselves at the point of dissolution.

In the middle left perhaps a couple embraces; the pair mesh and disappear into each other in their embrace. It is a couple surprisingly like Brancusi's *The Kiss,* which could be seen at the Armory. Middle high is an embryonic and Chagall-like couple reclining in the air (Chagall's name stands to remind us that the organizers of the Armory Show must have been led to the Bateau Lavoir painters but not to those at La Ruche, whose national origins were, most often, the same as those of immigrants to America; in other words, La Ruche, not at the show, was painting the authentic "Ellis Island art" that America was afraid of). A doglike body upper left (or a cow?), the sun upper right but appearing again in the center, with its spokes of light inside it, a broken fence, a high-heeled shoe bottom right unless it is a sloppy reminder of the dog or cow. . . . All these images are under threat of dissolution from deformed drawing, irrational composition, and obsessive coloring, whereas in Braque, Picabia, and Picasso composition is extremely tight, even tighter than what representation would dictate. Kandinsky is too loose, he appears not to want to help organize the viewer's gaze; in this sense the viewer confronts his or her own loss of control. In the cubists you recognize the objects you can find; in Kandinsky you doubt the reality of the objects you see.

Even before the Armory Show Kandinsky had seen the difference. In an excerpt from *Concerning the Spiritual in Art* that Stieglitz had just published in *Camera Work* for July 1912, Kandinsky wrote: "In his [Picasso's] last work (1911) he arrives by a logical road to an annihilation of the material, not by analysis, but by a kind of taking to pieces of each single part and a constructive laying out of them [sic] as a picture. At the same time his work shows in a remarkable way his desire to retain the appearance of the material things."[49] In the same essay Kandinsky defined three modes in his own painting: "Impression," "Composition," and "Improvisation," this last defined as "a largely unconscious, spontaneous expression of inner character, the nonmaterial nature."[50] "Improvisation" called for a more purely emotional response, even a disorganized one. It was a

far stronger test of the viewer's tolerance for ambiguity and uncertainty, and therefore a stronger test of his or her ability to open up to a painting beyond all learned responses about what art was supposed to be, in terms of composition and color combinations, for example. And so, though I do not mean to say one could have predicted it, the painting received no attention at all (also, it was somewhat hidden away from the fracas, with the lone Kirschner in a room with English, Irish, and German work, none of which came in for much discussion). It had to remain the most invisible of the revolutionary works at the Armory Show, not specifically because of its distance from representation, though that fact helped, but because it did represent something, and yet nothing well enough hinged either to consciousness—that is, observable in real surfaces—or to rationality, which is the cubist appeal to a world resolvable into geometries. To enter the world of *Improvisation* would have required, in terms to come later, an availability to the repressed; given greater prominence, the work might easily have led to more violent resistance than Duchamp's playfulness managed to cause.

Of course Stieglitz was already primed to recognize Kandinsky's quest for the "spiritual in art," both from his acquaintance with the painter's writing and from his whole campaign in favor of the antiphotographic in art. For Stieglitz, the Armory Show was anticlimatic as an aesthetic demonstration, but it was a watershed for positions he was solidifying on both painting and photography, positions that would last him a lifetime. He could not abide the Armory Show establishing the primacy of European nonobjective art over American work, in part because it represented the success of a rebellion he had started and which was now taken away from him. But more importantly, it upset him because the rebellion had now absorbed all sorts of other motives, with the commercial motive foremost, and this was not the rebellion he had had in mind. Matisse at 291 was intended to free Marin (for one); with the Armory, the result was mainly that Matisse outsold Marin and, devastatingly, neither was any better understood. He therefore moved on now, in a perverse way liberated by the success of the Armory, to give priority to his Americans at 291, an endeavor that would ultimately end in his showing them almost exclusively in his galleries of the 1920s and later. Although the few years after 1913 saw Europeans enough at 291, as the gallery even toyed with the rebelliousness of Dada, Stieglitz came to be mistakenly considered chauvinistic in the defense of his "seven Americans." This is a misunderstanding. He was always fighting against the current, and when it turned in favor of Paris, he took the American side more determinedly. In a frequently cited letter, he wrote to Paul Rosenfeld:

America without that damned French flavor! . . . No one respects France [more] than I do. But when the world is to be France I strenuously hate the idea quite as much as if the world were to be made "American" or "Prussian.". . . That is why I continued my fight single-handed at 291—That's why I'm really fighting for Georgia. She *is* American. So is Marin. So am I. Of course by American I mean something much more comprehensive than is usually understood. . . . Are we only a marked down bargain day remnant of Europe?[51]

The artists of American modernism need not have an inferiority complex, if he could do anything about it; the art dealers and patrons were the ones who let the Parisian art world make New York look provincial.

More relevant to my argument at this point is that the Armory Show put an end to the debate about whether painting had to compete with photography and be valued for its accuracy in imitating nature. Fifty years earlier photography had threatened to put painting out of business. When this did not happen, because art was definitely something the artist made and not by the click of a button, the photographers tried to imitate some of that making process. Now painting was not only made but made up, superseding representation and glorying in pure construction, as in cubism, or pure imagination, as in Kandinsky's work. These things photography could not do, or so it appeared in 1913. And yet Stieglitz had gotten painterly photography out of his hair, and had contributed to clearing the ground for the new painters as they untied themselves from the concrete record. His unmanipulated prints now accepted the record, and the question waiting for him had become, Could some important degree of powerful expressiveness still be generated into the recorded document that was his lot? His interest in Kandinsky was profound and personal, as Stieglitz was searching for the spiritual, and to a large extent already achieving it in his own intractable medium of photography, which presented almost insuperable ties to the concrete, a record unable to declare its spirituality. He was, in a manner of speaking, working on nonphotographic photography and, to underline the paradox, he was doing it through direct, unmanipulated photographs.

4.1 Alfred Stieglitz, *The Street Paver*, 1893. Gelatin silver print, 8 × 9.3 cm. Alfred Stieglitz Collection, image © Board of Trustees, National Gallery of Art, Washington.

4 Outside the Armory (1912–1913)

The ending of the previous chapter was meant to prepare for a discussion of Stieglitz's showing of his own work, mounted at his Little Galleries as a counter to the Armory Show, a counterstatement and test of the strength of photographic artwork in the face of the most radical and exciting work in painting. As we have seen, he had already set himself up for the comparison right on the premises at 291 itself, without recourse to outside venues. Further, he had invited into the pages of his *Camera Work* not only these radical images but radical prose as well. Rather than go directly to a consideration of Stieglitz's countershow, his tiny Secessionist Armory, I would like to embed it in a wider view, in particular to see the way in which his journal *Camera Work* reflected the work going on at 291. This context involves mainly two of the five issues that appeared between August 1912 and June 1913. Although these issues are termed special numbers and published undated (and probably meant to be purchased separately, outside of the regular subscription), they can be identified as being from August 1912 and June 1913. These two numbers of *Camera Work* frame the Armory Show in time and, significantly for my purposes, print texts by Gertrude Stein: in August 1912 two "portraits" of Matisse and Picasso, harbingers of the two *monstres sacrés* of the big show to come, and, in the June 1913 number, one

"portrait" of Mabel Dodge, as if to confirm the artistic gains of the show, if not even greater ones. Stein's two appearances serve as the bookends of my discussion of Stieglitz's own show, one before, one after; while it might seem reasonable to be more synthetic, discussing Stein's productions on the one hand and Stieglitz's on the other, I propose to let *Camera Work* dictate a more developmental view, in keeping with the spirit of the operation as the participants saw it, and as Stieglitz himself wanted to frame the presentation. I am trying to recreate, then, something of the effect of a number of contexts evolving around my moving subjects: Stein's changes, at least in the public's eye, from before to after the Armory; *Camera Work*'s announcement of and response to the show; Stieglitz's evolution up to that point, which served as his counterstatement at that crucial moment; and all within the context of an evolving appraisal of the fate and strengths of photography, of American art, and of European and American avant-gardism in the year before the Great War descended upon Europe.

Camera Work

Camera Work began publication in January 1903, with photographs by Gertrude Käsebier in lieu of Day's, who as we have seen in chapter 2 refused Stieglitz's offer to give him this first act in the limelight. It ceased publication in June 1916, when it featured Paul Strand for a second issue in a row. Almost enough said, already, about the enormous distance traveled, as *Camera Work* led American art photography by the ear from a distillation of high Victorian wistfulness to stark, broadly drawn modern abstraction.[1]

Beginning publication close upon Stieglitz's contentious departure from the Camera Club and editorship of its *Camera Notes, Camera Work* was to be the organ of the "Photo-Secession," a designation Stieglitz adopted from similarly named movements in Vienna and Munich. While the exact meaning of the term, for Stieglitz as for the other participants, always remained a touch vague, impressionistic for the most part, its meaning does gain some clarity in comparison to ideas of rebellion, revolution, and a complete break or rupture that we habitually associate with modernist and avant-garde movements. While the Secession does mean to break away, it does so to run a distinct but parallel course rather than to destroy and replace previous mainstream practices. The Secession is thus conscious of being, and remaining, different, while recognizing that the mainstream goes on; it is defiant and critical, but at least in part resigned to its own marginality, with some degree of pride. It protests the outdated conceptions, inconsistencies, blindness, exclusions, arrogance of the culture at

large, to function as a corrective by example and attack, to prod, to be the gadfly within the educated culture where it finds its audience along with its opponents. As the subtitle of Alfred Kreymborg's little magazine, *Others,* had it: "The old expressions are with us always, and there are always others." Still, while the Secession might have liked to merely chart its own artistic course in parallel, its goal of producing images out of the fundamentally modern qualities of the camera inevitably allied it with all sorts of more thoroughly radical, modernist, avant-garde, even anarchist movements and personalities, and it clearly preferred these associations to being linked to any traditional or conventional movement in the arts. A purely Secessionist position became increasingly difficult to maintain in the maelstrom of more aggressive movements, but we ought to see that it *did* sustain it for a good number of years on the American scene, roughly the life of *Camera Work* itself. During this period modernism did not exist, but was called postimpressionism, a concept obviously more unsure about its meaning than the Secession.

Obviously Stieglitz could not, in 1903, articulate such parameters for a Secession in comparison to movements that had yet to surface in the arts. In his opening issue's "Apology," he remained innocent of any modernist or avant-garde rhetoric, calling for a renewal of camera work in the most fundamental terms: his publication "will appear to . . . those who have faith in photography as a medium of individual expression," and will publish only work that "gives evidence of individuality and artistic worth, regardless of school."[2] But the modern fact is there, hidden in the operation: on the one hand, make the medium produce art, but on the other affirm that good art continues to be individual expression—that romantic ideal to be carried over, but which the medium of the camera had seemed to render impossible, or defunct.

What, then, was this secession *from?* It was not only from artwork that had gone stale through the copying of Victorian, conventional styles, but more importantly from the dictatorship of the entrenched institutions, galleries, art schools, and professional art organizations that enforced or at very least sanctioned copying or imitation. In the area of photography, the clubs were not enforcing any intrinsically photographic aesthetics but those of a different medium, painting, and not any painting but that as practiced in the decline of Victorian energies. So what I just described as a two-part call by Stieglitz is in fact one seamlessly combined exhortation: look to the medium of photography itself for the means of individual expression, not rote or mechanical repetition. The new technology could presumably produce an art emanating from and reflecting the American "Adam," the new, young, forthright, Whitmanesque body of an American world.

Also hiding in this "Apology" is the tension in the term "pictorial," which had originally served to set photography as art apart from commercial work, but which quickly came to qualify, derogatorily, a photograph trying to look like a painting. In reaction to this latter sense, Stieglitz had, by the time of the Armory Show, given up "pictorial" for the term "straight" photography, which did not mean he would not crop or heighten effects, but mainly meant that he would not search for the diffusing effects of paint and brush. This "straight" expression, full of the implications of frankness, truthfulness, clarity, and directness, anticipates the prescriptions of Ezra Pound for the poetic "image," or imagism, and thus for modernism itself as it developed in the English-speaking world. It may be considered an early sign of that "masculine" aspect of modernism, as it reacted to a Victorian feminization of culture, all in gauzy veils. However, before leaping from that to the idea that Stieglitz should be seen as antifeminine in his modernism, be it noted that he inaugurated this early modernist program of *Camera Work* with a woman's work, the photographs of Gertrude Käsebier (and if he had had his way, it would have been with the work of a decidedly effete if not gay man, Holland Day).

The presentation and contents of *Camera Work* were of the highest standards attainable by the methods of production of the day, all in a periodical that refused to be concerned with making a profit. Texts were not the chitchat or technical hints of earlier photo journals, but serious discussions of aesthetics, along with quite sophisticated tongue-in-cheek commentary. In lieu of the few halftone illustrations distributed among members' columns, notices, and advertisements, Stieglitz offered artists' portfolios in full-page, hand-pulled photogravures printed on the finest Japanese tissue and mounted onto high-quality art paper individually chosen to enhance the prints. Expense seemed to be of no concern, nor did Stieglitz spare himself: "He exercised quality control with a vengeance and with dedication," writes Pam Roberts in her introduction to *Camera Work: The Complete Illustrations.*[3] The photogravure, a sort of lithograph really but from a metal plate, was produced by the very best companies, and Stieglitz came to rely most on Frederick Goetz in Munich; his inability to get access to Goetz's work during the war contributed to the demise of the magazine. While *Camera Work* cost only a dollar an issue, and four dollars per year, it put into the hands of its 600 or so subscribers prints of such high quality that they vie with originals, showing almost no grain at all. Some of Stieglitz's most famous images in circulation today exist only as photogravures and are sold or exhibited pretty much as originals.[4]

Obviously this care for what amounted to original prints served to support the claims *Camera Work* made for photography as a high art. In

fact, as far as reproduction was concerned, the magazine was presenting images of finer quality, and better fidelity to the images' "originals," than could be obtained for paintings. This would still be true for a book today, unless one were to lithograph all the plates. When it came time for *Camera Work* to present color plates—for example, in 1911 for Rodin's watercolors—Stieglitz again pushed at the limits of the technology and had Goetz supply "coloured callotypes" of really fine delicacy. Taking this opportunity to criticize the slovenliness that commercialism imposed upon art reproduction in America, he pointed out that this printer in Munich was an American, but "one compelled, in pursuit of his artistic ideals, to expatriate himself."[5] *Camera Work* was then a constant and insistent reminder that one could obtain Arts and Crafts quality from the new technologies of reproduction, as long as one were willing to push them rather than succumbing to how easily they could get away with the job. Virtually alone, Stieglitz's luminous magazine established photography as an art form for North America and Europe, by being itself a work of art, a serious and intelligent devotion, "the most artistic record of photography ever attempted."[6]

Since this record of the Photo-Secession was the organ of the Little Galleries at 291 Fifth Avenue when those two small rooms were beginning to show paintings and drawings instead of photographs, *Camera Work* also began to print and discuss painting, and began to support the nonrepresentational, so-called nonphotographic trends that led to postimpressionism. At first the caricatures of Marius de Zayas appeared in *Camera Work* 29 for 1910, after they had been shown at 291 in January 1909. In the gallery, de Zayas had been preceded by Matisse at the end of 1908, but apparently Stieglitz had not felt his mainly photographer subscribers were ready yet for the *fauve*. In 1909, 291 showed four photographers, but eight exhibits of paintings and drawings. By the following year only one photographer was shown per season, if that; from January 1911 to May 1917 there were only four photographic shows. *Camera Work* followed the Fifth Avenue rooms with greater restraint, nevertheless losing almost all its baffled subscribers by the end: Matisse was in number 32 (1910), Rodin in number 34/35 (1911), Picasso's one *Drawing,* which Stieglitz had bought, closing number 36 (October 1911), two Marin watercolors in number 39 (July 1912). This brings us up to the present moment of this chapter, to the special issue of August 1912: no photographs at all, nor any discussion of photography, only paintings and sculpture by Matisse and Picasso, some of which were waiting to be featured at the Armory Show in a few months, and some short and very unusual texts, perhaps the first nonobjective "portraits" to appear anywhere. This issue completed a cycle of justification for photography and

began another, already well under way in the gallery, of undermining mimesis in artwork entirely, or at least enough to make the term "Secession" seem a bit dated and the title *Camera Work* a misnomer.

One Is One Who

Stein's portraits, "Matisse" and "Picasso," were brought to 291 by a friend of Stein, May Knoblauch, in December 1911 or January 1912, when Stieglitz was already planning an issue of *Camera Work* on the two artists.[7] He had visited Paris in 1909 and, in the company of Steichen, had visited first Sarah and Michael Stein, then Leo Stein and his sister. The photographers sat mesmerized by Leo's declamations for over an hour and a half while Gertrude, whose name Stieglitz did not catch, sat on a chaise longue and never said a word. When Mrs. Knoblauch came to 291, Stieglitz, as he recalled it, accepted the texts without even inquiring who wrote them, and thus only made the connection later.[8] At the time, Leo was the one from whom people expected a great commentary on modern art. However, Gertrude's portraits were not exactly commentaries, of which there had been a good deal already in the last few years of *Camera Work;* they were rather the thing itself, a modernist reworking of perception itself in the domain of words. In a page-and-a-half "editorial," Stieglitz presented Stein's portraits, arguing: "in these articles by Miss Stein, the Post-Impressionist spirit is found expressing itself in literary form." The articles bore a relation to "current interpretive criticism" "exactly analogous" to the relation of the new painters to the older schools, and thus represented a "Rosetta stone of comparison."[9]

While the debate is joined as to whether literary cubism is, in its principles or practices, the same as the painters' version, one may note that here, from the beginning, the emphasis is to distinguish the mediums, leaving writing and painting to pursue their revolutions on separate if parallel tracks. The debate has received much critical treatment, and Stein's own statements, which she later modified, make the tight link and then deny it.[10] But at the time, and in these pages accompanying pictures of the works of Matisse and Picasso, the audience was at very least invited to associate image and text as performers on the same cutting edge of modernism, in its most extreme and almost comical form. Stieglitz ended his editorial: "We wish you the pleasure of a hearty laugh at them upon a first reading. Yet we confidently commend them to your subsequent and critical attention."

When Stein sent a copy of the special issue to Bernard Berenson, whom she had met socially, he was polite but hardly amused: he thanked her for the "pamphlet" full of

extraordinarily fine reproductions of Matisse's & Picasso's. In a moment of perfect peace when I feel my best I shall try to puzzle out the intention of some of Picasso's designs.

As for your own prose I find it vastly more obscure still. It beats me hollow, & makes me dizzy to boot.[11]

Hardly taken with Matisse, Berenson was obviously going to prove hard put to enjoy the following sentence on him, which itself came after a half page or so of almost identical sentences: "Some who came to know that of him, that he was a great one, that he was clearly expressing something, came then to be certain that he was not greatly expressing something being struggling." Clearly!

Writing is not painting. However, it is just as certain that a family of similar or related gestures can convince us we are in the presence of modernism. The similarity to cubism of what Stein was doing is both interesting and exciting, even while it remains a bit imprecise at various levels. One of the things such writing shared with cubism was the repetition of extremely basic elements of the medium, shifting these simple elements around like building blocks, their positions in the sentences making for slight differences, but differences all the same, even salient differences to the degree that the field of text as a whole remained monotone. The overall effect was a field of concern outside of time, rather than the progression, drama, or narrative that linear arrangement would seem to demand, or provide. On the other hand, a huge difference with cubism or postimpressionism was that Picasso and Matisse appeared to be modifying the referent itself, distorting reality as an observer could see it for himself or herself, whereas Stein was disconnecting her sign from its referent, which she may have had to accept in its integrity, somewhere out there, outside of her words. She was making language turn circles around its unattached self. While one could find bodies and tables in Matisse, and parts of bodies and tables in Picasso, there was no way to find any "thing" or anything happening in these so-called portraits, from which the subjects themselves had been banished except for the titles, where the names of the artists floated over their respective texts like a challenge the author was not even bothering to take up. Picasso's cubism, Matisse's postimpressionist fauvism, each in their distinctive ways, asserted the independence of paint and painted or drawn form from the bodies represented (or no longer precisely represented), but their work simultaneously teased the viewer to look for what was barely or poorly represented, to see that these had been and remained fragmented or distorted. Stein, on the other hand, did not fragment words, and even her sentences and syntactical structures remained intact at this point. But

she was working with such a restricted vocabulary, and one that was so highly pronominal—in the sense that what remained to be discovered, or searched for, were the *words* of things, people, and actions that were missing, not the referents themselves—that readers could see only a kind of pointing at absences, a sort of idiotic expression of inexpressibility. This was the writer's way to make her reader conscious of the medium: she does not provide the linguistic sign of a thing or person, which we all accept too readily as actually being them, but withdraws to the pronoun, the mere sign of the sign. And the pronoun replacing "Matisse" sapped the artist of agency in the even slight changes his portrait might grant to him. The only clearly intelligent activity in the portraits was the subtlety of the changes, the repositioning of elements in the larger scheme of hypnotic repetition, an intelligence that hostile critics could recognize even while they mocked the results.

The fact is, no one can really read through these portraits, short as they are, without being obliged to do so. One can admire them, admire what Stein is making language do, and ultimately appreciate the new qualities she is mining out of it, but it is unlikely the portraits can be enjoyed sufficiently to make us pursue to the end, which is so much already in their beginnings. They can be much enhanced by being read aloud, as Stein was so good at doing with similar texts, in an almost stately rhythm full of pauses that only she understood and a good bit of humor in her oddly British-inflected accent. Repetition is not a precise term for what she is doing, for much of the point is that nothing is really repeated, no phrase is the same once it has been preceded or followed by another "same" one. Once again this looks like pictorial cubism, not because, following Cézanne, she is repeating her basic pieces of square and circle, but because a square above is functioning differently from a square below it, or to the side, or bunched up in the middle. One is foundation, another is roof or cover: or capital, body, footing, to be read first (on the left) or later, entering or leaving, packed or fleeting, etc. . . . The same issue of placement is key to the texts. In the first paragraph of "Picasso" there are four sentences, all of which share the basic elements "One whom some were . . . following was one who was . . . charming," but not one of the four is only this (that, also, would be a distinct possibility, maybe later). Sentence one puts "certainly" into my first ellipsis and "completely" into the second. "Completely" is dropped in the second sentence and returns in the third, where "certainly" is dropped. We begin to see what to expect for sentence four in this almost mathematical game: it is "One whom some were following was one who was certainly completely charming." So Picasso is now a thoroughly fine fellow, but we are no longer certain of his having a following. Not to worry, in

sentence one of the next paragraph, the absented "certainly" returns with added emphasis, as "Some were certainly following and were certain. . . ." Certainly (it is a large part of Stein's art that it becomes so contagious) this text plays out as the "Rosetta stone" for cubism, with its reductions and increased subtleties constructed around a few "repeated" elements, elements that are not rendered as thematic representations of reality but as the building blocks of the medium itself, word, phrase, and line.[12]

It is actually harder to read Stein than a painting by Picasso, because of the immediacy of the whole painting at a glance and its sustained and complete presence as we scrutinize it. As with any text, we must read these portraits over again, to let ourselves evolve in Stein's becoming, an evolution that seems more likely to be unraveling in time than progressing from one point to the next. The text seems stalled in an experiment with words, and is talking about what words do, or can be made to do, even more obviously than Picasso is "talking" about painting. Both artists' works lean intolerably toward abstraction as a means to wonder about how a medium can represent at all. In such an operation, both painter and writer are seen as experimenters more than as creators of artwork, opening up a radical questioning of art in modern times, whether or not the audience or even many co-workers would yet see this material as itself art.

Further, there was a progression in the writing of abstraction in this special issue of *Camera Work,* with the Matisse plates coming first, followed by Stein's "Matisse" but then followed immediately by her "Picasso," leaving the plates of the Spaniard's work for last. Stein's own development from portrait to portrait stands together as a piece in the pages of *Camera Work,* at first contrasted with the Matisse as a sort of reprieve in language from his visual excess. Yet no, as it turns out, it is not a reprieve but a "worse" abstraction, and is immediately followed by a worse again "Picasso," which trumps both the Matisse and "Matisse." This textual displacement of Matisse by Picasso actually mimics what happened to the two artists in the Stein household in Paris (though we have no evidence that, as Gertrude asserted her own taste in the face of Leo's, Stieglitz could have known anything about it). Jane Walker has analyzed this development in Stein's view, from what she saw as Matisse struggling for expression to Picasso as a creator, and she cites Stein's notebooks: "Not express yourself like Matisse but be giving birth like Cézanne and Picasso and me."[13] As far as the audience might take in the difference between the painters as they could see them in these plates, I would say the Matisse images conveyed a riot of overripe, garish, uncontrolled sensuality (or eroticism, to be more blunt), while Picasso conveyed a nervousness, even an anxiety over the breakdown of rational

forms and perception itself. Sitting high in between these two groups of disturbing plates, the two Stein texts looked very controlled; in fact critics, while they made their dismissive fun, seemed generally to recognize that Stein could write and was in control of her means, rather than incompetent. "Matisse" was more belabored, involuted, and "Picasso" limpid, even if there appeared to be nothing much at the bottom of the pool. In "Matisse," Matisse is a "he" who is "expressing" and "struggling," though as the text advances "he" becomes more and more frequently "one," at the same time that "expressing" begins to falter so that the "being struggling" is not so well perceived or grasped by those who have been watching him, such as Gertrude and Leo themselves. Near the end Stein writes: "some were certain that this one was not greatly expressing something being struggling."

The reader who valiantly went on to "Picasso," which followed immediately and was as yet unmediated by the Picasso plates, was plunged headlong into an indefinite world of "one" who never is any specific "he." While we do stumble upon a few mentions of "himself," basically "one" is all there is to him, both the naming of and the pronoun for Picasso, who has to that degree disappeared: "This one was one and always there was something coming out of this one," and "this one was one having something coming out of this one." In this second sentence, the syntax (though not the sense) leads us to wonder if there are not two different referents for "one," so naturally do we require to read "coming out of *him.*" Stein hammers at us with this "one," which becomes rock-like in itself, without reference; perhaps it stands for any one among the new artists and writers, perhaps for Stein herself, substituting her virtuosity for that of a more famous or infamous man whose identity has been left behind in the title, only a decoy, an excuse for writing about oneself. Such a substitution is not so different from the trick of *The Autobiography of Alice B. Toklas,* in which "she" (Gertrude) is really "I" (the writer), as she reveals on the closing page. But that is a book written later, in 1934 when "she" is famous, mainly for knowing and being known. Here, in 1912, Picasso is the known "one," but he is deconstructed into "one whom some were following" rather than shown as a creative person in his own right, thus reflecting Gertrude's role as one of those who watch and appreciate, as the one who chooses him. While this gaze of hers dominates the text, even to the extent of her voice dominating the painter, it is probably not the role she wished for herself as a writer, though it was largely the one that came to her in the history of modernism.

Coming before Picasso's images in this issue of *Camera Work,* "Picasso" is already their terminus, anticipating not the first and earliest of the images, the representational *Wandering Acrobats,* but the last

(excluding sculpture), the 1912 *Drawing* which Stieglitz had bought, one box upon one box. . . . One is *the* one being followed throughout the portrait as well as throughout this whole special issue, and that one is Picasso and/or Stein and/or Stieglitz; the whole issue of *Camera Work* is a portrait of the avant-garde on the cutting edge, and willing to expose itself as mere process.

Stein's texts thus actually put *her* forward as an artist to be reckoned with, and they were the first to do so for her (only *Three Lives* was published earlier, at her own expense, and that volume does not predict the radical experiment of these portraits). Though she was not, in fact, the owner of any of the Matisses or Picassos at the Armory Show—some were her brother Michael's, some Leo's; others belonged to the artists' dealers, or Stieglitz himself—she became intimately associated with the painters' work, and her apartment was their famous venue in Paris for visiting Americans. The texts attempt to establish her as a writer, not the collector and interpreter, all the while interpreting, trying to make the follower the leader. This first taste of Stein the avant-gardist was further enhanced for the public by being followed by so little more of her *oeuvre*. Like Duchamp, she became famous by appearing to withhold production, although unlike him she tried quite hard to be visible and to publish her work. Her prose became mythologized through its rarity and its difficulty. And both text and mythologizing did a wonderful job for Stieglitz. Stein added another medium to the field, a second front for the deployment of modern art as the site of the nonphotographic.

Stieglitz to the Test: The New New

The August 1912 special issue of *Camera Work* appeared a scant two months before Walt Kuhn arrived in Cologne to see the Sonderbund show, as if to prime the three men, Kuhn, Davies, and Pach, in their European search for the "New Men" they would bring to New York. They duly visited Gertrude, to see her famous walls at 27 rue de Fleurus, though, as it turned out, their borrowing for the show was not from her personally.[14] The Armory Show ran from February 15 to March 15, 1913. Marin's oils and watercolors hung at 291 from late January to February 15, when ten of these (all watercolors) moved on to the Armory Show. Subsequently, two days after the Armory closed, 291 hung Picabia, until April 5. In this careful manner, one of the most advanced Americans and one of the most advanced—if not inscrutable—Europeans framed Stieglitz's photographs at 291 (February 24 to March 15), just as two advanced artists had framed Stein's texts in *Camera Work*. At the same time, the Little Galleries stood to be judged by New

Yorkers, who would compare its wares to those offered by the huge art fair taking place a few blocks uptown. In these little rooms at 291 Stieglitz set his photographs in the very center of these unfolding envelopes of modernism, in a relation to the new movement in painting quite analogous to Stein's portraits poised between works by Matisse and Picasso. Even more emphatically, he arranged his work as equal, yet in stark contrast to the splash at the Armory: "During the big show of Post Impressionism I shall exhibit my own photographs at '291.' It will be the logical thing for me to do. So you see I am not forgetting photography and I am putting my own work to a diabolical test. I wonder if it will stand it. If it does not, it contains nothing vital. It will be the first show that I have ever given myself at the little place all these years."[15] But no matter how much he hoped his work would stand up, so that a visitor stopping in after seeing the mammoth show further uptown could feel she was looking at things, or one aggregate thing, of equal or comparable worth, it would definitely not be on the same grounds of spectacle. The two minuscule rooms of the Little Galleries took their stand with much smaller and quite colorless images, a sobering up after the riotous bash on Lexington Avenue, which was a Barnum-like event for consumption by many, regardless of their interest in art or art movements. Stieglitz's photographs had to assert a cold, unfanciful realism, and in miniatures, in contrast to expanses of exuberant color and invented, even fantastical forms. In this sense he was being remarkably documentary, even if that is the last quality we would ascribe to him today as a photographer. Yet he was on the side of the documentary in comparison to both postimpressionism and pictorialist photography, as a look at the article by de Zayas below will show. There is great sobriety, a great cool-headedness in the images in this show, in terms of both the citified subject matter and the "straight" treatment accorded to it. By contrast, on the one hand the Armory Show was "hot" and, on the other, most other American photographers were somewhat tepid, staging their scenes indoors or in lovely parks, remaining at very best diffusely impressionistic and romantic. Lewis Hine might provide the lone exception to this photographic romanticism from which Stieglitz saw himself, once and for all, disengaging his work.

Stieglitz showed about thirty prints, not all of which can be identified with certainty. Articles in the press identify half a dozen; to those I think we can add the four just reproduced in *Camera Work* 41 for that January of 1913, and those constituting his largest personal contribution to *Camera Work* two years earlier, in number 36 (1911), when it appears he had thought of making a big summing up of his work before there had been any idea of an Armory Show. I won't bother to list everything,

but at least the ones we can be sure of, as they were mentioned in the press reviews (I give titles as they appeared): *Winter on 5th Avenue, The Terminus, The Two Towers, The City of Ambitions, Gossip, Katwyk,* and possibly *The Hand of Man. Winter on 5th Avenue* could be one of two images, the famous *Winter—Fifth Avenue, New York 1893,* which I've looked at in some detail in chapter 1, or another *Winter, Fifth Avenue, 1893,* more rarely seen despite its fine, almost cubist enveloping and crossing planes.[16] *Two Towers—New York, 1913* is also infrequently reproduced, and was first seen in *Camera Work* 44, later in 1913. This view of Madison Square would be the most recently taken of the images that we can be certain were shown.[17]

The 1911 issue of *Camera Work* had contained sixteen photogravures; these included many of the most famous pictures Stieglitz ever took, and their enduring reputation suggests he hung them at the time of the Armory as well. These are mainly views around Manhattan, the building images we know well, but also views of children swimming, a more informal, peripatetic Stieglitz looking at common public pastimes. There are also images of people at work in the city: *The Terminal (1892)* and *Excavating—New York (1892).* We begin to see that Stieglitz was working with grittier subjects than he usually gets credit for, especially when he begins to use the hand-held camera. Even *Spring Showers, New York (1900),* with its diaphanous, picturesque quality, features a street

4.2 Alfred Stieglitz, *The Asphalt Paver—New York, 1892.* Photogravure. In *Camera Work,* no. 41, 1913. Digital scan, Rare Books and Special Collections Division, McGill University Libraries, Montreal, Canada.

cleaner positioned as if to defend the lone, wispy tree in the foreground from the onslaught of vehicles lined up in the mist across the middle of the image. If we add to our Little Armory Show *The Asphalt Paver—New York (1892)* from the four pictures in *Camera Work* 41 (1913), we have quite a growing list of New York street workers, even if they are not the images we, or the photographer, have chosen to retain as *his* signature subject. Still, they participate in the major theme, in that the subject is the modern city, this New York which is reiterated in so many of the titles. As Sarah Greenough has recently pointed out,[18] New York City is the theme Stieglitz presents in all three of the 291 shows coinciding with the Armory Show: Marin's, his own, and even Picabia's (whose works at 291, as opposed to those at the Armory, have all been produced since his arrival in the city). It appears there is only one single image to take us away from this modern enveloping of the photographer-flâneur, just one dissident image of repose in nature, *Gossip—Katwyk (1894)*. That photograph was salvaged, so to speak, from the only other issue of *Camera Work* that Stieglitz had taken over for himself, *Camera Work* 12, way back in 1905. There, city and nature, along with some portraiture, shared the stage; but in the 1911 issue and, I think, this 1913 show at 291, the city has all but displaced nature and portraits; it has been set as the common, modern ground zero for 291 to test three modern artists.

The photographer out of doors must surely be Baudelaire's modern flâneur-artist par excellence, and in the modern American city he would be an improved model. Baudelaire drew his man as an artist afloat in a modernized, modernizing Paris, searching through the crowds or, more precisely, loafing while alert to what might pass by or transpire. He is a moving, turning voyeur who takes pride in not having any precise intention of use or gain. But despite the huge transformations under way in Paris under the direction of the Baron Haussmann, despite the demolition of ancient streets and organic neighborhoods in favor of wide, long avenues, Baudelaire's flâneur is there for the crowds, which are even greater on these presumably alienating thoroughfares. In Baudelaire's discussions about the painter of modern life, the modernity of the site enters only peripherally, even if it is the root condition for all the rest; he is interested mainly in the overpowering presence, movement, and transitoriness of the crowd.[19]

In fact, one should see that Baudelaire is looking back, that his flâneur is trying to enjoy a "vie moderne" that is already being displaced by Haussmann's urbanism, as Shelley Rice describes it.[20] After the city had been redrawn, sectioned off by its new arteries, the neighborhoods became isolated, pockets of the picturesque that were no longer everywhere in one's way but hidden within, lurking around the corners of the

city's lighted boulevards. The peopled boulevards, lit into the night, were the flâneur's original stamping grounds. In a later, early-twentieth century modernism, Apollinaire's flâneur was more of a searcher, a discoverer of places hidden away from the boulevards in which to recover the lost role of a decent flâneur, who finally became an "errant," a wanderer, an artist not entirely lost in spirit but only tenuously attached to a speeding world.[21]

New York for Stieglitz began as a far more oppressive place than Paris, at least as he sensed it upon returning from Europe early in the 1890s. When he began to think of the American city as the place he would engage in his art, he could still see something older, something better rooted to contrast with the city's newness, with its continuous physical renewal, and one can see his balancing act in the title of his first collection: *Old and New New York.* Yet a strong hint of something radically different resides in that "new New." Even the old New York was new compared to a European city; it was a place where all the work of man was almost entirely within memory, relatively speaking, and its spaces posed no determined resistance to complete overhauls, or entire erasure and rewriting. Especially above 14th Street, where the city had been laid out in its now familiar rectilinear, rationalized configuration, hardly any street or avenue would bend to historic interruption. In Paris, Haussmann cleared slums in order to run avenues grandly up to monuments in waiting, providing a vista to view history.[22] In New York, any monument you might look forward to building would almost certainly be obliged to take its place, democratically, in the lineup along the sides; monuments, such as they were, should not step out of the ranks to make their claims on history too vociferously. The vistas ran, in principle, back to nature: east or west to the rivers, north to nothing visible at all, or the sky, a greater and far less human-scaled infinity than Baudelaire had in mind. Mainly, everything in this New York was in passage, both newly made and already prepared to be replaced by the new new.

Stieglitz was one of the earliest wanderers, after Whitman, in this overdetermined modernity with so little use for a usable past. He was soon to be followed by Frenchmen, Cendrars in 1912, Picabia now in 1913 and again with Duchamp in 1915, these last two making news in print, extolling New York to its own surprised inhabitants. The two came as marveling visitors, tired of an unerasably old Paris, both of them cynical about the success of erasures but still unrepentant in their efforts. Like Baudelaire before them, they were ready to take the voyage, to plunge "Au fond de l'Inconnu pour trouver du *nouveau!*"[23] and they found New York to be the place of unknown potential in which to find this novelty. As an American, Stieglitz had returned to New York not

with new eyes but with fresh ones. Also, he had not returned as a painter but as a photographer, which makes something of a difference as to what kind of flâneur one becomes. The photographer, even as he wanders in the city, does not observe it and then return to his easel, with his sketchbook or mind full of impressions. As a photographer he is bred to continue his wandering, and these streets are the site of his actual art work; in a way, the act of photographing is itself a part of the *flânerie,* rather than its product. Put differently, the photo appears as an instant along the path of the wandering rather than a later elaboration and recollection of it. The painter confirms, reinforces, layers his gaze, may upon reflection change it entirely; the photographer gambles on a split second with a long sustained look, hanging the whole meaning of an hour's scrutiny and patience on a fraction of an immediately lost moment. In this way, the product of his gaze is full of loss, whereas a painter's production is a working up of repossession. The painter calms his loss, shores up brushwork against it; the photographer is always tottering into the next unrecorded instant when the scene he has managed to catch is gone. Despite developing, cropping, printing, and dodging, the photograph declaims the presence of its ever-fleeing origin, the flâneur's moment.

What better city, then, for such passing than the new New York? It passes faster and more inexorably than the old city, for lack of the staying power long histories provide, and by virtue of how well we, in it, sense that it has only recently been built and will certainly be replaced, that one or even both of these transformations are liable to take place in our single lifetime. The oppressiveness of these gigantic, built masses may be in their bulk, scale, and evident weightiness, but such huge measurements still do not protect us from their transitoriness. Yes, there is terrible solidity to the city's constructions, but in the skyscraper it is more likely the future that seems to have depth rather than the past, depth of promise instead of historical depth. Such commercial promise has a circumscribed, skittish emotional depth, nothing really to build on emotionally. Further, the pervasive cubism of these newly wrought streets and buildings comes to underline the lack of history in them, as the rational appears to straighten out the rough edges and twisting paths of the historical. For while cubism was born not in the New World city but, rather paradoxically, in small villages of Spain or southern France, it was in America that the engineers and city planners managed to anticipate, on the ground, Cézanne's reductions. What better subject for the abstracting image-maker than these streets running straight to the farthest reaches, crossed only at right angles, all buildings, including churches and monuments, subjected to the same shove and forced alignment to the sides? Thirty years later, the final representation of this

urban arrangement would be Piet Mondrian's series of New York grids, where only the grids remain. Mondrian wanted to remove the irregularities, to accept the grid. For most of the artists of the beginnings of modernism, this dehumanization was something to resist or protest, something to be dominated if not reversed, even while the excitement of modernity could be embraced. These artists would want to reassert the presence of history's irregularities and interruptions, reinserting them into the monotone regimentation of right-angled rows upon rows of simple geometries. In this light it is interesting to think of the artists' and in particular the photographers' fascination with the Fuller or Flatiron Building, its unusual wedge shape dictated by the intersection of the new city grid with Broadway, the Native Americans' old path down the spine of the island, a sort of single but unerasable scar of history.[24] The photographer-flâneur has to accept the given, the city's more-cubist-than-cubist regularity, espouse it but then desanctify it. He directs his *flânerie* to stations from which the eye can determine perspectives that complicate the city planners' flat rationalities with detail scaled to the human.

For example, in *Two Towers—New York, 1913,* the eye might at first search out the source of the title, but even more so than with the Flatiron, these hardly dominate the picture even if they are, roughly, centered. Though we might expect a cannonball view down the avenue to dominate the image that view is interrupted, even countered, by the towers, as the eye, about to fly down the perspective toward the horizon, is jerked up twice to the very top of the picture by them, and a third building comes to frame the whole view from the right margin, darker and generally more substantial than the towers that are the presumed interest of the photograph. Meanwhile, the snow-covered railing in the foreground, running down and away from both the avenue's perspective and the distant towers, along with the snow-covered branches that occupy the very middle of the picture, contrive to override the city's geometry of unfettered passages to horizon and sky. The flâneur here is less interested in passing by than in reasserting those things that passing would neglect or presume to set aside; he is a retriever. If the viewer were looking at a photogravure—as she would have in *Camera Work* 44 later in 1913—rather than a reproduction, she would be struck by the strongly etched presence of these railing and branches. There is a three-dimensional effect in their tangible distinction from the rest of the picture, yet they are becalmed within this forceful presence, as if ceding nothing to the power of commercial triumph as represented in the towers. Still, these skyscrapers also are far more distinct in the photogravure, with individual floors clearly if delicately delineated. In the effects I have

4.3 Alfred Stieglitz, *Two Towers—New York, 1913.* Photogravure. In *Camera Work,* no. 44, 1913. Digital scan, Rare Books and Special Collections Division, McGill University Libraries, Montreal, Canada.

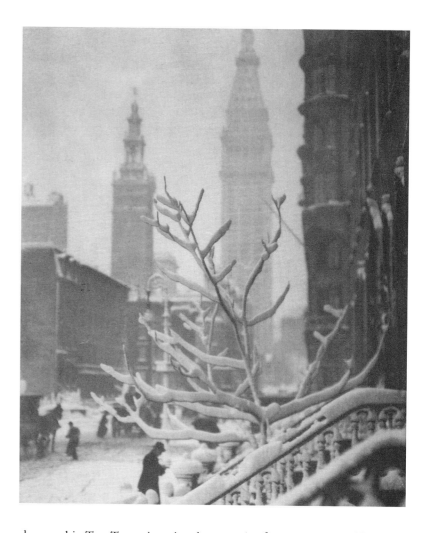

drawn, this *Two Towers* is quite the opposite from *Winter—Fifth Avenue* as I have discussed it in the first chapter. There the perspective is intact, though powerfully blurred by the snow slicing across the street and carriage, and the viewer is invited to concentrate on the activity in the center. Here, the center is dedicated to interrupting the cityscape, lingering on the sensuality of detail as a saving grace in the larger urban vision, and the angle on the towers has removed them from the grid, making them serve us rather than serve the grid by cutting them away from the regularity of avenues.

Buildings are not the only subject in this contra-Armory show. Rather, it develops a four-pronged anatomy of city culture: the overarching rectilinear grid, outmaneuvered as I have just observed it; the life of transportation in the busy arteries of the city, such as the famous, dark

Hand of Man and its white counterpart, *In the New York Central Yards,* along with the various images of horse-drawn vehicles such as the well-known *The Terminal;* lowly, always stooped manual workers on the margins of these arteries and these skyscrapers, such as the crew (and horses) excavating into the very foundations of the city project to make room for the new New York; and, to complete the picture, images of distance-taking, working people seen across the waters that surround Manhattan, approaching or leaving. Rarely in this collection would we find the city successful in its pretense of rationalizing and organizing modern life; instead, people, and the flâneur, move in and out and around the claim, stubbornly asserting personal vision within the commercial imperative.

4.4 Alfred Stieglitz, *Snapshot—In the New York Central Yards, 1907.* Photogravure. In *Camera Work,* no. 20, 1907. Photograph, Library of Congress.

In *The Hand of Man (1902)* (appearing in *Camera Work* 36), almost all of the image is dark. The darkness is pervasive enough for one to feel the mind itself darkening as it contemplates; only the elegant curves of the rails shine as they guide the eye from camera stance to the locomotive bearing down just to the side of us. But in *In the New York Central Yards, (1907)* (I reproduce the earliest photogravure; no telling whether the one Stieglitz used in 1911 and then in the 1913 show was the same or a newer version), the scene is a dirty white, an image completely smudged with soiled snow and billowing smoke. The same train tracks that shine in the first photograph are much more numerous and now black, as if to emphasize that the observer or artist can make what he wishes of them. The two photos were printed contiguously in *Camera Work* in 1911, and I expect they were shown together now at 291 (as they were in a much later exhibition), to reaffirm the power of the photographer-flâneur's vision. These are images of the grime and energy at the base of the buildings, of work in the web of industrialized communication and transportation that sustained the soaring "cathedrals of commerce," as the Woolworth building was called. Again, we can further refine our appreciation, or critique, if we consider the actual photogravures as they appeared together in *Camera Work.* These are not in the sepia tone of the Taschen reproductions. Lacking the graininess of reproductions, these two images in particular display *clean* grays, along with deep blacks and luminous whites without glare or sense of burn into the paper. Stieglitz rejects the easy solution of the sort that might portray a grimy subject with grimy image work. The texture of Japan paper fairly yearns to be touched, more intimate than a silver print can be with the confrontation of its bright aggression. The images are full of care rather than effect, and artistic decisions are in consequence more carefully and more fully embodied. In the photogravure's very white *Yards,* for example, we apprehend more forcefully the way Stieglitz has pushed his black buildings and dark locomotive into two groupings peering into the rest of the image from the middle of the side borders, two islands in the bustling white. While the reproductions of these two images assert the power of black and white to set up emphatic contrasts, the source prints in *Camera Work* offer to help the viewer past such polemical simplifications.

Though they are more famous, the images of trains are less numerous than those of boats or ferries, or of the city seen from vessels across wide expanses of water. There are images of men, principally, on their way to work on the island or home to the peripheries. The rivers are their escapes or respites (and other images, of the *Mauritania,* of an "aeroplane," or a dirigible, are even more definitely dreamy escapes). The traveling pause between work and home in the democratic sprawl is, of

4.5 Alfred Stieglitz, *The Ferry Boat*, 1910.
Photogravure. In *Camera Work*, no. 36, 1911.
Photograph, Library of Congress.

course, the heir to Whitman's famous "Crossing Brooklyn Ferry" (see Sloan's painting *The Wake of the Ferry, II*, discussed in the next chapter). The city primes one to need escape, not because of its monumentality but because of the relentlessness of its promise and demand, as we sense it in the title of *The City of Ambition*, and so it also, at the same time, reels its characters back in. Remarkably, here the flâneur begins to be identified with his loafing comrades, to gain a body. The stretch of downtime between home and work in this city as pure office space makes flâneurs of us all, if only we might turn our discontent to observation, as the photographer does. In *The Ferry Boat (1910)*, the city workers have no doubt failed to do so, as they show little interest in their moments of respite

while they await the docking and crowd impatiently, yearning, hopeful, or dreading the day. Every one of them sports his white straw hat as the photographer-flâneur catches them about to flood out of the wide mouth of massive, darkening ferry. Meanwhile, the brilliant white pilings don't so much await or watch them as suggest another massive but brighter transport ready to launch in some opposite direction, free of the city's attraction; but this hypothetical vessel in the image's foreground remains unpeopled, quite empty, unused. The flâneur stands on or near this alternate structure. By the association of his viewing position and the visual strength of the very white pilings, he proposes that the men in their white hats might join him. The pilings launch the imagination with a more glowing presence than the brooding ferry, and the viewer seems invited to join the photographer in his secession.

On the other hand, in *The City of Ambition* of 1910 (see the discussion in the next chapter), or perhaps *Lower Manhattan (1910)*, both printed for *Camera Work* in 1911, the flâneur is himself one of those on the boat. In these images, and in *The City across the River*, 1910, also printed in 1911, the flâneur alternately takes his distance or yearns, is free of the city's oppression or is able to measure its attraction. He loafs physically, but also and most importantly he does so emotionally, becoming in his own way detached from, objective about modernity. Making a respite of the trip, he captures its excitement, its anticipation of the city, or its waterbound repose, by reflecting upon all of it for a moment at a time, something his fellow travelers might learn to do from the photograph. His camera eye offers meanings for transitory places, so that he has himself become a kind of place full of the advantages of waiting, in their way something like what John Dos Passos later called the "Manhattan Transfer"; this was not a station in Manhattan but one of transit on the New Jersey side of the Hudson, and it stood, for Dos Passos as it might for Stieglitz, for the decision to go to New York, or not. The photographer-flâneur asserts a position of reflection at the margins of the juggernaut, refusing to throw himself under its wheels and signaling useful, soulful value for business's downtime.

The Flâneur in the Document

The special marriage of interest and indifference is a hallmark of the modernist observer, indicating his alienation from his commerce-driven culture. He became the solipsistic Axel, the artist in his ivory tower meditating upon his own increasingly rich forms and distressed mind.[25] James Joyce's hero, Bloom, is still a wanderer in a city full of concretely detailed realities; but aesthetic form, cultural reference, myth, and dream

overwhelm the novel's Dublin. Compared to earlier documentary photography of a city's buildings and monuments, by Baldus for example, Stieglitz's is decidedly on the side of a personal expression that is an individual wrenching into form, but I should want to defend him from the accusation of high aestheticism. In context we ought to be able to see his flâneur as more balanced in the struggle between subject and object, very much out in the streets and committed to all the variety of social and engineered life they propose to his lens. This photographer-flâneur is strong-willed and marks off his separation, but he is not dismissive. While I don't doubt that Stieglitz produced work more formal than, say, the documentary images of Hine, so would any photographer with the pretense to artistic work. The contrast with Riis or Hine, entirely legitimate in itself and for the purposes of clarifying distinctions, polarizes not Stieglitz but any artwork with the camera. The tendency to disallow Alfred Stieglitz as a photographer of the real city, even though he virtually discovered the city as a specifically modern subject for art, is anachronistic, and leads to recent judgments for general consumption like the following, on the Flatiron image: "no longer a building, it has been transformed into a mirage. Stieglitz, as he has so often, denudes the building of its solidity and function as an office. The realist context gives way to an imposed ideal frame of reference. Thus Stieglitz seeks to maintain his perspective always at the expense of the commercial, historical, and material aspects of the city he photographs."[26]

We are given a very different view, and in the proper context, by the very astute Marius de Zayas in an article for *Camera Work* 42/43, dated April-July 1913 (though this issue may not have been distributed until later, perhaps November). The article means to describe the situation of photography at the critical time of the Armory Show (and the same issue reprinted many of the press reviews of Stieglitz's countershow, both favorable and less so). De Zayas develops a detailed contrast between what he decides to call photographer and artist-photographer. The first represents "something that is outside of himself" and pursues a "free and impersonal research," whereas the second gives a "personal representation," he "veils the object with the subject." The history of art, up to the use of the camera, is the history of subjective man trying "to represent his feeling of the primary causes." Even if de Zayas is imposing an overly romantic idea of art before the arrival of photography, what follows remains surprising: Steichen is the artistic photographer, Stieglitz is the photographer. The latter "has begun with the elimination of the subject in represented Form to search for the pure expression of the object."[27] Odd to note, Graham Clarke, the critic cited above, has reversed these roles in his appraisal, placing Steichen in a group he opposes to Stieglitz,

whose Flatiron is "divorced from the chaotic textures of the city streets."[28] But Stieglitz was precisely the one photographer of his time to have freed himself from romantic projection into his work, work which I think we can see, with proper perspective, as remaining balanced, in that reality is not distorted but rather invested. De Zayas writes that Stieglitz "expresses, so far as he is able to, pure objectivity"—that is, he is more intensely interested in what is truly there than in what he can express *about* it. Still, of course, as he sees it. The documentary camera is the facilitator of this vision, really a precondition. Stieglitz's art is, I should say, Apollonian within the whirlwind of nascent modernities; he is not the radical "experimentalist" (de Zayas's term) for the sake of rebellion. Stieglitz doesn't like the word "artist," but he is trying to see the sense of the American city for the American soul, arranging these buildings, boats, and working citizens to elicit a viewer's pleasure in seeing clearly into forms that are, themselves, the concrete expressions of a culture's yearnings.

In contrast to the riot of colorful, eccentric expression splashed across the walls of the 69th Regiment's armory, the images Stieglitz showed at 291 were a model of sobriety, even a call to realistic order in one's dealings with the modernity of the city. Stieglitz, as a photographer, did not have to dismantle representation in his response to modernity anywhere near the degree his Parisian friends felt they needed to. His "straight" and probing look at this city would itself supply the modern match for the new subject, even if, fifty years later, comparisons with Weegee or Robert Frank will make him appear idealistic and lacking in grit.

Interiors

It might seem perverse to suggest that Gertrude Stein's portraits were devoted to anything similar to de Zayas's "pure expression of the object," until we imagine her objects to be, like chemical salts in a photographic print, the objects her writing hand was using—the written words themselves or, we might say, the pure expression of expressing.

The second special number of *Camera Work* appeared in June 1913, thus closing the season of this eventful artistic year in New York. More even than the earlier special issue with her portraits of Matisse and Picasso, this one focused on Stein: it featured an article about her by Mabel Dodge, herself the subject of Stein's text in this issue, and it also reproduced a portrait of Stein by Picasso, thus coming full circle from her portrait of him in *Camera Work* nine months earlier. Adding further to this self-mirroring, Stieglitz reproduced one of the paintings Picabia had shown at 291 in March and April, and Picabia's wife, Gabrielle

Buffet, wrote an article on him and the new painting movement, "Modern Art and the Public." While these three women do not quite dominate the special issue in terms of numbers, they fill its opening pages and suggest that women could have serious roles to play as critics and creators, and that Stieglitz was not adverse to giving them prominence in his publication.[29]

Mabel Dodge had returned to New York from Italy only recently, though in time to have gotten involved in the organization of the Armory Show. She was soon to open a salon in her apartment at 235 Fifth Avenue, hoping to rival Stein in Paris and Stieglitz at 291 or Arensberg on 57th Street, but hers never became such an advanced center, nor even one that emphasized the arts. At the moment, her principal credential was that she was the subject for Stein's portrait, like Matisse and Picasso; she had had it bound in Florentine wallpaper wrappers and circulated among her friends and art-minded acquaintances. Muriel Draper said to Mabel: "Ducie Haweis [Mina Loy] and I wanted to wire from London, 'we understand the cover (!), we *know* that!'"[30] Dodge had been enlisted to write her own article, "Speculations," for the special Armory Show issue of *Arts & Decoration,* and while she makes frequent comparative reference to the artists showing in the Armory, the specific text she is discussing, "Portrait of Mabel Dodge at the Villa Curonia," remained as yet unseen by the public, who had only the two earlier Stein portraits in *Camera Work* to go by.[31] Readers were invited to take pretty much on faith, and rumor, that Stein was both difficult to understand and worth the trouble, but a few quoted passages in Dodge's essay were not necessarily reassuring on this last point: "It is a gnarled division that which is not any obstruction and the forgotten swelling is certainly attracting. It is attracting the whiter division, it is not sinking to be growing, it is not darkening to be disappearing, it is not aged to be annoying. There cannot be sighing. This is this bliss."[32] To end her essay, Dodge chooses to cite not her own portrait but "Picasso." Just in these two excerpts, we see the distance Stein had traveled in intelligibility: "in Gertrude Stein's own words, and with true Bergsonian faith—'something is certainly coming out of them!'"[33] *Arts & Decoration* advertised Dodge as the one person to make this material intelligible, and valuable, in no uncertain terms which were not repeated in *Camera Work:* "Post-Impressionism, consciously or unconsciously, is being felt in every phase of expression. This article is about the only woman in the world who has put the spirit of post-impressionism into prose, and written by the only woman in America who fully understands it."[34] This is despite Dodge's own disclaimer only a few paragraphs in: "the most that we can do is suggest a little, draw a comparison—point the way and then withdraw."[35]

Just how much Mabel really understood is not easy to say, but can we do much better? "Speculations" speaks of breaking new roads, of the fourth dimension and Bergson, all markers of the advanced discussions taking place at the time. However, she has a more personal response as well, and is particularly sensitive to the music of words, rhythms, and cadences; she asks us to feel their effect, "strenuous" or "tranquil," but not look too hard for meaning, even though Stein "has produced a coherent totality through a series of impressions."[36]

We may be able to get a bit closer through another of Dodge's texts, which casts her as the eyewitness (almost) to the composition of her portrait. "Portrait of Mabel Dodge at the Villa Curonia" was written late summer or early fall when Stein and Alice Toklas were guests at the villa and when the writer may have attempted to begin a relationship with Mabel that was quickly nipped in the bud by an already powerful Alice. Dodge tells the story in *European Experiences,* the second installment of her *Intimate Memories.* Stein's portrait was written at night, in the bedroom of Mabel's husband, who was frequently absent. Next door, in her "white room," Mabel received an insistent lover, her son's young tutor, and half-heartedly fended him off while trying to be quiet for the author who was, at that very moment, immortalizing her. Dodge wrote that she and the young man "swayed towards the wide, white-hung bed—until we were lying, arms about each other—white moonlight—white linen—and the blond white boy I found sweet like fresh hay and honey and milk."[37] Is a detail like "the whiter division" in Stein's text a reference to a quality of Mabel's white bedroom and affair? Better yet, is Gertrude listening when she writes: "So much breathing has not the same place when there is that much beginning. So much breathing has not the same place when the end is lessening"? Though Gertrude may have been soaking up Mabel's semiplatonic tryst and filtering it onto her pages of semi-automatic writing, we also note that Mabel is giving her version well after the fact and very much with Gertrude's portrait in mind, since she reprints it complete in *European Experiences* only a page before describing the above scene.[38] In this 1935 memoir she may be rewriting life to fit her portrait; alternately, in 1912 she may have staged a scene for Gertrude's benefit. Still, it is not hard to see that large sections of *European Experiences* might be used as a gloss on "Portrait," Mabel's backward glance upon a text that made her famous and could now do with some elaboration. Her overly long description of the Villa Curonia (pages 131 to 174)—its discovery, reconstruction, refurnishing, and most especially a room-by-room appraisal and inventory down to details that are all related back to the *padrona*'s personality, deepest fears, and anguish—must be meant to prepare, albeit circuitously, for the

"Portrait of Mabel Dodge" when she reprints it in her book in its full, bewildering glory, as if it provided a meaningful summing up and distillation of the whole memoir. The time-consuming attention to the villa comes to fill a huge void in Mabel's life, but she knows that the void remains, so that all the time she is filling her house with objects she wishes to connect with, the text by Stein is accurate in filling its textual villa with evanescent objects that, sentence after sentence, dissolve into emotional perceptions: "An open object is establishing the loss that there was when the vase was not inside the place. It was not wandering. . . . There is that desire and there is no pleasure and the place is filling the only space that is placed where all the piling is not adjoining. There is not that distraction."[39] This last sentence is used as an epigraph in *European Experiences* when Mabel comes to describe her husband's bedroom, where Gertrude wrote and slept. The epigraph for the next section of the chapter, "The White Bedroom" (Mabel's room), is from Robert de la Condamine: "Possessing a soul, it is decreed that I must still ask all the fruitless questions, undergo the fruitless travail of the soul." This dire view of Dodge's fate can be found in many places in her memoir and is frequently associated with the house, for example: "This door was a very fair symbol of myself at that time, for it led nowhere. Like the fireplace in the hall, it was only for effect," and "How can I be expected to permeate this place with a fictitious personality!"[40] Here is a Mabel distressed at her accumulations, conscious of the vacuity at the core of her interior decorating and her "Making a Home," the title of this very long chapter on the Curonia. One may read Stein as having captured this anxiety, as different sensations loom from sentence to sentence, flit from object to absence in an alternating reiteration and loss of whatness: "There is all there is when there has all there has where there is what there is."[41] Oddly enough, with much vaguer terms and turns of phrasing, Stein appears contented enough in her somewhere villa, while her subject has inventoried a whole world of furniture, *bibelots,* and damasked cushions and drapes to give body to an interior where her own body can find neither vindication nor comfort: "Blue is right one day and all wrong the next. Why? Oh, the nerve-racking effort to *succeed!* Never attained."[42]

European Experiences can be a touching book, and an intriguing one to set beside Stein's memoir of the arts in Europe, *The Autobiography of Alice B. Toklas,* published only two years earlier. However, whatever insight into "Portrait of Mabel Dodge" we may glean from its subject's version, it cannot determine the main lines of its potential reception in 1913. Read on its own, "Portrait of Mabel Dodge" is much more obscure than "Matisse" or "Pablo Picasso." It is as if Stein had responded to the

criticism that the first two texts were weak in their lack of palpable content by demonstrating that she could add plenty of content and yet the clutter, of objects and responses, would not necessarily strengthen sense-making. Except for a few passages, there is not even much repetition in "Portrait," the aspect that had become the presumed hallmark of a text by Stein. Every sentence in "Picasso," after all, was quite comprehensible, if given the chance: "This one was certainly working and working was something this one was certain this one would be doing and this one was doing that thing, this one was working."[43] Compared to this circling of the "one" idea, in which the relations between "one" and "working" can eventually be sorted and tracked, the sentences in "Portrait of Mabel Dodge at the Villa Curonia" are centrifugal; the object or idea that initiates the thought throws off emotions or perceptions about it that the reader cannot easily, or cannot at all, relate back to their initiating source: "Blankets are warmer in the summer and the winter is not lonely. This does not assure the forgetting of the intention when there has been and there is every way to send some. There does not happen to be a dislike for water. This is not heartening."[44] This writing process produces a picture of the failure of the house's interiors to match or support the more vast interiors of people circulating there.

Nor is the profusion of negatives at all helpful; it is not a disliking for water that is heartening, but rather *not* disliking is *not* heartening. The negation of predictable responses to the things and events of the house is systematic, a fundamental method of regeneration in the text. But that seems contradictory. It may serve to convey two women's consciousnesses, those of Gertrude the guest and Mabel the host, launched into a social ritual of attempts to find sympathy in one another, without being so forward as to risk rejection: "In burying the game there is not a change of name. There is not perplexing and coordination. The toy that is not round has to be found and looking is not straining such relation. There can be that company. It is not wider when the length is not longer and that does make that way of staying away. Everyone is exchanging returning. There is not a prediction. The whole day is that way. Any one is resting to say that the time which is not reverberating is acting in partaking."[45] Most of the twenty-five paragraphs end with negatives, but, in most of the cases, the negation is of some sentiment or sense quite new to the paragraph, so that its material is not negated, nor is the text as a whole. "It is not inundated," and "Nobody is alone" are two endings to paragraphs, and can serve as two short examples to illustrate that the negative is not a loss, quite the contrary: no floods, no loneliness, as if the fear of interpersonal relations has been dispelled, and the villa can be a refuge from such fears or other threats from the outside world, despite

the insecure reality of its interiors. The very last line, "There is not all of any visit," neatly ends the little vacation without closure, a most promising negative that returns us to the promise of enjoyments in the opening line: "The days are wonderful and the nights are wonderful and the life is pleasant." Still, that opening sentence deflates expectation, one "pleasant" being a bit anticlimactic after the build up of two "wonderfuls." The ending sentence asks to be invited again, to renew or fill out the pleasure.

Compared to the scarcity of objects in "Picasso," the increase of things appearing in "Portrait," even with its negated negative responses to them, looks like an addition of color in contrast with the Spaniard's very muted cubist palette. Gone is the rational and reductive breakdown of expression as seen in the cubist avant-garde text announcing the Armory Show; now looking back on that show, *Camera Work* is ready to propose a reconstructive phase, a fuller and more sensual, if swirling world, more akin to work from Kandinsky (but the one painting of his which was in the show and which Stieglitz had bought was never reproduced in *Camera Work*). Though richer, "Portrait of Mabel Dodge at the Villa Curonia" is not a more reassuring text for the reader; it fails to construct her realistic world in familiar terms but on the contrary destabilizes it even more than the pre-Armory texts did. Those earlier portraits reduced the world, whereas this one multiplies it; it spreads over the villa and gardens of Dodge's Florentine refuge a multilayered fabric of free-floating consciousness which, even in such few pages of text, manages to reread that reality innumerable times. From the analytical reduction to the single one to a surreal surfeit itself indicative of more to come on our next visit, the voyage from one text to the next in the pages of *Camera Work* tracks an evolution from rationalist analytical cubism to Freudian surrealism.

In Stein's progression one may glimpse an important aspect of the general movement in the arts in New York between 1912 and 1913.[46] At first Stein proposed a new austerity, a modernist sweep of one's imaginative home to clear out the reassuring, polished accretions of Victorian furniture, all those accumulated overlays of comfortable thinking. "Pablo Picasso" leaves only a virtuoso dervish, artist or writer, turning in the middle of the emptied room, working at beginning the room's whole meaning all over again from scratch. Less than a year later Stein wraps up the Armory season with her redecorating all done. Much of the furniture may be back in place—or back in *some* place!—but the undecipherable messages that emanate from the pores and surfaces of crockery, tables, toys, and blankets translate a furniture we never understood. Its coded memories are no longer fixed but continually blossoming. The reader,

first starved, is now surfeited. This surfeit mirrors nicely the profusion of color and inventiveness that the French painters as a group brought to the Armory. In this comparison, among the Americans Hartley's soon-to-be-abandoned abstractionist mode might most neatly represent the viewer's starving, though the seeds for his arcane signage are already present. At first blush, Stieglitz's countershow would also have looked ascetic compared to the French work, a reduction of art to mere black-and-white mechanical reproduction; but, as opposed to any sort of abstraction, his machine work espouses the whole new world of the city without enslaving it to formalism. Though this is not the surfeit of Stein's later text, his exhibited images, taken together with those in Marin's preceding exhibition and Picabia's work in the one that follows, demonstrate a multiplicity of richly distinct, original responses to the new New York—responses that can be riotous and high-flying in Marin's watercolors, humorously mechanical in Picabia, or both objective and personal for Stieglitz. The high modernism of self-reflexive formalism has been initiated by 1912, but the Secession continues to insist upon using experimentation as a humanizing path into modernity as a defense against its oppressive forces. In a word, we can see the Secession as flâneur, rather than as modernism in flight from the rigors and cheapness of modernity. Taking stock of this commitment to a splendidly shiny if harsh modernity, in the next chapter I want to survey the Secession at its peak around 1915 and appraise its success at producing a committed form of modernism.

5 Mechanics of the New York Secession (1915)

In an essay attempting to define modernism, Richard Poirier has written: "Modernism happened when reading got to be grim."[1] Indeed, a strenuous grimness pervades modernism, in art or in writing, which comes from our difficulty of access. Such modernist work seems to bank on keeping many of us out, addressing itself to a well-primed cultural elite, but the difficulties arising from the avant-garde's experimentation with forms and extremely subjective points of view do not necessarily lead to the hermetic, self-reflexive work we associate with grim, elitist modernism. The Secession, a sort of preparatory avant-garde on the modernist road before it forked right to high modernism or left to Dada, embraced the experimental and the subjective, but resisted the artistic isolation that leads to grim art. Secessionists sensed from the outset a trap well described by Raymond Williams: "The positive consequence of the idea of art as a superior reality was that it offered an immediate basis for an important criticism of industrialism. The negative consequence was that it tended, as both the situation and the opposition hardened, to isolate art, to specialize the imaginative faculty to this one kind of activity, and thus to weaken the dynamic function which Shelley proposed for it."[2] High modernism quickly lost the "dynamic function," or even purposely gave it up by putting the modern surfaces of the experimental at

the service of a conservative or reactionary social agenda, which would be a different dynamic function that Raymond Williams did not yet have in mind. But the Secession was still functioning within Williams's first consequence, and not falling prey to grim elitist positions. In her marvelously detailed *The Great American Thing,* Wanda Corn also cites Williams on this same issue, but for her the artists of the Secession, Stieglitz foremost, fit Williams's epigram of "'modernists against modernity.'" While she goes on to seriously qualify such a blanket condemnation of the New York group, she nevertheless writes: "His [Stieglitz's] version of Modernism retained features of nineteenth-century aristocratic traditions in that it valued art, as Williams put it, 'as a sacred realm above money and commerce' and maintained older upper-class attitudes toward 'the ignorant populace.'"[3] On the contrary, I find that the artists and writers I will discuss in this chapter, and which I am only loosely associating under the aegis of the photographer, drew their energy from a fledgling modern society for which they entertained hopes so high that few citizens of the democracy could fulfill them. As the century advanced toward its first world war, these resolutely American modernists, with some curious help from Paris, attempted to maintain a strong, and to them necessary, link between modern art and modern society, as if not to let commerce run away with the whole culture. Their secession was aimed at the bourgeois's betrayal of the modernity from which he made his living. Admittedly, Stieglitz was not a muckraker, but at the same time he hoped for a great deal from democracy and its principles. His social commitment was serious, and his long war on the pernicious effects of commerce upon art was an important and modern, not aristocratic, action. In any case, he also did his part in feeding mouths.

Art and Industry

When Stieglitz declared his "Photo-Secession" in 1902, he found himself in a very different situation from that of his predecessors in Vienna, Munich, and Berlin, for he was rebelling against something more fundamental than official schools of art. Such organizations in America as the Camera Club and the New York National Academy of Design had much less authority than their counterparts in Europe because culture itself in America had little decisive power of its own. The long lineage of tradition and culture embodied in the official associations in Europe did not exist in America. Institutions here represented a more recent and superficial activity, supplying the pretense of culture, a recent veneer which the American moneyed class used to give itself the sense of not being entirely devoid of European sophistication and intelli-

5.2 Alfred Stieglitz, *Spiritual America*, 1923. Gelatin silver print, 11.5 × 9.2 cm. Alfred Stieglitz Collection, image © 2004 Board of Trustees, National Gallery of Art, Washington.

gence. Such an American approach to culture is nicely portrayed in Edith Wharton's *The Custom of the Country* when an American capitalist manages to acquire a French family's heirlooms, centuries-old tapestries that define their lineage. Stieglitz did not have to compete with an official and well-rooted culture for an audience, but had to convince a mercantile society that art had value at all beyond being an outward proof of gentility. It is a major paradox of American social development that the Puritans bequeathed to that society a spirituality that could be assuaged by sitting-room sentimentality and appear unsullied by profits at any cost. Mark Twain had greeted the new century thus: "I bring you the state nation named Christendom, returning, bedraggled, besmirched and dishonored, from pirate raids in the Kiano-Chou, Manchuria, South Africa and the Philippines, with her soul full of meanness, her pocket full of boodle, and her mouth full of hypocrisies. Give her soap and a towel, but hide the looking-glass."[4] Stieglitz, for his part, summed up his long-held views of Victorian society's obsession with a disembodied spirituality in a cropped picture of a gelding in harness entitled *Spiritual America* (1923). While this photograph may appear at first to be a heavily formalist close-up endeavoring to contrast the textures of the horse's body with those of human-fashioned leather and metal harness, the title invites us to look, with some irony, at what is missing within the harness framing. The photographer told the story, or prestory, of this image: in Paris, "along the curb many women were at market. The horses stood throbbing, pulsating, their penises swaying half-erect—swaying—shining. . . . No one cared to be seen staring at the animals yet it was clear that everyone was aware. . . . In New York such a thing would not have been permitted, all the horses in the city being geldings."[5] What we have been brought to stare at in that dark space is an absence, a removal. Spirituality in America requires curbing the stallion's unruly energy. Or, to read the title a bit differently, a "true" spirituality that would be capable of including sexuality has been vacated, the spirit stifled by propriety and sexuality harnessed to drudgery. Indeed the very stasis of the image, its formalism, should be identified with the emasculation, sterility. The framing curves of the harness need not exert control, of horse or of image, but only serve to reiterate a subjection that has already been implemented. *Spiritual America* names the opposite of Stieglitz's desire for a spirituality that would not need to cover the vital energies of the body, to obliterate both the sexuality and the economic aggression of Twain's turn-of-the-century America. The painters of the academies provided soap for the profit-taker's parlor, but Stieglitz proposed, at least as part of his program, the looking glass.

This metaphor is further apt in that, until Stieglitz, photographs with pretensions to art had been doctored, through the use of soft focus and the application of ink or paint, in order to approximate—copy, really—the allure of painting. There was a moral aspect to Stieglitz's fight for straight photography, because clarity in the image carried its meaning for clarity of moral vision as well. It is important that the American Secession began with enlisting the camera, the era's machine brought out into the open field of culture. In Stieglitz's hands, this machine was turned on itself in a way, Frankenstein's monster forcing his maker to look him in the eye. Looking again at *The Hand of Man* of 1902, we see the locomotive challenge us head-on, spewing its filth over a grimy and barren landscape. We cannot imagine the merchant's wife hanging this print in her home—not to mention *Spiritual America*!—next to the ubiquitous *Death and the Maiden* or a portrait of her virginal daughter because, quite simply, it does not prettify, either aesthetically or morally. Yet, for us, it has beautiful movement and determined power. The hunched locomotive bears down on a straight line leading slightly off to the right while the viewer and photographer stand to one side, on another track, which is unoccupied and gracefully intertwined with others. This is the perspective of the Secession, standing aside and dissociating itself from commerce, but still tied to the energy and hope of democracy, the industriousness of industry. In America, commerce replaces authority, of art institutions for example, and is insidious rather than peremptory. It makes for a slippery adversary. But by embracing the machine as a new and vital development of society, and thus inevitably a part of culture, the Secession was also being subtly aggressive; if the magnate made himself out of machinery and skyscrapers, could he convincingly jettison all that baggage when it came time to look cultured? The portrayal of heavy machinery in art at this juncture in American history strikes me as a *dare* to the buyer, a challenge to hang the looking glass.

Closer to the main moment of this chapter, the year 1915, Stieglitz's *The City of Ambition* of 1910 is a mechanically reproduced work of art portraying the American engineer's most accomplished dream. The tall, sleek buildings of capitalism tower over a somewhat more human-scaled ferry and port, but smoke as they do so, as if the whole world were a factory. The scene is backlit; it appears to be early morning, so the buildings are in semidarkness, somewhat spectral, yet massive, while the sun illumines the chimney smoke and the glittering water. There is a sense of great bustle and energy, yet with no human figures. The tip of the railing in the foreground reminds us whence we view the scene, and a wharf on the right has the effect of a bridge linking the city to these viewers and enhances a classical perspective of progressive depth and height.

However, the camera eye, resting at ground level, is forced to scan upward over a scene no European artist ever saw in land- or cityscape. The slowly rising majesty of tall mountains, with their peaks miles off in the distance, have nothing in common with the abruptly vertical, geometric masses of these buildings erected by and filled with unknown people. The viewer pauses over the shimmering water, which is sensuous and bright, even intimate in comparison; the exalted city, spectral and busy, beckons. Here is combined a critique of the city's appeal: a poeticized distancing from the ambitions of the ferry-riders or our own ambivalent ambition residing with them, and a drastic collapsing of nature and city that is dictated by both the skyscraper's transitionless rise and the camera's ability to encompass it. The image cannot be constructed on a perspective of progressively receding planes, but instead must create a sort of stage set, with progressive recession from our hand to the foot of the buildings and then an abruptly vertical, flat plane of buildings hung like a curtain backdrop. Despite the ease with which this city of ambition can be circumscribed by the photo's viewer, the image is solving a difficult problem of modern representation, one that obliged such artists as Robert Delaunay working with the Eiffel Tower or John Marin sketching the Woolworth Building to dismantle them in order to pack them into their frames. The camera machines the image of our industriousness, redrafting the manner in which that image can be framed and delivered.

In particular, framing may now be dictated by the necessity for the camera to take what comes to it at the opportune moment, and by its inability to rearrange reality for the benefit of a more sublime view. The aesthetic must be a virtue arising out of this necessity, a refashioned framing for new, hopefully democratic advantages. For example, Stieglitz's *Going to the Post,* 1904, is remarkable in its composition because he has retained the sustaining beam that goes right up the middle of the picture. Other girders at the top and shadowed spectators at the bottom continue the framing. Rather than a separation of foreground and background, here we are presented with a separation of left from right, especially since all the horses in the field run only on the left side of the post. The viewer's eye keeps landing in that empty half-ellipse of track, as if the picture lacked something there. This division in the race has been accepted by the artist as more important than the race itself. In fact, the artist could probably have moved to take his shot, but he has decided to stick with an assigned or available seat, like the rest of us. There are two groups, audience in the foreground and racing horses in middle to back, but there is also a sideways separation, as if there were two pictures here; the splitting frame removes us from both, letting the

5.3 Alfred Stieglitz, *Going to the Post, Morris Park,* 1904. Photogravure, 1905. In *Camera Work,* no. 12, 1905. Digital scan, Rare Books and Special Collections Division, McGill University Libraries, Montreal, Canada.

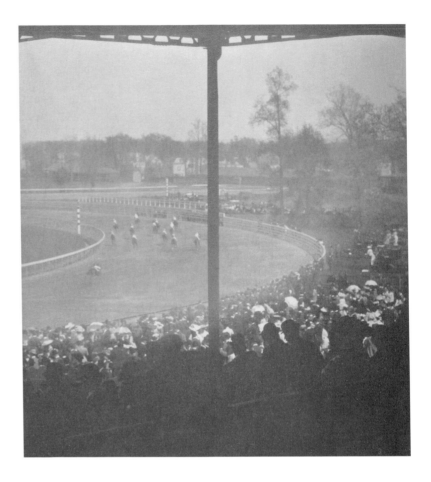

view fall back and away from us, which leaves us in intimate shadows in *front* of the foreground, well out of the sun or limelight.

This attempt at removing oneself from the center of the American action, which I am showing to be, paradoxically, one result of a democratizing camera, can also be found in the work of many other artists of the period. For the Ashcan School it took the form of looking directly at seamier sides of life, under the El as it were. These painters changed the subject, and were much denounced for portraying unedifying scenes. While we would normally look to the modernist to be more interesting in terms of form, the Ashcan painters could also recompose remarkably, looking differently under the pressure of looking at different kinds of things, so that the structure of their work accompanies their secession from the old subjects previously acceptable to painters and their public. In his painting *The Wake of the Ferry, II,* of 1907, John Sloan breaks up the stormy scene with the dark supporting posts of the ferry. He cuts up

CHAPTER 5

5.4 John Sloan, *The Wake of the Ferry, II,* 1907. Oil on canvas, 26 × 32 in. The Phillips Collection, Washington, D.C.

the expected scene, drops the illusion that the boats in the distance should hold our interest, and brings us closer to the figure of the woman at the right and to the ferry we are on, even though we see so little of it. We only know we are rocking, as the lone passenger leaves something or someplace behind. It is a painting remarkable for its lack of content, except for the framing forms. An accordion fence further separates us from any scenery, even interdicts it, and the woman's position and posture make her as much a viewer as participant; we view her viewing of nothing too specific, a dreamy voyage of unknown outcome.

Both of these pictures, of racetrack and ferry, show a removal from the great fine subject, in these cases the exciting horse race or promise beyond churning waters. This development is discussed at some length in Peter Galassi's now-classic *Before Photography.* The artist becomes the victim—but the willing victim—of his painting position vis-à-vis his subject; he can no longer compose his picture, only take it.[6] The array of objects arranged in progressively distant planes, with the prime, glorious object of one's interest occupying a finely calibrated position within the perspective, disappears in favor of what appears to be available: custom-tailored bows to ready-made. A given monument barely peeks out in the distance from behind a myriad of impoverished buildings because we could not find, or were not permitted, a better place to stand. Though I feel reasonable in attributing such a change in point of view to photography,

5.5 Everett Shinn, *The Orchestra Pit, Old Proctor's Fifth Avenue Theatre,* 1906. Oil on canvas, 44.291 × 49.53 cm. Yale University Art Gallery. Bequest of Arthur G. Altschul, B.A. 1943.

which would be a tool perforce of democratization, Galassi believes that many painters, usually minor ones he finds, chose similar arrangements for their material. Everett Shinn was a popular painter of theatricals and dancing girls, all suffused with the bright, delicate light of his master Degas. In *The Orchestra Pit, Old Proctor's Fifth Avenue Theatre* (1906), however, he does not foreground the shiny performers; his alluring girls on the stage are behind and cropped, while the center of the picture is occupied by the back of a head. We don't even see what instrument this man is playing, and we are further separated from the stage and from the musician by a curtain. This is a dramatic and quite modern break with the portrayal of a period's light pleasures, rendered via the presumed bad luck of sitting in the wrong seat, though it is no doubt an expensive one. The glitter recedes, is for others, and we contemplate our unprivileged position. The contingent point of view of these last three pictures, by Stieglitz, Sloan, and Shinn, ruins the fine topic and focuses our attention on broad, interrupting structures that limit old views and force new ones.

While Galassi insists that painters did this before photographers, certainly the photographer was more apt to feel the pressure of his medium and, as he snapped his picture with ever shorter exposure times, the pressure of an instant that could not admit the leisurely preparation for the sublime. A photographer like Lewis Hine, who rarely paid much

attention to composition in his early documentary portraits of slum dwellers and new immigrants, could nevertheless find himself with a negative in which space became structured in dramatic ways dictated by both the position of his camera and the constrictions of modernity: thus a photograph like *Boys at Work, Manchester, N.H.* (1909), in which most of the picture is in darkness, and a boy's head rests embedded inside the machine he works at. The statement is similar to a later one from Chaplin, as he is dragged through his machine in *Modern Times* (1936), but Hine's image is more subtle, and patently real. In another instance, one of Hine's familiar figures, the young paper boy *Danny Mercurio* (1912), is surrounded by the cleanliness and order of Washington, D.C. The heavy matron caught stalking awkwardly off to the left is separated from the spunky Italian boy by a great deal of pavement and class, a distance increased by their respective gaits, the boy's easy stroll toward the camera and the matron's rigid arm and stiff kick, as it were, at the frame of the picture. The street boy is at the perfect center of this image; considering his small size and classical composition's abhorrence of the static center, he is drastically central, a sort of island of spunk in the wide, rational, and Apollonian city of L'Enfant, while the dark, veiled bourgeoise has been pushed back to the margin. She may well be miffed at the camera's rejection of her importance; in any case, the left edge constantly upsets the picture's balance, as it is difficult for the eye to encompass the boy and the woman at the same time.

5.6 Lewis Hine, *Danny Mercurio,* 1912. Photograph courtesy George Eastman House.

Though Hine may have paid relatively little attention to formal composition, we may say that in this instance his roving lens stood in for him in this regard. Stieglitz, on the other hand, paid a great deal of attention to composition, but he also had to heed the camera and the facts of the scene as it stood. He thus struck a balance between controlled form and uncontrollable, but accepted contingency. He heeded his medium and turned expression into choice. A very early example of this balance, *Sun Rays—Paula—Berlin,* 1889, takes advantage of a Vermeer-like staging, but, as the order in the title indicates, the window blinds cast a different light over an otherwise ordinary, if not sentimental, image.

5.7 Alfred Stieglitz, *Sun Rays—Paula—Berlin,* 1889. Gelatin silver print, 22.6 × 16.8 cm. Museum of Fine Arts, Boston. Gift of Miss Georgia O'Keeffe, 50.822. Photograph © 2003 Museum of Fine Arts, Boston.

CHAPTER 5

Whereas the impressionist might have given as much importance to the lighting here, Stieglitz, without the advantage of color, has done something quite different, and new. The scene has been overcome, flattened into abstract bands repeated in various tones on the window, table, and walls, as well as on the wicker chair and the birdcage, where the pattern of lines is further complicated. The figure, tablecloth, and room as a whole have volume, but in large areas of the picture the light works against volume. It gives prominence to the candle, which is already ribbed and set against an unlit, rather extravagant wallpaper. The paraphernalia on the wall is massed together against the dark paper but also broken by the strips of light. The sentimentality and nostalgia of the photographs and ribboned hearts here recede before the power of the structural massing, which is produced almost entirely by shadows and broken shadows. Whereas in painting shadows represent background and fading away, working negatively to permit the major subject to emerge and tower, camera work must permit shadows to become the subject, an emphatic scattering of light that displaces, then reorganizes Paula's collage of images and imaginings of hearts, bird, and repeated portraits. Further, the whole photograph is a band of light across the middle of the frame, with top and bottom in darkness. Stieglitz has waited and worked for the precise quality of this light and these darknesses, for the moment he could balance them against each other and together against the sentimentality of the girl's wall display; he restructures the meanings of the image's banalities without obliterating its objects, which include photographic portraits on the wall that are very different from his own.

This early photograph, dated 1889, can be read as remarkably modern for its moment, as its success at making shadows rework straightforward representation predicts the early abstract work of Strand, whom Stieglitz was about to show at 291 and in *Camera Work* in 1916. I will return to Strand later in this chapter. But the power of the machine to rewrite artwork reached a slightly earlier climax, in 1915, when Marius de Zayas and some friends launched *291,* the most radical magazine of its time.

291 or *291*

Much has been made of various aspects of *291* that signal the contributors' severe criticism of or disappointment in Stieglitz. However, a good look at the magazine's contents and the actual behavior of the main contributors ought to show that the breach, if breach there was, is exaggerated. In the main, I see two mistaken assumptions: that Stieglitz could not abide some ribbing, and that he could not abide independent

thought on the part of his collaborators. Or, as it was seen by the other camp, de Zayas and Picabia thought Alfred couldn't take a joke or accept work newer than his own. No doubt there was a type of father-son relationship at work between the photographer and most of the artists he dealt with. He had already been through a few artistic revolutions before the Dada one which *291* was about to launch upon, and he had to be a figure of accomplishment rather than fellow traveler for any avant-garde in 1915. At the time of *Sun Rays—Paula—Berlin,* Francis Picabia was ten years old, de Zayas nine, Picasso only eight; in 1915 Picabia was thirty-six, already aging for a young revolutionary, and Stieglitz was fifty-one. There certainly may have been differences between the generations, but this elder still provided far more nourishment than did any notable predecessor. Their subsequent relations with Stieglitz yield no evidence that either de Zayas or Picabia gave up on him, nor that he, for his part, disowned them. One could more easily argue that, like the best of fathers, he was happy—or certainly not unhappy—to see the boys stray from him. As he wrote to de Zayas during the making of *291* on the much touchier subject of a second venture, the Modern Gallery, "I feel it's a good *thing that things are happening with me away,*" and, three days later, "For years every one seemed to rely on me—I suppose it was my fault it was so—& during the past year or so I tried to make it clear that that attitude of *waiting for me to do something* was not fair to 291. . . . Fortunately you saw—understood—took the initiative."[7]

This initiative, the Modern Gallery, was an attempt to sell modern art in New York, a commercial job that Stieglitz had always refused to perform at his Little Galleries at 291 Fifth Avenue. (The Modern Gallery opened with a show of work by Picasso, Picabia, Braque, and Stieglitz in October 1915, a flight up at the corner of Fifth Avenue and 42nd Street, across from the New York Public Library.) On the other hand, *291,* the magazine, was meant to be the expression of a small group of like-minded avant-gardists who would experiment in language and image in a mildly satiric vein, the spirit of experiment, as an ideal in itself, remaining their connection to their namesake, 291. Stieglitz did not produce new work for this publication, with the exception of three brief, related texts in the first issue. Still, he was a constant reference throughout: his famous photograph *The Steerage* was the centerpiece for number 7–8; there were various representations and discussions of him; and of course the very title itself referred to the business address of both 291 and *291*. De Zayas, Paul Haviland, and Stieglitz were the editors, these last two and Agnes B. Meyer each covering one-third of the costs for a sheet that ran for about one year, with numbers 5 and 6, 7 and 8, and 10 and 11 combined so that in fact only nine issues appeared. The famous

drawing by Picabia that is considered critical of Stieglitz's commitment appeared in number 5–6, and Stieglitz responded by letter to what appears to be criticism from de Zayas in number 9; nevertheless, another letter from the photographer, dated March 20, 1916, shows him doing all the work with the printer for the last issue and fighting to save publication costs, of which he is now paying more than his expected third.[8] The covers of numbers 1 and 5–6 are "portraits" of Stieglitz, by de Zayas and Picabia respectively. The inaugural cartoon-portrait is inscribed "291 throws back its forelock"—while we have to assume *291* the magazine is meant first, nothing bars *291* the gallery from inclusion—and thus the adventure is begun with a gesture imputed to Stieglitz. Other covers were by Steichen, Walkowitz, and Marin from the 291 group, and Braque and Picasso from Paris; the Little Galleries at 291 had shown these two, and then Picabia, in back-to-back exhibits just a few months before the first issue of *291.* The magazine, while certainly remarkable in its presentation, was to represent a quicker exploitation of the avant-gardes than the extravagantly produced *Camera Work,* but it was still the meeting place of the same New York and Paris avant-gardes to be found at Stieglitz's gallery. Number 7–8 focused on *The Steerage* (1907), of which Picasso was reported to have said, "This photographer is working in the same spirit as I am."[9] I take this comment to be a recognition less of the content of the image than of its use of a collapsed perspective. The last issue of *291* features a Congolese sculpture on the cover, a discussion of modern and "negro" art by de Zayas, and angular work by Archipenko and Brancusi. De Zayas was to attempt to sell both modern and African art in the Modern Gallery, without much success, an effort that followed through on their experimental linking at the 291 gallery, when Stieglitz showed Picasso, Braque, and African sculpture together in early 1915.

So, while *291* may seem to become rather quickly quite machinist and Dada (or pre-Dada as it has been called, since the term had not yet been coined), it was also, and throughout, eclectically avant-gardist. With Stieglitz, Marin, Walkowitz, stream-of-consciousness poems, futurist "parole in libertà," and late-nineteenth-century African sculpture, it stayed true to a Secessionist inquisitiveness. It was probably inspired by Apollinaire's avant-garde journal *Les Soirées de Paris,* but this Parisian journal did not show much of an aggressive or Dadaist tendency, and the only visually innovative work was the few "calligrammes" of his own that Apollinaire printed in the last two issues before the war closed his review down. In these last few issues for the spring of 1914, *Les Soirées* had been interested in the popular arts, but not at all in the machinery aesthetic that Duchamp and Picabia were soon to develop in response to their visits to America. *291* did not derive its defiant and

joyful modernist appearance from *Les Soirées,* but rather some of its artists and material, as a sort of demonstration of the fraternity of the avant-garde before it was scattered or even liquidated by the war in Europe. Apollinaire's "Voyage," which opens *291*'s first issue, is taken from the last issue of *Les Soirées,* number 26–27 for July-August of 1914, where it was printed with three other calligrammes, then termed "idéogrammes." This issue of *Les Soirées* contained four cartoon-portraits by de Zayas—of Apollinaire, Vollard, Picabia, and Stieglitz—which clearly set the stage for the idea of four abstracted portraits by Picabia for *291* (the last two by de Zayas had already appeared in the April 1914 issue of *Camera Work,* though that issue may not have been in circulation until October). The previous *Soirées* showed work by Archipenko (as I said, he appeared in the last *291*), and, finally, number 22 of *Les Soirées* (March 15, 1914) had reproduced paintings by Picabia, the work of his first voyage to America at the time of the Armory Show. Some of these "American" works had already been on the walls at 291, in March and April 1913. *Les Soirées de Paris* could thus feed off 291 before *291* returned the favor, but, as these 1913 Picabias were not yet in the mechanical modes that were to make number 5–6 of *291* so innovative, at least in that respect the American magazine was not so much inspired by the Parisian journal as conscious of continuing its avant-garde work, at the very moment when the war was about to shut down such work in Europe for almost four years. This adventure into what America might be able to contribute to modernisms was certainly de Zayas's brainchild. *291* began publication about seven months after the demise of *Les Soirées* (August 1914 to March 1915), but its seeds had been planted in his mind much earlier. Witness these words to Stieglitz in September 1914 after he left "France and specially Paris in very bad condition," carrying the work by Picasso, Braque, and Picabia and the African sculpture for the show at 291: "I believe that the war will kill many modern artists and unquestionably modern art."[10] So modern art might survive in New York, which defiantly threw back its forelock in the person of an angular and abstracted, generally modernized Alfred Stieglitz.

From the outset *291* explored a marriage of abstract visual form and private, spontaneous-looking writing, matching a freed-up consciousness to the machined forms of modernity as if they were two sides of the same coin. The opening poem by Apollinaire, "Voyage," is not only constructed of words arranged into shapes, but contains an actual image on which to hang the poet's thoughts—electric wires running through porcelain insulators, an image which, in turn, suggests the signature opening on a musical staff; his words of longing are sung to the traveling music of a new means of speech. The poet's words are scattered about

the page, retaining a left-to-right sequence but obviously eager to disrupt it. They are dispersed when it is time to speak of stars ("nuit . . . pleine d'étoiles"), or clumped in visually neat, repeated groups like the regular clicking of train wheels over the rails when the poem's train disappears into the vales and the woods:

OÙ VA DONC CE TRAIN QUI MEURT . . .
DANS LES VALS ET LES BEAUX . . .

Even if this poem can be seen as the beginning, or the instigation, of typographical experiments to come in *291,* those will go quite a bit farther in disrupting language. Meanwhile, printed directly below "Voyage," with a thick black line separating it, is a short text by Stieglitz, "One Hour's Sleep—Three Dreams," a purposely unconscious stratum like a latency below Apollinaire's reasonably explicit declaration to a lost or disappearing love.

Stieglitz's dreams appear real enough; they seem to retain some degree of spontaneous, irrational, or at least not overly willed details, and a general demeanor of the dreaming state. On the other hand, they may have been extensively recomposed, all to focus on a woman, and they end with the same statement of awakening, even though, if they were all actually dreamed in one hour, the reappearing woman is not so easily to be discounted. It is also possible to imagine them, the middle one most certainly, as being written (or dreamed) after reading "Voyage": the speaker and the woman *traveling* together "in the *moonlight,*" she growing *pale* (the italicized words are also in Apollinaire's poem). More interestingly, the dreams are revealing of Stieglitz's perception of what is happening with this *291,* so much so that we may wonder if he himself was conscious of their "Freudian" meaning. By 1915 there was already much talk about Freud in Greenwich Village art circles, and Stieglitz owned books by the Viennese doctor, so we can also surmise that he had no qualms at all in unveiling his pains, if that is what they were, at the birth of *291.*

The opening sentence is, quite bluntly, "I was to be buried," and similar deaths occur in each dream: in the second dream he "slipped away," continuing to walk "onward"; in the third the woman says, lying, "He killed himself." At first the recurring woman is the only one in a group (including "the whole family") who questions the fact of his death; then she is a companion starving for sustenance, which he is able to materialize for her with a kiss; finally, she becomes a mad, passionate lover who loves someone else, her ideal lover, but she mistakes this man for the dreamer/narrator, and after kissing him stabs him to death in an

act of violence which, the dreamer says, suddenly makes her "perfectly sane." On the wall, then, appear the words in blood: "He killed himself. He understood the kisses." We may take this woman to be *291*, born as a "Fille sans mère" ("Girl born without a mother"), to cite the title of Picabia's drawing in *291*, number 4 (June 1915); she embodies de Zayas's estimate of Stieglitz's achievement in number 5–6 (July-August 1915), the number with Picabia's machinist drawings: "He married man to machinery and he obtained issue."[11] True to Freudian form, the dreams are quite explicit about the sexual foundation of the intellectual endeavor, and at first blush these texts would confirm that, in Stieglitz's mind, *291* was killing him off. However, many of the details tell a significantly different story, for he in no way resists his deaths; he even acts to bring death on in the third dream, and in the first he is already dead, but not yet successfully buried. In each case he is benevolent toward the woman, for she is the one who requires reassurance as he bows out. In dream one, his burial is his "wish" to be "carried out," and no one cares except this unknown woman; in dream two, the woman and he tramp together for days, and when she finally pleads for food he makes it appear by kissing her, though he has told this "child" there is no food, "only Spirit—Will," and then he walks off without her noticing; finally, in dream three, he declares he is *not* her lover, though she desperately needs him to say he is, because she had needed to kiss him. He then brings on his own sacrificial death at her hand, so that she may become sane. The point seems to me sufficiently repeated, even if it is doubled and contradictory: an older Stieglitz has died, in part because of *291*, but it is precisely *291* that needs him dead yet is afraid of letting him die. His job is to leave, for himself, and stay while appearing to leave, for her; that is, he wanted another voyage, but *291* needed him along on theirs, as a father both honored and rejected. This is, of course, as Stieglitz-the-dreamer saw it. How the other editors took its meaning, we cannot say for sure; but they chose a layout that sets the dreams as a subtext to Apollinaire's surface voyage, planting a sexualized and ambiguous series of deaths below the open, happy rebellion of type-forms against the old sentimentality of romantic yearning. The above and below division of expression that inaugurates the magazine is probably reflected later in Picabia's famous portrait of Stieglitz on the cover of number 5–6; the photographer is always both missing from what is above and a foundation for it.

But more typical of *291* than an exhibit of above and below is a show of side by side, that is to say, of quite different statements on the same topic brought together on terms of perfect equality. This is precisely the testing that *291* saw itself as carrying over from the Little

Galleries. De Zayas seems to have been at the center of all of these visual and verbal composites, with Agnes Meyer, Katherine Rhoades, and finally Picabia. As he wrote Stieglitz in August of 1915: "The number in question [number 9, for November 1915] is a very interesting one for it shows two subjects treated by four minds. We have chosen the drawings by Picasso and Braque which are both of the same subject as are the two that Picabia and I made. That in itself makes a very interesting point for our paper."[12]

In this collaboration for *291*'s ninth number, the most radical and spectacular of its experiments, we cannot tell if de Zayas and Picabia are portraying the same woman, or whether the subject they hold in common is woman in general. I incline to the former, since the Picasso and Braque look like renderings of the very same violin, or of the same image of a violin, as a pin in each holds up one of the cubist planes and details other than the musical instrument are repeated. However, nothing we know of the "three graces" of 291—Marion Beckett, Agnes Meyer, and Katherine Rhoades—permits us to guess one of them is lurking behind *Elle* or *Voilà elle;* perhaps it is all three of them in a collage of the Modern Woman. Within de Zayas's page the form of address shifts, from direct at the top, or beginning, with "FEMME! TU VOUDRAIS BIEN TE LIRE DANS CE PORTRAIT" ("Woman! You wish you could see yourself in this portrait"), to the indirect third-person in the title "ELLE" at the bottom. We can tell that this is indeed the title because de Zayas refers to the work as such in his letter of August 13, though more print-minded viewers might think it is the "FEMME!" at the top; but isn't that quite the ambiguity raised by the typographical experiment? To tip the scales, the collaborators, while presumably working out their pages entirely separately, have definitely linked them at the bottom, putting "ELLE" and "VOILÀ ELLE" close enough, at the bottom, to be read together, reproducing a mannerism of Picabia's syntax for titles, as in "ici, c'est ici." From this central title nexus, the two pages lurch off quite independently, though they may share a rather stiffened motion from bottom left to upper right.[13] Both images are composed of pieces only tenuously linked: in one, the woman's language has been sprung free of the typographical moorings of sequential thinking; in the other, machinery parts have been disconnected, if not atomized, yet retain elements of connectivity. The reading eye wanders arbitrarily, trying to puzzle out the connections between details, or fragments of object or sentence, occasionally skipping across the page to the facing page for some clue to the bewilderment in the first.

De Zayas's portrait has universally been considered to be critical of his subject, whoever she is, trashing her for her brainless immersion in physical pleasure. To cite one piece of evidence: "atrophie cérébrale

CHAPTER 5

5.9 Marius de Zayas, *Elle,* and Francis Picabia, *Voilà elle, 291,* no. 9, 1915.

causée par matérialité pure," words de Zayas breaks into various font sizes as if to signify a complete failure of rigor or coherency. But there is serious praise in de Zayas's portrait. The central "image," set in the largest typeface and of imposingly uniform size, is male and derogatory: "HURLUBERLU," which means hair-brained or a nutcase; or, as the dictionary has it, a crank.[14] The woman who might wish to read herself in this portrait sees herself rushing off in all directions from her nutcase male, dispersing herself all around his pretentious claim to solidity. Looking for this male figure across the way, chez Picabia, we find what has been accepted as a gun; but it is hollow and empty. To take a sampling of statements about the woman in *Elle* that point to her strengths: running like a spine along the left edge of the male, "she did not learn about love-making from literature"; straight across his head, "she is not

afraid of pleasure"; to his right, in large letters, "she delights in the places where he has lived" ("elle jouit" frequently means sexually, but "elle jouit avec" makes me hesitate, and thus I've generalized her pleasure); "no intellectualism"; "not the mirror to her male"; finally "JOUissance à déchirer son être social" ("ecstatic at shredding her social being," unless it be "*his* social being"!). This last is particularly revealing, if I read *Elle* correctly enough as calling upon the woman to be much more advanced than her male lover in a rebellion in behavior and sensuality aimed at freeing herself—and probably them both, as far as I see the writer concerned—from Victorian sexuality. When we assume that de Zayas's take on her physicality is negative, we fall back into our own cultural prurience. This woman's dangerous mind is a positive antidote to the men's chatter, perhaps late at night at the Arensbergs, bogged down as it is in "littérature," or fruitless intellectuality. In an earlier text, for number 5–6 of *291,* de Zayas warned America against its intellectuals and argued his case in sexual terms: "American intellectuality is a protective covering which prevents all conception," "they are dangerous counterfeits," "they wish to impregnate you, believing themselves stallions when they are but geldings." On the other hand, cultured New York is a "circumspect young girl or a careful married woman" rejecting the "seed" of the spirit of modern art.[15] With *Elle,* de Zayas has an American woman take a different stand that is productive and individualistic.

There is a wealth of ejaculating forms in this typographical liberation of words, but all the "jouissances" are hers, that of the "slave who frees herself." Despite the sexual allusions, we should not rest with teasing physical attributes of the woman out of the physical shapes the statements take. Even at that place where we might identify two breasts, the text reads, "Je la vois dans sa pensée" ("I see her in her thinking"). The visual shapes translate her mind and emotions, and her "jouissance" is pleasure in her mind, even if at times she is thinking of her body. Portraits such as these were, after all, called psychotypes; Stieglitz described them a year later as "an act which consists in making the typographical characters participate in the expression of the thoughts and in the painting of the states of soul, no more as conventional symbols but as signs having significance in themselves."[16] Apollinaire's words had formed into a concrete visual picture imitative of his poem's denotative sense, but *Elle* is more abstract, as far as direct visual representation is concerned. *Elle* is also more concrete when it comes to bringing the letters and words to a life of their own, as they embody the moves of the woman's mind at work and play, perhaps dreaming in pictographs that she would only put words to afterward. As Arthur Cohen has written of letters in type, what had been a transparent medium is now "twenty six

beautiful and exotic shapes which can slink or lurk, stand erect or be flattened . . . living things squirming on the page."[17] The pianissimo line that leads to the title at the bottom, and which in print culture implies we approach the last word, states in modest but self-assured letters that "Elle" is absolutely free of the self-punishing restraint of a hairshirt, since "cilice" functions with the same metaphoric sense and force as its English translation. This confidently figured freedom would then be a summing up of all her other resistances and freedoms in the psychotype; she is simply, at her best, no longer the masochist in her corset.

I don't raise the issue of the corset innocently. Picabia had planted one, quite incongruously, onto the electric circuitry of a car engine in his portrait of de Zayas for number 5–6 of *291.*[18] But in New York the discussions of the new rule-breaking and artistic woman had frequently been linked to the real and symbolic dismissal of the corset, as displayed in this quip in the *New York Call:* "this summer's Style in Poetry, or the Elimination of corsets in Versifying."[19] Two months earlier, in *Rogue,* a less well-read publication but one much closer to *291* and Greenwich Village culture, had just appeared this unsigned epigram: "Forecast for 1916. Shorter skirts and suffrage."[20] *Rogue* was published by Allen and Louise Norton. In her column "Philosophic Fashions," written under the name of Dame Rogue, Louise dealt extensively with the modern woman and her relation to fashion codes. In the penultimate issue a year and a half later, she wrapped up her assessment of the freedoms granted by looser clothing with a pun on corsets: "Ladies believe now that comfort means control and as that is what they are after, they won't be stayed."[21] This is not a text de Zayas could have seen before he wrote *Elle,* but Louise and Allen were close friends of the Arensbergs and knew their French visitors: *Rogue* published Duchamp, and Louise would leave Allen in less than a year's time to marry Edgar Varèse. The *291* group certainly would have seen the earlier issues of *Rogue,* such as the first issue of March 15, 1915, which published Gertrude Stein and the very nude and nubile ladies in Clara Tice's drawings that Anthony Comstock had attempted to confiscate. Finally, *Rogue* also published the poetry of Mina Loy, whose "Aphorisms on Futurism" had already been seen in *Camera Work* in June 1914 (number 45). The female contributors to *291* were no doubt modern enough to be front-line candidates for the "décorseté" *Elle,* but I am suggesting that any number of women in New York, or their published texts, might have fed de Zayas's fantasy work as positive models for an "Ève future" to be found on these shores.[22] A few lines in Mina Loy's poem "One O'Clock at Night," published in *Rogue,* strike me as especially similar to lines in *Elle:* "Beautiful half-hour of being a mere woman / The animal woman / . . . / Indifferent to cerebral gymnastics."[23]

Although Loy herself was not yet in New York, her poems for *Rogue* already experimented with expressive spacing on the page.

Putting together de Zayas's and Picabia's titles, we obtain "ELLE, VOILÀ ELLE"—just the sort of verbal emphasis the painter is so fond of for his New York series of mechanical drawings, here as well as in number 5–6 of *291* for July-August 1915. In that famous issue where he portrays his associates, we find *Voilà Haviland; Ici, c'est ici Stieglitz;* and "*c'est de moi qu'il s'agit*" for himself (though not the title in this case). There is a barker quality, a Barnum ringmaster producing a parody of the "Ecce homo" which, at other times, Picabia may invoke somewhat more directly. Let there be no mistake, he proclaims, this is the authentic presence you have been waiting for, true-to-life performers of the modern arts, even if you cannot recognize them in the baffling machinery of their utter Americanness. Following this machine aesthetic, in which aspects of personality are decanted into discreet mechanical devices, the overall function of the reconstructed apparatus parallels the mind and essence of the subject, not unlike the psychotype after all, but the gears, wires, and tubes that go nowhere in particular add up to a character who is hardly running smoothly. He or she may be the subject of a satire, but so is the machinery. Since the machine does not work—as far as we can tell—it portrays a person who has not come into existence to be useful, like a car. And, no doubt, Picabia was interested in those alluring aspects of the car that did not pertain to usefulness either, although he did love to drive. Whatever engineered motor or its technical manual Picabia may have used as a starting point for the drawing, the ur-machine represented an abstract ideal, America's perfect, smart, and sexy car, but he has transformed it into an elegant and simultaneously comical performance, not unlike a Rube Goldberg cartoon, but where no amount of explanation would work; it is entirely mute as to its behavior, though it is sprinkled with sibylline phrases.

Picabia discovered his machinist style only after arriving in New York for the second time. He was struck by the city's more nakedly mechanical life, quite lacking in the tempering effects of many hundreds of years of tradition. In an oft-quoted interview in 1915, he declared: "This visit to America . . . has brought about a complete revolution in my methods of work. . . . Almost immediately . . . it flashed on me that the genius of the modern world is in machinery and that through machinery art ought to find a most vivid expression."[24] Note that he does not speak specifically of American machinery, but of how machinery strikes one upon visiting the new world, where suddenly it is no longer cloaked in more soothing cultures. As to *Elle* specifically, the hood is definitely off. William Camfield suggests an overtly sexual image for this

drawing, with a female target near the top and the object left of center a gun aimed at her.[25] Almost all of Picabia's machinery was purposely erotic, appropriately uncovering the Victorian's displaced sexual energy, but I wonder if he wanted to be that blunt. The gun, if that is what it is, will in fact miss the target; it has a three-dimensional, rounded barrel but a flat cross-section of a handle, which doesn't look like a handle anyway. The target or disk is both held and manipulated by wires or, it appears more likely, it is in charge of manipulation, regulating something *beyond* the "gun" (or is *elle* shooting herself?), some obscure piping. We are being led on, puppets at the end of Picabia's wires; since the machine appears to be able to do something, we obediently search for its function. Are we meant to ever know much more? Picabia is mocking our irrational trust, the American's religious trust in machinery, in anything Edison or Ford wants to give us.

Picabia had a certain amount of knowledge about cars, or interest in such knowledge, considering he went on to own over 100 automobiles in his lifetime and, at the turn of the century, the driver needed to know his machinery. Duchamp said his friend had an "esprit automobile,"[26] in which much of reality could be restated in car terms. Our interpretations might profit from organizing his work into systems of cooling, combustion, lubrication, electricity, carburetion, each a sort of cosmology with its particular application in dealing symbolically with the human body. While it is asking too much to do all that here, it is useful to see that this drawing is about carburetion. Before the First World War, the owner of a car had a much closer, hands-on relationship to his vehicle's operation. From his or her seat behind the wheel of a better car, the driver controlled all sorts of motor functions quite simply by hand (indeed, the success of Ford's Model T was in large part attributable to how little mechanical intervention was required from the driver). Conveniently placed, like temperature controls today, were oil drips for each individual cylinder, a water pump lubricator, and, on a central disk on the steering wheel which is the closest thing I have seen to Picabia's so-called "target," one hand lever for throttle control and one lever to advance or retard ignition. These controlling levers are shown in the hands of the independent American *jeune fille* in a car ad for the *Saturday Evening Post;* like Picabia's drawing, the advertisement's text lends the girl's "beauty and vigor of youth" to the car, which implicitly returns them to her. Picabia proposes to portray a woman in the driver's seat; *elle* controls the throttle, which would be a butterfly valve inside the pipe at lower left, and with the other lever she times the engine's explosions. Now, in a portrait of *her,* and not of the male, has she taken control of her own accelerations and timing or of his? If we can trust a title, the answer is the

5.10 Advertisement for the Lexington Minute Man Six automobile, *The Saturday Evening Post*, 5 April 1919.

All the Beauty and Vigor of Youth

former; but the male might well be in here somewhere. The cutaway "gun" looks more like a float chamber than anything else, an apparatus that should be connected to a carburetor and accumulate a supply of gas to await the engine's demand (so then, it is not a shooting penis but testicles!). All this carburetion has to do with mixing gas and air in the right proportions, so as to get the best explosion; is the woman gas or air, or is she the whole picture, an engine to be moved, and, at the same time, the deciding force controlling that moving? But perhaps Picabia doesn't even want to say. This mix which he is so fond of—rounded 3D objects interrupted by cut-away, schematic drawings—is akin to the *écorché* bodies of anatomical drawings, and must be meant to dispel the energy of mimesis for an almost painful examination, a baffled peering into places we are not meant to see or fathom. The artist looks under the hood, is a bit astonished, and admits his inability to say anything about what he sees; in any case, he doesn't pretend to be able to interpret. The sex that is dissimulated here is marvelously incomprehensible; as Picabia later wrote: "Notre phallus devrait avoir des yeux, grâce à eux nous pourrions croire un instant que nous avons vu l'amour de près."[27]

PORTRAIT
D'UNE JEUNE FILLE AMERICAINE
DANS L' ÉTAT DE NUDITÉ

FOR-EVER

F. Picabia
5 Juillet 1915
New York

5.11 Francis Picabia, *Portrait d'une jeune fille américaine dans l'état de nudité, 291,* nos. 5–6, 1915.

Picabia's famous series of mechanical drawings that precede *Voilà elle,* five in all for number 5–6 of *291* (July–August 1915), are not all of cars: Stieglitz and Haviland are represented, respectively, by a camera (however, with a car shift stick and brake in the background) and a portable lamp. De Zayas is electrical with headlamps, a generic young American girl is a sparkplug, and Picabia himself is probably combustion combined with a horn.[28] I suppose we may say he is blowing his own horn under the tricky title *Le saint des saints,* which can mean what it looks like, or the breast of breasts, or the breast of saints, or the saint of breasts, or the saintly drawing ("Le saint dessin"). As I have said for *Voilà elle,* the language that complements the drawing proper makes an extra effort to say that this abstraction is not abstract, but that it truly *embodies* its subject. But the language does not help us to understand very much, and the clues it drops may actually serve to preserve the mystery of personality; it also returns power to what is seen, crippling symbolic interpretation of any general sort, forcing us, now, into constructions out of personal associations and desiderata from the artist's life. The simplest are no doubt *Voilà Haviland,* represented as a portable light, and *Portrait d'une jeune fille américaine dans l'état de nudité,* who is a sparkplug.[29] Haviland is such a wonderful source of intelligence that he does not himself require a mover, and so the wire's plug is duly omitted. The young American is, as seen by the Frenchman, a *bougie allumeuse* (a sparkplug), or simply an *allumeuse,* which is slang for a sexual tease. The thread is perfectly perpendicular to the line of entry; it therefore looks perfect but in fact does not screw. I doubt Picabia's English was up to this pun, but, visually, there is no consummation possible; he could, however, think of the *pas de vis,* the screw thread, which is an easy pun on *pas de vice,* or "no vice." The Frenchmen in exile found American women terribly alluring in their athletic, healthy bodies and overtly flirtatious manners, but ultimately disappointing when it came to their availability for or ability at love-making. "For-Ever" takes the place of what I presume was "Ever Ready," an already familiar brand of battery-driven lights that had made its name by saying its lamps were ready in a flash. Not this one; she is not de Zayas's girl, who is *noyée par le vice* ("drowned by vice"), but a young lady priming the pump for an enduring commitment that Picabia would certainly never make.[30] Signing himself "Le Fidèle," Picabia would credit his wife Gabrielle Buffet with a more flexible or adjustable character: "She corrects one's behavior while laughing," he wrote on a portrait of her as a double windshield, an image he copied with almost no modification from an ad for Ford accessories.

Remarkable, how much need for light there is in these portraits, with only the self-portrait not requiring any: Haviland's lamp, the young

American's spark with a flashlight's name, de Zayas's headlamps, Stieglitz's camera. Despite the eureka quality to "J'ai vu" at the top of *De Zayas! De Zayas!,* all attempts to see risk failure: no plug for Haviland, no access to the cylinder for the girl, no connection of de Zayas's headlamps to any of the many electrical connections available in the picture, no bellows to usher the light from lens to film plate for Stieglitz. The elements are all there, but always victims of dispersal, collapse, or omission. The engineer's smoothly running machines have been cut down to size, or returned to their experimental stages where they appear closer to the human in their failures to live up to the laws of physics. Their laws of behavior are, instead, those of Alfred Jarry's "pataphysique," the laws of exceptions, as he called them, which are of course no laws at all. Thus

the chaos of the most complex of the drawings for this July-August 1915 issue of *291, De Zayas! De Zayas!* Here the headlights are connected only to each other, the steering wheel to the crankshaft (if Camfield has the right source, the wire from the center of the steering wheel was for an electric horn),[31] and the wire from the distributor (the circle with four contacts around a central one) ought to go to the sparkplug, not to the coil (which is supposed to be connected to the central post on the distributor). All electric circuitry leads to the centrally placed crankshaft in its bearings, mixing discrete systems, and the crucial current for the spark comes out of the bosom of the corset, which in turn suspends the headlamps in lieu of stockings. This engineer is a true innocent, from another planet. The indication of watery waves under the title, combined

5.15 Francis Picabia, *Ici, c'est ici Stieglitz, foi et amour, 291,* nos. 5–6 (cover), 1915.

with the Greek reference (found in his *Petit Larousse* dictionary's pink pages) to arriving upon the shores of salvation, make this auto manual montage a celebration of Picabia's discovery of America, where he finds a charmingly incoherent mismanagement of the country's powers that only de Zayas is attempting to put into some order.[32] Above right, "J'AI VU et c'est de toi qu'il s'agit" ("I have seen, and this is about you") is a phrase identical to the one Picabia uses for himself in his own portrait ("c'est de moi qu'il s'agit"); this statement reasserts that there are no mistakes in the drawing, all errors are correct and true aspects of his collaborator.

I've saved for last the cover of this issue of *291,* the portrait of Stieglitz. It would be much simpler to be able to think about it without the gear shifter and handbrake. The stick is in neutral—*au point mort* in French, which conveys an even stronger sense of failing to advance—and, in the past, I have concurred with the accepted notion that the brake is engaged. However, after looking at many photos of old cars, I believe it is not; to be engaged, the brake would have been closer to the vertical. What the brake has been made to do is to point into the lens of the camera, and with more precision than the "gun" in *Voilà elle,* even if it is in the background, in waiting. By contrast, Stieglitz's foregrounded bellows, as all critics agree, have fallen away, as a sign of impotence many feel, but more directly as a chiding by Picabia for his thinking about closing the 291 galleries before the job of bringing modern art to Americans was accomplished. Assuming the camera stands in for Stieglitz, is the car Picabia, also reaching for the ideal, yet having his own trouble in advancing? Or, if Stieglitz is both camera and car, will he make a bit more progress if he changes horses, for a more aggressive, explosive aesthetic? It is hard to make neat sense of this image, unless we could put the car in gear, and aim. To add to this unstable hermeneutic circle, Konrad Cramer reported that the bellows of Stieglitz's camera actually did sag when Cramer was photographed at 291 in 1911, and were held up by string and adhesive tape.[33]

I see no way of reading the inscription of the title, "Ici, c'est ici Stieglitz, foi et amour" (". . . faith and love"), as negative or ironic. The words are explicit enough and forcefully enough imprinted on the image to guarantee that the criticism in the broken bellows is well intentioned and an appeal to Stieglitz to bring his old equipment out of its retirement, as he had not been doing new work at this time. His lens is in good shape, as far as we can see, and the ideal is not really out of reach at all; in fact it is terribly close. In the original print, which Stieglitz owned, the letters for "ideal" are twice as large as in the version used for the cover of *291.*[34] What is missing from our understanding of this image is what Picabia himself thought of the ideal, or idealism, or having ideals: in *Ici*

Stieglitz, is "ideal" a mistaken objective for modern work, or is it Stieglitz's problems with attaining the ideal that we are meant to consider? The German typeface is a clue critics have all followed, a strong suggestion of German nineteenth-century philosophical idealism. It would look quite different if we could ascertain that the lettering came off an automobile battery (see note 31), in which case it would already represent a turn toward modern machinery. In any case, "L'Idéal" reappears prominently any number of times in subsequent work by Picabia, in poems in his *391* magazine, for example. Interestingly enough, it appears in exactly the same position on the page as here, and under fire from commentary below it, in a broadside-style four-page magazine called *La Pomme de Pin* which he published with Jean Crotti, Duchamp's brother-in-law. In this Dada manifesto we are advised to approach "L'Idéal" by looking at a Picasso painting while remembering a Velázquez hanging behind us. This short lecture reads like an encomium for the modern only as long as we retain the meanings of the classical. On the front page of *La Pomme de Pin,* we read: "Our head is round to permit thinking to change direction," and "There is only one thing that is almost absolute, it's free will."[35] For Picabia, the ideal is a far cry from the Platonic, and he won't even grant absolute value to his own ideal of free will (*libre arbitre* is literally "free judgment"). The positive and sloppy anarchy of Dada is as close as he is willing to get; extrapolating, we may see floating above Stieglitz's camera precisely a form of this "libre arbitre" for his own use. My sense is that Stieglitz would not be getting kicked twice in *Ici, c'est ici Stieglitz,* for both interrupted vision and a mistaken objective (not so incidentally, the camera lens in French is the *objectif*). The objective is fine, especially considering the degree of faith required to keep it in view. A letter from Picabia written a few years later confirms this position by reminiscing that, in those heady days in New York, only Alfred and he, Francis, had had ideals they stuck to, while others tergiversated with remarkable agility: "Je pense à notre vie de New York, où vous et moi nous étions vraiment les seuls ayant un idéal qui n'a pas varié. Comme celui de nos amis, avec une *prodigieuse dextérité*—."[36] The ideal, here, must be tied to the inscription, "faith and love." As it is unlikely Picabia knew much personally about Stieglitz's career up to this point, he must have used the terms in response to how those around him, such as de Zayas, spoke of the photographer. Seven years later this view had not changed for the members of the Stieglitz circle, and Georgia O'Keeffe well knew the history: "Alfred Stieglitz has furnished most of the faith and enthusiasm during the past forty years that makes photography of enough interest to force this number of *MSS.* He also has faith in the painters and the writers and the plumbers and all

L'Idéal

Lorsque vous avez en face de vous un Tableau de Velasquez et que lui tournant le dos, vous voyez un Picasso, pouvez-vous constater la distinction entre ces deux Tableaux ?

Vous cessez de voir le Velasquez quand vous tournez le dos. Mais vous conservez subjectivement l'image Velasquez et vous apercevez le Picasso objectivement, d'où s'en suit une critique qui est la racine de l'idéal.

FRANCIS PICABIA.

LUMIÈRE FROIDE
LUMIÈRE CHAUDE = LUMIÈRE

CHALEUR CHAUDE = BRÛLURE
CHALEUR FROIDE

= Energie = MOUVEMENT = MYSTÈRE

Christian / André BRETON / André BRETON / louis Aragon / Jean Crotti

ROGER VITRAC, directeur d'"aventure"

TOUT n'est que friction dans le monde. — Simple question d'amour et de coiffeur. L'homme né coiffeur passe son temps à faire la tête des autres, comme on fait les poches. Et le rare c'est qu'il y réussisse.

Le pôle négatif est aussi nécessaire que le pôle actif et les deux extrémités de la ligne droite se touchent dans la circonférence.

Liquidation des Stocks.

1.000 RELIGIONS À VENDRE

La Croyance vient de l'Education
Elle rencontre sa perte dans le raisonnement
Mais la foi ne se trouve que dans le Mystère.

J. CROTTI

ITINERAIRE
Pour aller à Fréjus : L'AUTOBUS
à Cannes : LA CORNICHE
en Vous : L'ASCENCEUR
au-delà : LA VIE.

BAZAR DE SAINT-RAPHAEL
Grand Solde d'Idées
Quelques Pensées DE Pin de saison
RÉELLES OCCASIONS PRIX SANS PRÉCÉDENTS

André BRETON

MA GLOIRE

D'OR Je rêve : d'Or je lèse : je parle d'or, je les endors. Il vit un cadre de stuc. Accro-pot. y voulut mettre un tableau. Il l'y mit vivant il-li-mi-té-ment.

CH

Les Cubistes qui veulent à toute force prolonger le cubisme ressemblent à Sarah Bernhardt.

F. P.

Tristan Tzara le perfide a quitté Paris pour la Connerie des Lilas, il est décidé à mettre son chapeau haut-de-forme sur une locomotive : c'est plus facile évidemment que de le mettre sur la victoire de Samothrace.

Mon Amie n'avait qu'un œil de verre : elle où DA : aussitôt elle en eût deux de la même couleur. C'est depuis lors que la lune attique tique à l'une des lunes nettes de l'Opéra.

MAX JACOB

PIERRE DE MASSOT

CONGRÈS DE PARIS

Ribemont Dessaigne un jour qu'il était à poils mit un chapeau haut-de-forme pour ressembler à une locomotive, le résultat fut piteux. Vauxcelles le prit pour un tuyau de poils — même pas, mes Chers Amis, il avait tout simplement l'air d'un Con ! ! !

INQ avais son parapluie MARCHE forcément droit.

other fools. He seems to be the only man I know who has a real spiritual faith in human beings."[37]

American Mechanics

There is no denying that Stieglitz was thoroughly conscious of producing strongly expressive work with a machine. He inscribed a letter to Picabia onto an invitation to a 1921 retrospective of his work: "It is a great pity you are not able to see this exhibition filling 210 feet of running wall space. It is creating a real sensation because of the life-force expressed in a direct way—& through the machine—without any 'ism' of any kind."[38] But the machinery of modern America did not have the same meaning for the Frenchmen like Picabia and Duchamp who came to New York as it did for American artists. The French enjoyed, even took glee from the effrontery with which manufacturers could display cheaply made goods. Such display was part and parcel of the new mass culture, where commercial self-advertisement was barely restrained by old rules of propriety. *Américanisme,* as it was called, was largely an exoticism, and it served the French as a contrast to their homeland, where similar machines were kept in their place by strong cultural prejudices that Picabia and Duchamp were happy to see questioned, if not entirely overthrown. Whereas craftsmanship, presumably the first step to high art, was still powerful in Europe, it was being sorely threatened there. This threat led to the Arts and Crafts movement in England and its offshoot in America, but in America craftsmen were becoming an endangered species. Although the cheap object or novel design may initially have pleased Duchamp, he soon returned to a strong sense of craft when he assembled his *Large Glass,* and went on to a very pure craftsmanship uncontaminated by "art" when he reproduced, painstakingly and many times over, his oeuvre in miniature for suitcase format. Picabia, definitely more cynical, drew unknowable machinery in collapse, like a teenage boy in his shop with plenty of parts and no idea. It was new material for him, but it was not part of a social critique, just piecemeal reminders of a New Woman who would have no lasting effect on his life. Americans had to part ways with this early version of Dada, as their uses of machinery had to be enlisted in a salvage operation, an attempt to redirect American culture out of metal wastage. Machinery threatened to soil their bed, a problem the French were not sensitive to since they were, as far as they knew, only here for one-night stands. The fact is, in 1917 Picabia was driving a Mercer, a beautiful, handmade car built in New Jersey, and not a Ford, built by extremely high-paid low-skilled workers repeating simple tasks over a conveyor belt. Sherwood Anderson would

5.17 Morton Livingston Schamberg, *Painting* (formerly *Machine*), 1916. Oil on canvas, 76.5 × 57.8 cm. Yale University Art Gallery. Gift of Collection Société Anonyme.

write in 1922: "To me it seems that the Ford automobile is about the final and absolute expression of our mechanical age—and is not the Ford car an ugly and ill-smelling thing? And against the Ford car and the vast Ford factories out in Detroit I would like to put for a moment the figure of Alfred Stieglitz as the craftsman of genius, in short the artist. Born into a mechanical age and having lived in an age when practically all American men followed the false gods of cheapness and expediency, he has kept the faith."[39]

CHAPTER 5

5.18 Paul Strand, *Abstraction, Porch Shadows, Twin Lakes, Connecticut, 1916.* Photogravure in *Camera Work,* no. 49/50, 1917. National Gallery of Canada, Ottawa. Gift of Dorothy Meigs Eidlitz, St. Andrews, 1968. © 1971 Aperture Foundation Inc., Paul Strand Archive.

An American artist whose work seems to resemble Picabia's was Morton Schamberg. But there is no Dadaist mockery in Schamberg, and less humor than fancy and delight. His machines retain beauty in their poise and a proposal of usefulness. They may be useful mainly for our sense of well-being, productive as embodiments of the idea of possibilities. Shorn of connection to anything outside themselves, as they are all well isolated and floating in the middle of his picture frame, they have been immobilized, in contradiction to their nature. They reverse Picabia's procedure, making the cutaway view or diagram into solid, living machinery; that, or they follow through on the Frenchman's intuition, which has left them at an embryonic stage, that there is life in the cutaway anatomy. Whether Schamberg's machines are real or invented (he would then be inventor as well as painter) remains to be shown; most criticism tends to see them as real, but the viewer must resign himself to their intrinsic beauty, which, to the artist's mind, was musical. They have weight, while Picabia's of this period are sketchy or schematic; they do not bewilder the viewer, but rather are calm, even friendly. The crash of machinery is stilled. The coloring of *Painting (Machine),* for example, enhances the idea that this contraption might be on vacation and not so inhuman after all. I have said Picabia's machinery was human as well, but that was by analogy—the sparkplug stood for igniting desire, for example—but Schamberg's machines have character in themselves and cannot be quickly reduced to allegories. Dada machines are klutzes; Schamberg's are dreamy and sequester an almost rosy hopefulness from the noise and dirt of factory drudgery. They appear, nevertheless, to be ready to work, and it seems this one sews, with its thread and beautifully curved bobbin holding it aloft. Many have searched for the sewing machine that modeled for this painting and its close relative, *Painting VIII (Mechanical Abstraction),* and William Agee has shown that the model for both is, instead, a wire book-stitcher.[40] Schamberg keeps us guessing at its function by overly symmetrical angles of view and a subsequent compression of parts, perhaps with crucial ones hidden and attachments flying wide of the central agglomeration. What we read, in such abstraction, is a compact security in wheels and gears that hold together better than they could show in reality, and an eccentric freedom in arms flying to work, whatever it is the arm chooses to do.

At the time, one would have thought it impossible to refashion reality this thoroughly in a photograph, but Paul Strand, encouraged to abandon the impressionistic soft focus by Stieglitz, quite suddenly began to recognize the hard edges of straight photography in all sorts of daily objects, machines and buildings, as long as they could be seen from unusual angles or in tight close-up. In *Abstraction, Porch Shadows, Twin*

Lakes, Connecticut, 1916, he shot from so close, and at such an angle, that he felt he had to name the object in a double title, and then extend that into proof of some existing locale, as if to assuage the viewer's doubts. The long bars of shadow, which in Stieglitz's earlier *Paula* served to cut through and reorganize the scene of the woman at her table, now serve only themselves; they don't organize but actually *make* the picture, an evocation of pure light and dark at play among railings that no longer have any control over the artist. Of course the geometries of buildings and machines lent themselves, if not exactly to abstraction, then at least to a shift toward new form. The original forms for this photograph are probably not so exclusively modern, yet they seem to have been generated by thinking about the larger, newer geometries. Such semiabstraction makes a virtue of the photographer's restricted angle of vision, as if he had been hemmed in, the way he might be in a downtown street; and this restriction is sought after, both to render the object strange and to structure mass and light with the barest nod to representation. There is another version, *Porch Shadows,* taken perhaps twenty minutes later, in which the triangle of light at bottom right cuts a swath clear across the white surface, and the picture has been further cropped at the top to remove the pieces of wood that provided some reminder of perspective.[41] With the viewer's loss of bearings, imitation becomes abstraction, a construction that, before our eyes, countermands our demand for explicit representation, for the photograph as Roland Barthes's defined it: "ça a été," or "that has existed."

Strand's famous *Wall Street, New York,* 1915, shows the balance, or perhaps it is a tension, that the Secession could achieve between social comment and the abstract play of light and volume. Figures have entered the scene as strictly minor elements, while most of the space is relinquished to the heavy shadows of stone that monitor their progress. The people are few in number and dispersed, while the building is monolithic and mockingly rational. The perfectly aligned, negative masses in the building so dominate the picture that it seems the figures, also black but small and irregular, are being chastised for some sort of waywardness. The image reminds one of Fritz Lang's later *Metropolis.* But no matter how abstract or expressionist the photograph became, it had to maintain that "ça a été" effect, some conveying of real objects. In fact, the more abstract the image, the more solid and palpable were its components collected from reality. Abstraction in photography brings out texture, for example of the stone in *Wall Street,* or of different treatments of metal in Strand's images of his Ackeley movie camera (images which bear comparison to Schamberg's). Such solidity is a salutary aspect of photography, a control and limit in that abstraction must work with forms that

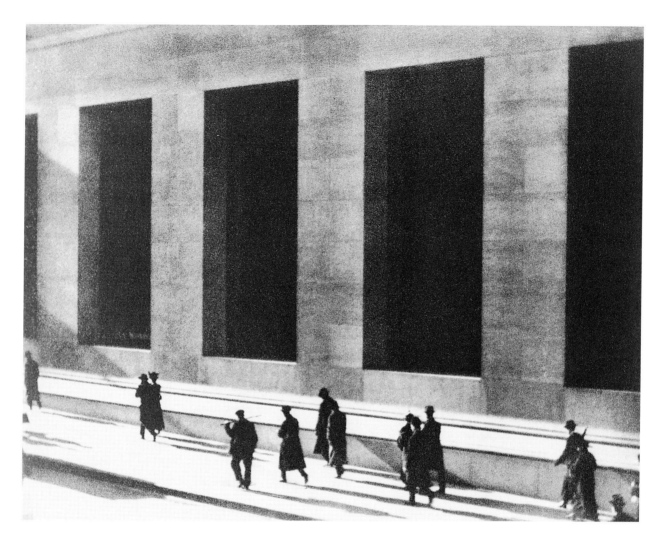

5.19 Paul Strand, *Wall Street, New York,* 1915. Photogravure in *Camera Work,* no. 48, 1916. Photograph, The Library of Congress. © 1971 Aperture Foundation Inc., Paul Strand Archive.

retain, indeed impose the tactility of real things. This is an essential aspect of the Secession's resistance to a disembodying modernity. Fredric Jameson explains with great force the economic changeover from quality to quantity embedded in the "generalized equivalence" produced by the well-developed money system:

> This means that where before there was a qualitative difference between the objects of production, between, say, shoes and beef, or oil paintings and leather belts of sacks of grain—all of them, in the older systems, coded in unique and qualitative ways, as objects of quite different and incommensurable desires, invested each with a unique libidinal content of its own—now suddenly they all find

themselves absolutely interchangeable, and through equivalence and the common measure of a money system reduced to the gray tastelessness of abstraction.[42]

To be clear, "abstract" does not at all mean here what it does for the artist, who is working to oppose "gray tastelessness," with a reinvestment of desire in a world she herself has to rematerialize. I have taken a stab at this point at the end of chapter 1. American consumer culture is indeed abstract, as it displaces desire onto newness and improvement, on the ever-repeated replacement of what *au juste* it hardly matters, and in this manner desire is kept running, but at idle. Abstraction for the Secession artist, and for much of modernism, is a search to reframe the underlying and fundamental materiality and, like a good craftsman or craftswoman, to revive our access to its "libidinal content." In 1901 Frank Lloyd Wright gave a subsequently famous talk at Hull House in Chicago entitled "The Art and Craft of the Machine." Making the link between the best motives of the Arts and Crafts movement and an American modernism attentive to the value of bringing out the sensuousness of materials in machined forms he wrote: "The beauty of wood lies in its qualities as wood. . . . The machine at work on wood will itself teach us . . . that certain simple forms and handling serve to bring out the beauty of wood, and to retain its character. . . . In itself wood has beauty of marking, exquisite texture, and delicate nuance of color."[43] This is a fair description of Secessionist abstraction (and in 1912, Wright himself was termed a Secessionist),[44] as it strips away imitative detail to reach for the heart of materials. Thus we may yearn for the stone surfaces in *Wall Street,* yearn to save them for ourselves from the elaborated, symbolic use Strand shows us the market has turned them to. Alternately, in his later close-up images of the Ackeley moving camera, we are brought to an almost purely sensual appreciation of finely machined machine parts, with little concern for their use.

What photography could do less easily was permit the imagination full license to distort and recombine the objects of reality, to make them less solid and secure. Instead of Strand's massive oppression, *New York Stock Exchange* (1924) by John Marin, realistic enough in its facade, appears no more than that—a facade. The frame of the scene is irregular and contracted, and the buildings seem to crash together and explode out the top, their tenuousness enhanced by the artist's use of watercolors. They have power but no cohesiveness. These two renderings of Wall Street make a remarkable contrast, one that we can translate into contrary critiques of the economy: we are oppressed by Strand's image; we cannot control or restrain Marin's. The latter's work seems enthusiastic,

5.20 John Marin, *New York Stock Exchange,* 1924. Private collection. © 2004 Estate of John Marin/Artists Rights Society (ARS), New York.

but it is hard to tell the direction of its energy, and this is his comment, as if he could sense the crash coming, but in the meantime he'll go along with the excitement of the boom. Another image, closer to the period I am looking at, is *Brooklyn Bridge* (1910), a subject Marin worked at a great deal. The bridge is splitting up but also pulling everything into its center. The figures seem to advance confidently enough, and the general rumpled look is rather friendly, particularly with the two outboard streetlamps. The way across the bridge—which was soon to become Hart Crane's symbol of modernity in America in his long poem *The Bridge* (1930)—appears difficult, certainly, yet not uninviting. Marin portrays a chaotic energy to which the camera has no access by reducing buildings to elements and lines the camera cannot draw. Since the photograph has

5.21 John Marin, *Brooklyn Bridge,* 1910. Watercolor, 18 1/2 × 15 1/2 in. The Metropolitan Museum of Art, The Alfred Stieglitz Collection, 1949. © 2004 Estate of John Marin/Artists Rights Society (ARS), New York.

no lines at all, to be antiphotographic would be, precisely, to draw lines that are not illusions of reality. On Marin's drunken bridge, man and woman are enmeshed in their own creation, attempting to stave off reification. Marin's buildings are always going in two or more different directions at once, collapsing down through the pavements and flinging themselves upward. Nothing solid goes to the safety of the edge, so the buildings are mainly bits and pieces with no good hold, flying up and back, tottering, or squeezing into the picture. These are houses of cards caught at the moment the builder has just fumbled, and all the flying flat planes are seen in the one instant the artist, juggler of forms, can still keep them in the air. Marin's various Woolworth buildings, particularly, are small monuments to a five-and-dime society. Looking at his contribution to *291,* the cover for number 4 (June 1915), we see an unnamed

5.22 John Marin, the Woolworth Building, cover for *291*, no. 4, 1915.

structure which, by its resemblance to many other sketches, is certainly this Woolworth, the tallest building in New York at the time and boastfully referred to as "the cathedral of commerce." More contraction in the middle, no frame markers, buildings barely outlined in short, unfinished strokes, no top at all to the highest structure (a very gothic crown in reality). What holds the buildings together is the way they seem to huddle away from the edges of the paper. Possibly the elements of a church with its spire are scattered down the middle, as if glued to the spine of the higher structure. The only thing that is sure here is the artist's penstroke, which betrays no hesitancy as it dismisses the laws of physics.

I will have more to say about poetry and its dealings with the machined city in the next chapter, but it is worth saying here that poets may be seen to respond to the city in ways comparable to artists.[45] The requirement Ezra Pound set for modern, imagist poetry—that it live "close to the thing"—might seem at first a far remove from what Marin is doing, though not far at all from Strand's concentrated close-ups. Indeed, a call for images that were "clean," "sharp-edged," and "dry" to replace the late romantics' "fuzzy," "gummy," and "wet"[46] approaches to representation is easier to apply to photography than to language, and reminds us of the passage from softened focus to Stieglitz's straight photography. Pound's dichotomy translates more diffidently to Marin's work if we are thinking only of imitated objects, but while his shattered objects are not clear to us, in fact they are dealt with clearly. A Secessionist poet like William Carlos Williams manages to combine the photographer's narrow-field close-up to the thing at a precise moment of meaningfulness with the modern painter's dismemberment of his means, the poem's syntax. When Williams read "Overture to a Dance of Locomotives"—at the very same Independents' exhibition of 1917 that rejected Duchamp's urinal[47]—his listeners in the room could not see what he had done to his poetic line. Words coming before and after make good sense of the extraordinary "of those coming to be carried quicken a,"[48] though I should add we do not know how he marked the line breaks with his voicing. But certainly for his book reader, Williams has insisted upon exhibiting a breakup not unlike Marin's. We must now read precariously. What was once a meaningful line, or a speaker's breath, slips away into the next line, which in turn may send us back to the first for a reconstruction. Another short poem by Williams of this period, "Spouts," begins:

> In this world of
> as fine a pair of breasts
> as I ever saw

the fountain in
Madison Square
spouts up of water
a white tree[49]

This is less a break with adequate syntax than a purposely disconcerting breach of the syntactical contract. Each short, unfinished line, thoroughly unpunctuated, finds its sense completed in the next, which itself awaits completion, as Williams meshes commonplaces with sensuous but seemingly unrelated objects. In its larger outlines the poem is a closely shot film in which the eye's angle of vision is drastically narrowed down, as in Strand's *Porch Shadows,* and forced to follow the delicate movements of the mind from body to fountain to nature before being allowed to draw back and see the fountain as a new whole. As each line in Williams's poem maneuvers us about this magnified, sensualized event with banal line openings such as "spouts up," "turns from," "back upon," "and rising," and "reflectively drops," the illogical but stunning breasts linger in the background, a juxtaposition with some fabulous and enticing contingency.

In "Drink," written in 1916, a man searches for roots, gropes for some sort of solidity combined with savor, which he at first sees in groves of fruit trees. He sees his drinking as akin to "The wild cherry / continually pressing back / peach orchards." But orchards then appear to be the wrong place to look; he will find his strength, roots, body in the tall sexual buildings of the shining city:

My Stuff
is the feel of good legs
and a broad pelvis
under gold hair ornaments
of skyscrapers.[50]

The sequentiality of such a poem is manipulated for an effect of dispersal during the reading and surprising juxtaposition in the end. The building is humanized, rendered sexual, and even loved; the body soars into the sky. Huddled on the white page like Marin's structures, and in a manner still unusual for poetry in this period, Williams's short lines leave us expectant but also make us see the objects unfettered by the expected elaborations of versifying; they propose uncommon, rearranged ways of perceiving linguistically unadorned, simple things. Witness the opening lines of the celebrated "The Great Figure," about the numeral seen on a rushing fire truck Williams glimpsed in the street on his way to visit Marsden

Hartley: "Among the rain," or, further on, the two lines "in gold / on a red." Much of the rearrangement is visual, moving unity out of the individual line we read. The object, the thing itself fleeing, is reilluminated via this sustained displacement of our expectations about poetic language.

Marin's *Brooklyn Bridge* and Williams's "Drink" both exhibit a form of fragmentation that nevertheless has centripetal force. The city is aggressive but not intractable. With a certain amount of aggression themselves, both painter and poet begin to carve some promise out of the city. Only a few years earlier Henry Adams had been considerably more cowed and distressed at the sight, writing:

> Nearly forty years had passed since the ex-private secretary landed at New York with the ex-Ministers Adams and Motley, when they saw American society as a long caravan stretching out towards the plains. As he came up the bay again, November 5, 1904, an older man than either his father or Motley in 1868, he found the approach more striking than ever—wonderful—unlike anything man had ever seen—and like nothing he had ever much cared to see. The outline of the city became frantic in its effort to explain something that defied meaning. Power seemed to have outgrown its servitude and to have asserted its freedom. The cylinder had exploded, and thrown great masses of stone and steam against the sky. The city had the air and movement of hysteria, and the citizens were crying, in every accent of anger and alarm, that the new forces must at any cost be brought under control. Prosperity never before imagined, power never yet wielded by man, speed never reached by anything but a meteor, had made the world irritable, nervous, querulous, unreasonable and afraid.[51]

At first the approach is striking, and wonderful, and we might imagine Adams on the boat from which Stieglitz photographs *The City of Ambition*. But soon, midsentence even, as Adams is engulfed closer up, he is more likely standing with Marin, though certainly feeling less amusement than the artist at the sight. He has neither the inclination nor the sang-froid of Picabia, and for him the cylinder really has exploded, not merely offered itself up in an exploded view. For Adams, in his enduring formulation, the Virgin's universe has been irreversibly replaced by the dynamo's "multiverse," and he left it to a later generation than his to make sense of the two, as Williams may be attempting to do in "Drink." New York was the first city of modernity, with which the Secession chose to wrestle on the terms of modernity. They faced the machine head on, by showing its intrinsic beauty or by subverting it.

They reframed it, or used it to split the frame and corner the human element as it seemed to them cornered by technology and commerce. They focused down so closely as to sever the object from its function; they atomized it and reconstituted it in some pristine, unexploited relationship to the body. While they initiated most of the means of high modernism, they put them at the service of the dynamic exchange with industrialism that Raymond Williams sees as their necessary challenge.

Stieglitz's famous *The Steerage,* 1907, is composed of broad powerful lines. Praised for its formal structure, it yet engages with the challenge Williams set for modern art. The gangway radically separates the two groups of passengers with an empty but shining passage. The funnel, boom, and staircase compress the frame from different angles, squeezing the rectangle, and the highlighted gangway slices through the middle of the compressions. The boom hems down the figures above, which are mainly dark, while there are lighter figures, mainly women, dispersed below. Slight poles support the gangway, so it largely floats through the center. Stieglitz set particular value on the round white hat above on a man peering down onto the group below, and on the crossed suspenders isolated against the large dark area. He wrote:

> I stood spellbound for a while. I saw shapes related to one another—a picture of shapes, and underlying it, a new vision that held me: simple people; the feeling of ship, ocean, sky; a sense of release that I was away from the mob called "rich."
> . . . Could I catch what I saw and felt?[52]

He saw the structure and how it organized the emigrants—for these are not immigrants to the new world, but those who have given up on or rejected the American dream, or who have been rejected by it. Later viewers would assume the picture was of immigrants, an interpretation that adds to its poignancy for us. The image contains much sadness, though apprehended from a distance, a predominance of pensive disappointment in the men above, stress among the women below. The more you look at the image, the harder it becomes to imagine Stieglitz did not stage the whole scene. The passage off the ship, the gangway, is pulled up on board and stored among these poor, and it appears forever freshly painted and empty, beckoning but chained off.

In this image Stieglitz builds new, already cubist forms—forms that had been waiting for him—yet clearly embraces a social function. The Secession considered that it had to work with modernity but was not required to sell out to it. As Stieglitz wrote of himself: "He is a workman who has been all his life on a strike."[53]

5.23 Alfred Stieglitz, *The Steerage,* 1907 (*Camera Work,* no. 36, 1911). Photogravure enlargement, 32.0 × 25.9 cm. Museum of Fine Arts, Boston, 50.830. Photograph © 2003 Museum of Fine Arts, Boston. © 2004 The Georgia O'Keeffe Foundation/Artists Rights Society (ARS), New York.

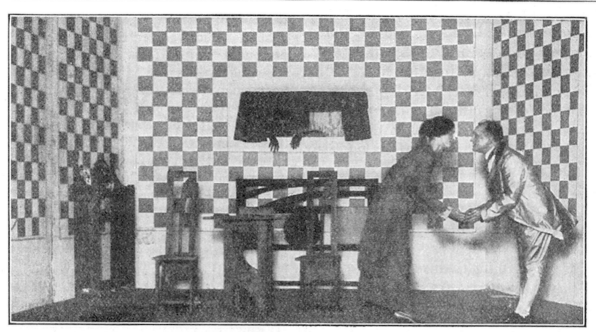

THE MUSIC OF THE MIMES

Alfred Kreymborg has gone to music to find the inspiration of his amazingly original dramaturgy. "Lima Beans" is described as a "scherzo for marionettes."

6.1 Mina Loy and William Carlos Williams in Alfred Kreymborg's *Lima Beans*, Provincetown Playhouse, December 1916, in *Current Opinion*, February 1918.

6 Days in April, Sweet and Cruel (1917)

This long chapter is staged in two parts: the first poetic, the second artistic. In the first we watch two poets in a writerly pas de deux, an exchange of poetic tests in readability that advances the development of the short, modernist poetic line as it engages with the modern city. A boxer-poet then intrudes on these two. In the second part, artists of all stripes, including anti-artists, flaunt their independence in a mammoth art show with few rules or group allegiances. The poets are invited to perform at this art show, in a demonstration of interdisciplinarity that I would like not to lose, and at the precise moment that America joins in the Great War and the avant-garde must bow its head to the patriotic fervor of the political occasion. Also, Stieglitz takes a photograph. It all constitutes quite a mouthful for one chapter, but I find it is valuable to keep the various strands of the Secession together, as it falls apart in the spring of 1917.

Near the end of the last chapter I discussed William Carlos Williams's poem "Drink" from the July 1916 issue of *Others,* the second number of Alfred Kreymborg's advanced magazine for poetry. The little magazines of the period, or "littles," were a relatively recent phenomenon, made possible, ironically, by the negative effect of the modernizations brought to mass-circulation printing processes. The linotype machine, for one, put older, hand methods of printing out of business, and made their materials, boxes of type and small printing presses, cheaply available to small publishers such as Kreymborg who had a restricted, more select audience in mind. In littles like *Others* or its famous predecessor, Harriet Monroe's *Poetry* (founded in Chicago in 1912), new work of the moment by various hands could be weighed and compared, a synchronic activity lost to us today as far as early modernism is concerned; we now read poems by Williams or Wallace Stevens in self-contained collections or college anthologies where we observe the poets evolving alone, solitary heroes of their own narratives. As something of a curative, I look here at a few of these poets as they staged themselves with and against others of their time, as they might have seen themselves evolving within a community of poets, artists, and social thinkers.

Further, while work by Williams over a period of many years might be compared to that of Stevens in our college anthologies, it cannot be compared there to poetry by the then-formidable Mina Loy, who was published frequently in New York from 1915 to 1917 and in the same littles as Williams, at times in the same issues of the same magazines, for the simple reason that Loy is absent from our anthologies.

The Bill and Mina Show: Staging the Short Line

In 1921, no less an arbitrator than Ezra Pound could put this rhetorical question to Marianne Moore: "Entre Nooz: is there anyone in America except you, Bill and Mina Loy who can write anything of interest in verse?"[1] In a 1926 review of Mina Loy's poetry for *The Dial,* Yvor Winters wrote that Loy and William Carlos Williams had "perhaps" the most "to offer the younger American writers," a foundation that might serve for "a generation or two."[2] This review was of Loy's poetry as it had recently been published in Paris by Robert McAlmon at his Contact Press, at the same time as he had published Williams's most recent work: her *Lunar Baedeker,* his *Spring and All,* both in 1923. We know that Williams, as much as he might have wished it, did not provide the foundation at that time that Winters predicted for him, but was passed over

for more than a few generations, while Eliot and Pound, and thereafter Stevens, took center stage. However, thinking as highly as we now do of Williams, we can read Winters with some wonder at what he called then "simply a speculation," and, especially, we are brought to wonder about this woman, an almost forgotten poet and artist who took the New York avant-garde by storm around 1916, and to ask ourselves what staying power in her work could elicit such praise from two acute and influential critics.

What follows is not a comparison of Loy and Williams, but rather something of a competitive dialogue in which each has a necessary part, a sort of erotics of poetic composition, or a short and passionate marriage of poetic minds, with the more famous, male poet doing much of the listening even while he may be surpassing his partner's work in various ways. It is an implicit, if silent dialogue, bred from a remarkable proximity of publication, a sort of accidental and not so accidental foreplay where they find themselves side by side and jostling for attention from an advanced audience.[3]

SHOW SCHEDULE

	Venue	Poetry by Loy	Poetry by Williams
1915	*Rogue* April 1	"Sketch of a Man . . ."	
	Rogue May 1	"Three Moments in Paris"	
	Rogue June 15	"Two Plays"	"Lyric"
	Others July	"Love Songs" (1–4)	
	Others August		4 poems, incl. "Ogre"
	Rogue August 15	"Virgins . . . Minus Dots"	
1916	*Others* February		4 poems, incl. "Metric Figure" and "Tract"
	Others July	"To You"	"Drink"
	Rogue October	"Giovanni Franchi"	
	Rogue November	"Babies in Hospital"	

Provincetown Playhouse, November-December, both poets act in Alfred Kreymborg's *Lima Beans*

	Venue	Poetry by Loy	Poetry by Williams
	Others December		16 poems, incl. "Portrait of a Woman in Bed," "Danse Russe," "El Hombre"
1917	*Others* April	"Songs to Joannes" (34)	
1917	Four Seasons Edition		*Al Que Quiere!*

Independents' show, April 18, both poets read

	Venue	Poetry by Loy	Poetry by Williams
1923	Contact Editions	*Lunar Baedeker*	*Spring and All*

Loy and Williams appear in print together for the first time in June 1915, in *Rogue,* a seemingly precious attempt at avant-garde publishing run by Louise and Allen Norton with the mainly financial help of Walter Conrad Arensberg. Williams had, up until now, published largely romantic verse, dreamy stuff that may have contained the desire for the new but had as of yet born little fruit in terms of authentic new diction, form, or content. His mainstay had been *Poetry* magazine, where Harriet Monroe would routinely edit his punctuation and capitalization. Mina Loy, on the other hand, from her home in Florence, was already making waves in New York, with poems in earlier issues of *Rogue* and, even earlier, with her "Aphorisms on Futurism" in Stieglitz's *Camera Work* (January 1914). With those often cryptic, always aggressive one-liners, and following the shock of the presumably futurist *Nude Descending a Staircase* by Marcel Duchamp shown at the Armory Show the previous year, Loy established herself as *the* proponent of the latest revolution in art. Yet by 1915 she had gone beyond her infatuation with Marinetti and Papini—both the theories and the men—to write more personal, less programmatic work in which the satirical imagination was freed, if not the words themselves as Marinetti had demanded in his futurist manifestos.

I suggested *Rogue* was precious; it went so far as to call itself "the cigarette of literature," and "our frolicky little five-cent magazine," as Louise Norton wrote in her memoirs.[4] Preciousness is a facile dismissal for us today, when we have difficulty appreciating the assertiveness of women who admitted to smoking in public, and of generally having a good time rather than being moral, educational, or proper. A full ten years and a world war later, the *New Yorker,* about to fold in its first year, was saved by printing the "scandalous" account of a young woman of good, high society who chose to admit in print that she and her girl-friends preferred cabarets to coming-out balls (to compound her violation, she quickly went on to marry a Tin Pan Alley Jew, Israel Baline, soon to pen "Blue Skies").[5] The particular scandal that served to launch *Rogue* was Clara Tice's sexy if slight drawings being exhibited on the walls of Polly's Restaurant in March 1915, and Anthony Comstock's attempt to confiscate them. Allen Norton intervened, buying them all up before the Society for the Suppression of Vice could come to remove them.[6] He and Louise then started *Rogue* the same month, reproducing Tice's charming and swiftly drawn nudes in the second issue, for April 1, 1915, the same issue which printed Loy's first published literary work, "Sketch of a Man on a Platform," most probably with F. T. Marinetti, the leader of the Italian futurists, as her model.

As I have said, Loy was already notorious in New York as a "futurist," that illusory beast lurking in the Armory Show. Her confidently

assertive "Aphorisms on Futurism," in *Camera Work* the previous year (number 45, for June 1914), was her first publication, a rather Nietzschean declaration against artistic timidity, calling for a new spirit of self-confident creation to sweep out old inhibitions:

> MAKING place for whatever you are brave enough, beautiful enough to draw out of the realized self.
>
> To your blushing we shout the obscenities, we scream the blasphemies, that you, being weak, whisper alone in the dark.[7]

However, by the time of her various pieces for *Rogue,* Loy had become quite critical, if not of futurism's basic modernist tenets, at least of the retrograde posturing of its very male adherents, men she knew well in Florence. From her "Sketch":

> Your projectile nose
> Has meddled in the more serious business
> Of the battle field
> With the same incautious aloofness
> Of intense occupation
> That it snuffles the trail of the female
> And the comfortable
> Passing odors of love[8]

This is more than a cigarette's worth of satire, and equally powerful work by Loy would appear frequently in *Rogue,* in seven issues out of a total of fifteen. The first issue of *Rogue,* the one preceding this one, spotlighted Gertrude Stein's "Aux Galeries Lafayette": "one, one, one, one, there are many of them," shoppers being who she means not quite to tell us. These innumerable "ones" could not help put her savvy readers in mind of her very single "one" of "Picasso" for *Camera Work* (see chapter 4). Here again something more revolutionary was taking place in the pages of *Rogue* than smoking. More pervasive in its pages, Louise Norton would write her column "Philosophic Fashions" for each issue, a send-up of women's reliance on clothing, perfume, and baths. For her, fashion and art could mix, with the latter infecting the former to the advantage of modern living: "Beauty for the eye, satire for the mind, depravity for the senses," she wrote, "after Beardsley." She may have coined an important term for us, calling yesterday's fashions "post-modern." These excerpts are from her ironic "Keeping Our Wives at Home," in the same issue with Loy's first contribution.[9] While there were certainly men about in *Rogue,* it seems to have sparkled with its women's work, like a coming-out party:

Stein, Tice, Loy, Louise Norton, Djuna Barnes. It was a woman's magazine using its own preciousness as a subversion, playful with the old and with the new as well, both corsets and women's suffrage, Stein's singled shoppers and the elusive Stein herself.

Loy appeared a third time in *Rogue* for June 15, 1915 (vol. 2, no. 6), with two plays that, if they were rendered playable, would only have lasted a few minutes. The first small play is a satire on an archetypical futurist creator, a Marinetti smashing up all the planes, walls, and props of his theatrical set, directing them into more and more frenzied motion as part of his program to orchestrate a violent, new artistic landscape, one that might attain "unison" with his own internal intensity. Upon this hypothetical production the curtain falls "continuously," asserts the stage direction. The second little play, "CittàBapini," is more interesting for us here because it reads like something Williams, whose "Lyric" appears two pages further on in *Rogue,* could identify with personally, even if the title pretty clearly makes a dig at the Italian futurist Papini. A man, greenish and full of innocent bravado, takes on the city, an entity that counters each of his declarations or aggressions with leering and yet greater aggressions. The greenish man is testing for his identity, battling the city that swallows him, execrating a woman for not being a man, fearing that another man will destroy his own uniqueness. He retires to a mountain to meditate on his difference, then spreads himself over the city "with a stylograph and a bouquet of manuscript," declaring, "Now I shall never see anything but myself."[10] Williams would not have remained indifferent to this parody of an ambitious yet insecure writer attempting to rewrite the city in his own image, for this personage was not unlike himself at this stage, the Rutherford doctor who traveled into New York when he could get away to mix with the artistic crowd and find where modernity was putting down its roots. Loy's presentation of a retirement to nature in order to formulate a better attack on the city is especially interesting in light of "Grotesque," a poem Williams had written some six months earlier and chose never to publish.[11] Here the city is explicitly identified as female and life-giving, and the country is male and calls upon the speaker "to oppose it / Or be trampled." It is an odd reversal, to transform the aggressive modernity of New York into a place "with tits in rows," and it shows Williams associating a powerful and fertile though probably interdicted sexuality with the locus of modernity, a place "full of milk" that "lies still." There is a blunt solidity to Rutherford, New Jersey, where Flossie remains with their child back at the house on Ridge Road, and where the Williamses would live until they died; but, even at the moment they were married, Viola Baxter in New York was a symbol of "worldliness" and "erotic adventure" to

Williams, as Paul Mariani has it,[12] and he mailed "Grotesque" to her. Soon, I venture, there would be Mina Loy, mocking yet enticing, not unlike the Baroness Elsa von Freytag-Loringhoven a bit later. The city taken as feminine erotic intelligence.

Williams's poem in *Rogue* is an accomplished lyric, later to be called "Chicory and Daisies," and he placed it third in his first collection of modernist verse, *Al Que Quiere!* (1917). In *Rogue,* the poem is not yet divided into two distinct sections, and thus the longer first part—in praise of the lowly, bitter stem—meshes abruptly with the four last lines, the daisy section, where a young girl who appears to be a Pre-Raphaelite apparition weaving flowers into her hair is suddenly tearing at the stems with her teeth. Beauty is attacked twice here: once in a methodical, explanatory manner, presenting the common and scorned flower of American ground as crucial to any new beauty—an Americanist theme to preoccupy Williams his whole poetic career—and in a second, almost unrelated moment when conventional and innocent beauty is shredded in the teeth of that very same conventional and innocent beauty, now revealed to be something violent and erotic in this young child. If we may assume that Loy, in Florence, received a copy of *Rogue,* I suspect she would have been struck by this new honesty about what might hide in sweet children. She was already writing poems of a similarly distasteful frankness about the desires, fears, and hates of young girls and women catapulted into a post-Victorian, unsheltered world. The lever of Loy's rhetorical attack was the state of being a virgin, which she saw as the main bargaining chip between men and women in conventional society (one might refer to her "Feminist Manifesto," never published but dating to 1914).[13] *Rogue* for May 1, 1915, had just published a similar satirical attack of hers, on girls as dolls in "Magazins du Louvre," the third poem in a short series called "Three Moments in Paris." Opening and closing the poem, she writes: "All the virgin eyes in the world are made of glass." Here female buyers eye the dolls, but avert their gazes from each other, "In their shame / Having surprised a gesture that is ultimately intimate."[14] It is interesting to think of this poem as pointing in two opposite directions for the editors, back six weeks to Stein's picture of another Parisian shopping mecca, the Galeries Lafayette, but now become far less depersonalized or abstract, and forward six weeks to Williams's "Lyric," where the conventional image of the beautifully innocent girl is derailed by her hitherto suppressed, violent impatience with a cultural demand to be blithe and dreamy. Better for Williams that American beauty lift its "flowers / on bitter stems" of chicory, or for Loy that "all the virgin eyes . . . have the effrontery to / Stare through the human soul."

Loy most likely did not receive the June issue of *Rogue,* containing this convergence of her interests and those of Williams, before her work appeared in the inaugural issue of *Others* for July, which she did a great deal to make famous. Alfred Kreymborg was the cofounder and editor of *Others* and may have known Loy's work only slightly by July 1915; but his financial backing was from Arensberg, who suddenly chose to back *Others* only a few months after helping to get *Rogue* running. Kreymborg's earlier venture, *The Glebe,* and his complete lack of interest in anything Beardsley-like must have convinced Arensberg that *Others* would be far more serious, and more seriously modern—though soon, for Arensberg, to be modern would become, on the contrary, not to be too serious at all, as he could witness in the person of Marcel Duchamp, who had arrived in New York in June and whom he was already supporting. *Others* might have owed its very existence to Duchamp's not arriving earlier, and it was *Rogue* that published the Frenchman's short text "The," where that word is entirely absent.[15] Devoted to poetry and its renewal by new talents, *Others* took over Loy and Wallace Stevens from *Rogue* and added Williams and Marianne Moore, to name the most famous. It took advantage of the availability of a radicalized artisan printer; "Mr. Liberty" refused to make a profit on a job he imagined to be for "redicals," and he charged only $23 per issue. Though Arensberg started out full of enthusiasm, down to searching out fancy paper stock, he was quickly distracted by Marcel Duchamp and his friends, who nightly invaded his apartment, and so Kreymborg found himself in full control and underwritten for a year. Loy's poems appearing in the first issue of *Others* must have been put forward by Carl Van Vechten, who had become her literary agent. Whoever else was involved, Kreymborg bore the responsibility and should get the credit for foregrounding the first four "Love Songs." While these poems appear to have scandalized even some of Loy's supporters, I suspect they didn't offend Williams, who wrote in the 1918 "Prologue" to *Kora in Hell:* "The best thing that could happen for the good of poetry in the United States today would be for someone to give Alfred Kreymborg a hundred thousand dollars."[16]

"We might have coupled / In the bedridden monopoly of a moment," she wrote, affronting Victorians and versifiers alike. Lines from the first "Song," "Pig cupid / His rosy snout / Rooting erotic garbage," on page one of *Others,* helped to brand it that "little yellow dog" of a magazine, running vers libre and free (or dirty) love together. Williams appeared not in this issue but in the very next, a month later, with these four, which Kreymborg must already have had planned: two "Pastorals" ("Little Sparrows" and "If I Say I Have Heard Voices"), "The Ogre," and "Appeal." I cannot overemphasize the importance I feel is due

these eight poems—four by Loy, four by Williams—as a group for the avant-garde, both in terms of what they share of newness and in how they might be distinguished as separate and distinct responses to modernity. They shared, of course, the fight for free verse, a bugaboo perhaps, yet not so frightening that it wasn't also a bit of a joke in the reviews and the press. A *New York Tribune* headline ran "Free Footed Verse Is Danced in Ridgefield, N.J."[17] Other poets also wrote this "vers libre," as it was called (to blame the French for what Whitman had started next door in Brooklyn!); in fact, Williams would be a judge for a vers libre contest published in the April 1917 issue of the *Little Review* (but all the verse was dismal). What was much more striking in these new poems was the shortness, the terseness of their lines, giving the reader hardly time to catch a breath. As imagistic as they may be, Loy's poems encode some intense idea, something to be pondered, and the density of such lines, one right after the other, baffles readers, stifles them with an intensity that seems unwilling to abate, unable to pause long enough to permit us to clear up the sense. Still, the diction is direct enough, too direct for the poetic liking of the period: "Spawn of fantasies / Silting the appraisable / Pig cupid. . . ." Winters wrote of Loy: "She moves like one walking through granite instead of air, and when she achieves a moment of beauty it strikes one cold."[18]

Williams's lines, on the other hand, walk through air lightly enough, with perfect clarity and simplicity, each one containing a small, stubbornly isolated construction block of the sentence. Where Loy's line usually puts two incompatible pieces together to make a self-contained explosion—or cul-de-sac—as in "Birdlike abortions / With human throats," Williams's single block is almost empty of sense until the reader moves on to the next line, and then the next, as in the first of the two pastorals: "The little sparrows / hop ingeniously / about the pavement / quarreling." Williams was already isolating the most discrete possible elements of his phrasing in order to make each more substantial and independently viable on the page. Such a language was meant to permit no loss of direct contact with its magnified referent. He wrote: "A poet witnessing the chicory flower and realizing its virtues of form and color so constructs his praise of it as to borrow no particle from right or left."[19] This is the structural import of the essential spine of grouped words running down the page, with no attention to any rhetoric to support it from the sides. While he practiced his new ABC's, rather than appear simpler he paradoxically looked more baffling than any other poet. At the end of the poem built of two minimalist pictures of sparrows and an old man in the street, he adds: "These things / Astonish me beyond words." He will eventually dispense with this sort

of tag, the didactic raising its unpoetic head. Here, and without our hindsight of knowing how Williams will eventually effect a more intrinsic sense of shock-in-the-ordinary, we should see that the closing comment is not strictly discursive but most likely effective because readers, as they reach that point in the poem, will be astonished to find the poet astonished. As far as the trained readers of 1915 were concerned, very little was happening in this poem, while in Loy's poems altogether too much was. Her lines stopped them cold, his flowed too elusively. *Others* was assaulting this audience from both far ends of poetic plenitude, with too much or too little to say in that same minimal apparition on the increasingly white page. That visual "silence" seemed to mean more and more as an absence, and the narrow band of language up the center of the page could no longer abide a comfortable eiderdown of polite, enveloping discourse.

About the subject matter there was more shock, of a sort that was not sufficiently disguised in other novelties. Both poets dealt quite scarily with children. Loy, for her part, seems to fear and abhor her own babies, after a bitter sense of irony about the lovemaking that produced them. The last stanza of the fourth and last "Song" runs, with much less obscurity than most of the preceding:

> But for the abominable shadows
> I would have lived
> Among their fearful furniture
> To teach them to tell me their secrets
> Before I guessed
> —Sweeping the brood clean out.[20]

The nurturing Victorian mother and keeper of the hearth had been stripped of sham; much more disturbing relations hid behind those arch yet presumably maternal pieties (and the baby *is* thrown out with the dishwater).

Williams was perhaps even more frighteningly Freudian in "The Ogre." The narrating doctor admits to running erotic thoughts all over and around the body of a mere child of a girl. At first he figures he is somewhat saved by the fact that, at least, this child with her "toy baby" does not know. Then he divines that she may well guess something of what is happening: "The tentative lines of your whole body / prove it to me."[21] In any case, the poem is further troubling by being addressed *to* the child. "Shy though Bill was in person," wrote Kreymborg in his memoirs, "blank paper let loose anything he felt about everything, and he frankly and fearlessly undressed himself down to the ground. Not

since the days of old Walt had an American gone so far, and readers were shocked all over again."[22]

These two first issues of *Others* show Loy and Williams already at the forefront of a scandalous avant-garde, working with the short, suspended line on a perilously expansive white page in ways no one else did, or dared. The expanse of blank page, like a sea of absent or suspended moral judgement, tossed up fragments of sexual energies too overt to be ignored. There was good poetry by Marianne Moore and Wallace Stevens in the very same pages, but their novelty appears quite baroque, almost retrograde in their various versions of fastidiousness. Loy's and Williams's verses, on the other hand, knife expertly into their audiences' moral and aesthetic opacity, their failure to recognize rude truths in a new world.

Almost a year passes before their next poetic meeting, in another issue of *Others*. Billed as a "competitive number," this issue is remembered above all others because it was compiled and edited by Williams himself and includes, among those we usually remember, Sandburg, Moore, Stevens, Amy Lowell, Conrad Aiken, Kreymborg, Loy, Williams, and Pound. Both Loy's "To You" and Williams's "Drink," which I looked at in the last chapter, address surprisingly similar subjects. She speaks to a writer trying to do a tightrope step above the commotion of the "shattering city," "wedged between impulse and unfolding." This writer is trying to turn herself into her subject: "Plopping finger / In Stephen's ink / Made you hybrid-negro." (The writer could be Loy herself, whose estranged husband was a painter named Stephen, yet the writer is not clearly identified as being male or female.) Success seems doubtful because the city remains, at the end, "Alien as your aboriginal," while this artist has yet to be transformed, in a "mask of unborn ebony."[23]

Whereas Loy speaks as any person writing rather than of or to herself explicitly, Williams, overleaf in this *Others* for July 1916, more clearly identifies with the person of the speaker. Whiskey is not a subject or issue here, but an image for a "tough way of life," wildness pushing back orchards. This artist must choose a locale where he can find "that solidity / which trees find / in the ground," and his choice, or more likely his necessity, is the city, which in the poem blossoms into a spectacular female skyscraper body. I touched upon this identification of human gender and city in Williams's poem in the last chapter but the comparison with Loy permits us to go further. While Loy's and Williams's subjects are very close, their attitudes are quite opposed: for her, the city is a "diurnal splintering of egos," for him it is a fortifying interpenetration of his ego and the modern female body, "under the gold hair ornaments / of skyscrapers."[24] Again for Williams the city is female,

and vigorously erotic. In Loy's "To You," it is more difficult to say whether this old European city (London, Paris, Florence?) strikes the poet with a "shattering," "splintering" masculinity or whether it does not more likely absorb a silent and noncommittal if imperious "you": "Lit cavities in the face of the city / Open their glassy embrace to receive you." Perhaps a vacant mother and a fragmenting—or fragmented—father are both embedded in her version, watching from below their gifted daughter with the "step tentative" on the high wire above. So while Williams's choice of poem might be casting a glance in her direction—and she was safely far, still in Florence, but on the other hand, that was his wife's name, Florence!—Loy, aggressively victimized as ever, speaks only to herself and her ghosts.

It is interesting that each poet, one male and one female, finds something sexually oppositional in the modern city. Such a pervasive place can hardly escape embodying the writer's Other, a place to be invested with all of the uncanny fears we desire to know, to embrace, or to exorcize. The man finds something receptive, thus primarily feminine, though the precise nature of that femininity is not what we might easily expect, as it is physically strong and healthy and either dominates or reinvigorates the male speaker of the poem. Thus the modernity that prompts the success of the poet is female but not passive; a place not of comfort or repose but of adventure. New York is splendid, towering, brash, and eroticized, the qualities that he wishes to bring to his poetry. In poetry, this city is available to him, and she must be preserved there, but most likely could not be satisfied outside of the poem's accomplished desiring system. I would hazard to say that Loy herself would eventually embody this same version of a feminized modernity for Williams, whether in her poems or in her person. The female poet, for her part, finds the city to be the ineffectual or monstrous meeting of "impulse and unfolding," as if her city, the product of male and female joining, were something shorn of identity by the very act that creates her and that presumes to give her an identity. What is the gender of a "you" or of its living space full of such shattered identities? For Loy the city is a place of gendered demands that are too difficult to reconcile, unless writing them out can serve as a version of reconciliation. In the twenties she would go on to query the quite specific relationship of Jewish father, named "Exodus," and prim British "rose" of a mother, a relationship that I am detecting here in 1916 sublimated into a general principle of the city as an arena for gendered battles over her identity. "Anglo-Mongrels and the Rose" (1925–27) casts her as an undecided "Ova," "Nemesis / of obscure attractions," unable to please, forgive, or embody both "Israel and Albion."[25] She is in exile, or exodus, and will continue to identify with that de-identifying wandering, but,

like her mother, she is not Jewish, and her mother has her tied up in not wanting to be. While "To You" appears to speak more specifically about a lover, the multitudinous city full of shadows that "are yours for the taking" brings her to intuit the familial spirits projected against the walls behind that lover, as through him they conspire to turn her into a mongrel artist, "hybrid," "deaf mute," "alien." The indeterminate sense of the poem is overseen by the balancing creative "you," who is tightrope walking, unable to commit, yet full of brutality and rage at the world below which will not supply a gendered opposite that "you" could admit to desire. In a curious family parallel between the poets, Williams's mother was Jewish on her father's side. A related hybridity is honored in the poet's middle name, Carlos, which was the name of his mother's beloved older brother who encouraged her to go to Paris and paint. For Williams, this middle name was his "South," connoting hot, creative Spanish and Catholic identities bracketed in his American Protestantism. For Loy, in "For You" at least, the image of hybridity is "ebony," a metaphor more likely picked up in New York than in Florence; later she will be the mongrel-rose.

Loy sailed for New York from Europe in October 1916, leaving her two children behind, and by November she had become part of a group around Arensberg that had been primed for months by Van Vechten and the pages of *Rogue* to receive her. At the same time that she was seeking an American divorce from her first husband, Stephen Haweis, she was hoping to profit from the strong reception of her prose and poetry in avant-garde New York. She was expected to have known the work of Apollinaire and Max Jacob in Paris, through Leo and Gertrude Stein mainly. Mina had herself lived in Paris and shown successfully at the autumn painting salons since 1905, and her futurist friends and lovers were well acquainted with Parisian goings-on, getting weekly reports back in Italy so as not to fall behind the avant-garde; she wrote of Marinetti:

> ramping the tottering platform
> of the Arts
> of which this conjuring commercial traveller
> imported some novelties from
> Paris in his pocket . . .
> souvenirs for his disciples
> to flaunt
> at his dynamic carnival[26]

So now Arensberg was surrounded by a French avant-garde in exile. The two most important had posed for a famous photograph with some of the *Others* group, before Loy's arrival, at a party Williams gave at his home in Rutherford, New Jersey, in April 1916: Jean Crotti (his portrait of Duchamp would be the closest the latter actually got to being visible at the Independents' show a year later) and Marcel Duchamp stand for the camera with Arensberg, Man Ray, Maxwell Bodenheim, Kreymborg, Williams, and a few others. Cravan had yet to arrive. Though Kreymborg was not very close to this advanced inner circle, well on its way to committing Dada, he probably held some considerable interest for Duchamp, as his game of chess was out of Duchamp's league, something rare in this group.

Kreymborg had managed to wrangle a spot for a very odd one-act play of his on the bill of the Provincetown Players, on MacDougal Street in the Village. While that theater group was ensconced in its own revolution of heavy realism, one member, William Zorach, thought a light thing like *Lima Beans* might be refreshing, though probably not significant. Kreymborg decided to cast Mina Loy, intellectual avant-gardist and liberated European in flight from marriage, as a middle-class wife-cum-soubrette, and to bring Carlos, as he called him in the credits, from quiet domesticity in Ridgefield into the city with "tits in rows" to play the husband. Mina and Bill thus met as pretty unlikely husband and wife. Kreymborg wrote that they nevertheless accepted their roles "with alacrity—the super-sophisticated Mina sniffling at the commonplaces of the marriage theme, and the self-conscious Bill in terror lest he blow up."[27] Certainly she was beautiful and he handsome enough. But the play was, in all its simplicity, an enigma. The characters were not to be played as real, but somewhat as marionettes. The poets could, then, just pretend at pretending to be a young couple in love. Amid short oft-repeated and completely artificial phrases of quite entirely domestic import, the wife decides to give her loving husband a change for dinner, string beans, as he never gets anything but lima beans. He returns from work ready for his beans, but exits in fury upon learning he'll get the wrong ones. She reapplies to the street huckster, and gains the coveted limas; he returns contrite, ready to eat anything she wishes to prepare, only to discover she has changed the menu to what *he* wishes (perhaps part of the effect was supposed to be that of an O. Henry story in comic strip). They kiss and make up, kiss and shell:

Why is a kiss?
Don't know. Love.
Why is love?
Don't know.

The various accounts of the rehearsals, including Williams's, have Bill kissing Mina very gingerly, to catcalls from O'Neill's actors in attendance demanding he stop pussyfooting around and kiss her like a man. However, emotion was not called for. On each of the occasions when the husband kisses the wife, the stage directions call for six "dainty" pecks. All of the emotions are played quite formally, as mere conventions, and, if anything, the play is a parody—with the lightest touch possible—of marital bliss and discord, a sort of meta-Hollywood one-reeler. In his 1918 "Prologue" to *Kora in Hell,* Williams wrote that few people knew how to read Kreymborg, to grasp his "bare irony, and gift of rhythm": "Kreymborg's idea of poetry is a transforming music that has much to do with tawdry things."[28] Implicit here is that Bill and Mina were instructed to deliver this subtle tone, which must have been an interesting lesson for them both, as well as some vindication of their own ways of writing. The revealing stage directions have not, to my knowledge, been reprinted:

> *Lima Beans* might be defined as a pantomime dance of automatons to an accompaniment of rhythmic words, in place of music. . . . Pantomime in the form of a semi-dance of gesture, in accordance with the sense more than the rhythm of the lines, is modestly indulged in by husband and wife, suggesting an inoffensive parody. . . . The reading tempo varies, slow to fast, fast to slow, in accordance with the sense more than the rhythm; the gradations might be prompted by an invisible maître-d'orchestre. Words, silences, pantomime—all should be presented inside a homogeneous rhythmic pattern. . . . As a color scheme, black and white might not prove amiss. Five-thirty P.M., American village time.[29]

The play was billed as a "Conventional Scherzo." It is, in fact, a formal dance, to the music of words. Our poets danced around each other in a set piece they might treat as a trifle. The play is a cool medium for them, free of dramatic undertow; yet the two actors are still charming each other by seducing together their very receptive and amused audiences with so slight a play. The words are used abstractly, a practice each has begun in his or her own work. Mina has come though Marinetti's famed "parole in libertà," to move on to a different meaning of abstraction—we might call it "cubist" poetry, a term that would shortly come into fashion in Paris. Bill is on the verge of the abstract line, where that small building block will be further reduced so that no meaningful sentence can be predicted from line to line. The two poets go through these quite silly marital paces and kiss twelve times, for the formal demands of the

play, while watching each other perform the short line live. He, while in reality a doctor well acquainted with the tawdry lives of women and children, mimics her innocent American male; she, while in reality the epitome of his dangerous Kora, interprets a version of Flossie, the wife who will stay home. She is his poetic Florence, imaginary wife as fabled and wondrous city.

Paul Mariani and Roger Conover both expect Williams tried to get more intimate at Loy's apartment, whence he fetched her each night for three weeks of rehearsals. In a letter to entice Carlos to the role, Kreymborg suggests that kissing Mina could never be reduced to mere playacting. For my purposes, I would be more intrigued to know what they said to each other, and of themselves as poets, on those long walks downtown and perhaps back. It is one thing to be working so close poetically yet never to meet; it is something else to walk through the city, she playing its powerful feminine embodiment for him—whether she chooses to or not—and he the authentic American poet of the shattered and the shoddy, which she must have begun to recognize as integral to the authentically modern; and both of them intensely concerned with the how and the what of poetry in a new and untapped time and place. "No one who has not lived in New York has lived in the modern world," she will declare to the *New York Evening Sun,* where she is crowned *the* modern woman, ahead of such contenders as the Baroness Elsa von Freytag-Loringhoven, Ida Rauh, Margaret Sanger, Louise Bryant, Margaret Anderson, and Jean Heap; she writes free verse, paints, acts, designs clothes and for the stage, the *Evening Sun* tells its readers; on top of all that, she can explain futurism.[30] She must indeed have been the most dangerous adventure in town, but not so much for her considerable beauty as for the intelligence of her modernist engagement with the newspaper's metropolis.

As they walked to the Village from Loy's West 57th Street apartment, we may imagine they intermittently rehearsed their lines, practicing minimalist meanings on each other and the buildings, streets, and crowds. And we can imagine the gendered street answered back, as each of them interpreted and reinterpreted its meanings for the play's rhythms. In the sequel of "Love Songs" Loy wrote in New York, and possibly was already writing in these last months of 1916, she questioned herself and a man in the city:

Desire Suspicion Man Woman
. . . The jolting crowd
Taught me willingly to live to share

Or are you
Only the other half
Of an ego's necessity
Scourging pride with compassion
To the shallow sound of dissonance
And boom of escaping breath[31]

To this look into the passion obscured by dissonant chatter and street noises, Carlos might have responded, thinking of how to play Kreymborg's words:

One may write music and music but who will dance to it? The dance escapes but the music, the music—projects a dance over itself which the feet follow lazily if at all. So a dance is a thing in itself. It is the music that dances but if there are words then there are two dancers, the words pirouetting with the music.[32]

Or, thinking more personally, he might have played her sardonic yearning for him, to which he could not yield:

You would learn—if you knew even one city— . . . our husbands tire of us . . . and we go hungry . . . for caresses. . . . Cross the room if the whim leads that way. Here's drink of an eye that calls you. . . . All in the pressure of an arm—through a fur coat often. Something of a dancing light with the rain beating on a cab window. . . . Risk a *double entendre*. . . . The men sniff suspiciously; you at least my dear had your head about you. It was a tender nibble but it really did you credit . . . you will never rise to it, never be more than a rose dropped in the river.[33]

No matter how tempted he, or she, might have been, Williams felt his family responsibilities keenly, and she was not likely in a romantic mood. Further, as they skirted the Hell's Kitchen area, they would both be reminded of their relations with children: the surviving debris of bad choices in love that she had succumbed to and was in the process of extricating herself from, and that he knew all too well in his practice in this very neighborhood. Loy had volunteered in a Florence hospital and had just published her reactions in "Babies in Hospital" in *Rogue* for that November 1916; Williams for his part, some six years earlier, had delivered and cared for some 300 infants produced by the poverty and prostitution of these West Side streets. The third section of Loy's "Babies in Hospital" eerily resembles Williams's habits of line, rhythm,

and statement, but she writes the style of poem that he could not yet have done, in 1909, when he had tended to a constant flow of scarred infants and children:

> Tend
> Do not touch
> Apparent flowers
> Of festering secret
> And the Fly-by-nights
> Such little things
> I cannot be your mother
> There are already
> So many ignorances
> I am not guilty of.[34]

In the same month of December 1916, while the two poets were still in Kreymborg's play, Bill had sixteen poems in *Others,* including "Portrait of a Woman in Bed" and the two well-known poems "El Hombre" and "Dance Russe." In that group, a rewritten "Love Song (I Lie Here Thinking of You)" serves as a reminder that, for Williams as well, songs of love had become as fearsome as they might be attractively erotic: it begins, "The Stain of love / Is upon the world!"[35] By reworking this song for *Others,* Williams may have wished to remind Loy that they were working similar fields. So while I expect eroticism enlivened their long walks, I see them mainly sharpening their poetic wits. "With the great towers of Manhattan before me," he had recently written, the big question was, again and again, "How shall I be mirror to this modernity?"[36] With the closing of *Lima Beans* (after sixteen curtain calls on opening night!), there is a few months' lull in their meetings and publications in *Others.* Williams has no good excuse to travel in from Rutherford; Loy is preoccupied enough, arranging for her divorce, starting a business of decorative lampshades, drafting the rest of the poignant "Love Songs." Their next meeting was in April 1917.

Colossus on American Soil

Whether or not there was meant to be something more than brainy flirting between Mina and Bill, on the grounds of chemistry, poetic interests, acting, or the nomadic spirit arising from a shared frailty of mixed identities, or all of these, the arrival of Arthur Cravan in January 1917 would announce an end to all that coyness, for Loy at least. Her first response to this man, whom she called "Colossus" in her memoir about him, hardly

suggests the power of their relationship as it would quickly evolve by late April or early May. Instead, her reaction sheds some light on how diffident she was at the time to begin any serious new relationship with a lover: "The putrefaction of nonspoken obscenities issuing forth from his tomb of flesh, devoid of any magnetism, chilled my powdered skin."[37]

Loy and Cravan, nomadic British citizens, arrived in New York only a few weeks apart and drifted slowly toward each other at the Arensbergs' nightly get-togethers, she arriving with her sponsors at *Rogue*—Van Vechten no doubt, along with Louise Norton—and he by less obvious routes, most likely invited by one or another of the Parisian exiles. He had just been published in New York, in a new venture called *The Soil,* which had been founded in December 1916. That same month *Rogue* had ended its fifteen-issue run with its most thoroughly avant-garde number, including Loy's "CittàBapini," Apollinaire's "Lundi rue Christine," Arensberg's own abstract experiment "ing," and Gertrude Stein's "Mrs Th——y." In this valedictorian issue, *Rogue* thanks the new *Soil* for the use of the Stein piece, but curiously the item, while clearly announced in *The Soil*'s table of contents, is missing from its pages. The message, then, was that *The Soil* was picking up the avant-garde ball, if erratically; but in fact, with the help of Cravan, it intended to play an entirely different, much more confrontational game.[38]

Cravan appears twice in that first issue for December, though the table of contents announces him only once, for an untitled poem called "Sifflet," which in its original form was an overt reminder of Whitman, free verse made of perfectly clear and willfully prosaic lines, and embracing the newer materials of modernity:

> The rhythm of the ocean cradles the transatlantics,
> And while the heroic express arriving at Havre
> Whistles into the air, where the gases dance like tops,
> The athletic sailors advance, like bears.
> New York! New York! I should like to inhabit you!
> I see there Science married
> To industry,
> In an audacious modernity,
> And in the palaces,
> Globes,
> Dazzling to the retina
> By their ultra-violet rays;
> The American telephone
> And the softness of elevators . . .[39]

Just as Whitman had predicted, "Fifty years hence, others will see," and Cravan arrives on schedule across the waters with new, dazzled eyes. The text from Cravan that is not announced takes the form of an epigram that the editor of *The Soil,* Robert J. Coady, attaches to the end of his own manifesto, "American Art," to reinforce his argument for a primitivist response to the world in order to create a new kind of art: "Come now, chuck this little dignity of yours to the winds! Go and run across fields, across the plains at top speed like a horse; skip the rope and, then, when you shall be like a six year old, you'll know nothing and you'll see the most marvelous things."[40]

Much of the short history of *The Soil* is told in this reliance on Cravan's writing, almost all of it taken over and translated from his *Maintenant* of 1912–14. Since many of the texts are about or by Oscar Wilde, one might expect somewhat of a continuation, in spades, of the tone and program of *Rogue,* but nothing is further from the truth. *The Soil* is the earliest promulgator and defender of American popular culture and of American machine and commercial cultures as the sources and foundations for new artwork in a new land. It is both more sophisticated about good artwork than *Rogue,* and considerably less highbrow in its choices of subject. "American art," Coady declares, is "The Cranes, the Plows, the Drills, the Motors, the Thrashers. The Derricks, Steam Hammers, Stone Crushers, Steamrollers, Grain Elevators, Trench Excavators, Blast Furnaces. . . . It is not a refined granulation nor a delicate disease."[41] These new manifestations are "the most marvelous things" Cravan is enlisted to praise. In this issue and those that follow, Coady goes on to review with enthusiasm comedians, boxers, horse shows, movies, and clowns, and to print installments of Nick Carter novels, the byword of all-American dime-fiction popular culture.[42] In the pages of *The Soil* modernist sculpture could be compared, in facing pages, to the Chambersburg Double Frame Steam Hammer, or Picabia, Brancusi, Jean Crotti, and Pascin gently mocked by comparison to Toto the Clown: "Toto is the most creative artist that has visited our shores in many a day."[43] The journal attacked high-minded art by vindicating the popular arts on the grounds of their vitality, joyfulness, democratic appeal, and most especially indifference to high-mindedness. Ironically, this particular clown was European, and in any event the Parisians themselves had already become interested in airplanes, cafés, circuses, and dance halls like the Bal Bullier, a favorite hangout for Cravan from 1912 to 1914. And, of course, they had become interested in America for the same reasons. Coady continued his attack on imported artists, who were probably party to his harangue: "Does the difference [in 'absolute expression'] make you [Jean Crotti] a big artist, the little artist a little artist and

the plumber a plumber?"[44] Coady here reiterates the idea of American plumbing as aesthetically challenging, a theme that runs through Dame Rogue's "Philosophic Fashions" columns in *Rogue* and will blossom in only a few months in Duchamp's urinal at the Independents' show. For Coady, America's provincialism is what has distanced it from European opprobrium and has fortuitously protected it, giving it the opportunities that await it now: "The isms have crowded it [American art] out of the 'art world' and it has grown naturally, healthily, beautifully."[45] With this sentiment the French exiles concur; when they celebrate the opening of the Independents' show with the first issue of *The Blind Man,* Pierre Roché, Duchamp's closest friend, writes, "New York, far ahead in so many ways, yet indifferent to art in the making. . . . Every American who wishes to be aware of America should read 'The Soil.'"[46]

Cravan does more than merely intrude upon this debate, when he arrives in New York to dominate the pages of *The Soil.* Even in the last issue for July 1917, after Cravan is most probably gone from the city for good, Coady writes a demolition of the Independents' artists, conducted one by one, on the model of Cravan's earlier savaging of the French Salon des Indépendants for *Maintenant* (March-April 1913). Though *The Soil* is determinedly devoted to American popular arts that Cravan's writings are not directly concerned with, its life span is nevertheless circumscribed by his presence in New York, with the first issue announcing his arrival and the last memorializing his departure. It is likely that Cravan's person, even more than his writings, is what impressed Coady; Cravan was, after all, a boxer and a self-proclaimed scourge of "artists." Further, his absurd boast to being Oscar Wilde's nephew was actually true; he was born Fabian Avenarius Lloyd in Lausanne, where his mother had moved to avoid association with the condemned dramatist; her husband, Otho Lloyd, was older brother to Constanza, Wilde's wife (through various family innuendoes, Cravan was actually in a position to think that Wilde was his real father, but he didn't make this claim in public). Cravan's scandalous disregard for art, as it was practiced by just about anyone, made him crucial to *The Soil,* where he played a double role, supporting discussion of the values and uses of popular culture and industrial machinery as both destructive of art altogether, yet somehow sources for something new and American. He mugged for Duchamp and Picabia, on the one hand, and beckoned to Strand and Sheeler on the other. The April issue of *The Soil* would feature Cravan as both boxer and hoax-monger, and the Independents' show would put him on a real stage so all could judge the new man, the anti-art pugilist. In April, Loy and Cravan gain stage-center in the littles, the boxer displacing Williams: her poetry takes up most of the April issue of *Others,* and Cravan's exploits fill out a large part of *The Soil* number.

PART II

Chronology around April 1917

January 1917	Picabia publishes first issue of *391* (Barcelona)
January 13	Cravan arrives in New York (Trotsky is on same boat)
January 23	"Arch Conspirators" party on Washington Arch
February 17	*Evening Sun* picks Mina Loy as "modern woman"
March 22	U.S. first to recognize new Russian government
April	Loy, thirty-four "Songs to Joannes" in *Others*
April	Cravan in *The Soil:* "Oscar Wilde Is Alive!," "Personal Appearance of Wilde," "Portrait of Arthur Cravan," "Arthur Cravan vs. Jack Johnson," and other related pieces
April	In *The Masses:* Max Eastman, "Revolutionary Progress"; John Reed, "Whose War"
April	In *The Seven Arts:* Randolf Bourne, "The Puritan's Will to Power"; Van Wyck Brooks, "The Culture of Industrialism"
April 1	Varèse conducts the Berlioz *Requiem* at the Hippodrome
April 2	Wilson asks Congress to declare war
April 3	Georgia O'Keeffe show opens at 291
April 4	Picabias arrive, stay at Louise Norton's
April 6	War declared
April 8	Billy Sunday rants patriotically to 22,000
April 9	Private viewing of Independents; R. Mutt's *Fountain* rejected
April 10	Independents' show opens; Duchamp and Arensberg have resigned *The Blind Man* (antedated?); Wilson calls for conscription
April 11	Isadora Duncan, with her troupe of young girls, dances to "Star Spangled Banner" and "La Marseillaise" at Metropolitan Opera
April 12	Latin Quarter Ball, at Grand Central Palace
c. April 15	Stieglitz photographs *Fountain* at 291
April 18	Poets, including Loy and Williams, read at Independents' show
April 19	Cravan addresses Independents on "The Independent Artists in France and America"; he is forcibly removed
April 20	Independents' Ball at Grand Central Palace, billed as Red Cross benefit
May 4	Psychiatrist E. Southard addresses Independents: "Are Cubists Insane?"
May 5	*The Blind Man,* no. 2, devoted to *Fountain*
May 6	Independents' show closes
May 14	O'Keeffe show at 291 closes; last show for the Little Galleries
May 18	U.S. draft enacted
May 19	Emma Goldman speaks at anticonscription rally, Harlem River Casino

June	Last issue of *Camera Work,* photography of Paul Strand; 291 closes its doors for good
June 15	Congress passes Espionage Act; Mina obtains divorce from Stephen Haweis
June 16	Emma Goldman arrested for antidraft conspiracy
September 22	Cravan in Port aux Basques, Newfoundland
October	U.S. government suppresses *The Masses*
November	Williams, *Al Que Quiere!*
November	Williams, "America, Whitman and the Art of Poetry," in *Poetry Journal*

Theaters of Revolution

The Society of Independent Artists' show of April-May 1917, dubbed "The Big Show" by the artist Rockwell Kent,[47] had to compete with and naturally was fated to be eclipsed by a far bigger show "over there," as George M. Cohan put it. Duchamp, Picabia, Crotti, Cravan, and others had left Europe to avoid the war, and hoped for a calmer field in America on which to fight their own, more modest, if radical revolution. But much of America was as eager for the big fray as the French had been before it had begun (Frenchmen had been misled to expect a three-week revenge for the defeat of 1871). Many young Americans felt they had a show to see, and they didn't want to miss the excitement: "The friggin' business'll go bellyup soon. . . . What you want to do is come with me an' see the war while it lasts," says a character at the end of John Dos Passos's *The 42nd Parallel.*[48] Frightening, and depressing, to see these young men rush to the slaughter as spectacle, and lucky for them that Wilson had managed to resist as long as he had, so that they might go with good chances of returning, and even do so with their energies and self-confidence relatively unscathed. The famous American writers who went did not even wait for Wilson's call; most served that summer as volunteers in various ambulance corps: Dos Passos, Dashiell Hammett, Harry Crosby, Hemingway wounded after three weeks at the front, and e.e. cummings in a French military prison for lacking in respect for a French officer. Fitzgerald trained, while he wooed Zelda, but the war ended too soon for him to go. Faulkner crashed while training as a pilot in Canada. These writers were considerably less naive about the spectacle when they returned, but in early 1917 they were not among the ranks of those resisting war for the United States. They were all men of a younger generation than the artists, poets, and political radicals who provided the intellectual tone of the Independents' show, those who in effect were inventing modernism. The show had been planned as a joyous and

democratic party, to take place in a new world too smart to go to war to defend Morgan's investments; after all, the conflagration had been going on, by April 1917, for almost three years, yet without the power to affect Americans very much, as far as the man in the street could tell. Wilson's decision was economic and had depended on the German blockade of Britain: when the Germans sank American ships, he prepared for war; when they stopped, he demurred. So, in fact, American markets were at issue (of course the United States was selling only to one side), as were American jobs in the long run, and when Germany resumed the blockade the die was cast. Wilson asked Congress to declare war, and Congress obliged four days before the Independents opened. For many of these artists, as well as for many a person in the street, John Reed's question "Whose War," for the April 1917 issue of *The Masses,* was a despairingly rhetorical one: "By the time this goes to press the United States may be at war." Already before the declaration, the stock market had surged, as brokers on the floor sang "The Star-Spangled Banner," tears running. Reed could predict the patriotic terror: all opponents would be branded traitors, all news from Germany censored: "War means an ugly mob-violence, crucifying the truth-tellers, choking the artists, side-tracking reforms."[49] Wilson's decision most certainly must have taken the wind out of many an independent artist's sails; in its sad context, the show is a swan song for an avant-garde that had social and political commitments underwriting their artistic ones. The next generation was not to follow them in their commitment but, after the war "show," was more likely to look to expatriates like Pound, Stein, and Eliot for artistic parents who passed for unpolitical. The Society of Independent Artists was still supposed to be a radicals' party, but its nature was forcibly changed and made Janus-faced. To put the best face on it, the press, if it chose to, could consider that a democracy in art was demonstration of how our democratic sense was ready and able to save democracy in every sphere, including that of nutty artists. For example, Frederick James Gregg contrived to end his review for *Vanity Fair* with a neat twist of optimism: "It is to be regretted that President Glackens' society should have hit upon a time for the show when the minds of men were occupied with the future of this nation. But it stands for the spirit of the greater freedom that all real Americans confidently believe will mark the end of the war. Art, like men, can live truly only when it is free."[50] I expect Gregg meant this as a kindness to the Independents, an attempt to reconcile the avant-garde with mainstream American sentiment. But for those free spirits we associate with the show, it was quickly apparent that its exhibits stood for an artistic and bohemian isolation from the rest of American patriotism, a patriotism so strident it could not recognize that the country

wasn't under attack. As early as late January, a few "Arch conspirators," as John Sloan named them, ready with the wartime metaphor, had sneaked to the top of the Washington Arch at the foot of Fifth Avenue and declared the independence of Greenwich Village from the rest of the United States. With Sloan at this little ironic dinner party were, among others, Allen Norton and Marcel Duchamp, the latter already involved in the organization of the Independents' exhibition.

At the same time, yet a third show was in the offing, far away in Russia but with close connections to New York. This was the real revolution taking place in Petrograd, where Lenin arrived on April 16 after the Germans shipped him from Switzerland to Russia in a sealed train, hoping to destabilize the Russian front. All through March the situation had changed drastically from day to day, and reports from Russia were confusing as well as very slow to arrive, so that it was nearly impossible to follow events from New York. But New York was certainly attentive; Trotsky had arrived here on January 13, on the same boat with Cravan, and he was lecturing in Russian, German, and English two or three times a day, editing *Novy Mir* (New World) with Bukharin, and writing for the *Jewish Daily Forward*. What he called "the second Russian Revolution" began to unfold after he landed here, its developments well outside of his control while he attempted to explain it and predict its direction from this "city of prose and fantasy, of capital automatism, its streets a triumph of cubism, its moral philosophy that of the dollar. New York impressed one tremendously" he continued, "because, more than any other city in the world, it is the fullest expression of our modern age."[51] Apparently Trotsky spoke, and was received, as if the revolution were about to take place in this admirable yet horrific new world. He also declaimed as much about the war in Europe as about the revolution; they were inextricably entwined for any socialist of the period who could see industrialists making fortunes by supplying the war effort. Trotsky attempted to leave New York for Russia, but on March 27 was removed from a steamer in Halifax (soon the British would help him home, thinking he would be useful in disrupting Russian foreign policy). His message was carried on into April in John Reed's article for *The Masses:* "The rich have steadily become richer . . . , and the workers proportionally poorer. . . . The speculators, the employers, the plutocracy—they want [war], just as they did in Germany and in England; and with lies and sophistries they will whip up our blood until we are savage—and then we'll fight and die for them."[52]

It is interesting to see Trotsky think of cubism as he observes the streets of New York; it is quite likely that his connections to the political left also led him into advanced artistic circles. He may have attended

a few talks at the Ferrer School, the anarchist center founded in part by Emma Goldman, or even sat in on the art classes of Henri and Bellows given there. These classes included at various times students like Sloan, Minor, Man Ray, and Walkowitz. Though these artists cannot be considered cubists, they were learning to redraft the ways the visual arts could respond to the "city of prose and fantasy, of capital automatism," as Trotsky called it. As we have seen, it was not unusual to group all of the artistic avant-garde together as cubist, futurist, or, most vaguely, postimpressionist, and for a person coming from Europe the American city loomed as the objective verification of these crazy new art theories. The hope of the left had been for the revolution to take place first in America, because it was both fully industrialized and systemically oppressive. For a short moment it might have seemed that Trotsky was here in New York to lead this social explosion within the "triumph of cubism." The war was the crisis to ignite the revolution, as it had done among the masses in Russia, whereas in America only the intellectuals worried about either the war or revolution. Not very radical politically, William Carlos Williams nevertheless felt strongly the connection between a capitalist war and his ability to create:

> Damn it, the freshness, the newness of a springtime which I had sensed among the others, a reawakening of letters, all that delight which in making a world to match the supremacies of the past could mean was being blotted out by the war. The stupidity, the calculated viciousness of a money-grubbing society such as I knew and violently wrote against: everything I wanted to see live and thrive was being deliberately murdered in the name of church and state.
>
> It was Persephone gone into Hades, into hell. Kora was the springtime of the year; my year, my self was being slaughtered.[53]

The left took many different shapes in New York at this time, and these tendencies were in the process of sorting themselves out just as the American government and public opinion were on the point of lumping all leftists together as loathsome "reds." At *The Masses* in 1916 resignations signaled a crisis between political leftists and radical artists, but the government would not distinguish. Isadora Duncan, heroine of a woman's freedom to express herself through her body, patriotically changed her Metropolitan Opera program to national anthems. Foremost among the "reds," and quite unchanging in her resolve, was "Red Emma" herself, diminutive Emma Goldman. As I noted in chapter 1, she was a political anarchist, something very different from Trotsky, and in spirit quite a bit closer to what was happening that

month in art. For years her political speeches had been interdicted in many American cities, and she would announce lectures on Strindberg and Ibsen as a lead-in to discussions of topics such as rights for women. In 1916 she had been jailed for fighting for contraception for impoverished girls so that they would not further impoverish their families. On March 26 we know she attended Trotsky's lecture in Harlem, and thoroughly disagreed with most of his ideas.[54] In May 1917 she would challenge authority again, speaking out at a rally opposing conscription. In a way, this grand "mother earth" (which was the name of her periodical) hovers over much of what we are observing; these two of her many jail sentences, one for protecting young women, the other for protecting young men, frame our picture of a fatal month when all freedoms in art were proclaimed while all freedom of expression was withdrawn in the name of patriotism. President Wilson called for American entry into the war on April 2, and on April 6 Congress made it official. For its part, the Society of Independent Artists officially opened its "Big Show" on April 10. By June Emma Goldman would be in jail again, charged with an anticonscription conspiracy, only a day after Congress passed its antiespionage act which permitted the government to deport almost any radicals it chose.

But American culture was not failing, primarily, because of its willingness to go to war for amusement or preening. That willingness was a result of a deeper, older failure—one that was also at the root of the difficulties for the creative mind, at least as it was analyzed by two of the most famous cultural critics of the time, Randolphe Bourne and Van Wyck Brooks, in the same issue of *The Seven Arts* for April. These two writers saw the war as a convenient and timely distraction from the moral confusion within American materialism. Bourne, who becausee of his renegade views was down to his last public outlet, wrote "The Puritan's Will to Power," implicating the moral founding fathers in an updated, Nietzschean hegemony. Brooks, in "The Culture of Industrialism," split the American psyche into creative and possessive, seeing the latter as dominating the national spirit to the almost complete impoverishment of the former, as well as the impoverishment of the masses the democracy was supposed to free: "It seems to me wonderfully symbolic of our society that the only son of Lincoln should have become the president of Pullman Company, that the son of the man who liberated the slaves politically should have done more than any other, as 'The Nation' pointed out not long ago, to exploit them industrially."[55] For Brooks the American is a wizard at making "his pile," who, given a moment to reflect, sees only a "blank within himself where a world of meaning ought to be." The culture of his title is made entirely of

imported ideas that serve to smother any natural, native creativity; staying with Nietzsche, we might imagine Brooks is dreaming of a Dionysian art and deploring an Apollonian one that is only a facade of creative order-making:

> [Culture's] function was rather to divert these [creative] energies, to prevent the anarchical, sceptical, extravagant, dynamic forces of the spirit from taking the wind out of the myth of progress. . . . Gilding and idealizing everything it has touched . . . [our orthodox literature] has thrown a veil over the barrenness and emptiness of our life, putting us in extremely good conceit with ourselves while actually doing nothing either to liberate our minds or to enlighten us as to the real nature of our civilization.[56]

For his part, Bourne finds this hollowness in the industrialist's morals to be not only prudish but especially imperial because the Puritan must impose his self-abasement on others: "He loves virtue not so much for its own sake as for its being an instrument of his terrorism."[57] Today we might call Bourne's puritan figure "passive-aggressive"; his genius is to make the culture relish its own suppression of pleasure.

Putting these two commentaries together, as *The Seven Arts* did for this April issue, we obtain an image of American society where ethical and creative choices are quietly and negatively enforced through an acquiescent community. Culture there is careful, conventional, and largely imported, to fill what Brooks calls "the wide blank." Together, the two writers present a perfect rationale for the hedonism of the Independents' show. Bourne ends by arguing that "the puritan is a case of arrested development," and that to enjoy the sun, love, and "the high moods of art" will be the signs of our maturity.[58] The playful arts of *Rogue,* the popular and aggressive arts of *The Soil,* the chaotic, unrestrained arts of the Independents' show about to open would be, in their view, a maturation of the American mind, not a regressive infantilism. As the sign of his budding maturity, the American would begin to open his eyes and see the arts for himself: culture will no longer be injected into him "from the outside," says Brooks, "pumped into the middle of [his] soul."[59] This view is remarkably similar to that of Henri-Pierre Roché in his appeal for open-mindedness in the first issue of *The Blind Man,* dated April 10, 1917, the very day of the Independents' opening. Both American cultural critic and French art critic voice this call for independence of vision and response, at this crucial moment when American culture is about to enforce conformity in all forms of expression, using the war as its excuse.

The Big Show, Même

Some better-known artists at the Independents' show, of the 1,200 represented, beginning with the first six artists in the show, in accordance with Duchamp's alphabetical order:

Bertrand Rasmussen

Edith Rathbone

Will Rau

Florence Rauh

Ellen Ravenscroft

Man Ray, *The Rope Dancer Accompanies Herself with Her Shadows (Theater of the Soul)*

Dorothy Rice, *The Claire Twins*

Diego Rivera

Adelheid Roosevelt, *Tennis Player Serving*

Morton Schamberg, *Painting, Drawing*

Charles Sheeler

John Sloan

Joseph Stella, *Battle of Lights: Coney Island, Chinatown*

Frances Stevens, *The World at War*

Raymond Duchamp-Villon, *Torso*

Maurice Vlaminck, *The Port*

Abraham Walkowitz, *Times Square, New York—Night*

Max Weber, *Women and Tents, Chinese Restaurant*

Gertrude Vanderbilt Whitney, *Titanic Memorial*

E. Clifford Williams, *Two Rhythms*

Beatrice Wood, *Un peut d'eau dans du savon* [sic], *Nuit blanche*

William Zorach, *Man and Child, The Wave*

George Bellows

Constantin Brancusi, *Portrait of Mme X (Portrait of the Princess Bonaparte), Prodigal Son*

Georges Braque, *The Fishes, Still Life*

John Covert, *Temptation of Saint Anthony*

Jean Crotti, *Portrait of Marcel Duchamp*

Stuart Davis, *Breakfast Table*

Robert Delaunay, *Saint Severin*

Charles Demuth, *The Dancer, Vaudeville*

André Derain

Arthur Dove, *Nature Symbolized, no. 1 (Sails), Nature Symbolized, no. 2*

R. Mutt [Duchamp], *Fountain* [not exhibited]

Marcel Duchamp, *Tulip Hysteria Co-ordinating* [hoax?]

Louis Eilshemius, *Supplication, The Gossips*
Arthur Burdett Frost Jr.
Willam Glackens
Albert Gleizes, *Music Hall Singer*
Juan Gris, *Man at Café*
Samuel Halpert, *Sail Boats—St. Tropez*
Birge Harrison, *Moonlight on the Beach, Red Sawmill*
Marsden Hartley, *Movement no. 7*
Robert Henri
Edward Hopper, *American Village, Sea—Ogunquit*
Rockwell Kent, *Newfoundland Dirge*
Mina Loy, *Making Lampshades*
John Marin, *Reminiscent of the Water Gap, Forms in Color*
Henri Matisse
Jean Metzinger, *The Nurse*
Georgia O'Keeffe, *Expression no. 14, Expression no. 24*
Walter Pach, *Sunday Night*
Francis Picabia, *Physical Culture, La Musique est comme la peinture*
Pablo Picasso, *Portrait (The Rower, 1910)*[60]

The three important exhibitions of art in New York before the end of the war were the Armory Show of 1913, the Forum Exhibition of 1916, and the Independents' show of 1917. Only this last was not juried, to follow the model of the Paris shows by the same name, which were, in Henri-Pierre Roché's words, "the first spring event of Paris—gay, frank, bold, fertile, surpassing itself every year—while the big jury exhibitions became more and more like grandmothers patiently repeating themselves."[61] While the two earlier American shows had been carefully orchestrated—the first in 1913 to demonstrate the new art, mainly from Europe, and the second in 1916 to promote Americans—the 1917 exhibition planned to hang anyone willing to put up six dollars. It was truly a free-for-all, an event that we might call, with hindsight, a New York happening. As an exhibition it could only have appeared incoherent, showing no tendencies in particular by democratically showing them all; but as an event it was quite extraordinary. The spirit of Duchamp pervades everywhere, though, as earlier at the Armory Show, he hardly appears to be a troublemaker, acting almost invisibly as he does, so that we can again marvel at his ability to disrupt and disengage at one and the same time. It was his idea to exhibit the painters alphabetically, further destroying any possibility of grouping tendencies. Furthermore, it seems he suggested the show start not at A but at a letter picked at random. This turned out to be the letter R, and an early alcove could make

bedfellows, as it were, of the cubist-turned-populist Mexican Diego Rivera and Dorothy Rice, with her Diane Arbus-like *Claire Twins.* The art critic Henry McBride went around four times looking for the exit; Arthur Cravan, upon running into him for the third time, said: "I'm glad I don't owe you money."[62] The show was truly a labyrinth, measuring out at about two miles of pictures. Reviewing for the *Sun,* McBride said he saw every sort of mediocrity and quackery, but he felt good work might all the better jump out at him, in a proportion of one to ten. That was not a small amount of good work, as there were over 2,500 pieces exhibited by 1,200 artists, about double the number of works shown at the Armory Show and four times the number of artists. But, as McBride wrote, the show "starts anywhere" and "will go everywhere," and he went to see it a number of times, coming out more confused each time he tried to make sense of the exhibition as a whole.[63]

The Blind Man (spelled in one word in the cover title of the first issue) appeared early in April, probably having been put together while the show was hung. It has been considered one of the first manifestations of Dada, in the spirit of Dada *avant la lettre,* but in fact it was mainly a call for open-mindedness and ought not be confused with the second issue, which immortalized the rejection of Duchamp's *Fountain.* The cover image of the blind man with his dog certainly seems to have a satirical edge to it, as he has no eyes, whereas the woman in the painting behind him does, and may be thumbing her nose; but the appeal to prospective viewers of the Independents appears sincere: give up all prejudices, all preconceived ways of seeing, all blinders. Freedom of expression in the arts should be matched by a freedom of seeing that, as Mina Loy writes in this optimistic issue, should be understood as a freedom from the education of seeing. *The Blind Man* calls for a referendum, for questions about paintings, guesses about attendance and sales, suggestions for stories and songs. In other words, it attempts to match the democracy of the show with a democracy of response. But much is to happen between this issue of *The Blind Man* and the second, for May. Thanks to the show's more radical organizers, the particular violations of seemliness it perpetrated made it nearly impossible for the audience to be magnanimous in their gaze.

Foremost among these violations was the very noisy presence of modern women artists, or even of any women artists at all. Conservative or modern, they showed equal courage and spunk by availing themselves of the open invitation to exhibit and braving academic critics on the one side and modernists on the other and all around them the general audience's doubts about women artists. An early indicator of their sheer number in the show is that the first alcove showed three women for the same

The Indeps

By R. J. COADY

The Society of Independent Artists, as I understand it, is founded upon the assumption that there is real art in our art world which cannot come to light through the various means of personal effort, friends, appreciators, impresarios, academies, dealers, clubs, groups, etc., and that it can come only through the free and open exhibition, and that this exhibition will bring more art into being, because all this has happened before in France.

This is too big an assumption to be taken for granted, and, in the absence of proof, there is much to be said to the contrary.

The society does not seem at all concerned about how and from where all this art is to come. They seem to have an idea that art ought to be and therefore is and will continue to come, from somewhere. Art does not drop from the clouds; on the contrary, I think, it begins with planting potatoes. At any rate, if the society is to bring forth and develop art, its first consideration should be to adjust itself to the source of that art, to the life from which it is to come.

There is a half hidden pretence that the Society is international in scope. This helps the idea of bigness and liberality, but does the Society hope to compete with the Paris Independant, of which it is an imitation? Does it hope to bring forth unknowns from France, the art centre of the world? And if so, how?

As those questions are unanswered I think it reasonable to assume that the Society is a national society and that its efforts and results are and will be national and that its value will depend upon the extent to which it is national and to the extent of its adjustment to American life.

To exhibit a large number of paintings and sculptures, the best of which were foreign, and the rest of which were a la foreign, shows neither an adjustment to local life nor a broad and liberal independence for which the Society has blown its horn.

It has been argued that the Society is young, that the exhibition is its first infant step and that it will grow, but they've dressed it in long pants and a high hat and it already has the habits of a bachelor. It tells us how art can propagate and take care of the home. That all the other societies are punk and the only up-to-the-minute real thing is i. t., it.

Mrs. Harry Payne Whitney's Titanic Monument
Photo by Pach Bros.

6.2 Gertrude Vanderbilt Whitney, *The Titanic Memorial,* 1915–17, as reproduced in *The Soil,* July 1917.

number of men (of these six, we remember only Man Ray who, technically, should have been shown under M, not R). There were many women in art schools, but until recently they had been barred from drawing male nude models, an issue over which the famous Thomas Eakins had resigned from the Philadelphia Academy of Fine Arts in 1886.[64] Women, more than men, were expected to stay within the bounds of decorum. In this context, one might recall, Edna, the heroine of Kate Chopin's turn-of-the-century novel *The Awakening,* whose artwork plays such an important part in her declarations for independence from husband and family. Edna commits suicide, and Chopin's daring in dealing with her heroine's independence and sensuality put an end to her career. At the Independents, women opened themselves to criticism from all quarters, for all sorts of reasons, even good ones. Rice's *Clair Twins* was heartily laughed at, and then perversely praised for making one laugh. The largest exhibit in the show, its centerpiece as some critics saw it, was the *Titanic Memorial* by Gertrude Vanderbilt Whitney, eighteen feet high

6.3 Adelheid Roosevelt, *Tennis Player Serving,* whereabouts unknown. As reproduced in *291.*

with an arm span of fifteen feet and carved from a single piece of stone. Its relationship to the sunken ship and its unfortunate passengers is not evident. All ideas of pain, loss, and death are ignored rather than transcended; any sense of tragedy or misfortune is thoroughly obscured by Victorian idealization and confident serenity. I find it to be a reasonably attractive statue of its genre, but it can hardly withstand the demolition Coady gives it in *The Soil:*

> This colossal statue is really as big as one's thumb. The piece of stone from which this statue was made would have been overpowering in any interior, but what Mrs. Whitney did to it took all the spunk out of it. I got the impression of a stretched out piece of chewing gum about to flop over, but that no one would have been hurt if it had. It was a stretching out that Mrs. Whitney evidently had in mind, but it was a mental, a sentimental, stretching out which might accompany a soft sigh somewhere among the roses. Its natural medium is tears, not stone.[65]

The modern artist should work in stone, not tears, and this distinction of Coady's points to the modernists' new interest in materials and the art object for itself, separate from well-intentioned content meant to plug the work into our programmed sentiments. Adelheid Roosevelt's *Tennis Player Serving* is a thoroughly accomplished work for the period, perfectly self-assured in all the lines and volumes of its abstraction. It had already been reproduced in the last issue of *291* a year earlier, along with de Zayas's pronouncements on the valuable lessons of primitive art for the modern artist. The reduction of forms increases the contrast, or we might say decreases the subtlety, between what is in light and what is in shadow. The first effect of this simplification, though it may include a sense of primitiveness, is a withdrawal of the subject at issue, a withdrawal that is emphasized rather than attenuated by the seemingly irrelevant and essentially conservative title referring to a sport still reserved for the upper classes. In *291, Tennis Player Serving* had been placed at the end of a polemical article by Picabia, as if to illustrate the Frenchman's game.

Much more radical, I expect, was Beatrice Wood's *Un peut d'eau dans du savon,* of which there remains only a sketched version made by the artist after the original disappeared, appropriately enough in a flood (this reconstruction is now in the collection of the Whitney Museum). Where the fig leaf usually goes, the artist has glued a real scalloped-shell-shaped soap. The erratic title may conceal some fear that calling it "Soap in the Water" would have too daringly called attention to just where the soap is. Duchamp particularly enjoyed the spelling mistake, along with the

inversion of "water in soap": instead of correcting her *peu* ("a little"), he told Wood to keep the error, now a pun in print only, and one that makes no sense: "an able of water. . . ." The composition appears to be sufficiently unbeautiful, statically centered, forms hunched over the middle with tub and body a close resemblance to the shape of Richard Mutt's *Fountain,* another intrusion of the bathroom that I am getting to soon. The innovation, and violation, is the real bar of scalloped soap, which does a number of things: it represents the intrusion of a real object representing itself, and a lowly, unglorified commercial object at that, one intended to keep bodies clean; it actually attracts attention to what it covers, instead of merely preserving modesty, so it is coy in the derogatory sense; and it reminds one of another, grander, most immaculate nude, Botticelli's, who rises out of the sea *on* a shall—here, in parody, the sea has been domesticated and pumped into the American home, and the generous, life-sustaining shell has been mechanically pressed out and hides sex from view instead of serving it up. The imitation, commercial shell-as-soap is now *more* real and present than the model, and serves to cheapen the myth while cleaning up its sensuousness. To cap the offensiveness, the work is funny about sex. The discovery that this painting was made by a woman prompted various gentlemen to leave their cards.[66] Accustomed to identifying with what was always presumed to be a male artist's gaze, the male viewer was tossed into an alien world of redoubled eroticism when he found the artist to be a woman, who was implicitly painting her own naked body, that is, flaunting her own sexual exposure. This image is not so much lascivious as aggressively unbeautifying, which is to say, uncovered, nondissimulating; it is the fact that a woman was uncovering *herself* that made the image too suggestive, that made the fun about getting clean look dirty, and a new openness look like a revealed secret.

Nowhere, at the time, was the connection of the hidden body and the collusion of industry and morality to clothe it with moral cleanliness made more explicit than in the sporadic work of the Baroness Elsa von Freytag-Loringhoven, living in New York at this time though not represented by any work at the Independents. She has recently been discovered to have aided Morton Schamberg in his construction *God,* of 1916, and it is possible she created it alone,[67] certainly it looks like nothing Schamberg was doing, but is quite consistent with the Baroness's later portrait of Marcel Duchamp and with her way of decorating herself. This *God* is a plumbing trap; perhaps He is caught in it. He rests his authority on a miter box, transubstantiating the carpenters' tool into the miter on His high priest's head. As someone who modeled for painters, the Baroness was in an interesting position to think of being exposed naked

as well as of creating nakedness. In a later text called "The Modest Woman," published in the *Little Review* in 1920, she explained the metaphorical relation of body to plumbing:

> If I can eat I can eliminate—it is logic—it is why I eat! . . .
>
> Why should I—proud engineer—be ashamed of my machinery—part of it? . . . If I can write—talk—about dinner—pleasure of my palate—as artist or as aristocrat—with my ease of manner—can afford also to mention my ecstasies in toilet room! . . .
>
> Toilets are made for swift cleanliness—not modesty!
>
> America's comfort:—sanitation—outside machinery—has made American forget own machinery—body! He thinks of himself less than of what should be his servant—steel machinery.
>
> He has mixed things! For: he has no poise—no tradition. Parvenu—ashamed of his hide—as he well might.
>
> Slips behind smoothness—smugness—sanitation—cleanliness. More!![68]

Beatrice Wood, the Baroness, and perhaps Schamberg understand that the bath, soap, and plumbing are embroiled in a slippage of meaning in which a moral imperative is projected onto the body; the artists, in a counter-move these two women and one man seem nicely attuned to, eroticize the soap which was supposed to suppress bodies, or place the American god-head in the last place Americans would be willing to look for it. Without the same hope that Brooks and Bourne stubbornly entertained for transcending the invasive commercialization of daily life, these artists develop strategies of ironic co-option, a modern art of resistance and accommodation combined. The as yet unnamed postmodern had arrived.

Admittedly, the plumbing work of the Baroness and Schamberg was not in this show; more of plumbing in a moment. One other woman who was present, possibly without her knowledge, was Georgia O'Keeffe. I have not found which two drawings or paintings Stieglitz sent in, the overflow from the show he hung at 291 at the same time, I would presume. Stieglitz was in the habit, at various times, of putting together for 291 something that he intended to stand in strong contradistinction to another event in the city. In this spirit, and though he and O'Keeffe were not to be intimate for another year, he had her show at 291 coincide with the Independents, thus conferring considerable polemical value upon her work. Since strong sexual qualities were already being attributed to O'Keeffe's work at the time, it would seem Stieglitz was not proposing so much of a countershow as a concentrated amplification, a more emphatic and coherent dose of female sensuality translated by a young,

already accomplished woman without social or artistic connections. At the Independents were two *Expressions* by O'Keeffe, a term we no longer find attached to any of her work. It makes one think of Stieglitz's later *Equivalents*. In any case, whether the term came from O'Keeffe or from Stieglitz, the title *Expressions* is a reminder of Kandinsky's famous treatise on abstract art, published in part in *Camera Work* in 1912, and of Arthur Wesley Dow's teaching at Columbia University. O'Keeffe had studied with Dow and readily absorbed his ideas on the relation of non-realistic, emotive painting to music. *Expressions* were, I hazard to guess, an improved title for a number of paintings and charcoal drawings in the 291 show named, there, *Special:* numbers 15, 21, 22, 24 (and numbers 2, 3, 4, 5, 7, 9, and 12 had been shown the year before in a 291 group exhibition).[69] The Independents catalogue lists *Expressions* 14 and 24, this second posing a bit of a problem since it is supposed to be hanging on the walls at 291 as *No. 24, Special / No. 24.* Whether this is my error or an earlier scribe's is less important than the buzz produced at 291, which made O'Keeffe a visible female presence in the city's art circles, the lone woman at the Independents with a one-person show running in tandem. The gendered rhetoric around her abstractions, which we have inherited, had already begun in the press; her entirely abstract *Blue Lines,* for example, described as "two lives . . . a man's and a woman's, distinct yet invisibly joined together by mutual attraction."[70] Other *Specials* could more easily be read as portraying a woman's body in dreamlike abstraction, and the *Expressions* were no doubt of this sort.[71] Most of O'Keeffe's obscure images of this period are actually abstracted from natural scenes and represent the Palo Duro Canyon, but nature always manages to seem sexual and feminine in her work. The most abstract of her paintings are also the most suggestive. In the abstract image, a well-delineated shape comes to represent something that is unknown in any precise sense but is intuitively recognized as inner, wrapped, and private; it is fetal—with all those implications, though not necessarily with fetus. She also exhibited nudes, but I think these were mainly shown a year earlier, in the 1916 show. They were looser, blotchy, mainly in monochromatic shades of bleeding watercolors, reduced to essential gesture but not to secure form. As with the rather similar Rodin drawings exhibited by Stieglitz in 1908, and seen by O'Keeffe at that time, the body is only a shadow of representation, though a vibrating one. Rodin's drawings were actually tighter, with penciled outlines, but I think similarly open to erotic interpretation. Again, with O'Keeffe, the difference is that the viewers knew they were dealing with a woman artist, an awareness that made her work dangerously sexier.

Blue Lines, showing at 291, is her most famous painting of this period. The lines were interpreted as one female and one male, as Tyrrell wrote, though the painting was suggested to O'Keeffe by New York buildings seen from her room.[72] Here minimalism has gone too far for readability; the lines are spiritual, the subject has been abandoned for only the suggestion of *some* subject, which remains unknown. The viewer is almost completely free, if he or she wishes; and also free to dismiss it as a scribble that terms like "cubism" or "futurism" cannot contain. Everything depends on reading the delicacy and purposefulness of the isolated brushstrokes, or it *is* no better than a scribble, but many in the 1917 audience—or later for that matter—would have trouble making the important distinction. If the two sexes confront each other, which is which? It can hardly do to look for the physical signs of gender; we are in a freer world. As O'Keeffe did not declare herself to be entirely, programmatically without subject, as in her *Train Moving through Dawn*—her very first sale—we can be encouraged to look for the object, and we are forced to conclude it has receded, like the train itself in the desert, smoke, and smudge, to occupy an almost imperceptible and, finally, unimportant space in the picture. What is in fact left is the shadow, the indistinct image cast by a cast-out reality (or representation). Perhaps in *Blue Lines* one shadow is facing not its source but another mere shadow.

Much abstraction can be thought of as a loss of reality, which has receded to a shadowy, ill-defined place in the self. Shadows themselves remain vivid yet unreadable, and are haunting stand-ins for realities that fail to declare themselves. In that month's *Others,* Mina Loy was publishing her completed "Songs to Joannes," which, I will propose, she read from at the Independents poetry reading. She spoke in a precise yet secretive manner, of bearing children among shadows:

> The starry ceiling
> Vaulted an unimaginable family
> Bird-like abortions
> With human throats
>
> . . .
>
> But for the abominable shadows
> I would have lived
> Among their fearful furniture
> To teach them to tell me their secrets[73]

Earlier, she had written for *The Rogue* "Virgins Plus Curtains Minus Dots," in which the innocent girls are locked up and lurk in shadows as

mere "curtains with eyes," as they await a real existence, the one a dowry would precipitate them into.[74]

All these women are particularly attentive to the shadowy living they were bravely or tentatively venturing out of. But women were not the only ones at the Independents' show to explore the eroticism of abstracted forms, challenging the invisibility of sex in American culture. One of art's great minimalists, Constantin Brancusi, was present, with a curiously ambiguous *Mme X,* or *Portrait of the Princess Bonaparte.* From its more frequently shown angle, it admits its affinities with the better-known Mademoiselle Pogany series. The eyes are faintly scratched in (though not at all in the version in the Philadelphia Museum), forcing the identification of a woman figure, despite the great degree of abstraction. However, from the other side, this abstraction from a female bust is just as clearly a streamlined male organ. Somewhere else, or at another time, this might be mere androgyny and a funny optical pun; at this event it is throwing overt sexuality at the heads of a very proper mixed audience. It is curious to consider that the model would be, in a few years, the leading sponsor of the psychoanalytical movement in France. Was it possible that almost no one among the American viewers was horrified by what the princess hardly repressed, except by putting it too much in view, like Poe's purloined letter? Taking a phrase from Loy about another sculpture by Brancusi, we might call this one "A naked orientation."[75] Apparently only one critic of the time publicly recognized the sexual metamorphosis; in a comment that raises the problem of a nonjuried show altogether—that is to say, the crucial problem Duchamp raised with his urinal—he wrote: "phallic symbolism under the guise of portraiture should not be permitted in any public exhibition hall, jury or no jury." He condemned the clandestine representation, declaring "America likes and demands clean art."[76] But for many other American viewers, the propriety of the title seemed to be enough proof there was no dirt here. Demuth, who was at the show, remembered the portrait for *Distinguished Air* (1930), an illustration for Robert McAlmon's story by the same name. Demuth had no doubt about what the statue stood for, and he used it, drastically enlarged, as a backdrop to sexual yearnings that also confused the sexes. Having failed to sufficiently arouse the passions in 1917 New York, the sculpture went on to be banned from the Paris Independents' show in 1920 (but perhaps the princess had something to do with that).

In Man Ray's *The Rope Dancer Accompanies Herself with Her Shadows* we have a fine and explicit example of the withdrawal of the subject, as well as the withdrawal of the artist from his handiwork. The viewer would perceive the small multiple-exposure acrobat easily enough, but

6.4 Man Ray, *The Rope Dancer Accompanies Herself with Her Shadows,* 1916. Oil on canvas, 52 × 73 3/8 in. Gift of G. David Thompson (33.1954). Digital image © Museum of Modern Art of New York. Licensed by SCALA/Art Resource, New York. © 2004 Man Ray Trust/Artists Rights Society (ARS), New York/ADAGP, Paris.

would never know that the colorful forms dominating her in the painting were her shadows without the convenient title printed at some intruding length on the painting itself. Here Man Ray has broken with the new principle of the unrelated or obscure title, which Duchamp and Picabia were toying with, but he has used it to tell the viewer she doesn't know what she's looking at (the title in the catalogue, however, is a more vague displacement: *Theater of the Soul*—my thanks to Francis Naumann for pointing out this identification). The shadows seem something like parts of a dress pattern; the artist explained that, in fact, they were even less than that, the forms left over in pieces of colored paper after his first renditions of the dancer's shadows had been cut out.[77] So they are precarious indeed, a collage of holes, or shadows of shadows the artist himself did not create. These shadow dancers replace the painted dancer/artist, who withdraws dangerously above. She is projected onto the circus ring below, and onto us, her and his audience. The dancer's connection to and control of her projections is tenuous though graceful, for these shadows have become more real than she is; they are in fact bold and largely primary in coloring. The dancer/artist admits the illusions of her own show, hoping desperately to rope them in; the flashy Barnum is bigger and probably better than she is, the shadow show more substantial than actor or artist.

As it turns out, one of the poems read by William Carlos Williams at the Independents harbors this disproportion between a performer and his displacement. In his "Overture to a Dance of Locomotives," Williams has also cut up his picture into lines that are mere remnants of the meanings we expect from them, for example: "of those coming to be carried quicken a." These scraps of lines replace the dance, or the life of the trains, with a dance of preludes to meaning, at times in verses that could be transpositions of Man Ray's own idea of the dancer's extremities multiplied into her projected shadows. For example, these lines about the sunlight on the clock above the waiting room: "Discordant hands straining out from / a center: inevitable postures infinitely / repeated."[78]

Insults to modesty, reduction of forms, parcelling and sequestering of the subject, foregrounding of shadows and of hiding, retirement of the controlling artist—these assaults on the art-going public come together in the special game of absence and presence that inhabits Duchamp's famously rejected urinal. How could it be rejected, in a nonjuried show? Its submission was, then, a test, a far-limit case, and from that point of view it was the jury that failed. The only grounds for rejection might be that it was not art, but Duchamp's position was that if the "artist" submitted it as such, who was to judge in advance that it was not? A second large issue is joined: who is the artist, and what is that person's authority? It is doubtful that Duchamp even thought of *Fountain* as artwork, since he was not much interested in the privileged status of art objects: "Can one make works which are not works of 'art'?" he wrote to himself while thinking out the *Large Glass.*[79] There was, then, some coyness in his providing a very visible signature, that of Mr. R. Mutt, for the *Fountain,* the sort of gesture associated with an artist—and his was not a discreet signature. At the same time, not identifying himself was important to Duchamp so as not to influence the committee, on which he sat and from which he resigned in protest. So *Fountain* was in large part a hoax, a function that partially eclipsed the degree to which it is much more, a challenge to the meaning of art and to the meaning of an artist as a creator. It is the hoax aspect that produces the charm of the following response in the press, a misunderstanding that is still captive to an older, genteel world of art relations about to be bowled over by the "real" *Fountain,* which almost no one in the world will ever see: "The exhibition will be open until May 6, but at no time will 'The Fountain,' submitted by Richard Mutt be shown. 'The Fountain,' described by those that saw it, as a painting of the realistic school, was excluded by a narrow margin of votes at a turbulent meeting of the directors of the society late yesterday afternoon. Explanations will be made to Mr. Mutt personally."[80] Mr. Mutt awaits his explanation yet, along with the return of his very realistic object.

Photograph of Mr. R. Mutt, The Artist

I have been reasonably successful so far if the subject of plumbing does not come as much of a surprise in a discussion of an art show. As I have already quoted him, Coady had questioned Jean Crotti's wire assemblage in the December 1916 issue of *The Soil*: "Is your 'absolute expression' the absolute expression of a big artist, how does it differ from the absolute expression of a little artist, how does it differ from the absolute expression of a plumber?" Presumably chosen for the extreme incongruity of any comparison to the artist as a constructor of culture, the plumber appears with some regularity in avant-garde strategies as the purveyor of a competing value. Coady even seemed prescient as to form; in the following issue of *The Soil*, for January 1917, he mockingly compares the authentic power of official monuments to that of heavy machinery, coming out in

6.5 *Fountain* and "The Richard Mutt Case," double page from *The Blind Man*, no. 2, May 1917.

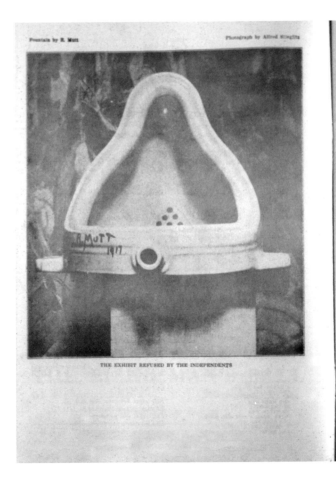

Fountain by R. Mutt Photograph by Alfred Stieglitz

THE EXHIBIT REFUSED BY THE INDEPENDENTS

THE BLIND MAN

The Richard Mutt Case

They say any artist paying six dollars may exhibit.

Mr. Richard Mutt sent in a fountain. Without discussion this article disappeared and never was exhibited.

What were the grounds for refusing Mr. Mutt's fountain:—

1. *Some contended it was immoral, vulgar.*
2. *Others, it was plagiarism, a plain piece of plumbing.*

Now Mr. Mutt's fountain is n[ot] immoral, that is absurd, no more tha[n] a bath tub is immoral. It is a fixture th[at] you see every day in plumbers' show window[s.]

Whether Mr. Mutt with his own han[ds] made the fountain or not has no importanc[e.] He CHOSE it. He took an ordinary arti[cle] of life, placed it so that its useful significan[ce] disappeared under the new title and point [of] view—created a new thought for that obje[ct.]

As for plumbing, that is absur[d.] The only works of art Americ[a] has given are her plumbing a[nd] her bridges.

"Buddha of the Bathroom"

I suppose monkeys hated to lose their tail. Necessary, useful and an ornament, monkey imagination could not stretch to a tailless existence (and frankly, do you see the biological beauty of our loss of them?), yet how that we are used to it, we get on pretty well without them. But evolution is not pleasing to the monkey race; "there is a death in every change" and we monkeys do not love death as we should. We are like those philosophers whom Dante placed in his Inferno with their heads set the wrong way on their shoulders. We walk forward looking backward, each with more of his predecessors' personality than his own. Our eyes are not ours.

The ideas that our ancestors have joined together let no man put asunder! In *La Dissociation des Idées*, Remy de Gourmont, quietly analytic, shows how sacred is the marriage of ideas. At least one charm-

ing thing about our human institution that although a man marry he can nev[er] be only a husband. Besides being a mone[y] making device and the one man that e[ach] woman can sleep with in legal purity with[out] sin he may even be as well some oth[er] woman's very personification of her a[b-] stract idea. Sin, while to his employees [is] is nothing but their "Boss," to his childr[en] only their "Father," and to himself ce[r]tainly something more complex.

But with objects and ideas it is differe[nt.] Recently we have had a chance to obser[ve] their meticulous monogamy.

When the jurors of *The Society of I[n-] dependent Artists* fairly rushed to remo[ve] the bit of sculpture called the *Founta[in]* sent in by Richard Mutt, because the obje[ct] was irrevocably associated with a certain atavis[tic] minds with a certain natural function of [a] secretive sort. Yet to any "innocent" e[ye]

favor of the Chambersburg Double Frame Hammer, which is the same shape as the urinal. I have said that plumbing, or more generally bathrooms, had been a frequent subject of Louise Norton's "Dame Rogue" columns for *Rogue;* in a remarkable coincidence (I guess), the October 1916 issue contains a sketch called "Baptist Church, Fiji Islands," the same Buddha shape that Norton will see in *Fountain* when she writes of it in *The Blind Man,* a sketch that appears on the page directly facing Duchamp's first English text in print, "The." Finally, that second (and last) issue of *The Blind Man* was to be almost entirely devoted to a sort of apotheosis of American plumbing, with how much irony it is not easy to say for sure. The toilet *was* being shown off in ads for American homes, and Duchamp would have been particularly conscious of this as, to this day, the French sequester the "water closet" from the bathroom; *faire sa toilette* refers to washing oneself. The original for *Fountain* is actually an institutional apparatus that would have appeared very elaborate to Duchamp, who was accustomed to the trough or mere hole in the floor (termed "Turkish") of French schools and restaurants; I expect he did think it was pretty good looking and an extravagance compared to French utility models.

Fountain raises two authorship questions, though only the second has much preoccupied Duchamp criticism: first, is Mott, or a designer working for him, an "artist" in any sense either on purpose or by accident, and second, does the found object, somehow no longer quite a mere urinal yet still a urinal, gain or even create an artist-creator in its finder? The answer to the first question can be yes, if we consider fine design and utilitarian craftsmanship close enough to "art," as in the case of objects museums are willing to collect and show under the heading of industrial design, such as MoMA's prize Olivetti 22 (thus the one I bought as a young student metamorphosed into an "art" object, and I concomitantly into an art collector). But Duchamp is not exploiting that designer specifically, though his gesture includes him; he definitely wants an object off the assembly line, an item from a sufficiently high number of duplicates to erase any sense of unique creation for the single one he has taken, precisely *this* one which he has chosen to rename as a new, unique object, *Fountain.* And, in a mocking reversal of the obliteration of the creator that he has just perpetrated, he provides it with a single, originating, but entirely fictional artist/maker: R. Mutt.

But there is no creating artist at all; Mutt is a front. For us, Duchamp is the artist, yet all he did was see, like the much maligned photographer. His idea is not so much to change the object of art as to change the nature of the artist, to abolish the arrogance installed in his identity. He picked from among the objects that industry produces with

no regard for higher or lower meanings, and especially no regard for taste of any sort, good or bad. Duchamp signs it "R. Mutt," withdrawing behind the comic character but also assigning the work, now dubbed *Fountain,* comic and decoy functions that admit the author is not the author; not Mutt, not even Marcel Duchamp. Furthermore, it is altogether possible that Duchamp is fooling us, his acolytes, as well and did not even pick the item; a letter to his sister dated April 11 reads in part: "Une de mes amies sous un pseudonyme masculin, Richard Mutt, avait envoyé une pissotière en porcelaine comme sculpture."[81]

The likely woman in the shadows is Louise Norton, whose phone number is given to the press by Demuth in a letter about the banned exhibit; this number is identified in his letter as that of "Richard Mutte."[82] Alternately, we can imagine a conspiracy involving Duchamp, Henri-Pierre Roché (who was financing *The Blind Man*), Norton, Beatrice Wood, and Demuth, among others. Perhaps Duchamp merely supplied the title, which is not saying little. What makes Norton a particularly interesting choice of artist, or nonartist, is that, as a woman, she had most probably never seen a public urinal; one can suppose that, as a group of these conspirators strolled past Mott's showroom at 17th Street and Fifth Avenue, she would be the one who might first see its alien yet aesthetic and ultimately symbolic value, though Duchamp also would have found this porcelain apparition on the avenue to be passing strange. Norton was, as well, the main writer in the second *Blind Man,* for May 1917, where she wrote: "to any innocent eye how pleasant is its chaste simplicity"; and, comparing the urinal to a Buddha, then to the legs of ladies by Cézanne, she goes on to reverse the direction of the comparison: "have they not, those ladies, in their long, round nudity always recalled to your mind the calm curves of decadent plumbers' porcelains?"[83] But I hasten to reiterate, Duchamp did not consider this readymade to be art. Only days after his object was submitted, it was already being co-opted into the art world by even his closest collaborators, though we can give them credit for thinking of a very new world of art. What finally returns authorship, or primary nonauthorship, to Duchamp is the mere fact that he may have been quite alone in understanding the degree to which *Fountain* was not art, a work but not a work of art; that it scratched all the rules of beauty and taste without signaling any desire to replace them with other rules. It was a truly quixotic gesture, as he recognized much later when Dada made its American comeback: "The fact that they [readymades] are regarded with the same reverence as objects of art probably means I have failed to solve the problem of trying to do away entirely with art."[84] Norton includes in her appraisal for *The Blind Man* the same erudite references she used in her "Dame Rogue" columns: de

Gourmont, Montaigne, Cézanne, and Stein. In fact, her opening and closing gambits in *The Blind Man* work the same conceit about monkeys and their tails that she had used in her last "Philosophic Fashions" column, for December 1916 only five months earlier. What may finally disqualify Norton from being the "creator" of *Fountain* is precisely this educated defense of an innocent eye still holding out for the comforting pleasures of art; these are not the pleasures a *Fountain* by Duchamp can be much concerned with perpetuating.

Duchamp, Mutt, Mott, and Norton equally share in not being the creator, in withdrawing from that honored role. Beyond that, not only is the object fatherless and motherless, it is itself materially withdrawn, in two ways. As with a photograph, it has no aura, for it cannot be unique, cannot be collected with a view to enhancing its singular value in the commerce of art. Secondly, when the committee refused to exhibit the piece, the audience at the Independents was deprived of the work—it would have been deprived of the artist in any case—and gained knowledge of what it had missed from the press, which was easily inveigled to expound upon an exhibit rejected by a show without a jury. The audience is then re-presented with the withdrawn object through a photograph in the second *Blind Man*—that is, it is portrayed by a machine, which of course is not a creator either—and they now see that the committee had suppressed something that itself was already a colossal suppression, of art itself. It is a most thoroughgoing withdrawal from the world of artworks, one that succeeds nevertheless, after blocking our view of another work of art in Stieglitz's photograph, Hartley's *The Warriors,* in returning with the full force of an idea. As the magazine explains: the piece is not immoral, since "it is a fixture that you see every day in plumbers' show windows"; it is not a plagiarism, because no artist claims or steals it; it does not fail as art, since "the only works of art America has given are her plumbing and her bridges."[85] The soaring of the bridge was being dealt with by others, Marin and Stella for example, and eventually Hart Crane. In this time and place Duchamp & Co. chose to demystify the engineers of cleanliness. Mr. Mutt's *Fountain* could be the fulcrum for the avant-garde's practical application of Brooks's and Bourne's critique of American culture: a shiny, smooth, and white obfuscation; a madonna and buddha allied in ambiguous erotics of receiving and giving; the confusion of the function of the one in the shape of the other; the exhibition of sexy dirt on a pedestal; the industrial object lured into desiring something beyond its exchange value; obliteration of the individualistic, entrepreneurial creator.

The rejected *Fountain* was removed from the premises of the Independents and taken by the conspirators to 291 so that Stieglitz could

photograph it. Both the object itself and photographic prints of it could be seen at 291 for at least a week or more. Critics question whether Stieglitz knew what he was photographing, or whether he knew Duchamp was the "author." Certainly he needed no one to tell him how radical an object it was as a submission to an art show, and he enjoyed at very least the violation of propriety it tendered; "it will amuse you to see it," he wrote Henry McBride on April 19, inviting him for a viewing.[86] A letter to O'Keeffe two days earlier suggests that Stieglitz was under the impression *Fountain* was the work of a woman. Though few critics have seen this letter, some have deduced from reports of its contents that Duchamp was putting one over on the photographer, as he had tricked the Independents' jury.[87] It is true that, earlier, Duchamp and Stieglitz did not immediately click, but they soon enough became quite fond of each other and, at very least, at this date were co-conspirators; I would not be surprised to learn that this very event marked the beginning of their admittedly sporadic friendship. This reading of their relationship is supported by Beatrice Wood's account of this meeting, at which she was present: "after a long conversation and a good deal of laughter, both men agreed Stieglitz should make a photograph."[88]

I have said enough about how indifferent Duchamp must have been to the question of authorship. Indeed, the shipping label on the urinal, plainly visible in Stieglitz's photograph, identifies Louise Norton as the person "submitting" the found object. Why bother to hide the perpetrator from Stieglitz or, if Duchamp had done so, would it not have been in good humor? Duchamp was definitely not one to get other people in trouble by his own fault, though his desire to absent himself was powerful, even engulfing. His behavior acted to counter any interpretation by the audience of a piece of work and to lure them into doubting a creator for it, but interpretation and attribution must rush to fill these voids, and gender, if not sexuality, will play a role. If this object appears feminine in its graceful, concave lines, who is staring at it on our behalf? The unknown creator, even if it is only the engineer-designer, must be a man; it is not difficult to assume, in that case, that the female object has been staged by Stieglitz, mere photographer, to underscore the feminine values. Interesting, then, to realize how much simpler it would have been for him to photograph *Fountain* in front of a painting by O'Keeffe. I doubt any other artist was hanging at 291 at this moment, considering how little space Stieglitz had to work with, and thus some of O'Keeffe's work had to be taken down temporarily to make room for the Hartley background in the photograph. Perhaps Stieglitz was protecting the reputation of O'Keeffe, whom he then hardly knew. In any case, for *Fountain* Stieglitz avoided maternal canyons in favor of Hartley's very busy display

of small and colorful parading figures in his *The Warriors,* perhaps to suggest Americans preening themselves for war. *The Warriors* provided the background for the streamlined features of the porcelain, as if such a Madonna-cum-Buddha, an artist's hermaphrodite, might calm the war-mongers' passions. It was a lot to ask of a piece of plumbing, which could not avoid conveying more irony about manufacturing than transcendence of beastly hearts. But Hartley's warriors are not fighting yet; the painting was done in 1913. This is a charming, flag-waving parade, of men as children fantasizing a jolly good show; against that view of the background, the urinal is a gaunt sobering up, a confrontation with an unadorned and unprepossessing reality.

Finally, how remarkable to realize that this photograph, made by one manufactured object of another, is the only evidence of the existence of the original *Fountain,* an original serial object now lost. It did have aura, because Duchamp singled it out, "said" it didn't have any, and then signed it anyway. Stieglitz then saved it, though when he did so he did not know its fate was to be lost; what he saved was its memory, a record into which many people have made investment. How remarkable, too, that we have not been able to find the precise model from Mott's catalogue, as if some Richard Mutt had sneaked into his factory and made a single prototype just for Duchamp's use. There is something damaging to the readymade's status if we cannot all find one, if its mass production can be even a tiny bit doubted. Only Stieglitz's rare positive print remains, a unique sign (or "index," as Rosalind Krauss might term it) pointing to a unique sign of a presumably infinitely reproduced and reproducible readymade. So many urinals, a few signed *Fountains* here and there, and just *this one,* real unto itself, where "R. Mutt" seems less a signature than an identification, part of the name of the faceless object; this is his photograph, showing he was there, if he was anywhere. *Ça a été,* insists Roland Barthes.

Curtain Down on the Avant-Garde

Centuries of European artistic tradition have been emotionally linked to seasonal renewal, reiterating the joys of springtime in April. But on the heels of the Great War, twentieth-century artists, largely urban, came to doubt such psychic renewal, so that, in T. S. Eliot's words of 1921 in *The Waste Land,* April itself had changed, becoming "the cruelest month." The Independents showed, at first, such hopes of renewal in American culture, waving the flag of complete freedom of expression and letting the works fall where they might. But the show also bore the seeds of a failure to renew, as it offered up to the fresh war spirit all sorts of grounds for dismissal.

Patriotism was ready to spike political dissent, obviously, but its reach was tentacular and was not long going to abide cultural irreverence or even singular creativity. And while the joyous nihilism of Zurich Dada was still unknown in New York, Dada was present in much of what Duchamp or Picabia did, and in what they were happy to see Cravan do publicly. He spoke to a high-class, largely female audience on April 19, ostensibly to enlighten them on "The Independent Artists in France and America." It is to be assumed that very few in his audience came forewarned about his scabrous review of the French Independents' show of a few years earlier in his own magazine *Maintenant,* where he had said, for example, that to improve Sonia Delaunay's work he would be glad to administer a good kick in the ass—and that had been for a friend! The facts about this organized outrage at the American Independents are variable, as befits any decent Dada happening, and the event stands as myth to history very much on the model of the original *Fountain.* Cravan cursed and began to undress, swayed and smashed the speaker's table with a boxer's punch; he hurled obscenities (or just one) at his audience; he was hauled off by police or by his friends, Picabia and Duchamp, who had liquored him up for his performance.[89] The audience understandably fled this disruption, Cravan's own war on art, artists, and patrons. With Cravan, and especially after the urinal, it made no difference to hope an audience would liberalize its views on art, since for him that would hardly be enough. The Dada strain was to prove too virulent for such an open system as the American. And, in any case, the triumvirate of extreme thinkers, Duchamp, Picabia, and Cravan, would soon be gone from New York, as would Crotti and Man Ray and, as I see it, the avant-garde as such.

The poets had read the day before, April 18, at an event that promised to "abolish rhyme, rhythm and reason" and thus to participate fully in the revolution of the Independents.[90] Greenwich Village was well represented, but, as with the show as a whole, there was more promise of revolution than profound lyrical renewal. Rhyme, convention-bound rhythm, and a reassuring amount of reason marked the work of Maxwell Bodenheim or Padraic Colum, for example. Kemp was all bohemian outpouring, befitting a tramp-poet, Stephen Vincent Benét was tame and even patriotic. I believe that only Loy and Williams, already engaged as we have seen in a thoroughgoing modernization of poetic expression, could have read work to match Duchamp's or Picabia's radical and surefooted reconstructions of perception. In this sense, they were together again, but alone on the stage of modern poetry. Additionally, Mina had the distinction of showing a painting at the Independents', *Making Lampshades,* now lost, and this made her doubly visible as a purveyor of the modern.

Bill read "Portrait of a Woman in Bed" and "Overture to a Dance of Locomotives" (given their modest length, perhaps he read other poems as well). Williams reported later: "Mina, to my surprise, pronounced me the best of those on the program."[91] Williams was now attempting to read out loud lines that, as we have seen, are visually fragmented on the page, such as: "of cities in a huge gallery: promises" and "of those coming to be carried quicken a," as well as "across and across from pale" (from "Overture"). We can only wonder how he articulated each of these discrete, isolated segments of meaning while being obliged, eventually, to voice their fall back into their somewhat worried sentences. To take up the last example: "across and across from pale / earth colored walls of bare limestone." All the light movement of the train station has been kept in one line, all the solidity of its walls in the other. The poet reading must play a delicate game of enjambment, end-stopping his run-on lines long enough for his listeners to feel the disconcerting breaks within expected units of thought. Throughout, the dance is sustained by lines balanced on one foot, as it were, overtures waiting for the beat to fall. I imagine Bill himself balancing on one foot, breaking his body language, breaching his silences with hesitations aimed at the words to follow.

Mina's poetry would have appeared obscure whether seen or heard. Unfortunately we do not know what she read, she herself neglecting to grant the audience a title: "Miss Loy gives us credit for a great deal of divination," felt one spectator, a comment we could apply to both title and content.[92] But I'm sure a poet would prefer to read new work from the printed page, and the April *Others* trumpeted the thirty-four sections of her "Songs to Joannes," a large part of her currently available work, including the first four songs which had already scandalized critics and readers. Her diction had not changed as much as Williams's over the two years in which they had confronted each other's work, but this was a much longer dose than anyone had seen. It shows her sustaining her power through a long work, one that at times resembles a woman's version of Prufrock's wandering in vacant streets and salons; but while Eliot's hero is petrified of approaching women, Mina's speaker is forever with her lover, while painfully aware of never loving blindly, romantically: "Or are you / Only the other half / Of an ego's necessity," and

> apparently
> I had to be caught in the weak eddy
> Of your drivelling humanity
> To love you most[93]

Loy has been criticized for having a bad ear, for jostling abstract, Latinate words. Certainly, for this early stage of modernism, she is out of step, overtly manipulating ideas about things as often as she offers up stunning and furiously direct imagery without clear reference. Yet one can sense that in such formulations as "Irredeemable pledges / Of pubescent consummations" she is hijacking the big words of Victorian intellectualized discourse, only to compress and savage them into coughing up the ghastly realities they are meant to euphemize:

> Irredeemable pledges
> Of pubescent consummations
> Rot
> To the recurrent moon
> Bleach
> To the pure white
> Wickedness of pain

Indeed, Mina is asking her lovers to join her in looking directly at themselves, and to recognize that they are also those "other" Victorians:

> Shedding our pretty pruderies
> From slit eyes
>
> We sidle up
> To Nature
> —that irate pornographist[94]

On this podium at the Independents we have a fine victory for the new short line, a victory brought about by both poets together. In both, the line's brevity reflects a world too violent and dispersed, or fragmented, to be taken in larger, more elegant, and breathable lengths. Gone is the pomp of eloquent, rhythmic periods full of confidence in the accretions of progress. This line is so delicate as to be almost adrift, and a large part of the reciting reader's challenge was to make the audience sensitive to the vastly enlarged field of blank page threatening to silence the terse phrasing. A strong sign would have been the dramatic speed at which the poets turned their pages. Verse pretends to occupy only a small part of the available page and seems thus inconsequential, only light verse; in fact, the space is just a vast breathing area into which the compressed meanings of the lines can expand. On this day the short line must breath differently on the wide stage of the exhibition hall meant for car shows, as poetry makes its claim to be just as new as the latest Packard; the vastness

of the mismatched hall is a replica of the big blank page. The line also mimics one's attention span during the walk or drive along the city street, where so many diversions are offered, if not imposed. The short line is conducive to surprise, just as there are always new distractions in wait at every corner. Each of her lines seems so final that we are surprised she can continue to the next without getting lost. His tend more to be cut off by the whiteness before they can make anything concrete, sending us more quickly down the page but leaving the residual sense of formulations beyond or beneath language in every line. Together, they shut down the conventionalized connections in either prose or traditional verse, to open up contact to things radically perceived. Mina's line is more self-contained than Bill's, and under the shock of her angry metaphors continuity is weaker; one advances by jerks. Mina nails the emphatic line to the listeners' forehead; Bill washes his lines over their eyes with a luminous quotidian.

Both of these modernists are unsparing about unsightliness in themselves and the new world about them. Exciting as she may have been in her beautiful and accomplished person, was Mina not also dangerous because of her uncompromising gaze? Bill also read a poem about an equally honest woman, one who insults the speaker of the poem from her bed and dares him to come closer: "Lift the covers / if you want to see me." Of this forlorn prostitute Williams later wrote: "I wanted to throw her in the face of the town."[95] While Mina is personal and anguished, Bill is more engaged with the social; but the same Victorian language of piety comes under attack, this time more explicitly: "Oh, I won't starve / while there's the Bible / to make them feed me."[96] Despite such explicitness in the woman's voice, much remains muted, implicit: the social forces that put her beyond the pale, but also other dangerous women dissimulated under her covers. It has been suggested that this "Portrait of a Woman in Bed" is of the Baroness, certainly the maddest of the Dada circle in New York, a woman who was attractive to Williams and who pursued him untiringly—all the way back to his Rutherford! She even mocked him for not sleeping with her or letting her give him syphilis in order to make him a genius. However, it seems unlikely Williams had been to her apartment before the publication of the poem in December 1916. The "Portrait" is of a woman he had known in his practice, and it reappears verbatim in a play about her in *Others* in 1919. Still, the Kora figure that obsessed him is not restricted to its progenitrice, and he did choose to read this poem standing next to Mina on a podium of revolutionary art. In "Dance Russe," which he placed right before "Portrait of a Woman in Bed" in *Al Que Quiere!* to be published in November, he described himself, "I in my north room / dance naked, grotesquely." In

contrast, he saw as exotic, or "Southern," the whole aggressive dispersion of old artistic values in favor of fresh perception, which Duchamp had perpetrated on the exhibition with his urinal and, along with Mina and others, in the second *Blind Man*.[97] As I have said, the "South" is what lurks in him as Carlos, bracketed by northern Williamses; and it left him open to an "Other" that he has projected as an aggressively feminine New York. His prostitute on the dole, the Baroness in her sexual vulgarity, and Mina in her brilliant independence all played their parts to make this northern city temptingly southern.

Mina, for her part, may have been willing to play a few scenes with the doctor, for the sake of what he knew about women and children behind the veil, but he lacked a real violence to match to her imaginary one. Her passivity—her victimization, I would even call it—was full of violent and brilliant defenses that he did not even dare to assault. Arthur Cravan would speak the next day at the Independents, creating its second well-remembered scandal. She had probably not yet been ravished by this "Colossus," as she came to call him, who brushed aside all her reserve with his own accomplished criminality. Since she found him, at first, horrid, even a bit of a fake, it is all the more remarkable that a powerful mutual attraction should develop so suddenly, to the great surprise of the other exiles in the Arensberg circle. She could fall for a boxer-poet but not a doctor-poet, even if his writing was far more relevant for her own. Amusing to realize, nonetheless that the name (Ova) she gave herself in her long autobiographical poem of the twenties, "Anglo-Mongrels and the Rose," echoes the cover art Bill was so proud of for his *Kora in Hell* of 1920, a drawing of a central ovum awaiting the best of the spermatozoa surrounding it. Once again, after Hilda Doolittle chose Pound, after Flossie's older and more beautiful sister preferred Williams's brother, after the alluring Viola Baxter beckoned to him from New York only for him to come too late, Mina also left Williams dreaming, as she succumbed to a man more aggressive and uncompromising in his artistic demands on the world. Williams the children's doctor was too civilized and, in any case, quite safely married.

Williams and Loy were to meet only a few more times, probably in New York when she returned to look for traces of Cravan, definitely in Paris when he took a sabbatical in 1924, and, artistically, one more important time when their work, pursued independently after 1917 for some six years, was published in France by Robert McAlmon.[98] The 1923 Contact Editions of her *Lunar Baedeker* and his *Spring and All* are among the important milestones of modern poetry in English, though both went pretty much unnoticed at the time. Today we value highly her precise, even pedantic guide to the barren nightscapes of love, and his

cantankerous belly music, prose-and-poem launch of a tentative spring which holds that unspecified "All" in reserve. The stage had just been stolen by a different style of poetry, that of *The Waste Land* published the previous year, a work which, Williams wrote later, "set me back twenty years": "Our work staggered to a halt for a moment under the blast of Eliot's genius which gave the poem back to the academics."[99] By "our work," he is referring to that of Marianne Moore, Loy, and of course himself. American soil was to be abandoned by the best writers: Pound and Eliot, now the leaders of Anglo-American poetic modernism, were in Europe, and Loy was, in 1923, in her third (or so) exile from Britain, attempting to live in Paris by decorating lampshades. Only Williams and Moore remained in America, in a sort of reverse exile there from the dominant current of modernism in London and Paris, and he was largely lost as an influence to the next, so-called Lost Generation which was to blossom in Europe in the twenties.

The entry of America into the war drove Picabia back to Europe, Duchamp to Buenos Aires, thence to Paris, and Cravan under cover in New Jersey and then on a northward trek that landed him in Saint John's, Newfoundland, not an easy feat. He reached Mexico by trawler, whence he beckoned to Loy. They married in Mexico City in the beginning of 1918. Within the year he disappeared, perhaps lost at sea, perhaps knifed. He left Mina pregnant with Fabienne. After her return to Europe, she would come back to Mexico, via New York and the Village, to search for Cravan for almost a year, to no avail.[100] Almost ten years later she wrote, in a poem entitled "The Widow's Jazz":

Cravan
colossal absentee
the substitute dark
rolls to the incandescent memory

of love's survivor

. . .

The widowed urn

holds impotently
your murdered laughter

Husband
how secretly you cuckold me with death[101]

Ten years after losing him, to the question from the *Little Review,* "What was the happiest moment of your life? The unhappiest? (if you care to tell)," she did care to say: "Every moment I spent with Arthur Cravan. The rest of the time."[102] That happy time was, for the most part, the avant-garde moment of the Independents' show and the lovers' few months leading into the summer in New York.

Dada, in its early, free New York form, did not have much time to survive either. The second *Blind Man* (now more clearly a two-word title) appeared as the Independents closed, containing within its protesting defense of *Fountain* the signs of giving up the fight for a freedom of seeing that it had called for in its first number less than a month earlier. In its avant-garde or Secessionist guise, it continues the call for such freedom, but when it wears its more purely Dada hat it is aggressively indifferent to any hopes. At the heart of giving up on all values there is a nonchalance that, I imagine, only Duchamp could live comfortably with. For example, Loy writes: "Duchamp meditating the leveling of all values, witnesses the elimination of Sophistication"; this is an elimination of which the avant-garde would approve, but Duchamp was, as Loy could guess, on his way to leveling more values than just snobbery. Stieglitz, for his part, remained faithful to Secessionist hopes, publishing in *The Blind Man* a proposal that, if put into practice, would certainly have made for a fine Dadaesque moment. His is the last word in that audacious little magazine, and it takes the form of a letter, dated April 13, in which he sums up perfectly the essential meaning of Duchamp's disruptive organization of the Big Show by going one last step further. Stieglitz suggests that next year they "withhold the names of the makers of all work shown." No names, even to the buyers, until afterward: "The public would be purchasing its own reality and not a commercialized and inflated name." In other words: no jury, no prizes, no cliques, no artists. Of course no audience would pay for that, nor would any dealers; as Stieglitz knew, it could kill the business, even of revolution. This proposal is a good example of Stieglitz's idealism, which did not so much transcend current relations in the art market as embarrass their premises. In his questioning of the foundations, Stieglitz is not so far from Duchamp. The date of the letter makes it unlikely that he had even seen the urinal yet, unless it was on that very day. The letter suggests he understood quite well the implications of *Fountain*'s having no artist-creator.[103] He then translates the premise of that readymade into the realm of all art, to validate works standing alone, no longer "playing . . . even into the hands of the artists themselves."[104] Duchamp may be destroying art, and Stieglitz the art community, but, that important distinction made, we see there is much overlap in the assault on art conventions by these two men.

I WILL NOW PROVE THAT A BULLET DOESN'T LOSE ANY OF ITS SPEED WHEN IT GOES AROUND CORNERS

R. Goldberg

DADATAXI, Limited.

ciated.
Your cooperation will be appreciated. The conductor of this vehicle will gladly be governed accordingly. It is our aim, however, to cater to the wishes of the majority. It seems impossible to please all. On the question of proper ventilation opinions radically differ.

VENTILATION

PUG DEBS MAKE SOCIETY BOW

Marsden Hartley May Make a Couple—Coming Out Party Next Friday

———

A beautiful pair of rough-eared debutantes will lead the grand socking cotillion in Madison Square Garden when Mina Loy gives a coming-out party for her Queensberry proteges. Mina will introduce the Marsden Hartleys and the Joseph Stellas to society next week, and everybody who is who will be who-er than ever that night.

Master Marsden will be attired in a neat but not gaudy set of tight-fitting gloves and will have a V-back in front and on both sides. _He will wear very short skirts gathered at the waist with a nickel's worth of live leather belting. His slippers will be heavily jewelled with brass eyelets, and a luxurious pair of dime laces will be woven in and out of the hooks. He may or may not wear socks. He has always been known as a daring dresser.

Attire of Debutantes.

Master Joseph will wear a flesh-colored complexion, with the exception of his full-dress tights. He has created a furore in society by appearing at informal morning battles with coattails on his tights. The usual procedure at matinee massacres is for the guest of honor to wear tuxedo trunks with Bull Durham trimmings. He will affect the six-ounce suede glove with hard bandages and a little concrete in 'em if possible. His tights will be silk and he wears them very short.

Before the pug-debs are introduced, Miss Loy will turn a gold spigot and flocks of butterflies will be released from their cages. They will flitter through the magnificent Garden, which has been especially decorated with extra dust for the occasion. Each butterfly will flit around and then light on some particular head. If you get two oleofleas on your dome, try and keep it a secret.

Description of Ring

The ring will be from the Renaissance period with natural wood splinters. The gong will sound curfew chimes at the end of each round. It will be played by a specially imported pack of Swiss gong ringers. The ropes will be velvet and hung like portieres. Edgar Varese, the violinist, has donated a piece of concert resin to be used on the canvas flooring, which will be made in Persia. Incidentally, the tights worn by the fighters will be made by Tweebleham, of London, purveyor to the Queen by highest award.

Master Marsden will give his first dance to his brother pug-deb Joseph, which will probably fill Marsden's card for the evening. Visiting diplomats in the gallery de luxe will please refrain from asking for waltzes.

—With apologies to "Bugs" Baer.

6.6 Page from *New York Dada,* 1921. Private collection.

New York experienced one more famous attempt at Dada in 1921 before it was abandoned here and Man Ray removed his Dada self to Paris: that is *New York Dada,* produced by Man Ray and Duchamp principally, which included, among other items, a poem by the Baroness, photographs of her by Man Ray, a cartoon by Rube Goldberg, a double-exposure photograph by Stieglitz, and a Dada manifesto from Tristan Tzara that names Stieglitz as a collaborator in a publication to come, named *Dadaglobe* (it never appeared). The cover celebrates Tzara's droll "authorization" to call the magazine *Dada* ("But Dada belongs to everyone," he wrote). In the middle of a field of "new york dada 1921" typed upside-down, Man Ray has photographed Duchamp as Rrose Sélavy, the Frenchman's female alter ego now part of the label on a perfume bottle. Like R. Mutt, the name inscribed on the male's toilet bowl, Rrose is the

anti-identificatory identification of a commercial receptacle, this time for women, and Marcel continues to fake going missing. Stieglitz received this publication from the conspirators, who were then in Paris, where Dada had gone to live for as long as it could survive its own joyful anarchy. To scholars of both Dada and Stieglitz, it has seemed that he was critical of the extremes of Dada and entirely unreceptive to its shenanigans; but his letter thanking Man Ray and Duchamp for *New York Dada* helps to support the different view I am putting forward:

> Dear Duchamp & Man Ray:
> It's quite a marvel—the N.Y. Dada.—The cover is a delight—That Dada—phot a wonder.—The skit—Hartley—Mina Loy—Stella most amusing—and Francis's letter a real message—It's all prod.—Heartiest congratulations
> Stieglitz
> Apr. 17/21[105]

Dada had fled the scene, and the Secession, as loose as it was, was further dispersed. Two poets had met; they could dance and sing, they could take a good hard sideways look at each other's page; they would let the curtain fall. They played for each other the gendered Other, the good and bad city, and, most importantly for the changes in poetry, they played counterpoint to each other's tentative new voices. Their times together were well spent. The new artists of the Independents, with their undermining of false modesty, their radical effacement of self, subject, and work, and their hijacking of commercial hypocrisy, had sufficiently deconstructed their audience's ability to see as it was used to. Within a few months, the war would close down important little magazines: *The Masses* was to be stopped in the mails and interdicted, *The Seven Arts* ceased publication, Coady's *The Soil* folded with the July number. Stieglitz was on the threshold of big changes, but in 1917 he could not see much reason for optimism. 291 closed with the O'Keeffe show, though not before he rehung it for her alone when she arrived in New York. The last issue of *Camera Work,* summer 1917, showcased the brilliantly modern work of Paul Strand, but the war had cut Stieglitz off from papers and workmanship in Germany, so all new initiatives were shelved. Still, even two years later he dreamed of a few more issues, writing to Picabia from Lake George: "There is tennis & swimming—and muscle-building—sanity of living without any ambitions.—O! yes I have one desire. And that is to publish a few more numbers of Camera work.—But lack of cash & the impossibility of getting any really good reproductions made [?] here make the appearance of such numbers rather

dubious." It is clear from this 1919 letter that Stieglitz was quite fin-
ished with movements, even the Secession, and would now devote him-
self, rededicate himself really, to his own photography, as he continued
the good fight for only a very small number of American artists to whom
he had already made many years of commitment: "The world's affairs
naturally always interest me greatly—But primarily as onlooker.—my
own photography interests me more than ever & I know I have finally
done a series of prints that are of living value. They would interest you
greatly I know.—Then too [there?] is the work of miss O'Keeffe which
means something to me too.—'Art' is not worrying me much—. Not
more than any particular 'ism.'"[106] That happy letter reflects the changes
in his life and work between 1917 and 1919. But in the spring of 1917
the future did not look so promising for the Secession's dreams of affect-
ing a large-scale reevaluation in the arts in America. The following let-
ter is a very sad one to read and, written as it was on April 12, 1917,
instead of merely reflecting the fate of the Independents' show, it pre-
dicts it:

The American Waste Paper Co.
70 Greene Street
New York

Gentlemen:
Under separate cover we are sending you a copy of a paper called
"291." We have several hundred pounds of this paper which we
wish to dispose of. What could you give us per pound for this?[107]

7.1 Alfred Stieglitz, *Ellen Koeniger (Morton) at Lake George,* 1915. Gelatin silver print, 11.6 × 8.6 cm. National Gallery of Canada, Ottawa. Purchased 1976. © 2004 The Georgia O'Keeffe Foundation/Artists Rights Society (ARS), New York.

7 The Serial Portrait (1917–1935)

> . . . & I know I have finally done a series of prints that are of living value. They would interest you greatly I know.—Then too [there?] is the work of miss O'Keeffe which means something to me too.— "Art" is not worrying me much.[1]

Near the end of the last chapter I cited a longer excerpt from this letter to Picabia, dated August 1919, to indicate how much things had changed for Stieglitz within only two years of the closing of the Independents' exhibition. The two main reasons he had once again become productive surface in this letter: the idea of the series, and the person of Georgia O'Keeffe. The two are entwined, as one might expect, and when he came out of what had appeared to many as a final retirement to exhibit his series of images of his companion, the event brought fame, or notoriety, to the subject as well as to the photographer. The exhibit took place at the Anderson Galleries in February 1921, an occasion that again impelled him to write to Picabia, inscribing the exhibition's invitation card: "It is a great pity you are not able to see this exhibition filling 210 feet of running wall space. It is creating a real sensation because of the life-force expressed in a direct way—& through the machine— without any 'ism' of any kind—I know you would be surprised could you

but see what I have accomplished in the last two years."[2] I find it revealing that he should bother to write to the Frenchman, an artist he could not expect to attend but whom he is singling out as a person of independent thought who toadied to neither "art" nor "isms." Though the anarchistic, Dada strain continues, it is easy to forget in the veritable deluge of new, ambitious photographs, which certainly look like artwork, and the sensual paintings by O'Keeffe, which Stieglitz would be presenting to the public in these next few years.

The exhibitions I refer to—I am speaking only of his photography and her paintings, and not the work of the other artists of their group who receive more and more regular showings in this period—run as follows:

February 1921: Stieglitz, 145 prints (1886–1921), some 128 of which had not been shown previously; 45 are of O'Keeffe
January 1923: O'Keeffe, 100 paintings
April 1923: Stieglitz, 116 prints
March 1924: joint exhibition, O'Keeffe, 51 paintings; Stieglitz, 61 prints

Forty-five pictures of his lover in his own first new show; her solo show, which launches her career for a second and more emphatic time; then a second exhibition of his own following immediately; and finally, as if it were in an unavoidable train of logic, a double show, she in a large front room, he in two smaller ones: this all seems well orchestrated to establish the image of the two artists as a pair, perhaps even equals, certainly artistic comrades-in-arms in the public's eye.

Miss O'Keeffe, the Series

In 1921 Stieglitz had not shown his work since 1913, at the time of the Armory Show, and he was now somewhat reborn. The word is not much of an exaggeration. Since the death of *Camera Work* and the Little Galleries at 291 Fifth Avenue, his already considerable career as a photographer and promoter of the arts had pretty well ended, as far as the public knew. He had been constantly in the news of the new arts until 1917. Now, at the age of fifty-seven, he might not have seemed too young for a semiretirement, time to rest on his laurels, and the announcement for this 1921 show refers to work stretching back to 1887, thirty-three years before. However, Stieglitz was not resting on his laurels; most of the work was new, only 17 prints of the 145 having been shown before. And 45 of these prints were of a young, unnamed woman whose relationship to the photographer was known to some and probably apparent

to the sensitive viewer. Doubtless the photographer did not miss the fact that his oldest exhibited print was the same age as O'Keeffe herself.[3] He was living a second youth through her, but not through her alone, as this artistic renewal included new views of the city and portraits of other new friends. Thus this was a show not only of youthfulness but of a new take on past subjects, a rejuvenation accompanied by a maturity in recollection. While parts of Henry McBride's review of this show in the *New York Herald* have frequently been cited to underscore the interminable lecturing of the photographer—"but greater than the photographs was Alfred, and greater than Alfred was his talk—as copious, continuous and revolutionary as ever"—the critic's essay in fact intends to convey something else entirely: to record the return to the American art scene of a much-missed personage: "Where Stieglitz had been there was a distinct void. . . . The main thing, Alfred, was there and they were happy." "They" included the likes of Marin, de Zayas, Hartley, Oscar Bluemner, Walt Kuhn, Walkowitz, for whom this return of the photographer suggested "that '291' was operating as usual and that this long hiatus had been a dream."[4] Stieglitz's absence had not been a dream, but at the very moment in 1917 when he had been obliged to close his gallery and journal, he had met O'Keeffe. His photographs of her were now the public sign of this powerfully erotic and powerfully artistic new relationship. Her new paintings and his new photographs had been kept largely private for three to four years, their admiration for each other's work bringing fruit only for the eyes of each other.

Cultural memory of the 1921 exhibition has usually centered around the photographs of O'Keeffe, which occupied close to a third of the show, or 45 of 145 prints (or 46 of 146). Lowe gives the first figure of forty-five in the body of her text and Whelan the second, but he otherwise seems to follow her in most respects. No doubt we may credit this serial portrait with the force of a "revelation," a term Stieglitz was fond of, and see its impact spread to engulf memory of the show as a whole. However, McBride makes no special mention of the series at all, spending his only detailed commentary on a "typical, bourgeois American sitting room," which he feels Stieglitz has magically transformed from "a bore" to an image that "would not tire one quickly." Later he merely includes "studies from the nude" in an overall listing of the various genres in the show.[5] McBride seems not to have been easily shocked by a bit of revealed skin. *Demonstration of Portraiture,* as this section is termed, includes short, two- to three-print sets on seven people besides O'Keeffe, including three other women; then come forty-five of O'Keeffe: about half of them the usual frame of portraits, eight of hands, three hands and breasts, three torsos. . . . There are, as well, three of feet, a part of

O'Keeffe's body that I cannot recall ever seeing in any book collection. Not only, then, is the *Demonstration* not about one person, but the famously offending or erotic views of the unnamed woman are at best six; and to take the concept of the nude more strictly, there are only three, the torsos. In fact, these torsos do not exhibit the blatant eroticism of the Ellen Koeniger images, which are listed under the discrete category of "water." While various book collections of these photos of O'Keeffe may reasonably reproduce the general emphases of the 1921 exhibition—with images of hands usually outnumbering the others except for images of her head and face, and reproducing one or two of the three torsos (I think no one shows all three)—no one but Stieglitz seems to like the feet enough to add them to the portrait, something I reflect upon below.

The idea of the series is, I believe, an invention of Stieglitz, to the degree that its topic is the passage of time and change as they affect a single subject. Of course there had been other sorts of photographic series: Du Camp or Frith in Egypt, the Bisson brothers in the Alps, Fenton in the Crimea, Brady in the fields of the American Civil War, Curtis on the Indians' plains. These photographers wrote the preservation of a moment, recording immobilized segments of time for the benefit of historical memory. Surveys of monuments were taken to preserve their glory before they crumbled, albums of natives were assembled to memorialize their life before the white invasions. Riis photographed all over the Lower East Side of New York with the intention of demonstrating that it should be demolished, removed from time. In all these examples, when the photographers recorded men and women, they did so once for each person, plucking a single image out of history to immobilize it in association with other people of the same moment, they too each foregrounded once. Given their intention, it made sense to take the portrait but once (with a few trials), as Stieglitz himself did in other cases, and like many other portrait-makers before or since. Julia Margaret Cameron's famous photograph of Thomas Carlyle did not need repeating, neither for her nor for us; her choice will always be the definitive portrait of the writer. But for Stieglitz the idea of the portrait moved into the idea of the series. In the 1921 show, there are three portraits of Waldo Frank and three of Dorothy True. To make the point of the new difference quite explicit, Stieglitz further explains the project under the heading *Demonstration in Portraiture* in the catalogue: "each set constituting 1 portrait."[6] This important meaning has been lost to us, as only the portrait of O'Keeffe is still thought of as a series. Of Waldo Frank I have never seen reproduction of any but the same one, where he holds half-eaten apples, a photograph that has preserved him for history with that symbolism and his comical, Groucho-

like face. However, Stieglitz has purposely reapproached his subjects, not to get the "best" view to label them with, but to watch them evolve in time and to propose that one image will not suffice to draw a portrait, but that a whole series is called for. The mutability of the subject spans ten seconds or ten years; circumstances come to alter character at any time, making it seem to leap years in the blink of a shutter or to regain a bright youth after many passages. As the concept of the portrait melts into that of the series, the character of the person we observe goes through many more transformations than can be suggested in a single image, as fine as it may be, even as she holds more or less tenaciously to her personality through the changes the photographer is revealing. The series invites us into this paradox of a person always changing yet somehow the same, as well as into the traditional paradox of mutability itself, that only mutability itself is not subject to change.

The idea of the series was not a new one for Stieglitz in 1921, nor even in 1917 to 1918 when he began with O'Keeffe's portrait. He had already begun, much much earlier, to assemble his pictures of New York in transition with his small portfolio of twelve nighttime images in 1897, *Picturesque Bits of New York,* and with titles of individual works like *Old and New New York* of 1910. Admittedly, the picturesque bits and others were not new images of the same buildings, as compared to the way in which one might return again and again to the same changing face or body. Any mutability series could take a lifetime to shoot, and it would always, if done well, imply a lifetime passing even if it did not take a lifetime to produce it. A city portrait would be even more time-consuming, or time-wasting, than one of human subjects. Time and again, the whole cityscape would have to be the subject, or the series would dissolve into the mere surveys of historical moments I referred to above. In fact what Stieglitz returned to in the early portfolio was time itself, the night, a condition that had been reputed to be impossible for photography. Night changed the city by changing light itself, and when the photographer mastered it, he revealed one of the greatest changes of the city, the lost half of its twenty-four-hour life. The 1921 exhibition contained some images of this sort—day and night images of the same scene, which changed entirely in aspect—but the full evolution of the subject remained a slow affair, even for a city as committed to deconstruction as New York, and it may not have been apparent to gallery visitors then that these images of New York belonged to a larger plan. The latter part of the next chapter will look at Stieglitz's last period of portraying New York, the culmination of some forty years of doing so, of waiting it out. At this point, I only want to stress that for him the series was not the job of a specific moment, a job one might commission to be

delivered a year hence, like Coburn's *New York* of 1911, for example; this was as true of portraying a person as it was of portraying a whole city.

Nor was O'Keeffe his first human subject for a series. The idea had come to him before they met, with the life of his daughter, Kitty, a person whom he obviously expected to see and know for many years, and from her infancy. However, his estrangement from his wife, even well before leaving her for O'Keeffe, and his own very difficult relations with his daughter, which leveled off slightly but then deteriorated completely with her mental breakdown, all contrived to make that family portrait impossible. He may have often wondered if he knew her at all; yet the series portrait implied he should know her very well indeed. When she refused to see him, was she not also saying she refused to be *seen* by him?

The remarkable if short series of at least twelve photographs of Ellen Koeniger, taken at Lake George in 1916, represents another, neglected series, though it is very much contained in time. These are clothed nudes, one might say, draped in an old and tattered bathing suit that looks more, to us, like old, wet pajamas. Both the displayed eroticism of this generous body and the spontaneous, lively composition are revolutionary for their moment, and frequently are more exciting than many of the very posed images of O'Keeffe to come.[7]

The need for long familiarity demanded by the series necessarily restricts the photographer's field of action. Even with O'Keeffe Stieglitz had already missed more than the formative years. His portrait of her began with a woman at thirty, and given his own much more advanced age in 1917—he was fifty-three—he could not think to photograph her for more than some twenty years. Those years during which he was able to portray her, to always add to her portrait the way Whitman added poems to the same but growing *Leaves of Grass,* run only from 1917 to 1933 and hardly represent a whole life, especially not of such a long-lived subject; O'Keeffe was ninety-eight when she died, outliving him by forty years. The photographer thus missed out on thirty years before and forty after. Still, there cannot be many portraits spread out over or among seventeen years, except in personal, family albums, which are an inevitable comparison to his intention. They were of course "his" years of her, but they were also her great years, spanning her life as an artist from public discovery to the pinnacle of her career as one of the most famous artists in America. They were the years of her maturity, and it is her maturation as both artist and person that is the captured subject of his camera lens. Again I wonder about the opening date for this 1921 exhibition: 1887. His birth to photography, embodied in some bucolic sense of a Europe now passed into history, is timed to match her physical birth. Now, in 1921, her body and his creativity are reborn together as if she

and he were of the same artist's age. In the sense that the exhibition as a whole cannot easily avoid connotations of autobiography, the portrait of O'Keeffe is the last record to date in the series of himself. More pointedly, the survey of his photography before 1917 becomes a record of awaiting her arrival into his life.

A discussion of the series stretches my scheme of attempting to draw generous but tightening circles around concise moments in Stieglitz's career. On the contrary, the series of images of O'Keeffe wants to force us out of the single moment of this remarkable 1921 exhibition, asks us to watch time go by through many moments, many clicks of the shutter, each of which adds another contrast to the sequence. There is, in fact, a strong paradox in viewing some 45 images that quickly begin to suggest that one ought not to stop in front of any one image but flow through the sequence, even on to the 350 or so he took and which, obviously, we will never see; the sequence we do see intimates the series we can only guess at. As good, as permanently expressive, as each shot may be, it is looking to establish not permanence, an essence, or some definitive labeling, but instead the value of one, full, fathomable station. In its way, the series is a denial of the single photograph, of photography. At the same time, it makes this exhibition in 1921, as one example, a performance, a voyage. Yet the series does not have the seamless quality of a film but is made of stops and turns and leaps we make from image to image, contrasts that Stieglitz constructs for us outside of the moments in the frames. A single photo stops time, contemplating timelessness; the series of stops appears to stop time between the successive images, and throws them into a progression of contrasts in which, when we come upon continuity, even that comes as a surprise. Muybridge's stop-action experiments were, in this respect, part of an entirely other world, one of absolutely determined and expected continuity in tenths of a step, each frame of almost no interest at all except in its inevitable fall into the next. His is a filmic continuity, searching for the secrets in the progress of a simple motion. Stieglitz's images are, each, a stasis full of the history of its subject to that moment, and, together, a series of histories that sometimes meet, as we recognize them from previous images, and sometimes don't, as we just as often stumble onto a new version of this woman further into the sequence. Photography no longer has its single scene; the scene of the Anderson Galleries of 1921 is four years long and counting.

Most of the photographs on the walls in 1921 are the well-known ones, ensconced in the history of photography by this exhibition. Many reappear together, with later ones from Stieglitz's portrait of O'Keeffe, in a beautiful oversize album that accompanied a 1978 exhibition at the New York Metropolitan Museum: *Georgia O'Keeffe, a Portrait.* Over thirty

years after his death, and almost sixty years since the original show, O'Keeffe retained the overall title, *A Portrait*. She chose the prints and their sequence, and she spends a good deal of time in her introduction speaking about Stieglitz's care in the making of prints, their individuality, and how she herself learned from him to appreciate them. Fifty-one plates are reproduced in the album, of which thirty-two date before 1920, and most were probably shown in the 1921 exhibition. It is unlikely that plates 27 and 28 were hung in 1921, considering the foregrounding of pubic hair in the one and the willful suggestion of it just above the cropping at the bottom. Stieglitz wrote in the announcement, "I feel the general public is not quite ready to receive them."[8] In 1978 O'Keeffe chose to add these two nudes of herself, though she omitted one of the three torso images shown in 1921. She is thus reproducing roughly two-thirds of the 1921 show, to which she adds about twenty images to represent the later years. Below, I slowly turn the pages of the Met's 1978 catalogue; what I intend is a personal and somewhat self-contained narrative which simulates that of an interested viewer in the Anderson Galleries in 1921, invited to make sense of this series called a *Demonstration of Portraiture, a Woman*.[9]

I begin with a classically proportioned portrait of head and shoulders, but its formality is immediately dispelled by that well-known, ironic smile, partly a smirk. The hair is tucked back, flattened against her forehead. She wears what has become an O'Keeffe trademark, the simple white collar against a black dress, as if she had always dressed to be photographed. The discreet but ubiquitous button at the bottom pulls the blouse down to a point, the bottom of a long triangle that is the center of gravity in the portrait. "Well, what do you think of *that?*" she appears to be demanding of the viewer, referring in part to her painting behind her. She doesn't seem quite young, and there is some frailty—though it does not seem to worry her—to her left shoulder and arm, which Stieglitz has pulled in from the frame of the print, an unusual decision as it is made on one side only. The almost comically high hairdo and the exposed throat make her seem tall and open to us, with a frank, forthright gaze back at the camera. This contented and relaxed salutation is in contrast to the swirling and circling of the indistinct and private picture behind her, which of course is also her; she is both very much exteriorized and very interior.

Plate 2. A torso, in fact, but dressed. Same clothes as before, though the open collar now plunges further down, marked by a thumb pressed into its low meeting point. A button is asserted, must remain visible, so this left hand wraps around it. Perhaps rather than being an image of the torso, this is one of hands, her famously beautiful hands; but, further, the

naked body is suggested as well, with the left hand cast very loosely over her breasts and the right hand cupped beneath, to catch or to offer, one can't decide, if one has to. Without being quite a transition to a state of undress, it is still an offering by her own hands and a formalized offering *of* those hands: she is the artist of her own body.

Plate 3. Of hands, somehow less formal in their gesture but engaged in an oddly formalized activity, molding the background painting's centrifugal, internalized cloudlike piece of ceramic-in-progress. She has exerted some effort, a contortion to keep the rest of her body out of the picture, forced beyond the frame. What is the object of this painting in the background, rendering the more abstracted symbol in contrast to the simple, plastic reality of the making and showing hands?

Plate 4. Suddenly the hat, a comic or eccentric touch; is she prepared to travel, no matter how undressed she may be in other respects? Marie Rapp, one of the "three graces" at 291, remembered it well almost seventy years later, calling it a "funny little pot of a hat."[10] The perfect, sculptured, stunning face, lips much fuller than those of the woman in plate 1. Her hands, used to manipulating with delicacy, are engaged in buttoning up—a shiny high button. Hands and buttons do not have to carry great symbolic freight in a single photograph, we begin to realize, because their meanings have time to develop in the changes from one photograph to the next. The hat caps the painting, a pocked gourd, or giant old mushroom, or sea-eroded porous rock, whatever it is contrasting with the smoothness of her skin (as it appears). She has moved from bemused intimacy with the camera to a formal gaze into the distance, as if to disdain being a subject for a portrait, yet serene and pleased enough with herself, both in herself and in her role as subject.

Plate 5. The hat sequence is revealed to be of a different time, as the fuller "American" portrait shows clothes different from those of the first plates. The button is now on her blouse; she is not leaving, but arrives with a different painting. The look is, again, not into the lens, not to the photographer who has forced this static, formalized pose. Obviously the hands are emerging as crucial to her language; not one hand, to paint or mold with, but always two, handling her worlds between them; that includes her body, as either protected or proposed through the button. Her face hides or contains a smile, but as so often already, it is a very formalized gesture or suggestion, in acceptance of posing, within which act some inner truth can be crystallized; for example, as a control exerted over a potentially romanticized expression of one's vanity. Her expression might be saying she is present in all seriousness and creative discipline, despite the appearance of a fantastical, blotchy skirmish in her painting.

Plate 6. A second visit to the scene of plate 4. It was two buttons, not one. The one hand is close to a fencer's parry, but she is anything but defensive. She won't go away, but will stay, with her hat and coat, and she declares it confidently, strongly into the camera lens.

Plate 7. Suddenly almost undressed, but in a surreal way, keeping her Chaplinesque hat on. No uncovered sexuality, but mostly skin under the hat and some shiftlike covering over the bottom of the image, which is probably cropped just above the nipples. Posed before one of her charcoal drawings, now not more of a mystery than her pose itself (what we called paintings above may also be black-and-white charcoals, as it turns out). Under the retained or mocked formality of her hat, she admits, with due discretion, that she is personally exposed in her artwork, or almost: a swirling, heavy head on a stalk of a neck. Or, she is neither undressed nor dressed, not even in any recognizable transit in one direction or the other between the two states but poised in indecision. The face seems particularly dressed, that is to say, beautifully organized for social presentation; but in this effect the hat may not help, signaling instead a permanent state of departure.

Plate 8. She has let down her hair, but not to luxuriate. Her face is heavier, tired or a little ill (she had been suffering from a serious bout of influenza when Stieglitz sent Strand to see if she would return to New York from Texas). Most noticeable, her head is far from the central position, but resting on the bottom of the frame and pushed to a corner, so that her drawing fills most the image; but we still can't see it well enough to guess at its meaning, except to see it gather around the newly released hair and accelerate up and away from the head as in a venturi effect. She stares down the lens, telling us to take her as she is. Only her head is in the frame, so nudity is not at issue, except that, with the previous image in mind, we know that we don't know what is outside the frame.

Plate 9. Indeed, following closely upon the scene of the previous image, the camera pulls back to include almost all of the drawing, the long length of her very dark hair, and her hands partially protecting the painting from attack, or just from view, but also in a very posed, angular configuration as if part of a frozen ballet. Her body is searching to make some abstract statement. The barest fragment of clothing reveals she is not naked, and was not naked in the previous shot, yet the revelation of hair under her arms speaks of nakedness in the sense of nondissimulation, honesty in exposure. These last three plates may be the ones that have led to the idea that Stieglitz posed O'Keeffe in the nude before her own artwork, as if to say he took her body just as he took her career and art in hand. But she is not exposed in front of her paintings; on the contrary, she is modeled, made more sculptural than erotic, and these

images refrain from eroticism, while letting us know she does have a real body that won't be hidden in the fact of "Art."[11]

Plate 10. A classically posed portrait of head, shoulders, arms, and hands, contrasted with a completely dark background. How formal, compared to many of the others, an image interested in form and texture, in "Art," and I feel its uninterrupted perfection is such that it is the most nude of all the images, largely through the perfect fullness of the shoulders and upper arm. But in this guess I feel more acutely the need to judge against an original print, to see just how nude, how denuded this suggestive pose is. In any case, it is nudity as contemplated beauty, a distancing from rather than an invitation to eroticism.

Plate 11. Finally, if what has gone before was to tease us, we see a breast, or rather a nipple, framed by two long folds of a loose shift that remove any suggestion of roundness of a breast and shape it into a larger, dressed composition. O'Keeffe seems tired or ill, and she may be as indifferent to nudity as to covering. Forearms and exposed bosom are drawn into an angled composition leaning into the fatigue of her face. With her hands against her forehead, she may be thinking about her options. Or wondering what she has gotten herself into. She may be more concerned with baring her breast than he, the composer, is. He both aestheticizes her exposure and encourages her to play with it. I think she is wearing the shift or smock she painted in when she was described at various times as painting in the nude, in New York in the summer and later, at Lake George, in her small isolated shack. She worked heatedly, one imagines, sweating the cool shapes out onto paper and canvas. The careless nakedness we see here is an interlude, a kind of exhaustion from the eroticism of creating, though it might pass for a feigned weariness with eroticism itself.

Plate 12. Same tired face as above, same hair and open smock, but now she stares, a bit aggravated, I would say, into the camera eye, and from above, dominating with impatience or annoyance the so-called mastery of the (male) artist. However, one ought not to forget that it is the photographer who has staged his lower position and her higher one. The center of the photograph is her throat, but lowering the camera attracts us to the open smock and brings her bony chest into prominence, with the central lines of her breasts leading the eye down and out of the frame, in a strongly communicated understanding that her breasts hang heavily, and are not classically high. She seems out-of-doors, thus even more daring of any viewer.

Plate 13. The first profile in this smock-clad subset. The face is flattened by the heavy dark hair, which covers the left of the image, and the unusually dense and well-defined shapes in a painting in the background

behind her (I don't recognize it as hers, but if it were not, that would be quite a change in the series). She may be a bit self-conscious about posing, but certainly does not seem self-conscious about her identity, as she defies the image behind her, which is acting to mesh her into a two-dimensional, modernist surface. She is proud almost to vanity, and willing to show to the camera a distinction that, in her daily dealings with friends as well as the public, she kept to herself. Or, perhaps, the camera is giving her a personal and physical stature that she would not have, in history, were it not for the photographs.

Plate 15. An uncustomary close-up, where the face reveals many imperfections, as it fills almost the whole width of the image. That wide scale forces us to focus, as in plate 12, on her throat. She has already been established as beautiful; here the beauty must be transferred from skin to something internal, the intelligence and grit behind the eyes. The photographer peers into the central, calm pleasure of her mouth. He wants to challenge the mere beauty, wants the camera to accept too much proximity and yet find it a beautiful excitement.

I won't try to maintain this snail-paced and merely verbal excursion through my mock-up of the original O'Keeffe series, but I hope that just halfway through I have conveyed a sense of its rhythms, of small or greater changes over a couple of years, and of a narrative of response to the camera as it alternates portraying her with and without her paintings, with and without the successful domination of the camera, with and without her own self-assertions. A reviewer of the 2002 National Gallery of Art exhibition, *Alfred Stieglitz: Known and Unknown,* finds looking at all the portraits of O'Keeffe "more of a duty than a delight," and blames the problem on Stieglitz's being artistically "reactionary" in this series, that is, unable to find a modern aesthetics for photography: "As a group, they [the O'Keeffe images in the catalogue raisonné] feel like self-consciously jazzed-up versions of 19th-century academic figure painting."[12] He finds them "tiresome," but, invoking nineteenth-century painting, he can hardly be thinking of the series as a concept and a procedure, since that is a medium virtually reserved for photography; it must be the posing that he finds retrograde. Plate 16 might play into his hands by appearing at first quite Pre-Raphaelite. But I find it much more hard-edged than that, the face making no compromise whatsoever with dreaminess. Plate 17 represents the smirk of the very first plate, but now much friendlier, as if having come around to sharing the humor with the viewer, whose gaze is seduced. I can't see subsuming this intimate and unpretentious, very real image under the category of academic painting, any more than plates 18 through 22, all of hands mainly isolated from the rest of the body and itching for things to do beyond their reach. Only one from among these,

plate 20, shows hands at work, in this case sewing; yet that image is iridized, trading the sense of function for one of pure design. These hands are also isolated from O'Keeffe's act of painting, the work that would give them their strongest meaning. But to show them in that act would be to distract from the hands themselves. Instead, these fine, elegant, and expressive hands join in the construction of a sort of naked body of their own, the true body of the artist. Then, in plate 23, an earlier image and the hands join; just fingers though, entering from below, to pull at her chest and throat. Stieglitz reassembles what he had previously examined in detail. But alone, set apart from the series, it is a pointless image as a portrait, of the nineteenth century or any other earlier period. The camera is sufficiently enamored of this body to record, and *feel,* what would normally be a transitional plan; or, we could say that in the series it can afford to multiply, indeed enjoys the luxury of multiplying, the sketches or studies of all the parts of this body. The series is an anatomy, in the sense that it wants to miss nothing, wants to know everything.

Half of our tour done and no scandal to speak of, though, in retrospect, it will seem the almost covered nipple of plate 11 risks being more pornographic than the full nudes to come. Plates 25 and 26 are the torsos, arriving finally as a shock, but not shocking for their nakedness or any pornographic value; they soar off the page, and being undressed only makes them cleaner, swifter, transcendent enough to seem almost out of body. These two are quite abstract, beautifully breaking up the space in all simplicity, as if there were no real difference between a real body and invented, composed form. The body is largely in the dark, the background using all the diaphanous light. Also part of our surprise is how this perfect nakedness arrives so late yet so completely in the *Portrait,* a neat break with what has gone before. Yet, if we think back on it, all the preceding series acted as our familiarization with O'Keeffe, and the development and pursuit of that mainly social intimacy has permitted us to arrive at the nude torsos with the sense of taking what turns out to be a natural step.

Further, these nudes are far from perfectly idealized bodies. This fact is powerfully brought home by a comparison Bram Dijkstra makes in his *Georgia O'Keeffe and the Eros of Place,* when he argues that this first torso, the Met's plate 25, resembles in various "essential" ways one by John Vanderpoel, once a teacher of O'Keeffe's in Chicago. Dijkstra reproduces the two torsos on facing pages,[13] but I find the confrontation of these two images even more instructive in their differences. For an example of the nineteenth-century academic nude continuing into twentieth-century art-school instruction, one can hardly do better than Vanderpoel's drawing, whereas, by comparison, in the Stieglitz photograph the far less

perfect form of his subject's actual body, as beloved and coveted as it may be, transpires at every point. Vanderpoel's woman has high, full, but perfectly decorous breasts, smooth and rounded body tone nicely fleshed out throughout, and a languorous pose from bottom to top, while the inclusion of part of the face affords us a view of demurely closed eyes. Every line is textbook. As for pubic hair, Vanderpoel hardly bothers to seriously hide its absence in dark shading. Stieglitz's O'Keeffe, on the other hand, is a bony woman, and the well-visualized heaviness of her breasts pulls her skin down to highlight the bones above her sternum. Below, her body is turned so as to bring her left hip bone to the edge between dark body and light cloth background, and the viewer's eye quickly associates this protuberance with that of her high-reaching and terribly dark

pubic hair. Finally, in part because of the angle, in part from what looks to be mere fact, she has almost no buttocks; the visual line runs straight down after the indentation at the waist. If anything, and especially compared to Vanderpoel's, this photograph translates the victory of the artist's accomplished desire to bring the beautiful out of what is, finally, just our bodies, to generate the beauty he *sees* without dissimulating what *is*. Stieglitz has not fallen in love with the perfection of her body, but is convinced of the beauty of the natural person he is willing to see.

And yet the body soars; outside of personality, it seems, coolly, aesthetically, as if this does not have to be any single woman, let alone the same woman, O'Keeffe, the person of the first two dozen pictures in the portrait. Yet again, if only by association, it remains her, but excised from the social realm; it is the sign of how far one may travel into personality, through the button, from social identities to intimate, personal ones (and revelations for her as well). It is an emphatic reminder that people are almost never portrayed artistically as *both* dressed—with us in the social—and undressed—that is to say alone, or revealed as alone—as if these two different states must remain separate because a person cannot or should not be portrayed as both public and private at the same time, or else the character would break up. But of course that double and thus complete portrayal is exactly what we are asked to take in here. Inevitably, we can come to see the nakedness or privacy in face or hands, their extreme intimacy and attractiveness of skin and bone, as well as the socialized version of the naked torso, its transformation into the sublime, a sublimation or, alternately, the public admission of a private life. The face can convey signs that tell us, or suggest they are telling someone, more about O'Keeffe's private intentions than the nude torso can reveal. This is, still, not to deny the sexuality of the nude; but we can admire it as much as we might covet it, or the body we imagine is there, and we can admire it differently when it is clothed, and differently from the way we usually view bodies that we see *only* clothed.

This revelation of O'Keeffe's naked body having been accomplished, in some three or four images, plate 29 begins a re-covering: a close-up of somewhat less pendulous breasts; the return of the frock or, we may guess now, peignoir, discreetly skirting the edges of the picture; the return of one hand, placed on her breast but not covering it. Plate 31, face dark and pensive, coat collar rolled high under her ears and mouth and held carefully and completely tight by the fine hands; she is as completely covered as she was a moment ago naked, and full of the privacy of her beauty, a privacy further declared to us by the sudden choice of a small format for the photograph. It is one of the greatest pictures of O'Keeffe by Stieglitz, and it is rendered even stronger in our examination of

sequence by its position after the nudes. Plate 32 marks a short transition, as a musician might recapitulate a theme or two: one hand against this black coat, and poised between two buttons, maybe two fingers lodged inside the flap to recall it was once pulled open or to assert it will now be held closed. Then, to end, plate 33, an almost haughty O'Keeffe, camera at midthigh height so that she towers, making the scene her own before accepting viewers. The hat has returned, worn high and back, arms are hidden behind the cloak she has wrapped herself in, slung around her in a sort of defiance before departure (there is a recall of the pose and draping Steichen sought for his images of Rodin's *Balzac,* reproduced in a 1911 issue of *Camera Work*). She is out-of-doors, the horizon is very low in the image; she takes her whole story—buttoned, unbuttoned, and between the two—away with her, on the mountain road. She has been open and frank in her body, and is now unadorned in her public guise; she presents herself as perfectly simple, self-confident, and off on an American, Whitmanesque tramp across the hills, on her own feet.

Her feet: precisely the image we lack. Including them, the 1921 show explored almost all of her body, dressed and naked and in transit between these two states of public and private imagery. Without transit, the bright and ever beckoning button, there is no eroticism, but it is not precisely eroticism that is to the point, despite the focus for many audiences on the torso, breast, and pubic hair. The nude and the dressed are, mainly, different personalities, clothing serving not so much to hide (except in transit images) as to replace the bare body with another bodily image.[14] When the series, as shown, ends with a clothed yet freed O'Keeffe, her nudity is both included, in the memory of our viewing, and surpassed; this woman, an artist, is other than her sexuality, as well as containing it. If Stieglitz ends O'Keeffe's story imagining her about to stride off on her own path, it is interesting that, of all the aspects of her to be revealed in 1921, only the feet have been withdrawn for any subsequent audience. They are either too insignificant for later critics and curators or implicitly too revealing of something, we know not what, but which Stieglitz definitely gave some importance to, with three photographs, the same number as for torsos.

The images of feet significantly modify our view of the *Portrait* as a whole. In *Georgia O'Keeffe: A Portrait—Feet and Sculpture, 1918,* her toes are crooked, even broken looking, an image of poor peasant feet with uncared-for nails. This photograph also includes the infamous phallic sculpture, here appearing very chalky and unreal, a hooded figure in fact, close up against an unidentifiable surface of skin.[15] In a second image, *Georgia O'Keeffe: A Portrait—Hands and Feet, 1918,* a sensual print on fine palladium paper, the pose is more relaxed, hands wrapped around

unshaven legs, feet appearing even lovely as they hang over the edge of the chair. Emphasis, then, slides from the nominal subjects to the unexpected frill of—bloomers?—high on her thighs. The image would have been more erotic in 1921 than it is now. The imperfect feet are an intimacy, through their vulnerability and mere exposure. But feet are not only erotic.[16] A third image, the one I reproduce, admits to remarkably beat-up, almost embarrassed feet. Showing as well her hairy legs, the photograph is clearly interested in the bared body, but it is virtually a debunking of desirable eroticized bodies, though her shift manages to billow out in a delicate elliptical framing of the legs.[17] In these photographs of feet, the effect of transit to the erotic is without glamour,

whereas they also give us proof of walking and standing as signs of work with independent style, "on her own feet," as the expression goes. Why do exhibitions and albums avoid these images, unless it is because they seem to transgress propriety as much as the censured nudes, though apparently without the same excitement? They translate too much unseemly, unladylike common enterprise, which is precisely why they make a strong contribution to our sense of the series as it comes to its temporary end, O'Keeffe about to turn and stride off on her high mountain road.

The photographs of feet also contribute to widening the scope of the series, so that we are less inclined to see other images as mere stalling or respite from the nudes, or to reduce the meaning of the series to a fragmenting of O'Keeffe's body, with a lingering on choice parts. Those torsos are not showcased nudes; they are a woman's body, along with whatever else she has the gall or grace to show us. While the surrealists were, at that very moment, on the threshold of breaking up the female figure, severing it into the obsessive details of their own fantasies, Stieglitz was marveling at all the parts in close detail and rushing all over the body with equally intense interest, then watching it reassemble in small increments, the whole picture being continually implicit as the *Portrait* was allowed to build. As if there might be some doubt in a viewer's mind as to whether this is constructive or fragmenting anatomy, the series builds in two directions at once: synchronically over the body in one moment, a sort of geography; and diachronically, over the time of their lives together, a history of this body, or of these geographies. This distinction from the surrealist effort to fragment is essential. In two subtitles near the beginning of her book *The Surrealist Look,* Mary Ann Caws demands: "Give Them Their Head: They Had One," and "Let Them Stand on Their Own Two Feet: They Had Two." Describing the surrealists' treatment of the woman and her body, Caws writes, "She can neither speak nor think nor see, nor walk and run, certainly not love and paint and write and be. Surrealist woman, problematic and imprisoned, for other eyes. She may be lit or framed, but she is not whole."[18] Already the series, in its necessary difference with any single representation, dismisses the sense of permanent fragmentation, time and time again, by pursuing all of the parts of the body. Though one could imagine a manipulation of the series concept to serve a dispersal of the body, an atomizing obsession with more and more details that would read as a never-ending dismantling, I see Stieglitz doing the opposite: giving in to the differences his subject shows him from pose to pose, recombining hand to foot, hand to breast, hand to face, ultimately to feel his way into the construction of that identity he intuited from the beginning, as if in

a piece-by-piece proof of his original assumption. The series serves to remind us of her many fine parts and various identities, but it also returns us to a rich but single, recurrent identity that registers as the personhood of Georgia O'Keeffe.

This is the sense in which I use the term "anatomy," a minute detailing that nevertheless is performed with the intention of lighting and constructing the whole view. The implied open-endedness of the series—to photograph O'Keeffe for as long as she stayed with or continued to return to him, and as long as he could hold the camera—signaled that the anatomy was never to be completed. This is as it should be, for this body is never going to be inert, but will change in time (and place as well), and will do so in its own good time, not Stieglitz's. He must be resigned to recording its passing, in her time and through his life. Differences in the elements of the series imply more differences, infinite variation; repetitions of the elements rehearse holding on to that which will be lost. Perhaps we should have preferred him to record more differences, other scenes. Shouldn't he have traveled to New Mexico with her, to photograph her there, a place she cleaved to more than to any person? But that was her time away from him, as he grew really older (in 1934, for example, she was forty-seven to his seventy), and she blossomed to her desert landscapes and became famous for doing so. It was a place in her heart from which she, or even they, excluded him. He could only record her returns, with skulls, or her departures, in her shiny black Ford. These images are all the more poignant in the series for collecting the signs that the anatomy cannot be complete, but contains loss. That is why it is Stieglitz's series, not O'Keeffe's, and to that degree a portion of his autobiography. For example, I find especially touching one image with the car that is never reproduced, a portrait with a road map. The excitement attached to the meaning of the car, the prospects connected to it through the unfolded, studied map, make the rich, sensual blacks and whites Stieglitz has managed to capture or create all the more poignant, and carry the feeling that all this beauty and anticipation prepare her imminent departure.[19] This strong sense that O'Keeffe existed without him, as well as with him, is mere recognition of a truth that does not subtract from the value of the many aspects of the anatomy Stieglitz had before him to convey. In any case, he had already been for a long time a photographer who did not move, did not search out his subjects in faraway places, even though that had been an early and enduring function of the photographer as the explorer of the exotic, the unknown, or the merely rumored who returned with the stunning, true document. As O'Keeffe recalled: "I never knew him to make a trip anywhere to photograph." If we require the wide world at large, Stieglitz is not enough. However, he

did us a different service when he stayed home, delving into a personal world the photojournalist, with her single, spectacular but disconnected moment, had not the time to bother with. Stieglitz enlarges his home-world, then enlarges it some more, inventing the anatomy of a world of feeling out of his anatomy of this one subject. O'Keeffe was, for him, big enough for this project: body, woman, person . . .

This is to assert that the single body, this body for this photographer, is immense and far-reaching in its meanings. William Ewing, in his *The Body: Photographs of the Human Form,* marshals hundreds of photos by many hands to illustrate a similar though multiple, survey-style anatomy of a whole genre. He offers numerous categories for the images under which to assimilate all the aspects of the photographers' interests: fragments, figures, probes, flesh, prowess, eros, estrangement, idols, mirrors, politics, metamorphosis, mind.[20] Ewing illustrates each category with a dozen otherwise unrelated images, but we could easily pursue any number of the categories in almost any single O'Keeffe image; in fact, we might see them surface innumerable times in different guises, in even a subset of the whole series, such as the forty-five or so photographs of the 1921 exhibition. As we are attracted to her flesh from one image to another (Ewing might have made a place for "skin"), don't we find it communicating prowess, or eros (itself certainly a sort of prowess), or the distance of estrangement, and are not any or all of these definite signs of her mind in the picture? While Ewing's chapters organize an extensive anatomy, Stieglitz's series, far from being narrow, complicates it richly. The single represented woman is quite prepared, I'm sure, to take on other grids, Mary Ann Caws's "surrealist look" or Anne Middleton Wagner's "plurality" of the self, in which she finds a "range of psychic and social states . . . cheeky, domestic, proud, withdrawn, contemplative, seductive, submissive."[21]

Georgia O'Keeffe—A Portrait, not to mention the series as a whole, maps a vast area of human nature and response within the compass of Stieglitz's single subject. Each of his showings would have been a new version, with repetitions and renewals; a new O'Keeffe was constructed, just as she herself constructed her own O'Keeffe, the portrait of a person she professed in 1978 not to recognize as herself. Over time, the portrait has congealed around a core group of images, but that was certainly not Stieglitz's objective and many different O'Keeffe's could be assembled. The four rarely seen images that I use (figures 7.3, 7.4, 7.5, 7.7) added to the three better-known ones (figures 2.6, 7.2, 7.8) offer a variation, a riff, one might say, on a Stieglitz O'Keeffe. Figure 7.4 is close to many more familiar photographs, but O'Keeffe has an effrontery in her smirk directed straight at the cameraman that the others lack. Part of that

7.4 Alfred Stieglitz, *Georgia O'Keeffe,* 1918. Palladium print, 23.4 × 18.9 cm. Alfred Stieglitz Collection, image © Board of Trustees, National Gallery of Art, Washington.

effrontery is her unabashed exposure of both breasts, far less idealized than in figure 7.2, and in their fine framing by her hands and arms, devoid of coyness. It is a completely untheatrical nudity. The legs and feet of figure 7.3 partake of a similar frankness; it is a relaxation after the effort of figure 7.2, the exposure of a nakedness behind the genre of the beautiful nude. The enveloping of fine white cloth both reveals a plainer truth of the body and contrasts with it. Figure 7.5, of 1931, is a late nude for an artist who took almost all his nudes of O'Keeffe in the first year or two of their relationship. There are four of these, very similar except that two are vertical, with O'Keeffe standing, and two horizontal, as here. These images bear a striking resemblance to an earlier painting by O'Keeffe, *Grey Line with Lavender* (1923). That title identifies the painting as an abstraction, but Stieglitz is now redrafting its shape as his own eulogy of her age-resisting body tone and shape (she is about forty-five years old here), asserting that both her work and her body remain youthful for him. The image of O'Keeffe painting (figure 7.10) has been reproduced rather frequently. We do not get very close to the person we really want to know about, the painter of close-up intensities. Though the image generates a sense of intimacy, of the artist's privacy in the tight country scene of her subject, she herself wears the scene of painting lightly. I will return to this image later. In figure 7.7, taken some fourteen years later, O'Keeffe looks off in almost the same angle, yet she appears far more decided, poised, set in her views, knowing. She is no longer

7.7 Alfred Stieglitz, *Georgia O'Keeffe,*
1929/1932. Gelatin silver print, 11.8 × 9.2
cm. Alfred Stieglitz Collection, image © 2004
Board of Trustees, National Gallery of Art,
Washington.

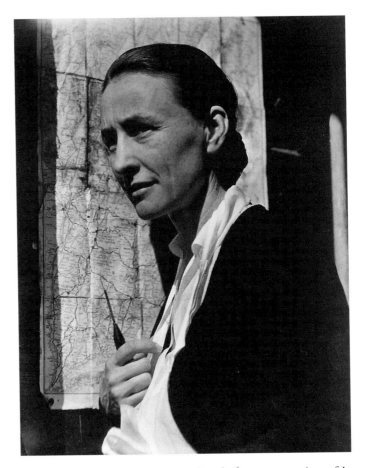

staged in front of her paintings but before a map, sign of her seasonal
departures to New Mexico which left Stieglitz for long summers at Lake
George (actually, the map is of western Connecticut and Massachusetts,
an area the two would have explored as a pair). Her face is the most pow-
erful of any images I can recall, and the photograph belongs very much
to the documentary vein of the 1930s. Considered together, my little
series is less dreamy than what is usually presented, balancing realism
and aestheticism in a purposeful alternation.

So it was not a series to be finished in a year or two, but one that
evolved during twenty years of photographing paralleled by a similar
period of evolution in exhibiting, of reediting his view each time: twen-
ty years for the subject's maturation, at home, under the photographer's
maturing and aging gaze. And I have said little enough about O'Keeffe's
own gaze, what she may be constructing in her look, friendly or haunt-
ing, what games she may be playing with the male photographer she is
so willing to meet through his lens.

Whose O'Keeffe?

Obviously it is not for me to argue that O'Keeffe was the victim of Stieglitz's male gaze, his manipulative art to acquire and publicly assert mastery over her artistry and soul by blanketing her body image with his photographs. The premises of such an argument are perfectly valid and useful in general, but I want to reassert a closer balance between these two artists. Indeed, Stieglitz—who I am convinced was in his heyday a force to only a handful of artists and collectors—by virtue of that handful's subsequently doing well in the marketplace of culture, and the fact that he never relented in his advocacies, has been transformed in cultural memory into a titan of influence, even a robber baron of cultural capital. For some, he has been seen as an ogre for O'Keeffe, her own Svengali. The projection of O'Keeffe as undeserving victim (after her death, be it noted, beyond the reach of her protestations) is remarkable, considering she had ample time and occasion to assert her independent powers for some forty years after Stieglitz's death. For many of those years she was far better known to the public than he, and was well known to defend her opinions and privacy with a peremptoriness that resembled none more than his own. It ought to come as a surprise that she must be extolled at his expense, even to making him a whipping boy for any failures we may perceive in her accomplishments as a woman and an artist. "Georgia O'Keeffe and Alfred Stieglitz: a conversation in pain" reads, accidentally of course, an e-mail from my library reminding me the book will soon be overdue; this randomly generated version of a title neatly sums up a powerful segment of the current climate of opinion about their relations, presumably from her point of view. The book with the maimed title features essays by three authors who all strive for a balanced view, but that effort is hampered by the climate of prejudice which requires that Stieglitz not be overpraised and that O'Keeffe rarely exhibit any human faults, only artistic merits. He has many terrible weaknesses, as she is the first witness to. On the other hand, he finds inspiration in her numerous perfections and achievements; that is to say, she may be discussed as an artist we have grown to love who had a beneficial influence on him, but he must figure only as a problematic human being whose influence on her was mainly self-serving and often harmful.[22] The current marketing of Stieglitz must now pay fealty to O'Keeffe, concede he is a tributary to her major position, which he had presumably tried to obscure or control. I think, for example, of the marketing of the authoritative biography of Stieglitz by Richard Whelan, a book that does not mention O'Keeffe anywhere in its title and only brings her onto the scene about two-thirds into the volume, on page 347, at a point which

is perfectly appropriate. Yet the publisher's jacket declares, above the title and author and facing the portrait of Stieglitz: "Photography, Georgia O'Keeffe, and the rise of the avant-garde in America," implicitly giving her credit for her husband's many years of work in support of photography and the revolutions in the arts which she had no hand in at all, whether before or after they met.

Did Stieglitz the photographer exploit his model, and did Stieglitz the gallery exhibitor exploit his artist? Loving or using the artist in the lover, loving or using the lover in the artist—how to say with certainty in the constantly shifting dynamic?[23] Further, we see the nude in a different light now, the rules of engagement, so to speak, having changed; but all the more reason for us to resist projecting onto a relationship between two exceptional people of seventy-five years ago our own versions of a photographer's proprietorial gaze or gallery manager's self-serving market strategy. O'Keeffe was a partner in her portrayal's stripping of American Victorian modesty, as she had already had occasion to balk at her community's squeamishness in Texas. The 1921 exhibition struck the chord of two avant-garde, more or less bohemian artists who were not in the least in thrall to the social norms in force, and the manner in which we choose to reconstruct those norms cannot, alone, tell us what O'Keeffe and Stieglitz were doing. The outrage alone may have made it palatable for both of them, worth daring American communities. "How could she do it?" I have been asked, but that seems mainly a rhetorical question full of today's correct indignation, and no answer to the real question will suffice to put to rest the rhetorical one. Another female informant of mine felt O'Keeffe must have gotten some pleasure from the process, or from the results, might even have "got off on it." She must have been aware of her daring, and, as icing, she could unrepress some dangerously felt pleasure at this admiration of her slight five-foot-four-inch frame. But we cannot put a definitive end to this part of the debate; only O'Keeffe might have the full, true answer of why she posed, and I think she showed she did not have entire access to it herself when she said the images seemed, after intervening years, to be of another person: "I wonder who that person is. It is as if in my one life I have lived many lives."[24] If we believe that, we should give credit to Stieglitz for seeing the many lives circulating in her, for seeing her rich identity as multiple. One of those O'Keeffes "got off on it," and sold the others on the project.

Even if I understate Stieglitz's power and gain, I doubt we come closer to the truth by arguing, as various critics have done, that in the 1921 show he is bragging to the public that he is in charge of producing not only the O'Keeffe persona but her orgasms as well; or that, to cite

an opposite view, his own work is a sublimation adroitly elaborated to withhold his sexuality from the Woman, whom he imagines as a blood-sucking sphinx. Also, the couple were having too good a time in their New York studio in 1918 for me to follow Benita Eisler into the "horror" she sees Alfred intuit at the source of his interest in Georgia's body: "devouring darkness defined the essence of Alfred's yearning and dread; the dark source of all mystery and terror, of life and death."[25] While these ideas at least have the merit of being sexy, I am finally knocked for a loop by the argument that O'Keeffe would have fared better, or been better off, if she had never met Stieglitz.[26] It is foolhardy to second-guess history, particularly when the evidence points the other way and the presumed victim chose to cleave to her persecutor/protector to the end of his life and beyond. O'Keeffe was under no duress when she wrote, thirty years after his death and in the same text in which she proclaimed his many faults and weaknesses: "He gave a flight to the spirit and faith in their own way to more people—particularly young people—than anyone I have known."[27]

A close look at their early relationship can show the extent to which Stieglitz did or did not turn O'Keeffe's career and person into a self-serving appropriation or exploitation. The simple opening fact in their story is that he fell for the work well before he had a chance to desire her person, so his inaugural move provides quite a neat parallel to her saying much later, as I have quoted her in note 22, "I believe it was the work that kept me with him." Stieglitz thought her drawings showed genius before he ever met her, and he gave her her first show at 291, in May 1916, without even knowing the budding artist was in New York. He did not know who she was, nor what she would look like in a photograph, when he made the famous statement about her, "finally, a woman on paper." He also said to the person who brought him the drawings, Georgia's friend Anita Pollitzer: "Are you writing to this girl soon? . . . Well tell her they're the purest, fairest, sincerest things that have entered 291 in a long while."[28] O'Keeffe's response, to Pollitzer, was certainly very pleased, yet also a bit coy about having her work seen by the public. She had gnawing doubts that she had anything to express at all as a painter: "I am glad you showed the things to Stieglitz—but how on earth am I ever going to thank you or get even with you." She claims she doesn't care if they are never shown, yet wants to know what an audience might say (this is an ambivalence we find her voicing at other times in her career). Public aside, though, Stieglitz's opinion is already hugely important to her, and it is explicitly linked to pursuing a career as a painter: "If Stieglitz says any more about them—ask him why he liked them—. Anyway, Anita—it makes me want to keep on—and I had

almost decided it was a fool's game.—Of course I would rather have something hang in 291 than anyplace in New York."[29] Shortly afterward, Georgia decides to take the plunge and write Stieglitz directly, to solicit his thoughts about *her:* "If you remember for a week why you liked my charcoals . . . —and what they said to you—I would like to know if you want to tell me."[30] From these few quotations I would deduce a number of things: that Stieglitz's interest in O'Keeffe's expressive body was aroused only after he had made a wholehearted commitment to her art; that she pursued him to some degree, in perhaps a passive-appearing manner, and in part because she could see he was already interested in helping her career; that when he hung a show for her in May of that year, and she arrived to demand that he take it down, he had responded to a vanity in her that she refused, or pretended to refuse, to recognize in herself; finally, that she was, when he praised her in January, hesitating to continue to paint and draw at all, or at very least was writing to a friend to hear objections to her quitting, and that in making her decision to continue to paint she needed Stieglitz's approval more than that of anyone else. I doubt that her life and career, even her artistry, were better off without him at this point, as at many points subsequently, and I doubt she was forced by him to do anything she didn't yearn for pretty transparently. She was happy to be coaxed.

O'Keeffe's difficulty in making important decisions increased in the following year when she could not decide to commit to the man she had fallen in love with, Arthur MacMahon, a young professor at Barnard College (he was her junior). Laurie Lisle believes she understood MacMahon would never accept her all-embracing desire to be an artist, an independent one at that.[31] This opinion serves to confirm, in my mind, that O'Keeffe's eventual relationship with Stieglitz arose out of his complete commitment to her as an artist, this quite aside from whatever personal love and fondness came to inhabit their lives.

Subsequently, O'Keeffe wanted to remain in Canyon, Texas, where she had been given a job as an art teacher, and she had no intention of returning to New York. Though Stieglitz regaled her with praise for her work, copies of *Camera Work* and *291,* along with his first photographs of her in front of her pictures, which she was proud to show off to her students, she felt the need to stay away from the man. She wrote Stieglitz's niece: "He is probably more necessary to me than anyone I know, but I do not feel I have to be near him. In fact I think we are probably better apart."[32] With that, the stage was already set for her long summers in the Southwest after 1929, stays that were never intended to be permanent while he was still alive. As proof that he thought her the best of the spirit of 291, he gave her a second exhibition, in April 1917.

It simultaneously advertised her as strong enough to stand against the whole Independents' exhibition, just as he had earlier tested his own work against the Armory Show, and important enough to represent the last statement his 291 gallery was to make before it closed forever. "Well, I'm through," he said, "but I've given the world a woman."[33] There certainly is some proprietorial pride in this statement, but not of the obvious sort, as the idea of birth is crucial. He hasn't taken her but given her away; indeed, he anticipates never "having" an artist again. His production of O'Keeffe is a father's, and he relinquishes her as she proves herself. She, for her part, had just shown up in New York, spontaneously, or impulsively; or at least so it has seemed in retrospect, though she wrote afterward to Pollitzer: "Stieglitz—Well—it was him I went up to see—Just had to go Anita—There wasn't any way out of it."[34] Her timing is interesting, as her spontaneity was seriously mulled over. Though her teaching had ended five days before she decided to leave Canyon, she managed to avoid getting to New York before her show closed, on May 5. An anxiety over seeing herself being seen should not come as a great surprise to us. A year earlier, Stieglitz had no doubt browbeat her, albeit in an altruistic and hardly selfish manner, when he wouldn't take her pictures down as she demanded. Now, he rehangs the whole show for her alone. For him, this is a great deal of physical and mental work, a great deal of esteem and graciousness; a great seduction, in response to what seductive, unannounced appearance of the woman we do not know, except that we know how he imagined her through her work, "purest, fairest, sincerest." For her, seeing the rehung work is to bask in his complete conviction and confidence in her value as an artist but expressed only to her, to prove her value to her alone, since she seemed to require the proof. She should paint; the public, and the sale, need have nothing to do with it. I imagine he gave her pretty much exactly what she wanted, including the fabulous luxury of not having to ask for any of it.

With these magnificent assurances O'Keeffe returned to Canyon, to a job in which the teaching aspect was probably quite acceptable, but where small-town middle America was asserting a patriotic fervor she found far too intolerant, not to mention its native puritanism, which she found laughable. She was outspoken on at least the first count, and people were looking aslant at her criticism of anti-German prejudice. The small-mindedness of both the town and the school contributed to her failing spirits and health in her very first term; she requested a leave of absence and went to stay with a friend, Leah Harris, on a farm in Waring, Texas.[35] It is here that Paul Strand came to visit, delegated by Stieglitz to determine if she could not imagine herself better off in New York. I don't say "persuade her to come," which is how we would naturally read

Stieglitz's selfish motives. It is remarkable how much emphasis he put on the necessity that she not be persuaded by others. For example, he wrote Strand: "If she wants to come—really wants to—feels the necessity—and feels that she can stand the trip physically—all else would arrange itself."[36] Strand was with Georgia and Leah for about a month, alternating a number of roles: he was potential lover of Georgia (he probably had taken the job of emissary to cover for his own motive in coming); then suitor to Leah, who might or might not have been in love with Georgia; representative for Secessionist and liberal-thinking New York in general, and for Stieglitz more specifically as a potential Maecenas; and he was a photographer, having already once seduced Georgia with the abstracting close-up work of 1916, and in Waring proceeding to photograph Leah in the nude. All of the relations in this western ménage were, I'm convinced, platonic; the evidence ought to lead us past our own "liberated" prurience, and we should read the scene as taking place more likely in a novel by Edith Wharton than one by Henry Miller. Regardless of what he felt physically about O'Keeffe, Strand saw his first duty to her, if he were to take her on, as providing for her, though this admittedly old-fashioned concern was not exactly the bourgeois one for household goods and parlor comforts but called upon him to provide the leisure and the means to do her work as an artist: "If I had money I might be able to help her—I know I wouldn't be afraid despite the difficulties of living with such a person. But I haven't—so it is all very clear to me that I am not the one. Besides, it is very clear to me that you mean more to her than anyone else—so it seems that you and she ought to have the chance of finding out what can be done—one for the other."[37]

Both Strand and Leah Harris recognized O'Keeffe's need for a "stability of living," and they saw her as a combination of child and adult woman, a determination that was not, therefore, restricted to Stieglitz's fantasizing.[38] I doubt that "child" was used derogatorily, even though the word conveys a sense of helplessness, of requiring help from others. In terms of being an artist, the word described the spontaneity and directness of one uncontaminated by academic strictures, not childishness but a child's acuity. We must remember that Stieglitz had shown children's drawings at 291 for the value of their youthful perceptions, as yet free of the censorship of teaching. Modernism retained that aspect of romanticism that reviled academic teaching for burying expression under layers of traditions disassociated from their meaningful sources. Further, the growing discourse out of Freud insisted that the examination of childhood revealed great psychological depths, raw insights that should not go unheeded. Later that summer, in a letter to Dove, Stieglitz not only categorizes Georgia as a wonderful child— "O'Keeffe is truly

magnificent. And a child at that"—but he includes his rejuvenated self: "We are both either intensely sane or mad children.—it makes no difference."[39] In the twenties, Frieda Lawrence could still see this sort of "childishness" in O'Keeffe when she referred to her as "unmuddled."[40] When, near the end of May 1918, Strand goes on to photograph Leah nude, he writes to Stieglitz: "This afternoon—finally nude—very wonderful—you can imagine how free things must be for anything like that to have happened. . . . [Leah had to have] no fear for that."[41] While O'Keeffe was drawing Leah at the same time, and thus served as chaperone, it is relevant to understand that they were acting freely, taking liberties both from and within the confines of propriety. Strand and Leah had ventured beyond the boundaries implicit in the forms of conventional virtue to explore a more authentic or original meaning of virtue, a child's innocence. It does not sound to me as if they were looking to transgress sexually, and I hazard to guess the adventure was, even, the more exciting for their restraint, which was the reasonable price to pay for "purity." It is further interesting to realize that, though these photographic studies of Leah modeling nude have been lost or destroyed, Stieglitz was well aware of their being taken, and so there is a second precedent, after his own photographs of "Ellen," for his nudes of O'Keeffe.

When, a number of months earlier, Stieglitz had dispatched Strand to Texas, the ostensible reason was his concern for O'Keeffe's health. Her symptoms have never been clear, perhaps influenza, perhaps "consumption," as tuberculosis was called. I suggest her psychological state—the problems brought on by being both outspoken and relatively uninhibited in her small, tight Texas community—must have played a large role in the difficulty of formulating a purely physical illness.[42] Whatever the actual causes, their resistance to a cure only increased Stieglitz's fatherly impulse and concern, which he voiced by letter but especially by proxy in the younger and very attractive person of Paul Strand. He did not intend to stand in the way of Strand and O'Keeffe if they chose to make a go of it. He in fact staged that chance while remaining devoted to her artwork, and, having begun a commitment, he would most likely have continued to work for her career. From her point of view we see the extraordinary value of Stieglitz as a father figure who *stayed* put, both physically and in his unrelenting and principled stance in defense of new artwork in America. This behavior was the very opposite of her own peripatetic father, whose absences were also psychological. In later years, when O'Keeffe wandered about her faraway desert, Stieglitz was always in his place for her, the rock to return to in the fall with the stones and bones she had collected. In 1918, however, the fatherly role led, slowly I

think, to another, less sublimated one. Strand "delivered" O'Keeffe into Stieglitz's care at Penn Station on June 9, 1918, and the older man took her to his niece's studio, visiting every day as her "strict nurse." Their relationship remained chaste in fact, if not in appearance, at least into August, even after he had left his wife and moved in, stringing a curtain between their sleeping spaces.[43] In their chastity, he mended her free spirit, she renewed his eye; in consummation they gambled they could keep their new childishness glowing. Given the successes of that arrangement, his return to his own work with the three series of buildings, of clouds, and of her, and her impressive and uninterrupted rise to fame beginning in the twenties, it seems perverse, if not highly prejudiced, to suggest she would have been better off without him—or, for that matter, that either could have been better off without the other.

O'Keeffe Presents Herself and Her Things

What do these early shows of O'Keeffe's work show us she might be saying about herself, in her own voice?

Stieglitz saw his job as bringing this essentially reclusive talent to an American public, since she could not be bothered to do so herself, and to foster a critical discourse around her, another job she despised, when it did not make her downright ill. For a certain period early on, he mainly held her work back from major exposure (in any case there is no indication she pushed for a showing between 1918 and 1923); this is not unusual practice for a dealer, which he had to be in some measure, in order not to peak early or flood the market with untested values. That market was small enough anyhow, and could not absorb much. But also, Stieglitz being who he was, he preferred to let her paint what she wanted for a considerable period without public feedback, and we understand her well enough to know that this would be something she wanted to be able to do. At the same time, he did not hide her completely away, but found occasion to defend her vigorously as an artist and as a woman artist. When an exhibition at the Pennsylvania Academy of Fine Arts organized by Arthur Carles in April to May of 1921 decided to pointedly exclude women, Stieglitz refused his collaboration until they rescinded the exclusion, and O'Keeffe was represented by three works.[44]

Another reason for their, or her, reticence to exhibit is that it is in her own drawn or painted work that O'Keeffe considered herself most naked, the most revealing of her person, the part of her she could hardly bear to show. Consequently, it is in the act of painting that Stieglitz showed the most discretion when photographing her, there being only one scene of her doing so that he offered to public scrutiny, as she sits

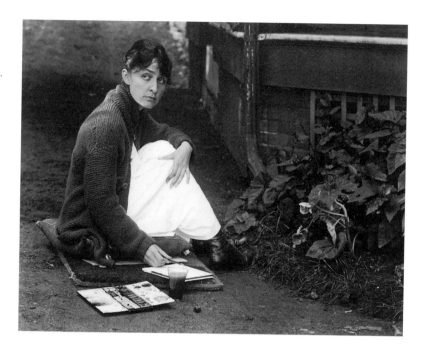

almost bundled up on the ground at Lake George delicately handling her
brush (or pencil, in another shot) off to the side of her, as if she could be
offhanded about it, without professional focus. From the perspective of
this discretion, her most naked self and most overt desiring take form
behind her body in those early portraits at 291, where the images of her
face, throat, and shoulders become her public face blocking our view of
her painted, self-expressing image on the wall. Finally, both O'Keeffe
and Stieglitz deemed her ready for a full-scale unveiling, at the Anderson
Galleries in January 1923: "Alfred Stieglitz Presents One Hundred
Pictures . . . by Georgia O'Keeffe, American," a presentation that grew,
as the show went into February, to some 137 works in all.

There were any number of striking shifts in O'Keeffe's conceptual-
ization of her work over the years, and at least three important ones
before the 1923 show. These shifts are interestingly connected to changes
in medium: to charcoal, from an earlier, poorly documented period of
schooling in all mediums, in her mind a time of enforced imitations; on
to watercolor for a greater freedom, controlled line giving way to color
and the aleatory seeping of water into paper; finally to oils and their sat-
urated permanencies, this about 1918 and thus connected to her arriving
in New York to stay for many years.[45] All three stages were made part of
the 1923 exhibition and were explicitly mentioned in the announce-
ment's full title. Most of the early photographs of O'Keeffe are taken in

front of the charcoals she drew when she decided her work before 1916 was not truly her own. While I am not a great fan of them as artwork, they are remarkable on at least two scores. First, they represent a powerfully willed break with traditional representation, being of unknown or difficult-to-recognize objects, though objects all the same—what I might call, oxymoronically, abstract objects—with titles like *Special* or *Early*. Second, they represent a conscious return to basics, exploring the simplest, first means to instigate a renewal of personal authenticity: "I decided to start anew—to strip away what I had been taught—. . . . I began with charcoal and paper and decided not to use any color until it was impossible to do what I wanted in black and white. I believe it was June before I needed blue."[46] Judith Walsh calls this process "a deliberate re-enactment of her art training."[47] The similarity to the restricted field of photography is hard to miss, especially as O'Keeffe had probably seen Strand's 1916 experiments. But of greater relevance is the similarity of the idea of an unspecifiable "Special" and the idea of a study. As an art school exercise, the practice with values of line and shading in charcoal was a personal, ultimately private testing and exploration. But O'Keeffe was now performing a study of something else with the old basics; no bust or old frieze to replicate, but almost hallucinatory forms that she wishes to reorganize. The charcoals can remind us of various works by Odilon Redon, a Frenchman who exhibited his black-and-white work at the Armory Show. In Redon there is both more clear representation and more overripe symbolism, or decadence; O'Keeffe is both simpler, with less "story," and more enigmatic. Her personal symbolism, while frequently reminiscent of decadent drooping or brooding, is not so overrefined, but energetic enough to feel like it is ready to ride roughshod over its own subtleties with the medium. As Walsh puts it (but of all of O'Keeffe's work): "Her pictures, which must be viewed intimately, offer a startling incongruity: their pristine and subtle surface contrasts with the bold graphic design."[48] So we see, already in this early period of charcoals, a repeated, double insistence that can be found throughout her career: inelegant larger strokes (of heavy black in charcoal, of large, almost lumbering forms in oils) and carefully variegated shadings, the thumb or cotton wad modeling the soft underbellies of her bold, abstracted shapes; a delicacy with the personal detail that restrains the bravado of larger forms. One example is *Special No. 13,* of 1915, to the extreme right in figure 7.9, a record of a 1944 exhibition.

With the watercolors, particularly of nudes dated 1917 (some feel they are of Leah Harris, and thus date from 1918), the addition of color does not add dimensions as much as it withdraws, notably the drawn line. Far more than charcoals or oils, watercolor is an art that poses difficulties

7.9 Installation for *History of an American, Alfred Stieglitz: "291" and After,* Philadelphia Museum of Art, 1944–45. Yale Collection of American Literature, Beinecke Rare Book and Manuscript Library. From left to right: O'Keeffe, *Nude Series VIII,* 1917; Picasso, *Drawing,* 1911; Stieglitz, *The Steerage,* 1904; O'Keeffe, *Blue Lines,* 1916; O'Keeffe, *Special No. 13,* 1915. Picasso image © 2004 Estate of Pablo Picasso/Artists Rights Society (ARS), New York; all others © 2004 The Georgia O'Keeffe Foundation/Artists Rights Society (ARS), New York.

in delicacies that are hard to correct. O'Keeffe's nudes are largely monochromes, a few deft strokes that are taken over by what the paper will do with the various flows of water. She had seen the Rodin drawings at 291 in 1908, though she later wrote they had meant little to her then. Rodin's pieces are marvels of looseness, of giving in to the stroke and the paper support, but O'Keeffe goes an important step further than Rodin by beginning with no lines at all. In this she does not so much build on the charcoal work as finishes with it; unless you find, in retrospect, that she was already fighting with line in the charcoals. All the definition of her figures must emerge from the brushstroke alone, producing a high number of quick studies that do not lend themselves to reworking rather than fewer, more pondered ones. The intention must have been to practice the

The Serial Portrait (1917–1935)

stroke itself, after the models from Japanese art that she had studied with the influential Arthur Wesley Dow at Columbia Teachers College in New York. See her nude in figure 7.9 where, in the 1944 Philadelphia exhibition, the watercolor is purposely contrasted with a line drawing by Picasso.

In her watercolors there arises a confusion in the image very different from that of the charcoals. The subject is obvious, and the viewer need not rush to the symbolic. At the same time, no line assists definition, and there is no telling where the brilliance or luck of the stroke leaves off and the felicity of pigment-thickened water meeting paper takes over in portraying the quality of flesh and the flights of bodily form. In other words, having returned the subject to us, at least as a proposition, O'Keeffe makes herself the more free to give herself up to the medium, dappled, speckled, puckered paper under drifting or pooling colored waters. In other watercolors she has less overlaying of strokes, as an extended palette restricts bleeding to only carefully chosen areas. Her 1917 group entitled *Untitled (Abstraction/Portrait of Paul Strand)* bleed a good deal but retain carefully delineated white lines—that is, unpainted paper—around the important mass funneling down the middle. More than the nudes or the fine watercolor landscapes of this period, these "portraits" appear thoroughly abstract, jettisoning representation more thoroughly than Max Weber or Dove before her, more than the famous Kandinsky. Her use of the medium, where the absence of paint is the closest indication of line, underwrites this degree of distance from any object, real, reduced, or imagined, that might be portrayed; if only for that reason, these paintings are fully the opposite of the charcoal drawings. Nowhere in her work was she more free.

The proportion of abstraction to objective work was high at the 1923 exhibition—over half, says Barbara Lynes.[49] O'Keeffe's early oils could be almost as abstract, but, medium and intention aiding, the reworking and finished permanency appropriate to oils conspired to solidify her forms, giving solid bodies to abstract musings. In response to overly sexual, or so-called Freudian interpretations of these abstracted forms, O'Keeffe decided to become more objective, producing thereafter, and mainly in oils, large flowers, fruit, stones, and shells that filled her canvases to the brim. But we have too strong a tendency to conceive of the abstract and the objective work as alternating, coming in waves of almost angry, mutually excluding rhetorics. O'Keeffe insisted they were aspects of the same painted subject: "It is surprising to me how many people separate the objective from the abstract. Objective painting is not good painting unless it is good in the abstract sense."[50] For her, the object observed became abstract as she entered it into the picture, devel-

oping form on canvas rather than recognizability: "They [a roof shingle and a shell] fascinated me so that I forgot what they were except that they were shapes together—singing shapes."[51] O'Keeffe felt that she was always painting objects and that abstraction was her expressive method, a distillation which, in her mind, did not even dissimulate the object, so that she could write that some of her portraits "are almost photographic," though they have "passed into the world as abstractions—no one seeing what they are."[52] One ought not, therefore, look at her abstractions as being opposed to objective painting, but as a modulation of the objective, a learning to paint that rendered her objects emotionally real to her as images on flat canvas. When she consciously fled her very abstracted work to paint more recognizable, solid objects, hoping that their solidity would dispel real or imagined emanations of female sexuality, she failed quite spectacularly; what she had learned by abstracting forms carried back into her blowups of flowers, which revealed their deep fecundity, or into her special modeling of canyons, which closed their flanks over sinuous valleys.

The nature of the connection between object and abstract form was not new to her, in 1923 or in 1916 for that matter, anymore than it was unique to her. Dove, for one in the Stieglitz circle, had nicely verbalized the job before 1914, the year in which he had been cited at length in Arthur Jerome Eddy's well-circulated *Cubism and Post-Impressionism,* a book which O'Keeffe knew well:

> One of these principles which seemed most evident was the choice of the simple motif. This same law held in nature, a few forms and a few colors sufficed for the creation of an object.
>
> Consequently . . . I gave up trying to express an idea by stating innumerable little facts, the statement of facts having no more to do with the art of painting than statistics with literature.
>
> The first step was to choose from nature a motif in color, and with that motif to paint from nature, the form still being objective.
>
> The second step was to apply the same principle to form, the actual dependence upon the object (literal to representation) disappearing, and the means of expression becoming purely subjective.[53]

Dove searches out a simplifying motif as a principle already operating in objective nature; abstraction has already occurred before he gets to his second step, where he applies a principle of the revised object to his own created form. In this double operation, verbally very close to O'Keeffe's version, he evinces a desire not to modify the object as much as to reenter it more personally. As Fine and Glassman write, in a comment on the

passage from Dove: "Americans looked to the shapes and forms, the 'thingness' of the world around them, to reveal their inner states."[54] While there is no way to avoid personal expression, neither is there any way to surpass things. To give the last word on this interpenetration to O'Keeffe: "I have used these things [flowers, seashells, rocks, and pieces of wood, white bones on the desert] to say what is to me the wideness and the wonder of the world as I live in it."[55]

This "thingness" is worth examining for a moment, as Fine and Glassman are reiterating a generally held opinion that American artists of the time preferred to portray the concrete rather than to illustrate theory. Though O'Keeffe's eloquent statement sets objects as her first, generating principle, her sentence is constructed as a displacement; the things are not valued for themselves, in thingness, but are "used" "to say" the "wideness and the wonder" in her perception, narrowed to how only she lives in the world. In twenty-three words she finds room to assert her "I" or "me" three times. It is high recognition of her subjectivity, and honest; it is only within a point of view that objects can be hoped to assert any sort of emphatic thingness. The paintings of huge, engulfing flowers or one big, centrally placed pear are close-ups that, while they invoke abstraction in form in a manner similar to Strand's photographic close-ups of the same period, also embody a need to get ever closer and closer to the thing, so close as to really see a degree of thingness that is habitually neglected by the common man in his hurried and distracted life. Thus O'Keeffe is not offering the quiddity of the object so much as she is aggressing the viewer with it, demanding that he recognize his need for it. The close-up is the mode for making contact with reality in the context of one's lack of contact under normal circumstances of neglect and alienation. So this art is not, or certainly not wholly, a filter, that is, a sifting, reshaping, distilling of a felt reality but largely a philter, a precipitatory incantation to bring about an intense reality, just as much for the painter as for her audience. The painting as philter is a wish, because the artist feels the lack of cultural attachment to things.[56] The reason I see this distinction between thingness and wish for thingness to be important is that in 1920, as now, a hallmark of American culture was that, though it was recognized and decried as materialistic, its materialism bore little relation to the reality and value of material objects. Gertrude Stein wrote, in her famous autobiography of 1933: "[Americans] have no close contact with the earth such as most Europeans have. Their materialism is not the materialism of existence, of possession, it is the materialism of action and abstraction."[57] Ever-increasing quantities of new, improved, more convenient objects, always immediately translatable into monetary value, supported an American

7.10 Georgia O'Keeffe, *Alligator Pear*, 1923, pastel, as reproduced in *The Dial*, vol. 80 (1926).

Permission of Alfred Stieglitz

ALLIGATOR PEAR. BY GEORGIA O'KEEFFE

dream that was always abstract, in the sense that the dream to possess ever more emptied one's existence of any things meaningful in themselves. Americans were raised to cherish ideas about things, what these things meant in terms of newness and status, with newness itself an element of status as the replacement of belongings became even more praiseworthy than ownership. It devolved upon the resisting poets and painters to forego romantic dreaming and hammer away at their own alienated, "abstract" culture, to call for "no ideas but in things."[58] Granted, it becomes a little confusing when the artist reasserts a degree

of abstraction in her representation of thingness. But this artist's abstraction wants to enjoin the thing in a very personal discovery of its solid meaning, of the meaning of oneself in its context. For O'Keeffe, "abstraction" means personal, and thus subjective, commitment to the object, as a reality lesson for herself and for her viewers, and it is supposed to serve as an antidote to the American's "abstraction," his rush from one discarded thing to the next in search of exchange value that, he hopes, will abolish his mind's hunger. Of the audience's need for such a vigilant painter or poet, Wallace Stevens wrote: "I am the necessary angel of earth, / Since, in my sight, you see the earth again."[59]

O'Keeffe's things are not necessarily larger than life, as the canvases are not always large, but the object is more and more deeply penetrated, then exposed as it fans out to cut off our vision of anything else in the picture. She carried us further inside of what is outside of us, into the intimacy of what is purely, overwhelmingly other than ourselves. A pastel like *Alligator Pear,* which attained some fame at the time by being reproduced in *The Dial,* has a rocklike solidity that comes from the scale of the fruit's singular presence (and this despite the lighter medium). It is a boulder of thingness, so much so that it does not even have to literally fill the image to do so in one's sense of it. Space around this hardshelled avocado is blank, mere support for a terribly simple shape and its double shadow. Philterlike, the fruit imposes its material existence, and stands alone to affirm it cannot be used for any other purpose than being there, more than a little astonishing in the power of its muteness.

In many of O'Keeffe's paintings a similar shape, bulbous, full, and accidented rather than smooth, or erratic as compared to the neatly drawn, is invasive of the rest of its support, and is so large as to appear at times like a negative space; an avocado-shaped piece of sky or water, very close to pure, vacant abstraction. In her very personal projection of herself into her landscapes, this negative sky is, I think, linked to another recurring feature, the gash, or split, or slit, or scar down the middle of her canvas which, inevitably, sets up the sexual metaphor she abhorred to see discussed. Granted, you can hardly get away from it, though I believe it operated sufficiently below consciousness for her to miss or ignore it, she who could discern the portrait in an abstraction. Flower petals open invitingly down their middle, canyon walls rise like soft thighs around their meandering and partially hidden valleys. The overdetermined, central position of the gash plays a large role in its erotization by the viewer (in this game the artist molds the voyeur in the viewer); if O'Keeffe had placed it more off-center she might have succeeded in keeping her flower a flower, though the innards of her plants can hardly be freed of their own natural fecundity. But visions of sexual organs are a facile dis-

traction; to hang sex on the picture is to dismiss other thought about it. O'Keeffe herself uses the word "slit" when she recalls a scene she painted in 1916, an important and recurring one for her called Palo Duro Canyon: "The weather seemed to go over it. It was quiet down in the canyon. We saw the wind and snow blow across the slit in the plains as if the slit didn't exist."[60] This protected, meandering slit, hidden from natural hardships, is placed centrally among O'Keeffe's sensual cliffs and high plateaus, a deep refuge. In many other paintings the slit is white, a lack or absence among her monolithic forms that reminds one of the twisting slivers of white, untouched paper in the watercolors, their vacated lines. While the sanctuary of the slit hardly occupies much space in the pictures, it cleaves all the parts together, or cleaves them apart (an admittedly odd verb, which is able to do both, like these absent white lines). At times the split looks like the parting of two curtains, on a stage where, it is suggested, the unseen show is already awaiting us; for example, the famous *Pink Moon and Blue Lines,* of 1923, or her *Grey Lines with Lavender* of the same year (also interesting for its resemblance to a later photograph of her by Stieglitz, as I have noted). It is a torn curtain, the parting of a decoy and annunciatory world that reveals . . . , well, only reveals the proposal to reveal, for the moment. In other words, amid the colored ruckus of the "wideness and wonder of the world" lurks an aggressive but secretive self, the "I" that she says "live[s] in it," but more precisely an "I" represented negatively, as a secret passage through the material worlds she lives in. She knows herself to be a stasis of sorts at the center, the very center, but she does not know *what* she is, or it is not quite presentable. This place of privacy in the pictures is beautifully developed in her 1926 series of open, closed, "slightly open," etc., shells, where the metaphor of the not completely hidden self is pretty clear: coy white, in white, on white. Presciently, her first really serious beau, a fellow student from the Art Students' League in New York, had written her from Paris in 1912: "The Georgia O'Keeffe that I appreciate exists only for me. You will realize it when you are forty. The frank, simple little shell of doubt and uncertainty that you love to crawl in and out of."[61] In the painting of thingness as philter, the wide world is constantly being recreated to reassure one that there is more to reality than one's unrepresentable inner core.

In some of her oil paintings, the "uncertainty" of the parted curtain is enlarged upon in the ballooning of a sky seen through objects like a pelvis bone or what may be wind-worn mesa formations—or, in the more blunt view, an imagined, sky-borne absence on the other side of the vulva. The well-known *Music—Pink and Blue, I,* of 1918 is an example that leaves all interpretations open. Stieglitz photographed this painting

with O'Keeffe's memento mori sculpture *Abstraction* (1916) standing in the hollow area of the painting that I am trying to look into. As Sarah Greenough sees it, Stieglitz thus "appropriated O'Keeffe's art and transformed it to express his own idea that the source, nature and importance of O'Keeffe's art lay in her expression of her sexuality."[62] However, I find this potential phallus—which, Greenough tells us, is in fact a hooded figure sculpted in memory of O'Keeffe's recently deceased mother—a very odd representation of *her* sexuality. The photograph is of two sexualities at least, O'Keeffe having made both we see and Stieglitz having framed them both, and they do not consummate, or at least not without irony. I find that the gaping space, what I'm calling a balloon, outmeasures any assault this modest phallus might propose to make. Especially as a sexual dream it is not a very successful photograph, but is easier to read as a draped death figure against a backdrop of infinity; this reading may be too obvious, and also the sign of a work a bit too arduously conceived. But I find it instructive to ask why we are to stare, in O'Keeffe's painting, into this negative space that, in many later paintings as well, threatens to engulf much of the picture, pushing things which are not background to the painting's edges. She wrote:

> I was the sort of child that ate around the raisin on the cookie and ate around the hole in the doughnut, saving either the raisin or the hole for last and best.
>
> So probably—not having changed much—when I started painting the pelvis bones I was most interested in the holes in the bones—what I saw through them—particularly the sky. . . . That Blue that will always be there as it is now after all men's destruction is finished.[63]

It is a void that the self has expanded into, a place where she is at peace with a self-absorption so intense it can flood out the wide world without qualms or sense of much loss. And how remarkable to be able to say that one consumes, at last, the hole! Once there was the raisin, most desirable thingness; that has metamorphosed into an emptiness of the same shape, presumably an emptiness in the good sense, a Zen-like blossoming into desirelessness. You don't eat the hole in the doughnut, you just have to get there. Within and through the dead cow skull or pelvis, already deaths of desire, we ascend into a serene deathlessness, pass through the natural evil of men. Before such final, skied visions, the balloon as alligator pear, rock, flower, or shell evinced a relation of questing self to a material reality that was the more insisted upon for American culture's inability to perceive it. O'Keeffe did not feel anywhere near that inten-

sity for human beings, whom she almost never represented. At times of greater self-confidence, she pulled the curtain on her personal deserts and skies. The slit had been sexier by virtue of pretending to hide her, but the fully revealed stage—though at first it looked terribly full, heavy with objects—with a switch of the lights flipped from positive to negative, into a vast arena for an unspecifiable self that filled the same space: the sky as emptied metaphor, or as metaphor for pure, expressive abstraction felt to live at the heart of the object. In their own special way, the perfect, round stoneware pots that O'Keeffe produced at the end of her life solved the problem of such abstract ballooning in only two painted dimensions. These pots were concretely filled, albeit with pure space, and the tiny hole in each one's top gave real egress, or a breather, yet maintained the sense of an entirely contained and protected world space. The pot is a doughnut that holds its hole.

The Sky, as Limit

While O'Keeffe may be seen to be reclaiming her persona from Stieglitz during the twenties, he also was on a personal quest into abstraction, of an especially transcendent kind. By the time of the 1923 show, and increasingly in the two subsequent shows at the Anderson Galleries, Stieglitz evolved through a series very different from his portrait of O'Keeffe. His cloud photographs, held by many to be his supreme achievement, went through three namings as the meaning of his sky became more apparent to him. At first, there was *Music,* the same title we sometimes find among O'Keeffe's paintings, such as the one just discussed in which "music" is taken to mean something like abstract expressionism. Generally in these photographs there is interplay between the sky and a darkened earth, and a story or statement of sorts is played out mainly above, against its grounding below. Next he called them *Songs of the Sky,* in which human-made music has been removed from below to above, a vision of celestial choirs in which, usually, only a tag of earth remains in some corner, to tether the sky, and us, to a reminder of firm, dark, and songless ground. And finally came the enduring title for the series, *Equivalents,* from which the earth is banished, or we are freed from it, holding on to nothing solid and completely adrift in the air. This is a true, quite complete, form of abstract expression, except of course that such a term implies an important contribution from the spontaneous, gesturing hand of the artist, which in this case we have not got. The gesture belongs to the clouds, it would appear, which are forever changing themselves; God in some form or other. And "abstract" must be a misnomer, since these are real clouds; but in their vagueness, their mutability, and

our longing they are always saying something other than their mere selves. Finally, in its elegant but perverse way, "equivalents" says nothing real at all except to name a displacement, a deferral of knowing. Lacking knowledge, any reference at all, to hint at what the clouds might stand for or help us to feel, we are thrown back into the sky and clouds to satisfy ourselves with differentiating among them, to feel the changes in this music without a program.

Stieglitz gave one frequently referred-to account of the genesis of the cloud photographs, possibly not written for publication but published nonetheless, in a British photographic journal in 1923. There the photographer offered as first cause his annoyance at an idea voiced by Waldo Frank to the effect that "the secret power in my photography was due to the power of hypnotism I had over my sitters."[64] These are Stieglitz's words, not Frank's. The latter, in a short article for *MSS* which is quite effusive about Stieglitz's achievement, never mentions the word "hypnotism" with that sense of helpless subjects, but wrote praisingly of the power required of the operator of the "camera machine" to "fuse" the objective material and his own "subjective concept." This view seems quite in line to me with my discussion of O'Keeffe in this chapter. The passage usually cited from Frank as precipitating Stieglitz's reaction, or exaggeration, runs as follows: "The work of Stieglitz is more than half upon his subject and this fact brings clearer the old intuitive mechanism. By talk, atmosphere[,] suggestion, and the momentum of a personal relationship, Stieglitz lifts the features and body of his subject into a unitary design that his plate records. His work in thus *moulding* material is analogous to the work of any good portraitist, who does his moulding with his eye and his hand on canvas."[65] The extra emphasis on "moulding" may have been what set Stieglitz off. The last thing he wanted to do, I'm convinced, was to cram his subjects into his small frame, as opposed to *seeing* them recreated there, apprehended and gathered up through his lens. For Stieglitz his subjectivity was a sensitivity, not an acquisitive moulding. But that Stieglitz would misread Frank's intention enough to conceive of his essay as a criticism shows how touchy he was on the subject of his "mastery," in particular in connection with his portrait of O'Keeffe. We may see his annoyance justified to a degree if we think of how that portrait has been treated in criticism as an appropriation of O'Keeffe's person and art. So it is with some amusement that I note this phrasing in Frank: "Stieglitz lifts the features and body of his subject." He means lifts them onto his photographic plate, but the verb is telling, suggesting that the face and body of O'Keeffe, as one example, can be removed from their physical existence and put somewhere else, higher, into the sky. Other facts alluded to in "How I Came to Photograph

Clouds" show that pointing his camera skyward was a flight from losses closing in around Stieglitz: the imminent death of his mother, the aging-into-death of men, horses, and trees around him at Lake George. Yet there is little doubt that there is exhilaration in the cloud series, which translates the joy he felt in O'Keeffe's presence, in her body, and in her art as it might be expressed in a thoroughly abstract manner, and lifted sky-high. Any number of the *Equivalents* resemble, if they resemble anything on earth at all, the torsos in the O'Keeffe portrait series; those clouds that spread in large fields across the image transmit the texture of skin, and, alternately, her portrayed body soars into an elongated, abstract, wind-blown shape. There are other connections, explicitly made even if they are harder to intuit. One cloud picture, *Songs of the Sky, No. 2* (1923), which bears no internal information that might lead us to see a connection to flesh and bone, was renamed *Equivalent: Portrait of Georgia, No. 3* (c. 1925), and in 1929 Stieglitz spoke of an idea for a film in which cloud formations would alternate with an anatomy of a woman's body.[66] So the cloud series could be of himself up there or of her; or a limitless expression not tied to persons at all.

To contemplate clouds against the sky is to think of transcendence, of rising above daily concerns and mundane squabbles. Indeed, we like to find ourselves and our things up there, but more importantly we try to lift the bodies of man and woman out of themselves and into a celestial place of serene finality. At night the sky is full of all our star-studded history, but the great dome of night is never at issue in the *Equivalents;* even in relative darkness we look at the clouds of day, cryptic phrases strewn across an infinite field that we take pleasure in imagining we will inhabit with our best selves. "For the body was now invited to meet with God," writes Nadia Tazi.[67] Though the sky as heaven is a place dreamers aspire to spiritually, the portrayal in art of one's ascension cannot do without the body, a fact that produces the beautiful paradox of bodies rising without shedding their corporality yet seen as unsullied by earthbound existence. I doubt very much if Stieglitz held to any of the details of a religious transcendence, but what he took as a personal indictment, of himself as an artist, was that he was a powerful god when he photographed his subjects—ultimately, that it was *he* who dirtied their bodies. In a deeply personal sense that is what appropriation means. Further, he had nothing of the puritanical attitude in his treatment of O'Keeffe's body (or anyone else's), so an image of her as a body thrown into the sky is not a cleansing of her, or heaven's reconstruction of her virginity, because she was never soiled when she was portrayed as earthbound. His solution to Frank's criticism, as he understood it, was to transcend the representation of the body by forgoing the body entirely. While O'Keeffe

is implicitly up there in his clouds, that fact is not ultimately so important for us as viewers of any single image or of any given series of them. The clouds are real; but as important as that is and must always remain, they also seem to generate meaning, to be the equivalents for whatever we may have to throw up there. In a way, by giving up the solid, earth-bound subject, Stieglitz proved himself in even greater control of his camera, encompassing through his lens the most evanescent, the least tangible of nature's bodies, the closest things to nothing. A series of these nothings, which upon close inspection become terribly full of everything—I mean of everything you find yourself imagining, one thing after another—resolves into a guide through this transcendent no-place. The series becomes an anatomy of a spiritual voyage that turns out to be quite perfectly named *Equivalents*—a series of anyone's "stops on the way to heaven," as Tazi has it in her title, a series that is the proposal, never meant to be fulfilled in the sense of ended, of an infinity of photos of the infinite, the infinite to be understood as interior to each one of us. Meanwhile, what saves the series from such an exalted description is that it remains a series of real clouds.

In *Alfred Stieglitz: Photographs from the J. Paul Getty Museum,* there is an interesting roundtable discussion of Stieglitz out in the fields at Lake George taking these photographs. Sarah Greenough visited the site, that of the Stieglitz farmhouse, to watch the clouds roll over the mountains, and as they quickly disappeared over hills behind her, she was struck by how little time there was before they were lost to the camera. Weston Naef wonders about trying to frame these clouds; the object is not convenient, and Stieglitz had saddled himself with the most basic equipment, nor was he cropping or enlarging his finished prints. These difficulties, in part self-imposed, seem to dictate that the image cannot be "made," only "found," yet Naef agrees the image can be "a glorious picture" (as John Szarkowski says) and can only be conceived of as "made." Szarkowski sees the difficulty of stabilizing the construction of the image as the photographer works in from the edges of what he sees in his Graflex, "what is given" but what is constantly bleeding away from the image "because the edges are never in the right place!"[68] It is not only the consciousness of his subjects that Stieglitz has relinquished, but the physical fixity in time and space that they delineated. The speed of the artist's shutter is now matched—even outmatched, in the view of the roundtable participants—by the speed of the subject, a double speed in fact, that of passing and that of changing, on the run. Further, one must see the picture of Stieglitz hoisting this sky-aimed Graflex to get an idea of the physical strain involved for a small man of sixty, an effort very different from what we might exert with our 35mm or digital cam-

eras. He holds steady, awaiting the instant—but which instant, in all this floating stuff?—as with the mythical or merely apocryphal three-hour wait for the first photograph in this book. He did not wait, here on the hill, for three hours; I expect nature was kinder, and more generous with a multiplicity of opportunities. But the principle remains: he waits for the sky to "make" the picture, which he in turn waits to "find," though he may be said to "make" it with his act of choosing, as exercised in the field and, mainly in work with tones, in the darkroom. Standing there, at first with the camera down, waiting and looking, measuring, then deciding quickly, bringing up the behemoth, steadying his body, breathing carefully, perhaps hesitating long enough to lose it—to lose an

edge, which is to lose all the edges—following for a short way, we should say *pursuing* the image, watching what he wanted dissolve, but perhaps something as good reform out of already lost forms, thus changing his demand on the image, reformulating his lost expectation, worrying the muscles again that must not tremble through the exposure, lowering the camera again to wait some more, always in a double train of ecstasy of changing vision and renewed work—are these arduously obtained abstractions not as gestural in their fashioning of found into made as Pollock's flung drippings? Yet the photographer's strenuous gesture has been translated into nature's most effortless-looking one: made into found, that performance may be the most spectacular of equivalencies. Where Szarkowski sees a huge difficulty, in the fleeing edges, Rosalind Krauss sees Stieglitz exerting a master's control over the prime defining factor of photography itself, as she sees it, the cut or crop. In the *Equivalents* not only is the sky vast, Krauss writes, but it is "essentially not composed": "In this photograph there is a sense not merely of found or fortuitous composition, the luck of some accidental arrangement. There is, rather, a sense of the object's resistance to internal arrangement, a positing of the irrelevance of composition. . . . These images . . . stake everything on the single act of cutting something out—the gesture that makes them by cutting."[69] Indeed Stieglitz is cropping, composing in from the edges; but what is impressive here as gestural is that he isn't doing it in the darkroom but in situ, in the field, panning or steadying the Graflex. He composes the found as it floats its way into decomposition. Then, working with the series in mind, in another cut he salvages a new, made composition out of the next found, decomposing cloud: a sequence of risky gestures, "staking everything" again and again.

With the *Equivalents* I see the viewer drift or daydream past any sense of being manipulated by the artist, whose gestural making seems to free the picture even from his own volition. It is their quality of appearing found that frees the viewer. Stieglitz has not commanded the performance, nor is he a voyeur, for there is no secret in the sky, nor can he appropriate it, for there is nothing to possess. The photo is the record of a beautiful passing and disappearance. What the viewer collects in a passive mode is, along with the emotion evoked, his own poignant nostalgia for its passing. What he does more actively is to bring alive that lost emotion of his for the moment he enters the picture, for the shuttered moment during which the loss has presence. Even as I say the photo is a "record," I feel I have said too much, nailed it down. It is not in us, the viewers, that a precise emotion forms as the equivalent of some nebulous formation in the clouds, but in the image where a perfectly clear equivalent takes a shape to which we cannot give precise voice.

That is to say, it is the image that has specificity, not our emotion, just as a metaphor is concrete while what it stands for is an idea, an abstraction. The *Equivalents* have body, but, even as they may sing, they are the most voiceless and uninterpretable images imaginable, for as you attempt to translate them their meaning fades away from any specificity. Ineffably equivalent, they transport on high with a flash of immediacy, as if no language or medium or artist has been interposed, or can follow. As he wrote to the poet Hart Crane: "I'm most curious to see what the 'Clouds' will do to you. About six people have seen them— . . . —all are affected greatly & forget about photography entirely."[70] Perhaps this valuable idea, that the viewer, brought into a transcendent connection, would forget the medium, was given to him by O'Keeffe (unless, of course, he had hypnotized her with it beforehand). In the issue of *MSS* devoted to the question "Can a Photograph Have the Significance of a Work of Art?" (the same issue that Waldo Frank had contributed to), she had written: "If a Stieglitz photograph of a well to do Mid-Victorian parlor filled with all sorts of horrible atrocities jumbled together makes me forget that it is a photograph, and creates a music that is more than music when viewed right side up or upside down or sideways, it is Art to me."[71] Such prints are of "living value," as the 1919 letter to Picabia had it, of a transcendent immediacy that seems to have transcended technique. If Stieglitz can say, in that letter, "'Art' is not worrying me much," the corollary is that "art" will not worry the viewer either, as she vaults high above furniture, bodies, and even language about them.

8 Down from the Clouds (1929–1935)

Dark Equivalence

A second look at the cloud series can show an underside to transcendence, a struggle with loss that is further reflected in Stieglitz's renewed, serial handling of the new New York skyline. This final return to the city as his subject ends his career as a photographer, about 1935. But all through this period and beyond, until the day of his death in 1946, he kept faith with the small group of painters he had championed since about 1910, providing them with a place for free play.

I always imagined Stieglitz lying on his back when he was photographing clouds; that was my own projection. I see in the photographs a camera pointed straight up, with a feeling of going right past the clouds into the deep azure. Viewers can apprehend with some anxiety this perspective of measureless depth, of vertigo as it combines with a high degree of formlessness, and they do so with good reason. There are two forms of "up" at work here: the sky is still up, but the upside of the pictures has no definite relation to that. The whole field of the picture on the wall is up; not pointing upward but just all up there over our heads, the bottom as "high" as the top. We know that Stieglitz occasionally switched the direction of the print for exposition, though he had to know

how it had come out of his camera, with up at the top of the plate. He has brought the comprehensive "upness" of the horizontal sky down to our level, and hung it in a vertical image in which ideas of above and below are necessarily upset. Having separated the sky from the earth in these *Equivalents,* where we have no bearings, he projects the high horizontal vault onto the wall's vertical plane, and somewhat separates the sky from the sky, taking it further into abstraction and making it amenable to a large variety of emotional experiences. It is an odd yet thoroughly effective combination of disembodying and reembodying presented to us all at once. The security we gain from solid and grounded objects is denied us as viewers, and we must be willing to float off into the blue, holding on to little that is not ourselves. In our way, we recreate the risk that Stieglitz himself faced as he cut: "If we have not seen the risk that accompanies the vertigo in Stieglitz's cloud photography," continues Krauss, "then we have not seen the photographs. We would not have seen what he had to expel in order to make them work."[1]

To my mind, the major effect of defamiliarization in the *Equivalents,* even more than the somewhat surreal problem of up and down, is the very reduced scale of the images, the azure vault purposely reduced to a uniform contact print a touch smaller than the four-by-five-inch negative.[2] There is, as well, the matter of Rosalind Krauss's cut; one *must* cut in the gesture, remove for keeping what will always be a small patch out of the full reach of the sky from horizon to horizon. But why *so* small as four by five, instead of, at least, a ten by twelve, which would register as a large format and would have the merit of looking big on the wall, for a photograph, of at least appearing to desire to encompass the sky? It is a rhetorical question; he does not want to encompass the sky in that way, matching his biggest size to the celestial, but somehow to do the opposite, make his postage stamp metamorphose. The viewer in the room must approach so closely as to crop her visual field herself, notably to exclude, along with the room and its visitors, the other *Equivalents* on the wall to the left and right. She peers into the four-by-five image as if through a telescope, or as if she were herself the photographer with his two eyes tunneled onto his ground glass, and she is absorbed into an exclusive intimacy with the tight little image. As she enters it, it grows to fill her vision, becoming sky-size in the perception she has been moved to bring about within its diminutive borders. The image is conducive to a transcendent experience, as I have tried to outline it at the end of the last chapter, but it also entails a sense of loss; the viewer literally bathes in a nostalgia for the loss of what she sees revived in the image, for the time of her gaze into it. Like a small jewel, the delicate photograph expands in close-up reflecting worlds beyond, and worlds

lost, or beautiful gestures that no longer seem to count for much. The small images, originally printed on Eastman postcard paper virtually as a dare, are like letters, to be read at reading distance. It is a limit case of decontextualization, a removal from the exhibition room for the perceiving viewer and, also, a rapprochement with the sky, which has sent these little postcards to be read in private.

Without this absorption into the exclusive world of the photograph, many of the qualities of the *Equivalents* on the wall would be lost. We are meant to be plunged into it, and engulfed. The viewer steps up into the close-up position, a close-up with the faraway. It is a novel variation on the principle Strand and O'Keeffe worked at, of the close-up of estrangement inside the blown-up detail. O'Keeffe made the heart of something diminutive blossom out to fill her whole screen; Strand drew close to the edges between objects that would have their individual integrity only inferred, outside of his tightened frames. Stieglitz can never get that close, has in fact willfully chosen a subject he cannot approach at all. The cloud formations are tailor-made for this great, one could say *complete* distance—there being hardly any other greater visible one, except the absolutely blank, cloudless sky itself. But the viewer has been enticed into the close-up position, not so much, then, into the whole sky but into a sort of sampling of it; a detail, as with the two other artists, a crux of the sky that manages to give a sense of form to this epitome of falling out of form, a skyward daydream.

All this defamiliarization tends to make abstractions of the *Equivalents.* Not that the clouds are not recognizable as such, for they appear thoroughly real enough, and the images would not work their particular magic if they were less real. But, while real, they seem not to have the usefulness of the real, and are thus always opening up to the uses of our imagination. As the photographer Minor White has written, we want to see "things for what they are, and for what else they are."[3] These closely watched clouds are so fully inhabited with suggestiveness that it seems to displace their thingness. Or, they are abstract in the way dreaming can seem to be, solidity dissolving, reforming at the whim of the dreamer's unchecked desiring. The clouds are abstract in the way that dreams always manipulate stories we don't understand, even while we intuit that a meaningful story is being told. For, essentially, abstraction is the withdrawal of the story, or of the usable objects of living; it is always proposed as a minus, a reduction, a lack that the viewer wants to make up even as he is enjoined not to do so but to go with the flow, which is a critique of story-making.

The kinds of dreamwork these clouds produce, for Stieglitz or for the viewer, evolve through three main types, though there are examples of

8.2 Alfred Stieglitz, *Music: A Sequence of Ten Cloud Photographs (No. 1),* 1922. Gelatin silver print, 19.1 × 24.1 cm. Museum of Fine Arts, Boston. Gift of Alfred Stieglitz, 24.1732. Photograph © 2003 Museum of Fine Arts, Boston. © 2004 The Georgia O'Keeffe Foundation/Artists Rights Society (ARS), New York.

each appearing occasionally amid the others throughout the periods in which they were produced. For convenience, we might tag them with the three names Stieglitz used in sequence, always remembering that he could occasionally substitute one for another and that *Equivalent* could name them all. Below, looking for the dreamwork of symbolic projection, I find the images sorting themselves out a bit better in terms of the actual names of clouds, names that retain age-old, enduring associations that are often good clues to any human projection (I am thinking here of Bachelard's view that earth, water, fire, and air, while they tally poorly with modern scientific explanations, continue to have deep resonance for the psyche).

In the earliest type, well represented by the series first shown at the 1923 show, *Music: A Sequence of Ten Cloud Photographs,* the pictures maintain their contact with the earth, a strong horizon not seriously marginalized at the bottom, with trees in outline and even a lone house, as in no. 1. Loneliness is clearly objectified, not yet symbolized abstractly, in that small house which is twice lost: within the dark landscape, and beneath stormy clouds. The sky is speaking to us as a visible figure, still in the picture. We, as house, are diminished, and await the storm humbly; or perhaps we wait bravely, hunkered down in our modest yet sufficient structure.[4] The clouds in this image would not have made much of a point photographed alone, for they are indistinctly murky. They block the sky, cloud over thought. The image is not so unusual in its apportioning of material, but is reminiscent of nineteenth-century landscape painting except for the bleakness, the darkness of the earth, the sobriety of a vacated picturesque. Other *Music* images, already going by the name of *Equivalents,* dropped the horizon lower, usually including just the highest ridge below heavy, billowing cumulus clouds, the "heap" clouds with sky behind them, and likely the sun as well, which would produce the well-exploited effect of silver linings. This genre of image is the richest in objects: earth, tree, house, cloud, sun, sky, with even other sorts of clouds above. Ultimately, I think, it is the least interesting from the perspective of what the *Equivalents* do most profoundly. For cumulus clouds are storied clouds, the ones we turn into ships, rabbits, and haunting faces; they are heavy with imminent storms, happy resolutions, reconciliations, essentially of the passing of the grand clouds themselves.

The ground, and much of the grounding for building and unbuilding stories, is relinquished in my second type, Stieglitz's *Songs of the Sky.* Wondering about the value of changing "music" to "song," we realize that music, while not lost, has become voiced, by the artist or by someone he is listening to. This "singer" becomes a real presence at the same time that the image loses much of its more obvious objective content, and he or she imparts a degree of expressiveness to what has become increasingly abstract. It is one of these *Songs* that was later renamed for O'Keeffe. Wallace Stevens was to write a little after the moment of the *Equivalents,* in his well-known "The Idea of Order at Key West" (1935): "It was her voice that made / The sky acutest at its vanishing. / She measured to the hour its solitude." Solitude is no longer located in the little house we can so easily identify with, but is now removed to the sky where we must exert a greater sensitivity to feel it. More precisely, it is in the singer's report of the sky, which, as Stevens liked to play with the idea, cannot be separated from it: "And when she sang, the sea, / Whatever self it had, became the self / That was her song, for she was the maker."[5]

But the images I am primarily thinking of as *Songs* are even less solid than the *Songs* image that became Georgia, which is made out of the dissolving edges of cumuli. I am thinking of the fading wisps that are cirrus: tendrils, locks of fine hair, stretched curls, filaments. They are the most ghostly of the *Equivalents,* flotsam of barely sustained dreaminess traveling ever so swiftly across the picture plane. They are painterly, like silken brushstrokes, spare of pigment. They leave the traces of playful 100-meter dashes in indifferent collision or dispersal. These are the images in which the sky seems most joyous and exuberant, even though they appear to be the most short-lived moments. With cirrus formations that closely approximate a self-reflexive portrait of the artist himself sketching, these cloud jottings resemble pure gestures in the air, as if the traces were virtual. They were the scenes that disappeared the most quickly from the camera's ground glass, necessitating the quickest response from the photographer. Finally, it is interesting that it is the more stormy, dramatic, and intense cumulus clouds that Stieglitz should interpret as being O'Keeffe-like (an equivalent for O'Keeffe being quite different from representing her), rather than a cirrus image, full of its associations with hair, brushstrokes, and the general if vague sense of dreamy, Pre-Raphaelite beauty.

In the third type or mode, and to me Stieglitz's most powerful, the joy-in-passing of the cirrus is replaced by a field of steady presence. This

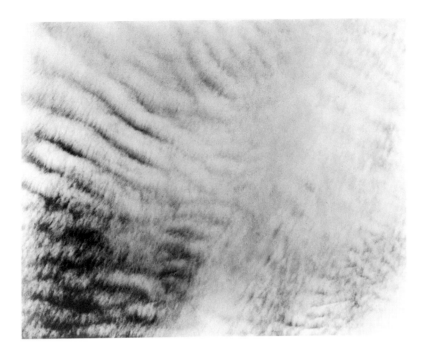

type, which makes up the final and quintessential *Equivalents,* best fulfills the expectations we have that abstractions will be free of objectlike formations, for its principle is repetition across the whole field of the picture. This field no longer has any interest in the play of discrete shapes within it, but at most exhibits modulations within the field. These images are the rhythmic spreads of stratus clouds, repeating with delicate variations the same continuous forms across a picture plane reduced not quite to two dimensions but rather to a sort of bas-relief. Of the three types of *Equivalents,* these images best produce the effect of clouds extending largely unchanged across the whole sky, beyond the borders of the image that we have. Each is like a swatch of tightly designed wallpaper, or herringbone twill. Rosalind Krauss writes (describing all of the *Equivalents,* as she sees them) that the images have "the effect of punching the image, we might say, out of the continuous fabric of the sky at large."[6] Her metaphor is particularly interesting in terms of the *Equivalents* as a series. Moving from one picture to the next, the viewer reconstructs a sky, albeit multiple. It is unlike a series by O'Keeffe on the same flower, in which the same discrete piece of reality is fully seen at different distances and in different states of its evolution in her mind. These mainly stratus clouds put us more in mind of a bolt of cloth, strewn out with beautiful but random folds. While each image of stratus may imply full extension beyond its borders, the next one we view is

a completely different stratus, a different bolt entirely; every photograph is a different sky. That is to say, the effect of viewing a series of these stratus cloud images is not the reconstruction of an infinite field of sky but of differentiated infinities.

The stratus covers all of the image with cloud—at times, a steady if pulsing pattern of modulations, at others, one mottled field in juxtaposition to another style of textured blanketing. Gerard Manley Hopkins saw God in such patterning, writing in "Pied Beauty":

Glory be to God for dappled things—
For skies of couple-colour as a brinded cow:
. . .
Landscape plotted and pieced—fold, fallow, and plough.[7]

Other terms in this poem, in which Hopkins springs loose syntax and rhythms to translate his excitement at discovering God in variegated surfaces, could also find their evocative place in trying to describe the stratus *Equivalents:* "fickle, freckled," "With swift, slow; sweet, sour; adazzle, dim." The photographer neither uses nor needs words, but his pied images make a direct appeal to our own unworded internal symbol-making. We are blanketed with a state of darkened being: not presented with symbolic shapes, but ourselves framed in a symbolic pattern, not an equivalent story but the symbolic texture of a whole sense, or fabric of life.[8] I see such a project as quite telling for Stieglitz at this point in his already long career; an old man looks over the whole state of his life, the feel of many different periods of endeavor, rather than passing in review dramatic, single events of gain or diminishing.

So much depends, then, on the fabric, on the textures. Yet a texture, or the play of a small palette of two or three textures, is the most difficult aspect of the photographic image to convey through reproductions. These layered, stretched-out strati reserve their powerful effect for the museum-goer. I have been deeply moved by single images I have seen, at the National Gallery of Art in Washington or at the Boston Museum of Fine Arts, and, presented with others, remarkably moved again, and surprised at the power of the changes to move me repeatedly, in the same session of viewing. It is as if Stieglitz has taken advantage of you. And while the strati touch me most, I read back into cumuli and cirri (some of which were produced later, in any event) the primacy of texture as a signifying force.

The strati are moody and dark, frequently lonely but, one feels, often with a defiance that comes in different guises, different kinds of cloth. The viewer's seeing is always tactile, the beauty of the surface calls out to

be touched. Wisps shine like damp fields of wheat, strato-cumuli produce a lump in the throat. Two wide ribbons of cloud, each a world apart in texture—silk and burlap, exotic luxuriance and potato sacks?—are separated, or perhaps just as well united, by a fold in the fabrics, a doubling over, a partial hiding, a conflicting redirection; or it is a gash, perhaps a scar left by O'Keeffe across the elephant skin that is Stieglitz in his sky. In textures we permit ourselves to bathe in our own surges of feeling. Nancy Newhall, dismissive of Lachaise's sturdy New England wife for fainting when she saw "the Blood of Christ" in a Stieglitz photograph, was "turned loose" one day among the *Equivalents* to emerge a couple of hours later "in tears. I had been through a tremendous experience. It was like a thunderstorm I felt in my head once in Paris when I groped my way out of the Louvre. . . . Music has done this to me many times, but though I deeply loved photographs, nothing like this had happened to me before, not even with Strand, Weston and Adams."[9] It is telling that Newhall would adopt a simile, the thunderstorm, from the very images she had just looked at. She had emerged from An American Place, as she had from the Louvre, not so much with a memory but with her own concrete equivalent, the dark pictures creating a revolution in her thinking about art. And she had not arrived as an innocent; her new thunderstorm had to overcome an earlier view of the power of the *Equivalents* as "mostly humbug, and Stieglitz at his romantic worst."[10]

On another occasion Stieglitz said to Newhall, "All these things have death in them . . . ever since I realized O'Keeffe couldn't stay with me."[11] The apparent contradiction of the stratus *Equivalents* in particular is that while they portray skies of loss and death, the images are nonetheless fine, full of grace. It is as if acknowledging loneliness and death for the individual, for himself, spurred Stieglitz on to produce his most finely felt and finely crafted work. While death is in them, the strati stay, are permanent fields of vision. They are intended to have "lasting value," more than the cumuli's fleeting eventfulness (O'Keeffe's actual leaving, for example), and more than the cirri's disappearing dance and song. He photographs his "passion," photography itself, in the form of swatches of tartan, paisley, herringbone, which become the published and permanent regalia of his private passion. Through their tactility they become real, and could outlast him on their own, after his haranguing was finished. The complete cloud coverage, and the powerful sense of its extension beyond the four borders, toward all four cardinal points, made each little image a complete and true place of the spirit. Finally, its permanence also seems to arise from what it portrays in the autobiographical sense, the constancy of the mind creating it. It is remarkable how much the strati resemble Edmund Wilson's description

of the mesmerizing monologues to which Stieglitz subjected visitors to the galleries in the twenties:

> a kind of impalpable net in which visitors and disciples were caught from the moment they came within earshot. It was impossible to interrupt or change the direction of this monologue, the tone of which was rather casual and which wandered from subject to subject but never for a second slackened—the ribbon of talk was as strong as a cable—and which influenced the mind of the listener in a way that was not accidental.[12]

Stieglitz made the directionless sky compelling, and important; through it his life and approaching death were to be measured. The mesmerizing fabric of the stratus was made of the same stuff as his speech, his person on the scene of his last years.

The Place: Self and Ideal at Play

Lake George in the summer was the place and time for Stieglitz's photography in the twenties, whether of O'Keeffe, skies, clouds, fields, or dying trees. In the fall, as late as possible, Stieglitz would return to the city where, after the age of sixty, he was not photographing but continued to run exhibitions, with the financial help of others. In this postwar period, into the so-called Jazz Age of the twenties and on into the bleak years of the depression, he devoted almost all the exhibition space and time granted him to a small stable of artists, most of whom he had already been showing at 291. Their names are famous: Arthur Dove, John Marin, and Georgia O'Keeffe in front; Paul Strand and Marsden Hartley close behind; Charles Demuth bringing up the rear—all Americans, all engaged in various, individual ways with painting American work in modernist veins. Stieglitz's galleries always encouraged the connection of American work and modernism but, as all isms fell away, it became enough to speak only of "American." American modernism was not deemed better than its European counterparts, but he found it was just as good, deserving its place in the sun, and since it did not have such a place yet, he would give it one here, until cultural imperialism no longer called the shots:

> America without that damned French flavor!—It has made me sick all these years. No one respects France [more] than I do. But when the world is to be France I strenuously hate the idea quite as much as if the world were to be made "American" or "Prussian." . . . But

there is America.—Or isn't there an America. Are we only a marked down bargain day remnant of Europe?—Haven't we any of our own courage in matters "aesthetic"?[13]

Stieglitz was well suited to lead this battle, first because he had already done so, and was famous for doing so for modernism as a whole and without national discriminations. He was also cut out for this role because he was an unimpeachable force against commercial exploitation—as both his supporters and his detractors knew—and, finally and most remarkably, because he seemed entirely willing to give up his own photography for long periods, as if the overall concept and principles underlying American creation and workmanship could be just as important to him as working them out in his own work. In this role of promoter, with an outrageously idealistic idea of how to promote, he fell victim to the various accusations of megalomania that dog his memory. If it seems to us on occasion that his position on American art was extreme and strident, shaded with an uncalled-for nationalism, we might note, as he did, that as late as 1936 MoMA could mount its landmark exposition *Cubism and Abstract Art* with almost no American representation.

Stieglitz had three places after the Little Galleries or 291. The earliest version of the portrait of O'Keeffe was shown in 1921 at the Anderson Galleries, a space lent by Mitchell Kennerley. Here Stieglitz showed, at first, himself and O'Keeffe, along with a rather famous auction of Hartley's work, which permitted the painter to return to Europe for some ten years. In 1922 Stieglitz organized another auction and sale, of some 177 works by diverse hands, with some Marins and O'Keeffes going for over $300, and a marble by Gaston Lachaise selling for close to $1,000. Such prices were godsends for the artists, but the great success of the auction idea was that it made available paintings by good artists for under $25. Barnes and Phillips sat and bid next to students spending their rent money. The idea of a tighter group of like-minded American artists coalesced around 1925, and Stieglitz ended his Anderson Galleries series with a show entitled *Alfred Stieglitz Presents Seven Americans,* which listed the artists on the cover of the catalogue in this order: Dove, Hartley, Marin, Demuth, Strand, O'Keeffe, and Stieglitz himself. The Intimate Gallery was then founded, and operated until 1929, when the crash rendered it even less viable than before. Quite early, at the time of its third exposition in 1926, the seven were no longer individually named but became "six + X," leaving room for additions to the group, it seemed, but more likely reflecting the fact that some of the seven were not always ready with new good work, or that some were finding other outlets for theirs. Artists who profited from the inclusionary aspect of the

new format were Gaston Lachaise, Oscar Bluemner, Picabia (in works handled by Duchamp), and Peggy Bacon. On the other hand, Stieglitz himself never showed in the four seasons of the Intimate Gallery. Only O'Keeffe and Marin were shown four times; Dove had three shows, Demuth two.[14] Hartley was shown only once at the Intimate, but that is to exclude his big auction. The gallery did not have a great many expositions, at times as few as three in a season; this number was hardly enough to judge whether Hartley and Demuth were being sidelined. In the last season there were six shows, with only Stieglitz missing; he had X-ed himself!

In 1929 An American Place was founded, and the basic project of the photographer to show his roster was continued uninterrupted until 1946. As Stieglitz grew older, he and O'Keeffe moved closer to this last and longest-lived gallery. A cot was set up on the premises, visible from the exhibition rooms, and Stieglitz suffered any number of small strokes right there, in the line of duty. It only seems odd that he did not die there, that the stroke that finally took him left him unconscious on the floor of his apartment, as he was about to go to his post at the Place, on July 7, 1946. At the time, the galleries were empty, fulfilling a wish he had voiced to Dorothy Norman a number of times, that when he died the walls would be bare and clean.[15] The last show had been Dove's, only down about a month. Over the last years, since about 1938, the Place harbored few artists other than O'Keeffe, Marin, and Dove, reducing the roster to three plus a sparse scattering of X's that included Stieglitz himself (his last one-person show was in 1935), Strand once (in 1932), Hartley and Demuth and, true X's as it were, George Grosz and Picasso (in a group exhibition with Stieglitz and the core group). Only two new photographers were shown, once each: Ansel Adams in 1936 and Eliot Porter in 1939.

So the roster shrank to a group of three, as Stieglitz aged. We might be tempted to see this as a falling back on sure values and a failure to keep up with the new. It is certainly true that An American Place could hardly be visited with the same expectations for revolutionary excitement as viewers had brought to 291. But Stieglitz offered a cogent reason for his end-of-days concentration. Speaking in 1946, the year of his death at eighty-two, he said to Norman:

> I feel my age not with sadness nor fear, but rather with a growing sense that I am inadequate to the responsibilities I have undertaken. If I show a person's work and cannot follow up, I become convinced I should not have presented it to begin with. I know that I should never do anything I cannot see through. I try not to.

> Young people come in and complain that I no longer exhibit new painters. They do not understand. . . . I must start nothing new so that I can at least follow through what I have begun.[16]

"Following through" is a fine sports term adapted to Stieglitz's commitment. The ball has already been struck and is gone when the follow-through occurs; it is, really, a state of mind and body that begins before contact and guarantees the ball's accurate course. So while the follow-through may look like a mere ending flourish, it is, instead, the faithful sign of a serious focus on the game. No more one-offs, in many directions, but just the complete and sustained commitment to a few people Stieglitz knew to be good, and whom he trusted would continue to improve, refine, and even rediscover their game. In other words, he sustained them in their life series, just as he had reduced his own work to a few extended runs. The beneficiaries were not numerous, but, rather than take Stieglitz to task for elitism, shouldn't we instead deplore the lack of other, similarly committed producers? The Place, as An American Place was called—and note that the full name suggested one place among possible others, while the familiar shortening recognized that no other had been created—was the privileged room in the sky (on the seventeenth floor, flooded with light), the ivory tower to some inevitable extent, where such follow-through took place, year after year. It was a study room not unlike the old laboratory of 291, but the avant-garde exploration of all of the new was replaced with the individual, yearly renewal of a few American artists deepening their perception and their craft. Stieglitz was leading a second secession, from a chic culture that had come around to the earlier secession of the radically new in art; so the Place may have begun to look stodgy, lacking in stylish shocks. But I doubt that it really was dull, only that, as we have already noted, Stieglitz had dismissed all isms and ismism itself. He was giving a few proven favorites the responsibility of demonstrating that American modernism was not just talk for a season. And he continued his harassment of the buyer, who was not to invest, and the critic, who was not to label.

A good deal has been written in the last few years on the sexual distinctions that Stieglitz, or his circle of critics like Paul Rosenfeld and Waldo Frank, constructed around the main figures on the short roster of the twenties' galleries. These gendered versions of the various painters' production assert two main themes of some importance to us today, as we attempt to defend an array of freedoms in sexual behavior. One is the assertion that O'Keeffe suffered at the hands of the Stieglitz circle because she was seen as working intuitively out of her individual, female body, whereas "the men" produced energetic, strong, phallic work, arrived at,

in contradistinction, with reasoned and sophisticated theoretical under-pinnings (here I see a curious lapse in logic in the argument that the phal-lic is better "reasoned" than the vaginal). Another theme is that Hartley and Demuth were slighted, as compared to the two other men, Dove and Marin, because Stieglitz was homophobic and much preferred to cultivate the exclusively heterosexual oppositions that his other artists could be invoked to illustrate. By the time of the Place, these paradigms would have been well established, much of the work having been done by Paul Rosenfeld, for example, in his collection *Port of New York* of 1924. If there is a villain in our view of the woodpile, it is Rosenfeld, with Stieglitz implicated because, we are given to assume, he had his friend hypnotized. But these agendas of ours do not fit their artist subjects very snugly. The sexual analogies of critics like Rosenfeld were made in a context that gives them a different function from the dismissive labeling we perceive in them, and the sexualized projections of the artists are more complex than they have been made out to be for the purposes of gendered politics. For this reason Marcia Brennan's recent study is a salutary, more balanced exploration of the gendered construction of the Stieglitz circle; she writes: "Despite the gendered opposition that critics identified with their work, Dove's and O'Keeffe's paintings share a formal similarity." This claim is a recognition of some problems with the paradigm since, as Brennan's context makes clear, the formal is what is gendered: "these discourses located gender broadly in aesthetic structures."[17]

I would offer some reappraisals to the gender arguments, tied to the actual work being done at the Place. Indeed almost any painting is or may profitably be seen as gendered, fraught with the imageries or modes of gendered thought. But the manifestation of gender is complicated by a number of other operations. For one, my distinction between the work as either philter or filter for the artist's projections means we often cannot know for sure whether O'Keeffe's vaginal flower, to take one example, is an expression of her own sexuality, as she saw it (even unconsciously)—which is how it was so often taken by the critics of the time and not, essentially, disclaimed by our own—or whether it was not, instead, an incantation, the sign of an acute lack she felt. Not only might O'Keeffe have been dreaming of a sexuality, or a sexualized interiority, that she did not feel she possessed or could live up to, but that desired interiority was probably more individualized than we might assume. Further, the self-portraying filter or desiring philter is at work at a specific moment and place. I find myself hesitant to rebuke critics or artists of the time for being dupes of sexual stereotypes, of overdetermining the enfolded femininity of O'Keeffe or the probing or even ejaculatory masculinity of Dove, when they were in fact fighting a different fight than

ours—the good fight of bringing the sexual life up into the consciousness and the discourses of American culture. It is true that Rosenfeld's prose can go over the top, for example when he writes of Dove: "A tremendous muscular tension is revealed in the fullest of the man's pastels. Great rhythmic forms suffuse the canvases; are one and swelled out to the borders; knock against the frame for egress. A male vitality is released."[18] I don't read this in the first instance as sexual stereotyping but as Rosenfeld's frontal assault upon his class's propriety, in particular that class's discourse on art. Rosenfeld is not tying his artists into their time's sexual straitjackets but is demonstrating their freedom from desexualized models, models which Stieglitz, for one, had already recognized as male-dictated. Granted, one might, without too much difficulty, pick out a stereotyping passage from one of Stieglitz's letters, for example the following, which has frequently been cited: "Woman feels the world *differently* than man feels it. And one of the chief generating forces crystallizing into art is undoubtably elemental feeling—Woman's & Man's are differentiated through the difference in their sexual make-up. . . . The woman receives the world through her womb. That is the seat of her deepest feelings. Mind comes second." However, not only is this passage not meant as a criticism, it is embedded in and subordinated to a larger argument, which begins: "Man, the male, had thus far been the sole creator of ART. *His* art—as until most recently he looked upon Woman as *His*. There is a new order in the course of development." There follows the better-known passage above, from Womb to Mind; then Stieglitz continues: "The social order is changing. Woman is still Woman—but not so entirely *His* Woman. . . . Woman finding an outlet—*Herself. Her* vision of the world. . . . somehow all the attempts [to express themselves in painting] I had seen, before O'Keeffe, were weak because the elemental force & vision back of them were never overpowering enough to throw off the Male Shackles."[19] While he is certainly prone to some male-female essentializing—as who, at the time, would not have been—Stieglitz sounds like an Emma Goldman anarchist preaching equality between the sexes. The import of the full passage is not biological but social, and clearly stands against the male prerogative as it manifests itself in the practice of the arts.

Even what I see here as the secondary concern, the distinct makeup of men and women, is not as cut and dried as one is inclined to assume, as the passage neatly pushes our buttons. Stieglitz felt that great artists were all primarily instinctual, though not blindly. "Of course Mind plays a great role in the development of art," he went on to say in this letter, probably responding as positively as he could to Stanton Macdonald-Wright's own very theoretically based synchronism. But the thinking

did not produce authentic expression, which is the sort of idealistic painting Stieglitz looked for. Furthermore, the critiques of the men's artwork did not depend on metaphors relating to the mind (it might be truer to call it "intellectualization"), as witness a description of Dove by Rosenfeld in which he sees him painting his own body into his nature images, with "intestine whites that seem to flow from the body's fearless complete acceptance of life itself." And Waldo Frank, the other critic most responsible for forming opinion about the Stieglitz circle, put Dove's work right in the womb (but the artist's own!), speaking of the embryonic and the artist's "pregnancy of spirit."[20]

This sort of evaluation, especially the aspects that were generated by Stieglitz himself, is certainly more interesting and liberated than the simple assignment of male and female markings to rank innate potential. The participants' readings of Freud, and of other writers on sex such as Havelock Ellis, were being used as a wedge to dislodge much more simplistic ideas current in American society. The great shock of pervasive sexuality, even in the very young, along with its repression and sublimation, was their greatest, most disturbing weapon. Prim-sounding authors like Henry James or Edith Wharton had not been blind to such things as infant sexuality, but they were discreet in portraying its functioning and effects. The Stieglitz critics, on the other hand, were making a bid for a change in social restrictions on the individual. Further, I doubt Stieglitz and the group influenced by his endless, "moulding" talk in conversations over many years simplified the psychoanalytical model as much as we need to in order to fit our liberation agendas. For the politicization of sexuality it is enough to cite the covert sexual identifications we can discover lurking in the paintings, but for Freud, such an operation no longer held much interest; the sexuality was not a hypothesis to be demonstrated but already a premise from which to work toward a more useful understanding of individuals. For us, it should be more valuable, in our appreciation of the painters' work, to see how they played their personal variations on the recognition of their biology in a shakily repressed community. As we can see, even Rosenfeld could discern interiority in Dove, and there is more thrust in some of O'Keeffe's dried bones, not to speak of her skyscrapers, than in much of Dove. A few distinctions between the painters of the Place should reveal subtler versions of the expressions and desiring within their respective sublimations.

O'Keeffe and Dove

O'Keeffe's work is far more solid on canvas, rocklike, I would say, dominated by thingness as I have discussed it in the previous chapter (and

8.5 Arthur Dove, *Rain or Snow,* 1943. Oil and wax emulsion on canvas, 35 × 25 in. Phillips Collection, Washington, D.C.

this effect is not diminished by extreme close-ups). These solidities are very static, in repose if not immobilized; their poise might even risk a deadness, except for the great intensity of O'Keeffe's scrutiny. Dove is more abstract, his objects frequently requiring titles to help us on to identifications we fail to make in the picture alone. Yet, these objects are shapely, and their shapes have body, heft, a quality of thingness to their play of textures. At the same time, they are almost never static in the composition, but move through the picture plane, often thickly like a heavy man, or they quiver in place not unlike Stieglitz's strati. On occasion O'Keeffe may become more dynamic, as in her excited, excitable *From the Lake No. 3* of 1924; but, tellingly, that painting calls to mind Dove's work—for example, his Gershwin series of around 1927—more than it resembles her other work. I can't see either of these versions of object relations easily reduced to projections of labia for her or phallus for him. O'Keeffe may be gathering outer objects into an interior mothering, or a form of interior possession that she is nonetheless eager to share as a somewhat benign vision. She brings a beingness to thingness, constructs her body metaphor out of things seen and collected; she then opens up her scene of possession to the viewer as something not quite conquered but made more present by her intervention, a caring that seems of a perfectly frank and open nature. She is an oyster, redelivering that irritant, that negligible grain of sand, as a polished and pristine pearl. Appropriately, the quality of her brushwork is a slow massaging of each coat over the surface, again and again until it is smooth. She is reproducing, but not herself.

Dove, on the other hand, flies out at the world, which is made more of things in action than things in thingness: thunderstorm rather than mesa, waterfall rather than lake, *Rain or Snow* rather than stones or fruit. Dove is not concerned with slowing nature down to make its solidity gel for us, but wants to encompass its moves into abstracted forms that stand in for his body sensations in pursuit. He might be comparable to Duchamp in his interest in movement except that Duchamp's interest is largely intellectual, whereas everything in Dove is full of sensuality, starting with a reveling in the paint itself, with its smell that Duchamp proclaimed he had become sick of. Dove's titles do not name objects in his field as much as his sensations about them. For example, see how *Rain or Snow* cannot be portrayed as things; it is a query about the weather and its season that is translated into an abstract vision of elegant, floating pieces of wet or frozen sky. The painting is a sensual idea. Nature is an extension of the artist's voluptuousness. He rubs his body up against it as he tries to match his own flight—that of his brush, his hand, his mind-in-the-paint—to that of the world. His forms, while

often biomorphic, are a good deal less amenable to sexual reduction than O'Keeffe's flowers, to cite the extreme example. Even when he accepts from a friend the description of "penetration" for a painting, the sexualization takes place in an active, energetic sensitizing of the mind's eye, rather than in some phallus shape, which in any case is difficult to locate in the image.[21]

Perhaps it is artists we have to rely on the most to sublimate the least, affording living desire a place to play itself out, as in a dream. We, the viewers, gain vicariously from this playtime, before we go back to business. The painting, with the sensuality of its paint and its forms, is the truest version of the artist's desiring, eventually made, in part, on our behalf; that was the double service Stieglitz saw art providing as he displayed it at the Place. The painting is a special meeting place of desiring, the arena where the outside world meets the inner, yet it is neither but a third place, a transitional space where an artist sorts out his relations in adventurous painted games he is tirelessly capable of reinventing, games that themselves reinvent the space they fill.[22] Dove himself thought of the painting as "self-creative in its own space," as he wrote to Stieglitz, and he thus gave it its special force as a border beholden to neither him nor the world alone.[23] Into the arena of transitional space rush the filtered or philtered desires of the artist, mainly the philtered, if we are on the subject of translating sexuality. Artistic creation is less a question of exposing oneself than daring to show what one dreams of looking like, on this site of special permission. In the case of O'Keeffe, it is interesting to note that the objects in her art are almost always collected, things she has picked up and taken away from nature, and stored: keepsakes she takes to herself. In contrast, Dove, bird by name (as was Stieglitz, "goldfinch" in German), is off into nature, loses himself in it— Dove was in fact a pretty serious woodsman—but shows his prowess in juggling its parts, keeping them always up in the air. If I did not find his work so sound and substantial, so thickly textured, I would say he was showing off. In the philter arena the parents, though they are not openly admitted, are nonetheless the artist's first and last audience. There, the artist settles accounts, pleads forgiveness or further indulgence, claims his innocence, declares his love for what is not permitted, outmuscles the competition. I see Dove telling his father, then dead, that he can make paintings as solid and essential as the bricks his progenitor made. O'Keeffe I imagine collecting offerings that are to console her mother for failing to keep the family together. These are just examples of guesses we might make that straddle the line separating a viewer's reach for deeper meaning and the artist's private struggles; which parent, for what reason, from what guilt, these are questions for analysands.

But such questions assist in leading us to see the transitional space, filled with paint, as a skin of sorts, the place the artist's body touches the outer world, or more precisely the place where her imagined body meets her view of the outer world. For in this light I see O'Keeffe as asking to be seen nude, the smoothed-out surfaces spare of accident—no folds, pleats, stitching, and the rare fold of skin the more touching for that. Bare bones and denuded skies, vast, almost monochrome expanses of petals, stones cleaned, huge, lone fruit polished. Her paint is a hyperreal sort of dream, the texture of showing oneself in all simplicity, and a refusal to dress up, even a refusal to perform; she demands that we accept her pristine, un-civil openness, requires that we accept the world as a perfectly smooth match for her authenticity. The world is stilled for us, as illumined by her exemplary nudity at its center. Dove's skin is harder to state in a word, is more variegated, changeable, pulsating. At times it surges in the composition, suggesting to some a phallic tumescence, though I find that tentlike shape which occurs so often to be more "intestine," as Rosenfeld had it, an invading cavity rising from the bottom of his frame. Hartley also draws this sort of triangular lump in many pictures, including *The Warriors,* which is stationed behind Stieglitz's photo of Duchamp's *Fountain.* Dove's version looks like a dream of a lump rising in the throat, the mounting toward consciousness of anxiety from below. But even then, more striking than any body part identification, this skin's surface is recomposed of materials from the outside world, which have adhered to it: a profusion of metal paints, sand, collages of shirts, wood, grass, newspapers, photographic plates, and steel wool. Dove is a tinkerer, a joker festooned with the nature he has presumably penetrated, a clown in festive clothing. In a review of Dove's 1934 show at the Place, Lewis Mumford wrote for the *New Yorker:* "Dove has a light touch, a sense of humor, and an inventive mind . . . a witty mind whose art is play, and whose play is often art."[24] As a skin, Dove's space is always moving, gesticulating, handling his nature; where O'Keeffe's luminosity comes from an emanation of nakedness, Dove's is generated by a sort of body talk that blurts out, mumbles, exclaims, or sings, and not alternately, from one painting to the next, but in combination in each painting, layered chords of talk. In fact, his painted space has multiple layers, as he evolved a complex method of overlays, underpainting in tempera or gouache, finishing in wax emulsion oils. His skin is opaquely layered but still shows forth multiple depths of tactility, as if he had managed to move his whole sensate life into it. In Dove's transitional space is his respiration; his paint is where he wants to breathe. As Turner writes of the colors of *Cows in Pasture* (1935), brown, black, tan "appear to be distinct passages of wax emulsion, casein, and gouache. They exude a soft, breathing quality

Arthur Dove, *Cows in Pasture,* 1935.
Wax emulsion on canvas, 20 × 28 in.
Phillips Collection, Washington, D.C.

redolent of the warmth of animal hide or of the velvet glow of butterflies
studied by Dove so long ago in the Geneva woods."[25] For Dove, paint-
ing is an intuition-driven attempt to synchronize his breathing and that
of nature, of whispering or shouting his breath out into the world in a
manner that will bring nature's breath into the circle of his picture. This
was his personal way of embodying the Bergsonian agenda so many read-
ers of *Camera Work* had been exposed to: "This intention [of life] is just
what the artist tries to regain . . . in breaking down, by an effort of intu-
ition, the barrier that space puts up between him and his model."[26]
Whether it can be called sex or not, Dove breathes and plays his world
much more richly in the surface of his paint than he could in his impov-
erished and harried life.

Marin

Marin is an artist always at play. He was the artist who was closest to
Stieglitz for the longest time, showing accomplished and reasonably
well-received work at 291 from 1910 onward, at a time when Dove was
still searching somewhat murkily, and O'Keeffe, entirely unknown, had
yet to draw her first abstract charcoals. Marin's is an aggressive form of
play, despite the lightness of his medium of watercolors, a toyland of
modernities in smithereens. If this play is a version of his sexuality, it is
a jolly smash-up, without much serious fury but thoroughly indifferent
to the solidity or coherence of things. He doesn't transform things or

breathe his sensitivity into them, like Dove, but cracks them or bends them out of shape. He does the same to their frames, the one he paints so frequently into the painting proper, and even the wooden one surrounding it, thus putting some question to the idea of hanging the work neatly, squarely. Reality is made flimsy or seen refracted through pieces of broken glass, as if to admit, with a high degree of carefree humor, that his vision, or at least his point of view, might be impaired. He knows reality is there, he seems to say, the Brooklyn Bridge, the Maine islands, but he can't see how to get there without fumbling through his own vision, tripping over his own easel. His skin, the paint in the arena of the transitional space, is watery, a place where the outer world looks like details from a shipwreck. And, of course, this skin of his is paper, watercolor paper on which reality doesn't quite affix itself but floats, is ready to float off or at very least become unfastened. While the medium does dictate a good deal of unpainted, visible paper, Marin goes well beyond fulfilling that necessity in disconnecting his pieces of objects, letting them flap in the wind like loose sails. Watery paint on virgin paper, perhaps that best describes his "skin," as I am calling his presence in the paintings; he paints the constant threat of his own disappearance, a reckless but vigorous staving off of dissolution, always painting himself away

8.7 John Marin, *Maine Islands*, 1922. Watercolor and charcoal on off-white watercolor paper, 16 7/8 × 20 1/8 in. Phillips Collection, Washington, D.C. © 2004 Estate of John Marin/Artists Rights Society (ARS), New York.

8.8 Installation of *History of an American, Alfred Stieglitz: "291" and After,* Philadelphia Museum of Art, 1944–45. Yale Collection of American Literature, Beinecke Rare Book and Manuscript Library. Against the back wall are Hartley, *Painting No. 5, 1915, Portrait of a German Officer,* 1914, and *Painting No. 2 (Arrangement, Hieroglyphics),* 1914; middle wall Marin, a Maine shore scene (possibly *Movement—Boat—Off Deer Isle; Maine Series No. 9, 1926), Mid-Manhattan No. 11, 1932;* front wall Marin, *Echo Lake* (listed in the catalogue as *White Mountain Country— Summer, Franconia Range, Echo Lake),* 1927, and probably *Lower Manhattan, from the River, No. 1,* 1921. For Marin: © 2004 Estate of John Marin/Artists Rights Society (ARS), New York.

from the edge of the tangible, where he insists on residing permanently, since that is where he feels art resides: "Comes the artist—he sees—he plays round about—never losing its [the object's] magical existence [.] and as the beauty of the flower is intangible and since you cannot copy the intangible—so it follows—this drawing we speak of is intangible."[27] This skin of his sensitivity is always under precarious reconstruction; he is building a hold on things, and that is his true subject—paint and paper—that is where his obvious ebullience lives:

> This is a tactile thing—to paint with paint and feel that paint
> What did you paint it on (on paper)—Well then why in the Hell didn't you give the paper a chance to show itself?
> . . . Give paint a chance to show itself entirely as paint . . . in these new paintings—although I use objects—I am representing paint first of all and not the motif primarily.
> What do the objects sit on—they sit on the paint therefore the paint must be strong enough to hold them.[28]

While Rosenfeld may have tried to validate Marin's art by making him the healthy, lusty producer of "painterly ejaculations," as Brennan phrases it,[29] I find his work more fragile than that term implies, and arising out of a greater need for the clarity of innocence than for rutting.

All three of these artists have the quality of children, of reaching back for an innocence in their relations that we would associate with a presexual childhood if it were not for the Freudian necessity to detect and accept sexuality in infants. As purveyors of desire—desire for openness, for thingness, for the smells of earth, for destruction and rebuilding— they seem to antecede strictly defined genital economies, but play like true American Adams and Eves in the Eden America imagined itself to be. Theirs is the constant American battle against the morbidity of social constraints, against letting oneself grow up into them. Here the issue of sexuality becomes confused, because knowledge of sex is the loss of that innocence (it is a constant and well-recognized theme in the fiction of Anderson, Hemingway, Faulkner, and others in the twenties), but the artists, at least as their critics saw them, speak erotically right out of that innocence. What the artists wanted, when they painted like children, was to keep their sexiness innocent and youthful, happily free of guilt. This privileged innocence was prolonged in the Place, where Stieglitz insulated his artists from having to deal with the commercialized moralism of their audience. Thus the well-lit, beautifully denuded walls of the Place, with its gnomic guardian.

Ironically, the most "masculine" of the work by painters in the group is Hartley's. No other has his rough, primitively portrayed bodies, his massive and encrusted iconic officers, his heavily outlined landscapes and purposely static arrangements of Native American motifs. The 1944 Philadelphia installation *History of an American, Alfred Stieglitz: "291" and After* shows the power of Hartley's large-scale stasis, self-contained and massive with weighty though elusive symbols, in contrast to Marin's more or less controlled leaps and splashing. Even Rosenfeld, who spoke of Hartley's "grace and charm" and "fastidiousness" (albeit "unaffected"), could call his art "simultaneously stiff and violent and whimsical." Later in the same essay he would refer to Hartley's "muscularity," which Rosenfeld felt had been lost for a while but which would be regained

when the artist returned to his New England ground and subjects.[30] Hartley seems to revel in what takes on the appearance of poor or naive drawing, as if to deny any suggestion of sophisticated artistry. Inarticulate lines, waterlogged or leaden surfaces, willfully stolid bodies, these suggest a doleful philtering to counter what everyone recognized as the grace and charm of his personal fastidiousness. I will look more closely at this doubled presentation, but first something must be said about Stieglitz's relation to Hartley the man, a relationship that intrudes upon the value of Hartley's work far more in our present-day evaluations than it did for the persons concerned. Wanda Corn, in a book quickly becoming a work of reference, sums up: Stieglitz "tolerated Marsden Hartley but was much sterner with him, probably because he deemed him wayward, sexually as well as artistically, and could never fully control him. Despite pleas to return home, Hartley continued to live abroad."[31] It is important to see that Stieglitz did not operate in this fashion, as it goes to the heart of the meaning he gave to the Place.

I think it is even too simple to say merely that Hartley was homosexual. Certainly he was something of a dandy—without funds—but there is a surprising lack of evidence of sexual activity of any sort. He attempted one affair and that with a woman, Djuna Barnes, who was herself far from a simple case (she always refused to be tagged as a lesbian, despite a powerful infatuation with a woman over a number of years, the core of her famous novel *Nightwood*).[32] No liaisons with McAlmon (despite some raunchy letters), Hart Crane, Demuth, Carl Van Vechten? This seems remarkable in a period when, in bohemian New York and among expatriate Americans in Europe, it would have been difficult to keep such a secret, one that would not have been so exceptional in the arts community. It seems more likely he was in the main sexually inactive, terribly suppressed, playing the ascetic aesthete and putting all his emotional life into his work. Townsend Ludington also sees in Hartley a sublimation that precluded any lasting close relations with men or women, favoring instead an ideal of male comradeship.[33] Hartley's most complex self-portrait, *Sustained Comedy* (1939), shows his piercing blue eyes, which he thought were his best feature, themselves pierced with arrows, making him a martyr to his own artistic—or erotic—voyeurism. He led a lonely, traveling life, impoverished and proper, the "hermit radical," to use a term of his own, an "eagle without a cliff," as one bon mot had it, or, another nickname that circulated, "the monk of fear." William Carlos Williams wrote of the painter's sexual loneliness, adding, "His whole life had been a similar torment which painting alone assuaged."[34] Such opinions about the man, however, did not prevent Rosenfeld, Williams, and Stieglitz from collecting his paintings.

The correspondence between Hartley and Stieglitz makes clear how extraordinarily supportive the photographer was during the periods the painter spent in Europe, and especially when he was in Germany, where, if he had been able, he would have stayed past the dangerous time in 1915 when the war forced him to leave.[35] At that time, Hartley was slowly becoming associated with the group being sponsored by Herwarth Walden and was, he hoped, closing in on fame along with the other artists of the Herbstsalon and the Sturm galleries, including the Blaue Reiter.[36] Various letters from Stieglitz show that he found a personal satisfaction in Hartley's progress in Germany and on German models, after the painter had quickly fled Paris because he had found people like Robert Delaunay too cerebral about their work. All through this period Stieglitz supported Hartley financially, sending him drafts that were largely loans against sales in New York which never took place, or rarely; most of the time Stieglitz sent money out of his own pocket. Hartley's letters are full of his soul-searching, his dreams, his accomplishments. Stieglitz plays the entirely indulgent parent, but eventually does feel Marsden must return home in order to watch over the exposure and sale of his paintings and, most urgently, because the drafts of money Stieglitz was trying to send into Germany were not getting through. For the home market, Hartley had to dispel the public's idea that his work was pro-German, a necessity that was just as disagreeable to Stieglitz as it was to the young American painter, if not more so.

Hartley, always impoverished, wanted to be in Europe, and the remarkable auction Stieglitz organized in May 1921 permitted the artist to go, for ten years. He had shown up in New York with literally one penny, which he flashed at Stieglitz when he took Hartley to dinner. He wanted twelve hundred dollars so that he could go to Florence, "write a book of hate, have a hundred copies printed handsomely and send them to a hundred Americans I know and know of. Then I'd commit suicide." Stieglitz went the rounds of the likely galleries to see if they would buy all of Hartley's "stock," some two hundred paintings, for the desired amount. Neither Daniel nor Montross would bite, though they did deal in Hartleys and the latter had one on the wall he was offering at $1,200. Stieglitz argued, how could they pass up such a deal? (For myself, I ask why Stieglitz was doing this footwork and pleading: why didn't Hartley do it for himself?) Finally, Stieglitz fell upon the idea of an auction, and Kennerley, owner of the Anderson Galleries, was game. After Stieglitz and O'Keeffe hung all the paintings, Stieglitz packed in a crowd and planted dummy bidders, though many works were let go for very little. Stieglitz bid for himself and carried bids in his pocket from some thirty people amounting to over $3,000, which is to say he had himself enlisted thirty

buyers. The sale made $5,000, and every penny went to Hartley.[37] He went to Europe, only to return in 1930, after Stieglitz had prepared the way, they both hoped, with a large show in January 1929. However, the 1929 show was not a success. Critics harped on the theme of a painter staying in America to paint American pictures, a theme that Hartley had indeed heard from Stieglitz but only for practical reasons: "You have really made no 'practical' contact in Europe and you are really without contact in your own country. Spiritually you undoubtably are achieving what you must achieve, but the so-called economic problem . . . is quite as difficult, if not more so, than it was when you originally came to 291."[38] Thereafter Hartley had only two one-man shows at the Place, though he was included in annual group shows. Stieglitz was always good for a solid meal once a week at the Shelton Hotel, where he lived with O'Keeffe, but the painter felt the photographer "too queer for words about prices & me." He resented seeing O'Keeffe's paintings going for far more money than he could draw. Stieglitz was hardly to blame, and I concur in the note of exasperation Townsend Ludington strikes when he describes the situation: "He saw himself standing against the world, and despite the help of Stieglitz and O'Keeffe he criticized them for their lack of enthusiasm toward him. One can imagine them asking what the man wanted."[39]

This was 1936, and their relations had soured, though that did not prevent Stieglitz from showing him at the Place in 1937. Hartley's Dogtown paintings celebrate his return to America and to American themes, treated with a vigorous expressionism. Carol Troyen speaks of "a primordial fierceness that would characterize his chosen subject matter for the rest of his career."[40] The exaggerated masculinity was continued in both treatment and subject when Hartley stayed with a fisherman's family in Nova Scotia. While these images, like many earlier ones, may well be encoded with messages of secret male desire, which Jonathan Weinberg has examined in detail, their purposeful crudeness blunts any expression of desire at all, but seems rather to translate into bodily forms a dumb acceptance of frozen technique and ideals.[41]

One earlier production, *Tinseled Flowers* of 1917, is particularly interesting for the nature of its sexual enactment. Despite its rather overt representation, it has not elicited comment about its eroticism, whereas a rougher treatment of the same subject in *Atlantic Window,* showing a much smaller phallic pistil for the flower, has elicited some comment.[42] *Tinseled Flowers*—curiously, just one flower is pictured—offers an ambiguous engendering, a delicate masculinity in the flower's female organ. The technique has a good deal to do with rendering this delicacy, for the painting is on glass, which requires building the painting back-

8.9 Marsden Hartley, *Tinseled Flowers,* 1917. Tempera, silver foil, and gold foil on glass, 42.8 × 23.5 cm. Museum of Fine Arts, Boston. Gift of the William H. Lane Foundation, 1990.413. Photograph © 2003 Museum of Fine Arts, Boston.

ward with highlights first, as the artist works on the back of a glass surface, not building up and toward the viewer but away from him. Hartley found it difficult, but not only because of the demand for dexterity; he was also toying with an anxiety about being transparent, as through a glass and yet receding from visibility, as the process layers the paint in a progressive action of blocking out. The addition of tinsel, a complete block able to reflect the viewing scene, also suggests a sham splendor (and may be a reference to experimenting by Duchamp). But normally the intention of painting on glass is to let light through, to color God's shining forth, and one is reminded of Hartley's enthusiastic reading, about this time, of the American Transcendentalists, and of his concern for the spiritual in art throughout his life. Returning to my metaphor from Winnicott, we see Hartley's transitional space of creation to be this small sheet of complete transparency, his transparent skin which is not covering his painting but supporting it. Further, the real difficulty is not painting in reverse but feeling one's brush upon the surface that offers no resistance. Hartley's heavy stroking finds no grasp, but is threatened with constant slippage; he negotiates between transparency and secrecy, layering cover over an initial exposure.

This is a one-time plea for an especially innocent phallus, attempting to rise out of its doubts, a vulnerable sexual identity looking to unveil just for a moment. It stands in contrast to his habitual, more gruff philter—a short stint in the glass arena as an almost accidental respite from his usually thick-skinned and opaque one. But in those heavily painted works, sexuality is so toughened up that it risks its vitality. Male figures, single or in groups, are for the most part so bloated and wooden that their energy appears petrified. Hartley has painted over his own expressiveness to create crudely carved icons in imitation of a folk artist, as if the people he portrays are actually doing the inarticulate work he signs for them.

Adams

I end this description of the Place as a site of the ideal with an artist who did not show there over a period of many years—who in fact showed but once and might have better grounds than Hartley to consider himself neglected—yet who could also testify to Stieglitz's uncompromising combination of care and discrimination. Ansel Adams arrived unannounced at the Place from California in March 1935 to show the old master his work. He was rebuffed at first, and, though insulted, accepted a later meeting at which Stieglitz went over his portfolio with lengthy attention, in silence, twice. He then declared the work "the finest prints

I have ever seen," and offered him a show, which Adams slowly assembled and printed with the utmost care for two months in 1936. "Their predominant characteristic," which made them "worthy of hanging at the Place," was their "sense of almost palpable light," writes Andrea Gray.[43] This assessment is particularly interesting because it was precisely the abundance of light that made the Place, on the seventeenth floor of an office building and with six-foot windows facing west, such a fine venue. The rooms were entirely denuded so as to offer the least distraction. For Adams's photographs the walls were painted 40 percent gray—looking for the middle of the black-to-white scale rather than overemphasizing the light or shadow in the exhibited images. Adams, who had always shown on white walls previously, declared, "I think the finest walls I have ever seen . . . , whatever is on them seems to hold its own life."[44] He would henceforth show against gray, even in his own home. Overwhelmed by how Stieglitz had exhibited his work, Adams wrote to a friend: "The show was presented in a way I can never describe. Not only were the prints hung in a visually perfect way, but the hanging actually psychoanalyzed me."[45]

Adams did not get another show, though friends of his told Stieglitz his morale could use one. He was taken up with making a living from his work, for the Sierra Club for example, and, though Stieglitz gave some tentative encouragement to send new pictures, Adams did not produce. He felt the need to impress, to meet the "standard" of the Place, and the 1936 show was not to be surpassed by later work, even in his own opinion. He wrote in 1941: "Stieglitz has seen only three sets of my pictures since I have known him. . . . It's up to me to show him more."[46] While I'm sure he would have welcomed an appeal from Stieglitz, he knew how much his commercial photography sapped the strength from the personal sort of work that was expected from him at the Place: "The Place means more than anything else in photography. . . . It is always wonderful to know that the pattern of perfection exists somewhere."[47] When Stieglitz died, O'Keeffe found the unsold prints from Adams's 1936 show and asked him what to do with them. He felt it was in the spirit of the Place to respond: "I could not think of selling those prints. They should go to those who might enjoy them—you [McAlpin], O'Keeffe, Norman, Newhalls. . . ."[48]

An American Place was, then, a perfect home in the clouds, a sanctuary and master class making few concessions to the marketing of art, and fewer yet to work that did not continually keep up to the standards that work set for itself. As we can see with Adams, it functioned in somewhat the manner of an honor system; the accepted artist turned the Place into his own conscience, and desired to show only his best self there. It

certainly had to appear elitist, yet its grounds of exclusion were not social or ideological or even sexual snobbism, but artistic genius and the powerful desire and ability to paint oneself into an American space of highly expressive authenticity.

The Beauty of Tall Buildings

For Stieglitz, the Place was not only situated in the clouds. He lived high off the ground when he was in New York, there and on the thirtieth floor of the Shelton Hotel where he and O'Keeffe resided, but the wide windows of the Place stationed him neatly before a veritable forest of very real, very well-grounded skyscrapers, which he photographed throughout the thirties, and this despite the fact that he had said he could not photograph and run a gallery at the same time. He lived and worked midway between the ground and the sky and patiently considered the city that had grown up around him.

It seems remarkable that the skyscraper series should follow the *Equivalents*, in the sense that one would expect the transcendence of the latter to be the more likely final statement of the aging photographer. The change in subject, a long-postponed return to a "delirious New York," as the architect Rem Koolhaas has called it, produced a drastic stylistic readjustment, from the almost dematerialized, disembodied little four-by-five gems to full-sized ten-by-twelve images full to the brim with cement and stone set at cubist angles. More importantly, if the *Equivalents* already contain and express the transcendence and death of the old man, what do the tall buildings convey, how can they top the clouds? I would argue that they speak of Stieglitz's desire to return to a cultural battle, one exacerbated by the high contrast of profligate skyscrapers to deep economic depression, and that they represent a change of heart about going out peacefully.

Many professionals preceded him in photographing new and high buildings in America, but they were almost invariably handmaidens to the commercial builder and his client, documenting entrepreneurial success in the grand style that confirmed the city was "not a place of chaos, darkness, and danger, but of order, light and intelligibility," as Peter Bacon Hales has described it.[49] I have touched upon this subject in my first chapter, in connection with the photographing of the Chicago exposition of 1893. Already an authority then, Stieglitz exerted some influence, as we have briefly seen. But as an artist, or amateur as he had it, he was not interested in such businessman's boosterism, nor in dissimulating the darkness; for him it was the photograph that had to be intelligible, though this might entail revealing the building, along with the

motives behind its conception, to be significantly less so. And yet at the same time, as a Secessionist, he had to engage in an open-minded dialogue and exchange with this building, and not close his eyes to its ambiguous beauty. More recently, there had been attempts to look at the city in a modern and independent manner; by 1910 Coburn had embarked on striking portraits of London and New York, and by 1929 a younger generation was ready to take up the challenge. However, a portrait is not a series. Stieglitz's project, a sequence built up over many years of a city, about growth, change, and dying in both subject and in object, is a far cry from the synchronic panorama of a sprawling New York at one moment in its history. Such a portfolio as Berenice Abbott's, though its title was *Changing New York,* has great value as a record of one moment in the life of the city; in a sense it is true to the first idea of the photograph, taking up just a snap of time, and it is full of a grit of life that had not been Stieglitz's subject for years. But Stieglitz's idea of the sequence brings the city along with the artist into history-making. It extends the very nature of the medium, in which one quick click is expected to tell all there is to tell and make the moment eternal, thus isolating it forever from all other moments. Abbott expands her moment, and of course the city offers plenty of material for that expansion; Stieglitz's series severely restricts the number of objects, but extends his expression of them through the days and the years.

At the time of his early city photographs, just after the turn of the century, Stieglitz had already hoped to produce a series of about 100. So the evolution of the city, of its spirit and its commerce, and of the artist himself were to be the issue, and not merely discontinuous observations on various buildings in 1904 or in 1915. The demonstration of his early intention is found in the December 1931–January 1932 show, at An American Place, of ninety-six prints, which included the earlier work of 1890 through 1915 alongside (in fact hung after) the prints of the 1930s.[50] It was his first exhibition since 1925, and he would have only one more one-man show, in three years' time. With a backward glance at three of the earlier shots, I would like to weigh the strength and importance of the skyscraper pictures of the thirties: they complete the sequence on New York begun when modernism in America began; they are informed not only by the changes to the cityscape but by his own abstract work with the *Equivalents;* and, finally, they constitute Stieglitz's last statement as an artist and as a commentator upon American culture. They are in fact his last expressive breath.

Old and New New York of 1910 was, no doubt, unusual for the time quite simply for the inclusion of such a huge, high, and unfinished structure in a print pretending to the status of art three years before the

8.10 Alfred Stieglitz, *Old and New New York*, 1910. Photogravure on beige thin slightly textured laid Japan paper, in or before 1913, 33.3 × 25.7 cm. Alfred Stieglitz Collection, image © Board of Trustees, National Gallery of Art, Washington.

Armory Show. It is nicely reframed on two sides with buildings that, for all we know, are as tall as the looming project, and at the bottom marked off with a hedge and its stone enclosure. This hedge curiously cuts off all view of the people in the street at the chest, leaving us mainly with their bobbing hats above darkened or turned faces; the one gentleman not obscured also asserts his presence largely by way of his well-lit hat. All these hats are neatly aligned across the bottom of the photograph, as if Stieglitz had waited for any passersby who would not conform to such a flattened lineup to leave (a year later in Paris, Stieglitz would be struck by the sense of freedom in women going bareheaded in the streets). The skyscraper skeleton is in a distant haze, but—and here is the interesting

8.11 Alfred Stieglitz, *The Flat Iron Building,* 1903. Photogravure in *Camera Work,* no. 4, October 1903. Rare Books and Special Collections Division, McGill University Libraries, Montreal, Canada.

aspect, which gets us past the merely "picturesque"—it does not rise or soar. It hovers, or crouches, a wide, flat-headed monster. Perhaps it threatens to advance upon the older, more civilized buildings; but the hats go about their business unaffected, or ignorant of what awaits them. The only attractive thing skyscrapers can do is to soar; this one might yet, as its perfectly identical floors sketch a potential repetition ad infinitum. They also repeat, in stacked formation, the flattened conformity of the hats along the hedge line. What is new and threatening in the present is that, though a specter, the skeleton fills the horizon entirely and uniformly, pressing small and idiosyncratic creations into lowly street places along with the people, who do not seem worried, so that the concern is ours, on behalf of the pedestrians and the friendlier buildings.

A more famous photograph, and an earlier one, is *The Flat Iron Building* of 1903. The Flatiron (Fuller) Building was considered to be an artistic success, and certainly it is allowed to soar here, in the company of a very strong tree. Three structures of the period struck the consciousness of artists at the time: the Brooklyn Bridge, the Woolworth Building, and this, the Fuller Building. All could be made to tower in images, but this one, with its narrow northern edge, was compared to the prow of an advancing ship, no doubt an appropriate symbol of the city itself expanding northward (one should compare Steichen's more elegant 1905 version, with wet streets, hansom and driver, and visually higher Flatiron). In Stieglitz's wintry scene the building both soars and advances out of its picturesque haze and into the park. Everything shimmers from the storm (appreciating this shimmering relies, more than some of the other effects, upon seeing a real print), and the prow is nestled in the fork of the tree, not without erotic overtones, while the branches in that high area of the photo appear like wild, random scratches on the plate. The figures of people are almost invisible, confused with the bottoms of tree trunks on the low horizon, which is neatly underscored with aligned benches and chairs. It is a bright, Christmas-season marriage of architecture and nature, in which the tree accepts out of a position of power, or at very least equality. There is sufficient strength in the tree, which will not be moved, as there is power, though of a different sort, in the building, and the two are in quite serene balance while all about them the weather lights up every surface.

In contrast with both of the preceding photographs, *From the Back Window—"291" (1)* of 1915 (see figure 2.5) casts all the buildings into darkness, or I should say into darknesses. Only their innards shine bleakly, while they themselves disappear into the various degrees of gloom. Instead of drawing on white with black lines, Stieglitz draws on black with rows of light boxes and snow-covered edges. Instead of the build-

ing being in a haze, looming ghostlike, it is rather the lights that are hazy, peering feebly. There are no people at all (it is true that the time required for exposure would have been a technical constraint in that regard), but a comical face on one building seems inescapable for the viewer, with his two walleyed lights and a smile made of laundry (the larger, right-hand "eye" is a poster with a barely visible face; perhaps this was meant to be more clear in the original, a large-format platinum print). There is also a layered effect of increased humanization, from high background to low foreground: distant, indifferent offices where everyone works late (note how few offices are not lit; this is not yet the era of the neon light left burning through the night); a middle ground with a few people home, living under the eye of some Doctor Eckleberg-like apparition; and in the foreground the incongruous laundry, not yet taken in, and perhaps a candlelit dinner waiting. But over all is the huge darkness, cozier at the bottom, spectral above. Rarely did a photograph of this time desire so much light, so that its structure, quite cubist as cubed architecture met the cubism of modernist composition, had to rely on so little detail to define it. Stieglitz is doing a great deal with very little, a modernist challenge of reduction in which he is already well ahead of both the architecture and painting of the moment. In this busy darkness, light, or hope, is at a premium; in any case, there is room for it but little assertion. All photographs become mute at a certain point, but here darkness increases the silence, as does the complete absence of people. Man is the more acutely missed because the nature of a photograph is so inclusive. So many places for life, but only one cartoon face. Freezing laundry is as close as the city night will give us of warm bodies.

These three photographs are, briefly, representative of Stieglitz's evolving New York through 1915. He seems to prefer conditions that impede perfect focus, and that soften or distance the cubist geometry of his compositions. From the ground, or the window of his brownstone, his camera may have to point up, to a New York constructing its future. But in the images of the thirties, Stieglitz has hoisted himself up to the level of his high subjects and, essentially looking straight out of his window, rather than up or down, he is better able to align the buildings' edges and their vast shadows with his own camera plate's edges. He turns the buildings into fields of light and shadow that divide up his image in the manner of the cubist painter, co-opting his subject's geometries for his own. As with the cloud images, by force of composition he has turned his objects abstract.

These images are the largest one is used to seeing normally in photography, almost eight-by-ten inches, as if the cityscape were bigger than the sky or as if its minute details must all be distinctly seen. While one

risked falling into the *Equivalents,* being seduced by close intimacy with their soft and often erotic suggestiveness, here a decent distance for viewing can be maintained, to grant the skyscrapers' claims, seen from afar, to spectacular sleekness and confidence. These real buildings of New York are cubism at the service of commerce triumphant, the straight lines of rationality, or rationalization accorded full pictorial authority. Or not quite full authority, when we acquaint ourselves better with the special qualities of these images, "crystalline and precise," as Alan Trachtenberg has called them, for they translate as well the artist's "self-declared alienation," and to do so they must be setting something of a trap for these fine icons of the marketplace.[51]

Alienation, whether it be Stieglitz's or that of the buildings and their financing, is most obvious in the absence of people. There can be no doubt about the willfulness of this omission, as there is not a human being in any of the photographs I have seen. We may contrast this absence with the presence of at least a few people in his earlier images of the city, but more strikingly with Lewis Hine's famous *Men at Work,* produced at the same time Stieglitz returned to New York's tall buildings. Hine's men fill the screen; in fact we hardly ever see the building, which is the Empire State, erected at the very moment the economy was crashing. The worker is glorified, the power of the human endeavor reaffirmed, so much so that Hine produces the most dynamically constructed pictures of his career. There remains a taint, however, which is that these photographs were commissioned by the managers for the purpose of publicity. Labor is co-opted, as is the photographer, for this glorious praise of capital rising, somehow, out of the ashes of the Wall Street fiasco (to update the issues, we might add that nothing is said or implied here about the Mohawk Indian steelworkers who made up the majority of these aerialists in Hine's record and would soon be back on their destitute reservations). Hine's was not a complicated vision; he wanted men's work to be recognized and poverty to be abolished, and he did not document hidden forces or ambiguous ones.

In this light Stieglitz's alienation, if that is what it is, appears more judicious. We note that his buildings are cut off both at the bottom and the top. With few exceptions in the series, none of these fine buildings is permitted to aspire, nor are any given ground to stand on. Stieglitz has quite purposely interdicted the sort of symbolism the skyscraper might have claimed by allusion to trees, with their heads in the divine skies and their feet rooted into the earth. The thirties were the time of architecture's drive for height. As the economy went way down, the fantasies went way up, as models of distraction and denial. But Stieglitz has his buildings going nowhere, has shown only the texture and principle of

skyscrapers, not their accomplishment. There are never any streets, which are for people, and almost no tops, which are for showing off on a skyline rarely seen.[52] Berenice Abbott, in her contemporaneous panorama of New York, imposed a more wonderful view, of soaring pinnacles from the angle of the pavement below. Contrasted to this worm's-eye view was the popular bird's-eye view, in which people are always busy little ants. Such images, even when taken by committed leftist photographers, always seem more amused or marveling than despairing at man's belittlement. In a democracy, anyone can climb or ride up the tower with the Kodak and be the one for whom all these scurrying others tarry. Stieglitz has opted for a simpler body view, for the isolated fabric and backbone of commerce, which he faces head-on and from an equally high footing, his own high floor. Seen thus, the structure is static, coming from nothing, going nowhere, and immaculately emptied of the human. At the same time, concentrating on the fabric of the structure, the image reminds us of the cloud pictures and the sense of abstract fields at play, here of the nature of stone, sash, and fluting as crafts of man.

Stieglitz's photos gain another advantage from the absence of man, since the signs of his labor cannot be absent. In *From My Window at An American Place, North,* of 1931, the sun picks out the two reaching arms of an immobilized crane, leaving more than half of the rest in perfect blackness. A sort of mock skyscraper rises in rather pointless brickwork with fake windows, in great contrast with the many real windows, left and right, which make up *all* of what is left of the visible; no one is watching and no one is working, though the means to work are stunningly delineated, constructing beautifully against the dark and rising cleanly even if they are below the camera eye.

The camera eye, and the viewer, can hardly miss the huge procession of so many blank windows in this series of photographed buildings, but they come in for special emphasis, whether in light or in darkness. In *From My Window at the Shelton, West* (1931), all the windows have been crossed out, like rejected shots on a contact sheet (of course the markings merely mean that the windows are newly installed, and no one is occupying the offices yet). Again, labor is represented in the absence of laborers, in this building and in the ubiquitous skeleton in the distance. The Waldorf Astoria is composed of a beautiful geometry, rendered as a studied solidity that might fly much better in the modern world if it were not burdened with its medieval parapets. The architects must wrangle not only with the famous setback regulation but with ideas of success and ambition that demand to be confirmed in archaic forms. What finally decides the issue between aspiring modernity and stumpy medievalism is how the light picks up the slivered edges of each section, to send

8.12 Alfred Stieglitz, *From My Window at An American Place, North,* 1931. Gelatin silver print, 24.3 × 19.1. Alfred Stieglitz Collection, image © 2004 Board of Trustees, National Gallery of Art, Washington.

CHAPTER 8

them all skyward as slim, repeated, but varied shafts. While the building itself lingers, the photograph both chides and soars. With more help from light, which he determines, than from stone, which he can appreciate but also measure, Stieglitz makes the building an actor in a play of his own devising.

None of his titles name the buildings, only his own vantage point, which for all of the 1930s part of the city series, some sixty-five finished photographs, is either his rooms on the thirtieth floor of the Shelton Hotel or the gallery of An American Place, his own carved-out spaces. From one critical perspective this resistance to naming may be seen as an effort to generalize, to remove the documentary function and enhance the artistic one. But at this late stage in Stieglitz's career, as in the history of American art photography, such a gesture is unnecessary. Something more remarkable is happening when Stieglitz reiterates, from one photograph to the next, "From My Window . . .". The viewer is reminded that the camera eye has been restricted, that it will not be moved yet can compose any number of varied environments for itself. It can make the monoliths pliable and control the fantasies that commerce would prefer to project about itself. There is some personal arrogance on Stieglitz's part; but he is also demonstrating to others that it can be done. Expression has not been intimidated or overwhelmed, despite the proliferation of overbearing, huge and heavy objects. One might object that his view, from a window or two, is narrow. But he doesn't need to control the whole skyline, only the fabric, the marrow of the skyscraper. In any case, the narrow view is the photographer's challenge, which he must turn to advantage.

To say his viewpoint is restricted to a few vistas is yet to say nothing about time, and *when* the pictures are taken. The control the camera exerts over the fabric of buildings resides with the eye's patience, as it waits for the changing light to bring a change to the building's meaning. Obviously the waiting is an important thread in my book, and it is amusing to think of Stieglitz now waiting in his room for a subject that will not, in itself, change, as a coach in a storm on Fifth Avenue some thirty-five years earlier had to. Then, the photographer waited for New York to move into position; but now only time, which is light, moves. A second view called *From the Shelton, West,* with the same perspective, removes the shafts of light running up the central structure, removes about four floors off the top, including one high setback, and shadows the lower part of the building sufficiently to break it up visually into separate entities. On the one hand the eye is carried along the tops of the city canyon toward the skeleton and the horizon, instead of toward the sky; on the other, forms have been reduced and most of the picture is in

8.13 Alfred Stieglitz, *From My Window at the Shelton, West,* 1931. Gelatin silver print, 24.2 × 19.3 cm. Alfred Stieglitz Collection, image © 2004 Board of Trustees, National Gallery of Art, Washington.

shadow. The building is more of a neat slab. In effect Stieglitz has progressively modernized the building, reducing its anachronisms and emphasizing its unornamented functionalism. In this sense, while merely continuing on the path he and colleagues like Strand or Dove had embarked upon ever since cubism and the first abstractions, he is also anticipating American architecture by some twenty years by turning the cityscape over to a dramatized Bauhaus-inspired slab.

A third version, *From the Shelton, Looking West,* continues the double process of reduction and darkening to produce the most striking of the three compositions. This image also appears as a lesson to demonstrate what can be done photographically with the other two. The skeleton is now white, and a little taller; most of the rest is in strong, engulfing, hard-edged shadow. Full center is a single windowlike lit surface, very delicate with its one hard and one soft edge. All else surrounding it is the darkness of the slab itself and the darkness it seems to cast into the street, making its darkness our own. As so often, a string of lit windows rises in

8.14 Alfred Stieglitz, *From the Shelton, West,* 1931. Chloride print, 24.3 × 19.2 cm. The Alfred Stieglitz Collection, 1949.782. Reproduction, The Art Institute of Chicago. © 2004 The Georgia O'Keeffe Foundation/ Artists Rights Society (ARS), New York.

8.15 Alfred Stieglitz, *From the Shelton, Looking West,* 1931. Gelatin silver print, 23.5 × 18.7 cm. Museum of Fine Arts, Boston. Gift of Miss Georgia O'Keeffe, 50.847. Photograph © 2003 Museum of Fine Arts, Boston. © 2004 The Georgia O'Keeffe Foundation/Artists Rights Society (ARS), New York.

the slab, in this case ever so delicately, as the light is in fact reflected off inside walls as it comes through the east-facing glazing. In some south-facing windows we discern *X*s also reflected off the office walls.

These transformations are not merely a matter of waiting out the light over the period of a few hours one day. More patience than that is apparent in the details of the work, which, by the way, I have arrayed in reverse order in terms of the time of day. This progressive fall of the object into darkness, joined to a rise into bleak abstraction, shows the artist imposing his vision upon the most immovable, intractable of objects, without himself being obliged to scramble; he only has to wait, and he appears to know exactly what he is waiting for. If we were to look at only two versions of this same perspective, the first and the third, we would gain an even stronger sense of the transformation Stieglitz has effected. But examples of such complete defamiliarization are not in short supply in the series. Two images taken from the same vantage point and sporting the same title, *From My Window at the Shelton, North,* both

8.16 Alfred Stieglitz, *From My Window at the Shelton, North,* 1931. Gelatin silver print, 24.2 × 19 cm. Alfred Stieglitz Collection, image © 2004 Board of Trustees, National Gallery of Art, Washington.

8.17 Alfred Stieglitz, *From My Window at the Shelton, North,* 1931. Gelatin silver print, 24.3 × 19.1 cm. Alfred Stieglitz Collection, image © 2004 Board of Trustees, National Gallery of Art, Washington.

of 1931, would at first appear, if we did not examine them closely together, to be of entirely different scenes. But this is the same RCA building, taken from the same height and similarly decapitated. The bright morning shot shows more heavily shadowed masses. A longer-focal-length lens was used so that, while the margin on the left is the same, the RCA building fills almost all of one half of the image. The early evening shot (in some versions the title is *Evening, New York from the Shelton*) illuminates the mass with lights from within, paradoxically giving greater lightness to darkness, and sends this more narrow slab boldly up the middle of the composition. In the lone detail that might remind us of the morning image, the skyscraper on the left, we are shown that this is far from the same day, as another seven or eight floors have been sheathed.

Another example of complete transformation is a pair taken from the Place: *From My Window at An American Place, Southwest,* 1932, and *Water Tower and Radio City, New York* 1933. The pervading darkness of the first

is ominous, by virtue of surrounding an almost peephole view of our now familiar theme of semi-clad skeleton. Only the dimmest of lights break the gloom, which is entirely foregrounded. In the second view the behemoth has been completed, and marginalized; perspective has been flattened to approach a two-dimensional composition. All is ungainly squares, with emphasis displaced from forms to aging texture; that is to say, to the brickwork weathering unevenly in the foreground and, especially, the completely irregular cracking and patching of the surface plaster on the top floor. It is as if the materials of the cubist city are straining to return to forms more natural to them. The antiquated wooden water towers, if anything, have fared better. In different terms, as one building comes into operation, in a sort of commercial Darwinism, the ancestor—of how few years!—has turned to blight, and is ready to be dismissed. Most likely the top floor in the foreground was already in this state of disrepair at the time of the earlier photo, when the skeleton was only a few floors from completion; but that was not what Stieglitz wanted to use it to say. Now there is a sadness about the ungainliness of the aging

foreground, and a sort of warning for the shiny new building that has little to boast about in the way of marking the skyline with any permanent beauty. Timing his shots, Stieglitz brings time to bear on the pretensions of expedient architecture. With light he assaults the building's self-interested claim to permanence, which I would say he has evacuated.

As a last demonstration, I would like to look at two photographs of the Rockefeller complex, structures that could hardly be accused of expediency. By all accounts this complex represented the most spectacular and successful project on the island, an integrated, mixed-use combination of plaza, buildings of different heights with artwork inside and out, and one dominating, soaring seventy-story near-slab, the newer RCA building, which used its slim setbacks beautifully. Built over the whole span of the depression, and despite its grace and various civic functions, it could hardly avoid the irony contained in the immense funds continually available for its many components while Americans everywhere were dispossessed. John D. Rockefeller Jr. had taken complete control over the original project, a new home for the Metropolitan Opera, which had been scrapped precisely because of depression uncertainties. Stieglitz himself had a bone to pick with Rockefeller who, he felt, was backing the new Museum of Modern Art, organized in 1929, as a showplace for European modernism almost exclusively, thus further impeding recognition for American artists, which we know Stieglitz had been fighting for since before the Armory Show. Dorothy Norman writes that the Place had been founded in direct reaction to the founding ideology of the Modern: "He [Stieglitz] is appalled by the idea that an expansive showcase is to be set up—that most of the money will be spent for staff and upkeep, rather than for the livelihood of American artists."[53] In 1935, the year of the two photos under discussion, the Modern had just demonstrated to its backers' satisfaction that a large Van Gogh show could bring in crowds as large as those attending a Radio City Music Hall spectacular.

This elegant RCA building (Stieglitz seems to have followed the company around the town with his camera) represented another, more personal threat. In 1932 O'Keeffe had accepted a commission for a mural, to decorate hundreds of feet of wall space in the Music Hall's powder room. Stieglitz had been dead set against accepting the commission for a number of reasons, most obviously because of the commercialization of her art, and for a mere $1,500 at that, at a time when he had managed to get her prices for easel paintings beyond the $4,000 mark. He must have seen the commission as a war for O'Keeffe between himself and Rockefeller. Stieglitz's subsequent victory had been entirely pyrrhic; when O'Keeffe had gone to inspect the surfaces prepared for

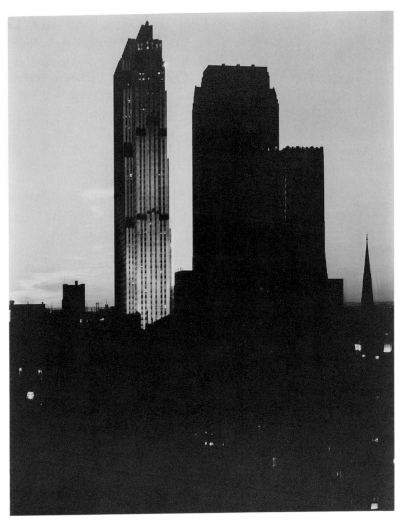

painting, the plaster fell down around her and she broke down, to the point of being eventually hospitalized for depression. Such strain did nothing to relieve the difficulties in their relationship, which had been partially resolved by her summers in New Mexico. She painted nothing between 1932 and 1934 (nor does it appear he took many photographs).

Here, then, is the unnamed culprit, one of the highest buildings on the New York skyline. I remind the reader that the photographer still has not moved; the massive building at center is the one under construction on the horizon of the trio of photographs looking west and discussed above. Our secure markers are the two dwarfed spires of St. Patrick's Cathedral, on the right and appearing as one in the night image; they were between the skeleton and the Waldorf in the earlier sequence.

Otherwise, Stieglitz has completely made over the landscape, as had Rockefeller, of course. In contrast to all other photos we have seen in the series, there is no framing by other buildings, such as the Waldorf with its parapets in the foreground. This threesome stands in the middle, alone and with nothing to bring it closer to us. They are in the sky. The structures are flattened against it by the longer-focus lens, so that 444 Madison in the middle stands in the same plane and on an equal footing with its more famous neighbors. In the evening photo darkness would envelop all, except that the RCA has decided to give itself its own light; one of these spotlights creates the illusion of the sun peeking out from behind the building. Ever-so-slight slivers of lit windows run like a slim row of razor blades up the edge of the International building, on the right, while some light blemish on the film emulsion is permitted to reflect down the full length of the RCA's northeast edge, enhancing its spectral quality. There is a resemblance here with O'Keeffe's painting of the Shelton with sunspots, in which the spots are those a camera lens produces rather than the eye itself. Perhaps St. Patrick's northern spire is being permitted to resemble a witch's hat, over two eyes cut into a pumpkin. Rockefeller's slab rises majestically, successfully from the shadows, projecting its own darkness into the sky and leaving all others in uniform, earthbound darkness save for a few erratic and quizzical lights.

The morning view maintains the bottom mass in similar, uniform neglect, though the spires identify themselves more distinctly than at night. Also, here, the slab itself is cut in two horizontally by a shadow, in a repeat of the horizontal separation of light and darkness affecting the whole picture. Earlier buildings are thus all leveled, not unlike the few people on the horizons of Stieglitz's earlier photographs. The principal break in this obscured mass of surpassed structures is the shaft of light slicing downward in counterbalance to the slab's symmetrically placed rise. This is not the first occasion we have had to notice such a knifelike use of light in the series; we also make the metaphorical connection with Steichen's famous portrait of J. P. Morgan, published by Stieglitz in an April 1906 issue of *Camera Work*, in which the arm of the chair the financier is gripping perfectly represents a knife blade. Closer in time to Stieglitz's portrait of the building's beauty and its symbolic devastation of others is Hart Crane's image of light dropping into the escarpment of tall buildings from the opening of *The Bridge*: "noon leaks, / A riptooth of the sky's acetylene."[54] It is with such a riptooth of light that Stieglitz forces the building's transcendence to betray itself in the street.

Stieglitz's use of light is always a game with time, which he wants on his side in his battle with commercial America. Time is what photography plays with, in its acts of composing and execution, and in the

8.21 Alfred Stieglitz, *New York Series—Spring,* 1935. Photograph courtesy George Eastman House. © 2004 The Georgia O'Keeffe Foundation/Artists Rights Society (ARS), New York.

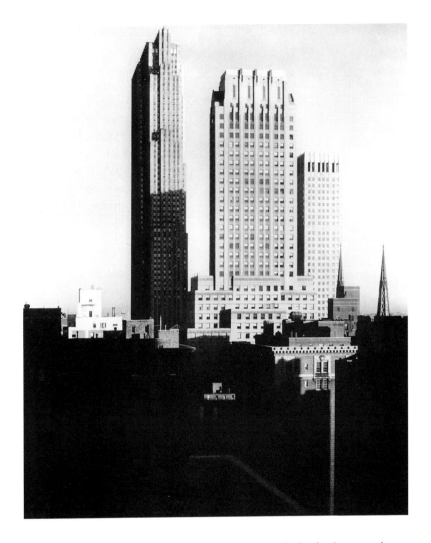

grounds for portrayal it provides to its audience. Indeed, photography as a medium misleads us by promising to isolate moments so short in time that the eye has never seen them. What can language provide faster than, say, a "split second," and how does that compare to a one hundred and twenty-fifth of a second's worth of experience? But at the same time there can be a thickness to the moment represented, the result of a waiting and a preparation for its composition, and a subsequent depth of looking into it with serious anticipation and consideration. The photograph can convey this pondering and this patience. By waiting so carefully for the lighted city to compose itself to his vision, Stieglitz has made it seem to be waiting in the image, which indeed has a thickness in time. He has given it what the writer and photographer Wright

Morris has called "the palpable sense of time as a presence."[55] By commanding the light to take the buildings, he has not only reconstructed the city but has also materialized it as a waiting presence in the photograph. O'Keeffe was acutely sensitive to this quality, and wrote about it to Dorothy Brett during the 1932 show of her husband's photographs:

> The Place is the most beautiful now that it has been at all—The rooms as a whole are more severe—more clear in feeling—and each print as you walk down the length of each wall and look at each print—it is as if a breath is caught—I wish you could see it—I think not many will see it as I do—It takes very good eyesight and it takes time—time not only to look but to think and let yourself feel it— and all of us here hate to take time to let anything happen—I am glad he is showing them but there is something about it all that makes me very sad—.[56]

After each of these single photographs, Stieglitz is waiting some more, and again and again, in the series. In not moving himself, in letting the time of day and the intervening years work for him, he alienates the beauty of the buildings from their acquisitiveness. He evacuates their false pretensions, and they are, as it were, full of their emptiness. Of course Stieglitz is also alienated, marginalized in the marketplace and even in the arts, and close to death as well. But he has chosen to come back down from the clouds to write a different death for himself, no longer one of resignation or transcendence but one with anger in its bleak forms and with the beauty residing in the resistance of craft. His death and ours, his light and ours are powerfully present in these last photographs, representations of an Olympian endgame in which business turns to stone the American spirit, yet can't avoid embodying it as well. In Stieglitz's protean views, skyscrapers are beautiful for the reasons he chooses, not theirs; that is the best testament he leaves as sole encouragement.

9 Conclusion:
The Secession's Unyielding Father

This book has proposed to focus closely upon a number of American writers and artists as they themselves reflected upon American modernity being absorbed into their work. For me, the first value of the study has been the practice of attentiveness to the early exposure of such new work. The more general remarks that follow are not meant to encompass everything I've examined, but rather to offer an overview of the Secession. If the summary here is not surprising, I hope it stands on more solid ground than it would have without my sequence of close-ups.

Ultimately the Secession evolved an American style of looking. Though not yet prepared to embody the large-scale rejection of modernity that runs like a distressed thread through classical Anglo-American modernism, as we see it most clearly in literature, Stieglitz's lens, along with the visions of many of those associated with him, inaugurated a resistance to the commodification and co-opting of art that has become one of its markers in the twentieth century. The cultural resistance of the artist has today become so commonplace as to be the norm; instead of singing the praises of the society that gave it birth and early values, cultural activity evolves in counterpoint, indicting society for betraying its promise, which indeed amounts to its promises. Such American promissory notes guaranteeing freedom of expression or Adamic youthfulness,

imagining its members as self-made, honest, truthful, and generous (to mention only a few ideals), instigated absurd expectations, ideas as starry-eyed as "the pursuit of happiness," that cornerstone. The position of the artist, at the time of the Secession and frequently since, has been to play the innocent. His work, or hers, voiced the creative person's disappointment, though often in the shape of the youthful dreams each held in trust. Heirs to a hazy American promise that was always melting away before it materialized, artists made it solid in the realm of the artistic imagination. American literature and art thus became more American than America, in fact created what we think of as "American." For we must realize this secession is not from American ideals but is a re-creation of them as a critique of their loss. The Secession created what we imagine as the Americanness of art produced here out of an intense desire to preserve the ideal from running out into the commercial sand. While it might seem today that the Stieglitz circle's work is not always acerbic enough to be considered truly critical of the American scene, we should realize that it created the basis on which we construct our judgments. The Secession functioned as an early, artistic anarchism within the larger economic and cultural one.

Wearing a number of different hats, Stieglitz was the president of this little Secessionist republic, the default president of a freewheeling community that depended more on his sustained indifference to power than we are apt to give him credit for. His goal, at which he was impressively, unexpectedly successful, was to set the intellectual and material conditions to encourage a number of artists to do their work; everything came out of that precept. Even Hartley, considered by critics to be a least favored son, recognized the extremely unusual generosity and commitment of the "dealer" of 291 and the Place, even to an odd fellow like himself. In 1933 he drafted an autobiography, *Somehow a Past,* where, since he did not publish it, he was probably at ease to speak his mind:

> [Stieglitz] shared with his associates whatever he had—and he had the special outstanding quality of never once suggesting, certainly not to me ever in all the years I was in the group, never saying why do you do this—why don't you do that. He seemed to know that what we all did was natural to us. He knew that our lives called for a certain scale . . . , and set to work accordingly to set us all to work knowing that work made us happy and that we were not fooling our time away or bluffing in any way ourselves or him. The understanding was perfect. He knew that one needed to go somewhere—that another needed to be still.

He knew that I was a traveler—and that my education lay out in the open free areas of the world—and that I must go wherever my education called for me to go. What an extraordinary condition it was—unique surely in the world of artists—one man understanding and believing in a number of outstanding types and seeing to it that they could live and work and produce more work . . . and I say— what a miracle. One man—one person who believed in several people all at once—and saw to it that none of these came to want.[1]

Hartley is able to read in Stieglitz's behavior a selflessness many a critic today is not inclined to grant. But Stieglitz's relative disinterestedness is precisely what made for the "extraordinary condition" his colleagues enjoyed. This is not to say he gave no advice, had no opinions. He lived by a concrete sort of idealism wrapped in an American dream, an idealism that he played out for himself and others as a model for personal, unattached expression in art among Americans. He advised artists to simplify what they searched for in the image, their vision if you will; this reflected his wish for an American dismissal of cant and veneer, of social ornament or pretense, a desire to remain true to the presumed innocence of the republic, the basic principles the democracy set for itself in a new, clean world. Within that simplification he recommended that the artist turn a heightened attention to the few details sturdy enough to have survived the general housecleaning. In his understanding, care for the detail was care for the presence of the individual in the landscape. The detail was the fulcrum for making, for treatment, the repository of ethical workmanship within the overall vision. In the treatment of the detail, artists affirmed most acutely the importance of craft, the quality that became, decade after decade, more and more threatened by the shoddiness resulting from a different American dream, the money-making efficiency of Taylor's production line. Stieglitz's secession is from American values as they were debased in commercial America, a secession from America's failures in the realm of its own idealism.

For these artists Stieglitz inevitably played the father figure, but of a certain sort; he was not so much Lacan's "non du père," an imperious interdiction which the French psychoanalyst saw embedded in the "nom du père," but the standing figure for what Stieglitz called a standard, one who remained uncompromising with vision and quality of execution. He consistently personified that double foundational stone even for people beyond his tighter circle—writers looking for the modern, Frenchmen teasing the art world with joyous cynicism—but most obviously, of course, for his photographers and then for his painters, who could rely on him, whatever else they came to think about him; he would not lose

focus or succumb when they themselves felt the cultural or commercial pressures to do so. That is the meaning of what Hartley, and Ansel Adams in my previous chapter, are saying about him. He was both their standard-bearer and their scapegoat in the battle against the allurements of commercial American culture. For him the standard, in the first instance an aesthetic issue, also translated into the symbol of a way of life: "instead of 'God Bless Our Home,' I would put up a sign saying 'Follow Through.' If you follow through, you create a graceful stroke in life. If you do not, you make a mess of it."[2]

The high demands he made on the production of artwork play out in two separate areas, his own photography and the work of artists he encouraged and sponsored. It is not a simple matter to determine why he could give up his own art for such extended periods if he took it so seriously and devote so much time and energy to the work of others. We continue to wonder how someone could put so much effort and conviction into these two competing endeavors of creation and promotion. Each is surely a sufficiently consuming site of personal vanity; to work with so much commitment to both strikes me as lacking much vanity in either. So I think this ability, or compunction, to commit so thoroughly in the two areas indicates how profoundly he felt the same vital principle operated for him in both; it was not a matter of whose work but of what shared American values. Of course that assessment makes him look quite unreal, a mythically good father. Is it possible he had no interest, at all, in any profit to be made by his position in relation to the artists, including himself? "I am not a National Asset," he asserted to a live audience, referring to a famous racehorse being brought back to the track at the time. "I do not want to be a National Asset. Do you know what I am to you? I am this: You feel that I am really interested, *disinterestedly,* in a thing in which you are interested, photographically."[3] This statement may appear a huge personal negation. But he does seem to believe sincerely enough that a good artist, even himself, is a fine racehorse to be valued for how he or she runs, and not for the profit to be made from the race.

The calm poise of Stieglitz's own work, "ideal" work if that is what it is, does not always play in his favor as a great photographer. What we more commonly conceive of as the fundamental realm of the photograph is connected to a sense of excitement—the excitement of immediacy, of coming into the presence of the real and exactly *there.* Our sense of the photo's purchase on reality is such that we are rushed to the spot, and we share in the breathlessness of the photographer's luck and intuition in having arrived there at the only right time for a meaning in its scene that, most likely, was never that one before and never will be that one again. This describes the quintessential photographs of Weegee or

Cartier-Bresson, which contain pleasures Stieglitz will not often offer us. Even the posed theatricality of Avedon searches out a "real" moment in the celebrity's passage that delivers to us some truth, we feel, whether contained in or hiding beneath the star's self-enactment. It is also true, though, that large volumes of Cartier-Bresson, for example, threaten to weary us, almost turning photography against itself as the viewer begins to feel he has, now, been taken to the same fountain too often, that "there" has become anywhere, a scene where materiality has grown soft. Janet Malcolm speaks of "tired eyes" in response to heavy volumes of single photographers.[4] But this phenomenon is precisely not what happens to us with Stieglitz, who was careful to make each image count as a pregnant occurrence. While I have spent some time trying to show that he did not eschew the record, we cannot go to him primarily for the accumulated record, but for the care he took to make the record show forth both depth to his surface realities and depth to his vision of them. No doubt few would want a diet of nothing but Stieglitz; on the other hand, rendered bleary-eyed by Weegee, we find many other sorts of sentiments to attach to the moments the elder master composed with such intense care. There is powerful photographic truth in Weegee's precipitous rush to the scene, the execution itself an image of his content—an imitative form. Stieglitz conveys an opposite sense, that the image has been approached and executed with a wealth of time and reflection. This method can produce an odd feeling, one which we have to wonder at, in the case of the ever-fleeting *Equivalents,* most strikingly. Going unhurriedly through an exhibition of the cloud series, one is moved not by a series of fixated skies but rather by the radiation of feeling produced by years of artistic concentration applied to a subject that is barely there at all.

Notes

Preface

1. Carl E. Schorske, *Fin-de-Siècle Vienna: Politics and Culture* (New York: Knopf, 1979), p. xxii.

2. Roger Shattuck, *The Banquet Years: The Arts in France, 1885–1918* (London: Faber and Faber, 1958); Dickran Tashjian, *Skyscraper Primitives: Dada and the American Avant-Garde, 1910–1925* (Middletown, Conn.: Wesleyan University Press, 1975); Peter Stansky, *On or about December 1910: Early Bloomsbury and Its Intimate World* (Cambridge: Harvard University Press, 1996).

3. Dada's rediscovery may be dated to Robert Motherwell's large edition of *The Dada Painters and Poets* (New York: Wittenborn, 1951), three years before Arensberg's Duchamp collection was permanently installed at the Philadelphia Museum of Art.

4. Mina Loy, *The Last Lunar Baedeker,* ed. Roger Conover, note by Jonathan Williams (Highlands, N.C.: Jargon Society, 1982).

5. Definitive work by Francis M. Naumann has been done in his *New York Dada, 1915–1923* (New York: Abrams, 1994), and for the show he curated at the Whitney Museum, with its expansive catalogue: Naumann and Beth Venn, eds., *Making Mischief: Dada Invades New York* (New York: Whitney Museum of American Art, 1996).

6. Marsden Hartley in a letter to Stieglitz circa February 1914, as reproduced in James Timothy Voorhies, ed., *My Dear Stieglitz: Letters of Marsden Hartley*

and *Alfred Stieglitz, 1912–1915* (Columbia: University of South Carolina Press, 2002). Paul Rosenfeld, *Port of New York: Essays on Fourteen American Moderns* (New York: Harcourt, Brace, 1924).

7. William Innes Homer, *Alfred Stieglitz and the American Avant-Garde* (Boston: New York Graphic Society, 1977); Bram Dijkstra, *The Hieroglyphics of a New Speech: Cubism, Stieglitz, and the Early Poetry of William Carlos Williams* (Princeton, N.J.: Princeton University Press, 1969).

1 The Coming Storm of Modernism (1893)

1. Woolf in *Mr. Bennett and Mrs. Brown* (1924). Vauxcelles in *Gil Blas,* May 25, 1909. Presumably, Vauxcelles had the allusion to little cubes from Matisse.

2. Van Deren Coke and Diana C. du Pont, *Photography, a Facet of Modernism* (New York: Hudson Hills Press, 1986), p. 10.

3. Stephen Crane, "The Men in the Storm," in *Maggie and Other Stories* (New York: Washington Square Press, 1960), p. 66.

 Richard Whelan, in his *Alfred Stieglitz: A Biography* (New York: Little, Brown, 1995), p. 118, is probably conflating two February storms, Stieglitz's in 1893 and Crane's in 1894. But, like Whelan, I am taking the impetus for both artists to be very similar, a snowstorm that comes to stand for a social crisis and that is premonitory for the photographer and a verification for the writer. Alan Trachtenberg, in his "Experiments in Another Country: Stephen Crane's City Sketches," *Southern Review* 10, no. 2 (April 1974): 265–285, speaks of "the same year" (p. 274). I believe Ellen Moers, who has searched out the actual dates, has it right in her *Two Dreisers* (New York: Viking, 1969), pp. 3–14.

4. Michael Robertson, *Stephen Crane, Journalism and the Making of Modern American Literature* (New York: Columbia University Press, 1997), p. 189.

5. Samuel T. McSeveny, *The Politics of Depression: Political Behavior in the North-East, 1893–1896* (New York: Oxford University Press, 1972), p. 33.

6. Dorothy Norman, *Alfred Stieglitz: An American Seer* (New York: Random House, 1973), p. 39.

7. Jay Martin, *Harvests of Change: American Literature, 1865–1914* (Englewood Cliffs, N.J.: Prentice-Hall, 1967), p. 208.

8. Fay M. Blake, *The Strike in the American Novel* (Metuchen, N.J.: Scarecrow Press, 1972), p. 18; Tony Tanner, introduction to William Dean Howells, *A Hazard of New Fortunes* (New York: Oxford University Press, 1965), p. xii; Martin, *Harvests of Change,* p. 208.

9. Cited by Tanner, introduction to Howells, *A Hazard of New Fortunes,* p. x.

10. Howells, *A Hazard of New Fortunes,* p. 391.

11. Willa Cather, *The Professor's House* (New York: Grosset and Dunlap, 1925), p. 187.

12. Alice Wexler, *Emma Goldman: An Intimate Life* (New York: Pantheon, 1984), p. 36, quoting from a 1901 interview of Goldman by Frank Harris. For various views of the influence of the Haymarket affair on Goldman, read Wexler, pp. 35–38; Candace Falk, *Love, Anarchy, and Emma Goldman* (New York: Holt, Rinehart and Winston, 1984), pp. 22–23; and Richard

Drinnon, *Rebel in Paradise: A Biography of Emma Goldman* (Chicago: University of Chicago Press, 1961), p. 19.

13. Drinnon, *Rebel in Paradise,* pp. 44–45.

14. *New York Times,* August 23, 1893, as reported in Moses Rischin, *The Promised City: New York's Jews, 1870–1914* (Cambridge: Harvard University Press, 1962), p. 259, n. 7.

15. Sue Davidson Lowe, *Stieglitz: A Memoir/Biography* (New York: Farrar Straus Giroux, 1983), p. 94.

16. Henry Adams and Alfred Kazin both as cited in Drinnon, *Rebel in Paradise,* pp. 45, 46.

17. John Dos Passos, *The Big Money,* vol. 3 of *USA,* notes by Daniel Aaron and Townsend Ludington (New York: Library of America, 1996), p. 785.

18. *Alfred Stieglitz, Photographs and Writings,* ed. Sarah Greenough and Juan Hamilton (Washington, D.C.: National Gallery of Art; New York: Callaway Editions, 1983), pp. 182–183.

19. Whelan, *Alfred Stieglitz,* p. 103.

20. *The Columbia Encyclopedia,* 3rd ed. (New York: Columbia University Press, 1963), p. 618.

21. Walter Benn Michaels, in his *The Gold Standard and the Logic of Naturalism* (Berkeley: University of California Press, 1987), discusses pressing the button and its relation of the mechanical to creativity (pp. 215–222). For him, Stieglitz located creation afterward, in the darkroom (p. 219); but what should we make, then, of his waiting three hours in the snow to get the photograph under discussion, or, if we think he didn't wait that long, of his saying one should bother? Reese V. Jenkins, in "Technology and the Market: George Eastman and the Origins of Mass Amateur Photography," *Technology and Culture* 16 (January 1975): 1–19, shows how Eastman absorbed all the technology of the photograph, buying up his competitor's patents and patenting every new improvement or discovery. He was also astute enough to realize that the money wasn't in the camera but in the film-processing. He was, however, very fair with employees.

22. Whelan, *Alfred Stieglitz,* p. 117. There is no record of the camera Stieglitz used. Cameras using four-by-five-inch plates were already standard before Kodak's box of roll film, so there was little reason to use a modified version of a retrograde innovation. There was a vast array of hand-held cameras for plates to choose from; Beaumont Newhall, *The History of Photography,* rev. ed. (New York: Museum of Modern Art, 1982), lists some forty-five, just as a sampler (p. 128). Of course, most were to be put out of business by Kodak. As an example found close to home, the "Folding Montauk" was repeatedly advertised in *The American Amateur Photographer* during the period Stieglitz was listed on its cover as editor.

Sarah Greenough suggests a Graflex, John Szarkowsi a "graflex type" single-lens reflex, in a roundtable discussion, "Alfred Stieglitz: An Affirmation in Light," for *Alfred Stieglitz: Photographs from the J. Paul Getty Museum* (Malibu, Calif.: J. Paul Getty Museum, 1995), p. 106. The only one of Stieglitz's cameras now in the Eastman collection that is old enough to have been used in 1893 is a Tisdell & Whittlesey "detective" camera: see

Therese Mulligan, ed., *The Photography of Alfred Stieglitz: Georgia O'Keeffe's Enduring Legacy* (Rochester, N.Y.: George Eastman House, 2000), p. 117.

23. While the phrase usually refers to the profusion of mansions just beginning to appear above 60th Street, this image encompasses, from the right, the stone railing of the Alexander T. Stewart house, some of which is visible in the uncropped negative; Mrs. Astor's house, where the annual ball defined the "400" families; and the first Waldorf Hotel, built there by Astor's nephew to cast a shadow over his aunt's house after his wife had tangled with the dowager.

 Stewart, owner of the biggest department store in New York, and an important customer for Stieglitz's father, had recently banned Jews from his hotel in Saratoga, a hotel the Stieglitzes had frequented before Stewart purchased it (Whelan, *Alfred Stieglitz,* pp. 26, 37). So Stewart was banned from the photograph.

24. Lewis Mumford, "The Metropolitan Milieu," in Waldo Frank et al., eds., *America and Alfred Stieglitz: A Collective Portrait* (New York: Literary Guild, 1934), p. 45.

25. See Alan Trachtenberg's chapter by this name in his *Reading American Photographs: Images as History, Mathew Brady to Walker Evans* (New York: Hill and Wang, 1989), pp. 164–230. Also see Merry A. Foresta, *American Photographs: The First Century* (Washington, D.C.: Smithsonian Institution Press, 1996), pp. 14–15 and 25–26, and Christopher Phillips, "The Judgement Seat of Photography," in Richard Bolton, ed., *The Contest of Meaning: Critical Histories of Photography* (Cambridge: MIT Press, 1989), pp. 18–19.

26. Moers, *Two Dreisers,* p. 11.

27. Ibid., p. 6.

28. William H. Carwardine, *The Pullman Strike,* intro. Virgil J. Vogel (1893, [Chicago]: Charles H. Kerr, 1973), pp. 23 and 98. Carwardine was a minister in Pullman and provides a fascinating contemporaneous account, with much firsthand information from his parishioners. Though he attempts to be fair, he cannot refrain from being outraged by conditions in his parish.

29. Cited by Vogel, introduction to Carwardine, *Pullman Strike,* p. xi.

30. In the 1870s Pullman finally put Theodore Woodruff out of business, even though the latter held the patents Pullman used; see Sigfried Giedion, *Mechanization Takes Command: A Contribution to Anonymous History* (1948; New York: Norton, 1975), p. 462. Giedion discusses Pullman's effect on the democratization of luxury rail travel, pp. 452–468.

31. Vogel, introduction to Carwindine, *Pullman Strike,* pp. xx–xxi.

32. Ibid., p. xxv.

33. Perhaps Altgeld had set himself up for punishment; he had just released the remaining Haymarket anarchists from jail, on the grounds that they had been convicted without evidence. His pardon prompted vociferous protest.

34. Alan Trachtenberg, *The Incorporation of America: Culture and Society in the Gilded Age* (New York: Hill and Wang, 1982), pp. 220, 224–225. Also see Erik Larson, *The Devil in the White City* (New York: Random House, 2003), for a fictionalized account which nevertheless collects a huge amount of

detail to document the exhibition's attempt to stucco over the economic situation of the working public as the depression deepened.

35. Peter Bacon Hales, *Silver Cities: The Photography of American Urbanization, 1839–1915* (Philadelphia: Temple University Press, 1984), p. 150. The main architectural organizer of the fair, Daniel Burnham, went on to collaborate with Olmsted on implementing L'Enfant's design of the capital city, revamped Cleveland and San Francisco, and then turned to his hometown to make Chicago, not unlike its fair, "an aristocratic city for merchant princes." See Peter Hall, *Cities of Tomorrow: An Intellectual History of Urban Planning and Design in the Twentieth Century* (Oxford: Blackwell, 1988), chapter 6; quoted here from p. 183.

36. Hales, *Silver Cities,* pp. 153–154.

37. To be precise, "America the Beautiful" ends: "Till nobler men keep once again / Thy whiter jubilee," predicting not only white buildings but, I fear, whiter men.

38. Stanley Wertheim and Paul Sorrentino, *The Crane Log: A Documentary Life of Stephen Crane, 1871–1900* (New York: G. K. Hall, 1994), pp. 96–97.

39. For this usage, see Donald Pizer, "The Three Phases of American Literary Naturalism," *The Theory and Practice of American Naturalism: Selected Essays and Reviews* (Carbondale: Southern Illinois University Press, 1993), 14–15.

40. Moers, *Two Dreisers,* pp. 61–69. Trachtenberg also has a careful discussion of successive narrative perspectives and their implications in "The Men in the Storm," in his "Experiments in Another Country," pp. 274–278.

41. Trachtenberg, "Experiments in Another Country," p. 277.

42. Crane, "The Men in the Storm," pp. 66, 67, and 72.

43. Robertson, *Stephen Crane,* pp. 94–95.

44. Crane, "The Men in the Storm," pp. 69, 70.

45. I am working from what I feel is the best reproduction available, full-size in Stieglitz, *Photographs and Writings,* plate 12. This was a carbon print and, in a reduced format, is given an attractive glossy eggshell tone in Sarah Greenough, *Stieglitz in the Darkroom,* an exhibition brochure (Washington, D.C.: National Gallery of Art, 1992), p. 4. Dorothy Norman's reproduction (plate V) is of the *Camera Work* photogravure (1905), which conveys a stronger picture of clouds of snow that all but blot out the buildings. This difference is clearly the photographer's decision and would lead us to a different view. Therese Mulligan reproduces all seven versions in the Eastman House collection: catalogue items 18-2. In the original carbon print (National Gallery of Art, Stieglitz Archive, box 21.94), the snow cutting across the team is much better defined. Book reproduction will invariably make black into dark gray, will muddy grays, and flatten the luminosity and tactility of whites, especially in their delicate contrasts with tones of light gray. Carbon prints could have an almost three-dimensional quality, blacks getting both glossier and thicker as they darkened against various tones of gray and white.

46. Susan Sontag, *On Photography* (New York: Farrar, Straus and Giroux, 1977); see, for example, her last chapter, "The Image-World." Alan Trachtenberg, in "Camera Work: Notes towards an Investigation," *Massachusetts Review* 19 (Winter 1978): 834–837, discusses her position sympathetically, and discusses the "gaze" and Roland Barthes, after p. 848.

2 Conservation Frames

1. "Museum Playing Collectors' Tune," *Globe and Mail* (from the *Wall Street Journal,* with the *New York Times* Service and Associated Press), October 6, 1999, p. C1.

2. Merry A. Foresta, *American Photographs: The First Century,* foreword by Elizabeth Brown (Washington, D.C.: Smithsonian Institution Press, 1996), pp. 13–15.

3. There is no photograph by Stieglitz in this Smithsonian exhibition, which shows the newly acquired Charles Isaacs collection. Perhaps Isaacs never had occasion to buy one of his works, but Stieglitz's absence from a public exhibition seems overdetermined. Secessionists to be found in the Smithsonian show include Brigman, Bullock, Haviland, Käsebier, Keiley, Mullens, Post, Seely, Steichen, Struss, and Clarence White, all of whom were included in the 1910 Buffalo show. Are we to understand that only Stieglitz, of this group, meets the standards of a clear "modern aesthetic" and therefore is to be excluded from a survey for which the meaning of "aesthetic" has become unclear?

4. Walter Benjamin, "The Work of Art in the Age of Mechanical Reproduction" (1936), in *Illuminations,* trans. Harry Zohn (New York: Schocken, 1969). For a recent discussion of photography, Benjamin, and the museum, see, among other articles in the same volume, Christopher Phillips, "The Judgement Seat of Photography," in Richard Bolton, ed., *The Contest of Meaning* (Cambridge: MIT Press, 1989), pp. 14–47.

5. Alfred Stieglitz, from an Anderson Galleries catalogue, 1921; quoted in Phillips, "The Judgement Seat," p. 14.

6. Phillips, "The Judgement Seat," p. 23; and see note 50 for the same situation persisting in 1951.

7. I used to repeat this tale with the proper grain of salt until a woman came up to me after a talk in Washington to tell me she had been one of those students.

8. This story has been excerpted or summarized in various ways, and told in full from Stieglitz's point of view in a privately published pamphlet in 1927. I am quoting from a facsimile of the original reproduced in Sarah Greenough's master's thesis, "The Published Writings of Alfred Stieglitz" (University of New Mexico, 1976), her page 523. I am grateful to Ms. Greenough for making her thesis available to me.

 Actually, three pictures are at issue here. For the full exchange of letters between Phillips and Stieglitz, as well as the text of the latter's pamphlet, see "Selected Correspondence," ed. Elizabeth Hutton Turner and Leigh Bullard Weisblat, in Turner, *In the American Grain: Dove, Hartley, Marin, O'Keeffe, and Stieglitz. The Stieglitz Circle at the Phillips Collection* (Washington, D.C.: Counterpoint, in association with the Phillips Collection, 1995), pp. 111–172. Of course Phillips's view of the proceedings is different from that of Stieglitz, whom he called at one point, in a letter to the press which he soon regretted, "Field Marshal Stieglitz" (p. 135).

9. Weston J. Naef, *The Collection of Alfred Stieglitz: Fifty Pioneers of Modern Photography* (New York: Metropolitan Museum of Art and Viking Press, 1978), p. vii. The collection contains 580 prints, about 20 shy of the Buffalo exhibition.

10. Letter from Stieglitz to Charles M. Kurtz, February 6, 1909, Albright-Knox Archives, RG3:1, exhibition records, box 2, folder 1. My thanks especially to Tara A. Riese, assistant librarian at the Albright-Knox library, who made this letter available, along with those cited below and many other contemporaneous Buffalo documents.

11. Letter from Stieglitz to Cornelia Sage, April 3, 1909, Albright-Knox Archives, as above.

12. Letter from Cornelia Sage to H. Snowden Ward, April 13, 1909, and letter from Sage to Stieglitz, April 19, 1909, Albright-Knox Archives, as above.

13. Letter from Cornelia Sage to Stieglitz, October 5, 1909, Albright-Knox Archives, as above.

14. The "controversy" is described in C. Robert McElroy, "The International Exhibition of Pictorial Photography," in Anthony Bannon, *The Photo-Pictorialists of Buffalo* (Buffalo: Media Study, 1981), pp. 120–125. Sage's announcement is reprinted on p. 121.

15. Letter quoted in Estelle Jussim, *Slave to Beauty: The Eccentric Life and Controversial Career of F. Holland Day, Photographer, Publisher, Aesthete* (Boston: David R. Godine, 1981), p. 141.

16. Ibid., p. 137.

17. Richard Whelan, *Alfred Stieglitz: A Biography* (New York: Little, Brown, 1995), p. 175.

18. See Stieglitz's article for *Photograms of the Year 1902*, pp. 17–20. Thirty-one artists were shown, and Day was among the eight with more than ten prints. Stieglitz writes that, in response to the National Arts Club requesting a one-man show of his own prints, he recommended the "exhibition be made representative of *all* that was best in American photography" (p. 18). In "Modern Pictorial Photography," Stieglitz also "reviewed" this show for *Century Magazine* (vol. 44 [1902]: 822–825), a periodical very resistant at the time to any idea of photography as an art form.

19. Gertrude Käsebier, as quoted in Jussim, *Slave to Beauty*, p. 142.

20. Stieglitz, in *Camera Notes* (July 1901), p. 33; cited in Jussim, *Slave to Beauty*, p. 151.

21. Jussim, *Slave to Beauty*, p. 135. To be quite precise: "He [Day] was about to be attacked on all sides, and from the rear, by Stieglitz, as well."

22. A. H. Hinton to Stieglitz, July 21, 1900; Reginald Craigie to Link members, July 30, 1900. The crucial letter from Stieglitz to Hinton, dated September 16, 1900, should be with these others (see Naef, *The Collection of Alfred Stieglitz,* bibliography item 1529) in the Alfred Stieglitz Collection of the Beinecke Library, Yale University, but I have been assured that it is not there.

23. Jussim, *Slave to Beauty*, p. 141.

24. Ibid., p. 152.

25. Stieglitz to Heinrich Kühn, quoted in Jussim, *Slave to Beauty*, p. 186.

26. Jussim, *Slave to Beauty*, p. 186.

27. William Innes Homer, *Alfred Stieglitz and the Photo-Secession* (Boston: Little, Brown, 1983), p. 44 and note.

28. Ibid., p. 54.

29. Naef, *The Collection of Alfred Stieglitz,* p. 186.

30. Robert Doty, *Photo-Secession: Stieglitz and the Fine-Art Movement in Photography* (New York: Dover Publications, 1978), p. 51.

31. Quoted in Naef, *The Collection of Alfred Stieglitz,* p. 186.

32. Letter from Stieglitz to Cornelia Sage, October 16, 1910, Albright-Knox Archives, RG3:1, box 2, folder 1.

33. J. Benjamin Townsend and Ruth M. Peyton, *100: The Buffalo Fine Arts Academy, 1862–1962* (Buffalo: Buffalo Fine Arts Academy, 1962), p. 26.

34. Cornelia Sage, interview, *Buffalo Illustrated Sunday Times,* October 30, 1910, n.p.

35. Sue Davidson Lowe, *Stieglitz: A Memoir/Biography* (New York: Farrar, Straus, Giroux, 1983), p. 147. Sage's letter is dated October 5, 1909.

36. See a more detailed discussion in Naef, *The Collection of Alfred Stieglitz,* pp. 192–196, where he refers to the pictorialists of 1910, organized against the Secession, as "the most despised art movement of the twentieth century" (p. 196).

37. However, McElroy writes: "more than half of the 605 prints and sixty-five exhibitors in the total exhibition . . . were unaffiliated with the Secession" ("The International Exhibition," p. 123). McElroy is not, I presume, counting any Europeans as bona fide Secessionists, and to the extent that Stieglitz was leading a fight among Americans, he has a good argument. The numbers would then be Europeans plus those in the open section, forty-six exhibitors, out of the total of sixty-five.

38. *Buffalo Courier,* November 4, 1910; {*New York*} *Evening Post,* November 9, 1910; *Buffalo Express,* October 31, 1910.

39. McElroy, "The International Exhibition," pp. 121–123.

40. David Octavius Hill, letter cited in Beaumont Newhall, *The History of Photography, from 1839 to the Present,* rev. ed. (New York: Museum of Modern Art and New York Graphic Society Books, 1982), p. 48.

41. See Mary O'Connor, "The Objects of Modernism: Everyday Life in Women's Magazines, Gertrude Stein and Margaret Watkins," in Jay Bochner and Justin D. Edwards, eds., *American Modernism across the Arts* (New York: Peter Lang, 1999), pp. 97–123.

42. Lowe, *Stieglitz,* p. 151.

43. For a recent discussion of stacked hanging, see Richard Dormant's review of David H. Solkin, ed., *Art on the Line: The Royal Exhibition at Somerset House, 1780–1836:* Dormant, "The Great Room of Art," *New York Review of Books,* June 13, 2002, pp. 32–36.

44. Alfred Werner, *Max Weber* (New York: Abrams, 1974), pp. 37–38.

45. See William Innes Homer, *Alfred Stieglitz and the American Avant-Garde* (Boston: New York Graphic Society, 1977), pp. 130–134, for a discussion of Weber's sure hand in combining these various strands of modern painting. Or see the more detailed analyses of individual paintings in Abraham A. Davidson, *Early American Modernist Painting, 1910–1935* (New York: Harper and Row, 1981), pp. 28–34.

46. See Homer, *Stieglitz and the Photo-Secession,* p. 145 for Weber's hanging, p. 146 for the Struss photograph. Whelan, *Alfred Stieglitz,* p. 282, says Weber did not hang Stieglitz's section; however, framing and the overall style of the rooms would hardly have been inconsistent.

47. See Mary Anne Staniszewski, *The Power of Display: A History of Exhibition Installations at the Museum of Modern Art* (Cambridge: MIT Press, 1998), pp. 61–62.

48. Quoted in Doty, *Photo-Secession,* p. 56.

49. Alain Sayag, "Stieglitz: un fantôme au musée," *Cahiers du Musée National d'Art Moderne,* no. 35 (Spring 1991): 54.

50. Lowe, *Stieglitz,* p. 260.

51. Stieglitz, letter cited in Dorothy Norman, *Alfred Stieglitz: An American Seer* (New York: Random House, 1973), p. 162.

52. Doris Bry, *Alfred Stieglitz: Photographer* (Boston: Museum of Fine Arts, 1965), p. 7.

53. Bry, *Alfred Stieglitz,* p. 29. At times the luxurious *Alfred Stieglitz, Photographs and Writings,* ed. Sarah Greenough and Juan Hamilton (Washington, D.C.: National Gallery of Art; New York: Callaway Editions, 1983), provides "better" versions of various images. Plates in both books were printed by the Meriden Gravure Co., but the National Gallery volume is on much heavier and more textured paper. However, the point not to lose sight of for the purpose of the present discussion is that Bry reproduces the specific prints Stieglitz made for and gave to Boston.

54. Bry, *Alfred Stieglitz,* plate 7.

55. Stieglitz, *Photographs and Writings,* plate 15.

56. Bry, *Alfred Stieglitz,* plate 11; Stieglitz, *Photographs and Writings,* plate 21, with the slightly different title, *From the Back-Window—"291."*

57. Bry, *Alfred Stieglitz,* plate 25.

58. Alfred Stieglitz, *Georgia O'Keeffe, a Portrait* (New York: Metropolitan Museum of Art, 1978), plate 14. The plates are by Meriden Gravure, the same company that printed the two aforementioned volumes, and the paper is of a heavier weight but of a slightly lighter hue, "Monadnock Caress." The source print is not the same, though I presume the negative was. This elegant book is made up of fifty-one images of O'Keeffe chosen by her from those belonging to the Metropolitan.

3 Before the Armory (1913)

1. Dorothy Norman, *Alfred Stieglitz: An American Seer* (New York: Random House, 1973), p. 118.

2. Alfred Stieglitz [sic], "The First Great 'Clinic to Revitalize Art,'" *New York American,* January 26, 1913. My thanks to Sarah Greenough for making this article available from her master's thesis. A reduced facsimile is also in Norman, *Alfred Stieglitz,* p. 119.

3. For example, see Barbara Rose, *American Art since 1900* (New York: Holt, Rinehart and Winston, 1975); Sam Hunter, *Modern American Painting and Sculpture* (New York: Abrams, 1972); Abraham A. Davidson, *Early American Modernist Painting* (New York: Harper and Row, 1981).

4. Sarah Greenough, ed., *Modern Art and America: Alfred Stieglitz and His New York Galleries* (Washington, D.C.: National Gallery of Art; Boston: Little, Brown, 2000).

5. The history of the first Grafton show is not so different from the novitiate of the Armory Show organizers, except for the preparation of one member, Roger Fry; see Peter Stansky, *On or about December 1910: Early Bloomsbury and Its Intimate World* (Cambridge: Harvard University Press, 1996), p. 174.

6. Milton W. Brown, *The Story of the Armory Show* ([n.p.]: Joseph Hirshhorn Foundation, 1963), p. 46.

7. Ibid., pp. 311, 313.

8. It was not allowed for sale at 291, to avoid customs when it was shown, and so had to be returned to Paris and brought back by Stieglitz for Davies, with customs due; see Norman, *Alfred Stieglitz,* p. 106.

 Of Davies, Jerome Myers wrote: "Thus it was that I, an American art patriot, who painted ashcans and the little people around them, took part in inducing to become the head of our association the one artist in America who had little to do with his contemporaries, who had vast influence with the wealthiest women, who painted unicorns and maidens under moonlight." Myers, *Artist in Manhattan* (New York: American Artists Group, 1940), p. 35.

9. Jonathan Green, ed., *Camera Work: A Critical Anthology* (Millerton, N.Y.: Aperture, 1973), p. 146. I will cite this source when possible, but the full record is only in the original *Camera Work* itself.

 Käsebier photographed Rodin in his Paris studio in 1906, but the 1908 exhibition at 291 was of drawings that came from the artist via Steichen. A second show of drawings was held at 291 in 1911, after Stieglitz himself had visited Rodin in Paris.

10. Brown, *The Story of the Armory Show,* p. 75.

11. Norman, *Alfred Stieglitz,* p. 240; Brown, *The Story of the Armory Show,* p. 268.

12. In Green, *Camera Work: A Critical Anthology,* p. 175.

13. Stieglitz cited in Stephenson in the *New York Evening Post,* in *Camera Work,* no. 29 (January 1910), p. 53.

14. *Camera Work,* no. 29 (January 1910): 54 and 53.

15. In Green, *Camera Work: A Critical Anthology,* p. 180.

16. "Representative List of Exhibitions," in Waldo Frank et al., eds., *America and Alfred Stieglitz: A Collective Portrait* (New York: Literary Guild, 1934), p. 314.

17. Norman, *Alfred Stieglitz,* p. 103.

18. *Camera Work,* no. 33 (January 1911): 47–48.

19. *Camera Work,* no. 36 (October 1911): 47, 48.

20. Reprinted in Norman, *Alfred Stieglitz,* p. 108.

21. *Camera Work,* no. 38 (April 1912): 45.

22. Letter in *Alfred Stieglitz, Photographs and Writings,* ed. Sarah Greenough and Juan Hamilton (Washington, D.C.: National Gallery of Art; New York: Callaway Editions, 1983), p. 225.

23. For a good synthesis of discussions of the Armory Show as a watershed in the advertising and commercial promotion of modern art, see the unsigned article "Marketing Modern Art in America: From the Armory Show to the

Department Store," at the site of the University of Virginia American Studies Program: <http://xroads.virginia.edu/~MUSEUM/Armory/marketing.html>.

24. The same appeal was made throughout the first *Blind Man* (April 10, 1917), to prepare the audience for the Independents' show, but with lower expectations, as the cover art makes abundantly clear.

25. Stieglitz [sic], "The First Great 'Clinic to Revitalize Art,'" p. 119.

26. Brown does not mention the painting, while *1913 Armory Show: 50th Anniversary Exhibition* (New York: Henry Street Settlement, 1963), p. 206, lists it but remains unsure (nevertheless including a half-page reproduction, p. 129). John I. H. Baur, in his *Joseph Stella* (New York: Praeger, 1971), figures that it was absent and that the story of its inclusion was an error due to Katherine Dreier's catalogue for the Société Anonyme (p. 31).

27. Theodore Roosevelt, "A Layman's Views of an Art Exhibition," *Outlook,* March 22, 1913; reprinted in *1913 Armory Show,* pp. 160–161.

28. Royal Cortissoz, quoted in Hunter, *Modern American Painting,* p. 68.

29. F. J. Gregg, "The Attitude of the Americans," *Arts and Decoration* (March 1913); reprinted in Barbara Rose, ed., *Readings in American Art* (New York: Holt, Rinehart and Winston, 1975), p. 69.

30. Meyer Shapiro, "Introduction of Modern Art in America: The Armory Show," in his *Modern Art, 19th & 20th Centuries* (New York: George Braziller, 1978), p. 150.

31. Quoted in Brown, *The Story of the Armory Show,* pp. 55–56.

32. Ibid., illustration after p. 24.

33. Ibid., p. 110.

34. Reminiscence of William Zorach, in *1913 Armory Show,* p. 94.

35. Duchamp in an interview with Francis Roberts, "I Propose to Strain the Laws of Physics," *Art News 67,* no. 8 (December 1968): "before the *Nude* my paintings were visual. After that they were ideatic" (p. 46). See my "Eros Eyesore, or the Ideal and the Ideatic," for the catalogue of the exhibit *Debating American Modernism: Stieglitz and Duchamp, 1915–1930* (New York: American Federation of Arts, 2002).

36. Brown, *The Story of the Armory Show,* p. 144.

37. Ibid., p. 174.

38. Ibid., p. 175.

39. John Cauman, "Henri Matisse, 1908, 1910, and 1912: New Evidence of Life," in Greenough, *Modern Art and America,* shows that some commentators conceded Matisse's skill (p. 86). But this did not help the painter's early reputation in America.

40. James R. Mellow, *Charmed Circle: Gertrude Stein & Company* (New York: Praeger, 1974), p. 99.

41. Quoted in Brown, *The Story of the Armory Show,* pp. 136 and 174.

42. Leo Stein, *Appreciation: Painting, Poetry and Prose* (New York: Crown, 1947), p. 162.

43. Gail Levin, *Synchronism and American Color Abstraction, 1910–1925* (New York: Whitney Museum of American Art and Braziller, 1977), reproduces *Painting No. 6* of 1913, which is in the style closest to the Zigrosser sketch

reproduced in this volume. Levin outlines the joint influences of Delaunay and Kandinsky (p. 43), and makes clear that any number of American transplants in Paris were painting in manners similar to Hartley's experiments at this time.

44. Carl Zigrosser papers, Annenberg Library, University of Pennsylvania. Zigrosser's faithfulness to other images he sketched, which we can recognize, suggests that his version of Hartley is quite reliable. He noted next to the Duchamp list, "The shingle artist."

45. Kenyon Cox, "The 'Modern' Spirit in Art: Some Reflections Inspired by The Recent International Exhibition," *Harper's Weekly,* March 15, 1913; in *1913 Armory Show,* p. 166.

46. Edward Steichen to Stieglitz, undated [February 1911], Beinecke Library, Yale University: Stieglitz/Correspondence/Steichen.

47. Stieglitz to Wassily Kandinsky, May 26, 1913, Beinecke Library, Yale; Stieglitz/Correspondence.

48. Stieglitz to a Mr. White, March 18, 1913; cited in Norman, *Alfred Stieglitz,* p. 117.

49. Wassily Kandinsky, from *Concerning the Spiritual in Art, Camera Work,* no. 39 (July 1912): 34.

50. Ibid., p. 57.

51. Stieglitz to Paul Rosenfeld, September 5, 1923; cited from Stieglitz, *Photographs and Writings,* p. 212.

4 Outside the Armory

1. For a detailed analysis of the early issues of *Camera Work* and a discussion of its politics and inclusions, see Weston Naef, *The Collection of Alfred Stieglitz: Fifty Years of Modern Photography* (New York: Viking and Metropolitan Museum of Art, 1978), pp. 116–124. For *Camera Work*'s predecessor, *Camera Notes,* see Christian A. Peterson, *Alfred Stieglitz's* Camera Notes (Minneapolis: Minneapolis Institute of Arts; New York: Norton, 1993).

2. Alfred Stieglitz, "An Apology," in *Camera Work: The Complete Illustrations, 1903–1917,* introduction by Pam Roberts (Cologne: Taschen, 1997), p. 104. Obviously I would take issue with J. M. Mancini's article on Stieglitz's "empire," "Alfred Stieglitz, *Camera Work,* and the Organizational Roots of the American Avant-Garde," *Canadian Review of American Studies/Revue Canadienne d'Études Américaines* 28, no. 2 (1998): 37–79. Mancini concludes that *Camera Work*'s "institution building" undid any autonomy in the audience and, far from promoting individuality in the artist, transformed "nearly all commentary to fit a single, coherent narrative" and orchestrated "the establishment of a complex institutional and discursive context for the reception of Secessionist productions" (p. 67). I conceive of Stieglitz's Secession as much less elitist, exclusive, and dictatorial than the version of high modernism Mancini sees already operating in *Camera Work* and at 291.

3. Roberts, introduction to *Camera Work: The Complete Illustrations,* p. 14.

4. For a discussion of this claim of quality equal to original prints made by Stieglitz himself, see Estelle Jussim, "Technology or Aesthetics: Alfred

Stieglitz and Photogravure," in her *The Eternal Moment: Essays on the Photographic Image* (New York: Aperture, 1989), pp. 37–48.

5. Stieglitz, "Our Illustrations," *Camera Work* 34/35 (1911); as reprinted in *Camera Work: The Complete Illustrations,* p. 581.

6. Citation of the Progress Medal of the Royal Photographic Society, awarded to Stieglitz in 1924 (seven years after the demise of the periodical), as quoted in Roberts, introduction to *Camera Work: The Complete Illustrations,* p. 29.

7. May Knoblauch, born Bookstaver, is the model for Helen Thomas, the heroine's lover in Stein's autobiographical *Q.E.D.* May went on to translate Apollinaire's *Les Peintres cubistes* for the *Little Review* in 1922 (9, nos. 2, 3).

8. Cited in Dorothy Norman, *Alfred Stieglitz: An American Seer* (New York: Random House, 1973), pp. 110–113. The source is not identified. Gertrude, in her *Everybody's Autobiography,* remembered the Paris meeting but put her silence in a different light: cited in Norman, *Alfred Stieglitz,* p. 241, n. 31.

9. This text may be found most conveniently, along with the Stein portraits, in *Camera Work: The Complete Illustrations,* pp. 660–666.

10. For example, Wendy Steiner, *Exact Resemblance to Exact Resemblance: The Literary Portraiture of Gertrude Stein* (New Haven: Yale University Press, 1978), or my own "Architecture of the Cubist Poem," in Eve Blau and Nancy J. Troy, *Architecture and Cubism* (Montreal: Canadian Centre for Architecture; Cambridge: MIT Press, 1997), pp. 89–115. Jayne L. Walker, in her *The Making of a Modernist: Gertrude Stein from* Three Lives *to* Tender Buttons (Amherst: University of Massachusetts Press, 1984), p. xiii, credits Stieglitz with understanding Stein's work properly, as a "Rosetta stone of comparison; a decipherable clew" rather than an imitation of cubism. She also refers to Marjorie Perloff as getting the analogy right in her *The Poetics of Indeterminacy: Rimbaud to Cage* (Princeton: Princeton University Press, 1981), pp. 70–77.

11. Cited in Mabel Dodge Luhan, *A History of Having a Great Many Times Not Continued to Be Friends: The Correspondence between Mabel Dodge and Gertrude Stein, 1911–1934,* ed. Patricia R. Everett (Albuquerque: University of New Mexico Press, 1995), p. 59.

Berenson was, famously, not much inclined to appreciate modernism; in his journals, Kenneth Tynan referred to him as "the arch-mandarin Berenson," and quotes him as declaring "Modern anarchy begins with Goya." In Tynan's "The Third Act; Entries from Kenneth Tynan's Journals, 1975–8," *New Yorker,* August 14, 2000, p. 62.

12. For a more detailed analysis of the principles behind the composition of the portraits, especially in the context of other work done before and after, see Walker, *The Making of a Modernist.* For a semiological examination of Stein's ideas on nouns and parts of speech in general, with generous quotations from Stein herself, see Steiner, *Exact Resemblance,* pp. 54ff.

13. Quoted in Walker, *The Making of a Modernist,* p. 95.

14. In 1912 the Picassos hanging at the rue de Fleurus were Leo's. In the next few years Leo soured on cubism, and when the brother and sister separated all the Picassos remained with Gertrude.

15. Stieglitz, letter to Ward Muir, January 30, 1913, in *Alfred Stieglitz, Photographs and Writings,* ed. Sarah Greenough and Juan Hamilton (Washington, D.C.: National Gallery of Art; New York: Callaway Editions, 1983), p. 196.

16. Reproduced in Waldo Frank et al., eds., *America and Alfred Stieglitz: A Collective Portrait* (1934; rev. ed., Millerton, N.Y.: Aperture, 1979), after p. 112, plate 1. The photograph is not in the original edition. It appeared as *The Street—Design for a Poster, 1903* in *Camera Work,* no. 3 for 1903.

17. *Camera Work: The Complete Illustrations,* p. 724, or see number 2 of the opening plates [no page] in Sarah Greenough, ed., *Modern Art and America: Alfred Stieglitz and His New York Galleries* (Washington, D.C.: National Gallery of Art; Boston: Bulfinch Press, 2000).

18. Sarah Greenough, "Alfred Stieglitz, Rebellious Midwife to a Thousand Ideas," in Greenough, *Modern Art and America,* p. 41.

19. Charles Baudelaire, "Le Peintre de la vie moderne," in *Curiosités esthètiques, l'art romantique,* ed. Henri Lemaître (Paris: Editions Garnier, 1962). For example: "La foule est son domaine. . . . Pour le flâneur, pour l'observateur passionné, c'est une immense jouissance que d'élire domicile dans le nombre, dans l'ondoyant, dans le movement, dans le fugitif et l'infini" (p. 463).

20. Shelley Rice, *Parisian Views* (Cambridge: MIT Press, 1997), pp. 38–41ff.

21. I am thinking here of Apollinaire's *Le Flâneur des deux rives* (1918; Paris: Gallimard, 1928), in which the author comes upon a personage who has wandered even further than he, the "Errant des bibliothèques" (starting p. 77). To a large degree, in *Le Flâneur des deux rives* the metaphor of a vast, wide-flung, and inexhaustible library stands in for the modern world itself. This "Errant," unidentified in the text, was the young poet Blaise Cendrars, who in 1912 had just written his first long poem as a wanderer through the neighborhoods of New York, a more truly modern city of exposed street life, as I hope to show below.

22. Rice, *Parisian Views,* p. 43.

23. Charles Baudelaire, end of "Le Voyage," in *Les Fleurs du mal.* This line was frequently cited by Parisian modernists of this period in defense of pursuing the adventure of the new.

24. I am not, however, assuming that Stieglitz's photograph of the Flatiron was included in this corpus of work shown in 1913. It appeared in *Camera Work* 4 in 1903. Steichen's color photo of the building appeared in *Camera Work* 14, in 1906.

25. I have in mind Edmund Wilson's seminal work on modern writers, *Axel's Castle: A Study in the Imaginative Literature of 1870–1930* (1930; London: Fontana, 1971). *Axel* is a novel by Villiers de L'Isle-Adam.

26. Graham Clarke, *The Photograph* (New York: Oxford, 1997), p. 76.

27. Marius de Zayas, "Photography and Artistic-Photography," as reprinted in *Camera Work, the Complete Illustrations,* pp. 709–710.

28. Clarke, *The Photograph,* p. 80. In the particular case of the Flatiron, I think Clarke has chosen poorly for a comparison, since Steichen's famous image is dripping in romantic nostalgia and chic. However, his evaluation could easily be sustained if one chose Stieglitz images carefully, relying on a few that

conservation culture has carried forth as representative. But the city images Stieglitz compiled for his 1913 show put the lie to such a generalization.

29. The other writers, males, were Picabia himself, a friend of his named Maurice Aisen, the critic Benjamin de Casseres, Oscar Bluemner, and John Weichel. Reproductions of paintings were all of work by men: Cézanne, Van Gogh, Picasso, and Picabia.

30. Quoted in Carolyn Burke, *Becoming Modern: The Life of Mina Loy* (Berkeley: University of California Press, 1997), p. 139.

31. Mabel Dodge, "Speculations, or Post-Impressionism in Prose," *Arts & Decoration* (March 1913), pp. 172, 174. This was the original title; for the *Camera Work* reprinting, only "Speculations" was retained. The texts are identical, with some modifications to paragraphing. "Speculations" can be found in *Camera Work: The Complete Illustrations,* pp. 719–722 (but, curious exclusion, not Stein's text).

32. Gertrude Stein, quoted in Dodge, "Speculations," *Camera Work: The Complete Illustrations,* p. 722.

33. Ibid. In point of fact, this is a misquote, or Mabel's rewriting, as Stein does not use an exclamation point and writes "him," not "them."

34. Editor's note under the title of Dodge, "Speculations; or Post-Impressionism in Prose," *Arts & Decoration,* p. 172.

35. Dodge, "Speculations," *Camera Work,* p. 719.

36. Ibid., p. 722.

37. Mabel Dodge, *European Experiences* (New York: Harcourt, Brace, 1935), p. 332. One can also consult Emily Hahn, *Mabel: A Biography* (Boston: Houghton Mifflin, 1977), p. 49.

38. In Dodge's chapter 13, "The Steins" (*European Experiences,* pp. 321–333), Leo occupies most of the space early on, and "Portrait of Mabel Dodge at the Villa Curonia" runs on pp. 328–331. James R. Mellow, in *Charmed Circle: Gertrude Stein & Company* (New York: Praeger, 1974), adds more elements for the argument that Stein, "subliminally at least," was listening to the scene in the white bedroom (p. 169).

39. Stein, "Portrait of Mabel Dodge at Villa Curonia," in Jonathan Green, ed., *Camera Work: A Critical Anthology* (Millerton, N.Y.: Aperture, 1973), pp. 233–234.

40. Dodge, *European Experiences,* pp. 147 and 153. The epigraph is from Robert de la Condamine, *The Upper Garden* (London: Methuen, 1910), a mystical or mystical-sounding treatise on gardens, which supplies almost all of the numerous, soulful epigraphs that pepper Dodge's book. I believe it enjoyed a small vogue at the time of its publication, as Louise Norton refers to it in her columns for her New York magazine *Rogue* in 1915.

41. Stein, "Portrait of Mabel Dodge," p. 234.

42. Dodge, *European Experiences,* p. 156.

43. Stein, "Pablo Picasso," in *Camera Work: The Complete Illustrations,* p. 666.

44. Stein, "Portrait of Mabel Dodge," p. 232.

45. Ibid., pp. 233–234.

46. For a discussion of the shift in Stein's work about this time, from the almost nounless writing in the continuous present of *The Making of Americans*

(written 1906–1908) to the profusion of unrelated nouns in *Tender Buttons* (written in 1911), see Peter Nicholls, *Modernisms: A Literary Guide* (Berkeley: University of California Press, 1995), pp. 202–210.

5 Mechanics of the New York Secession (1915)

1. Richard Poirier, "The Difficulties of Modernism and the Modernism of Difficulty," in Arthur Edelstein, ed., *Images and Ideas in American Culture: The Function of Criticism* (Hanover, N.H.: Brandeis University Press, 1979), p. 125.

2. Raymond Williams, *Culture and Society, 1780–1950* (London: Chatto & Windus, 1960), p. 43.

3. Wanda M. Corn, *The Great American Thing: Modern Art and National Identity, 1915–1935* (Berkeley: University of California Press, 1999), p. 23; citing Raymond Williams, *The Politics of Modernism: Against the New Conformists.* Corn is explicit in her note 63 (p. 364) that Williams is referring to the likes of Eliot and Yeats, but her text has the unfortunate effect of making it appear that Williams is saying these terrible things about Stieglitz.

4. Twain in the *New York Herald,* December 30, 1900; as quoted in Howard Mumford Jones, *The Age of Energy: Varieties of Experience, 1865–1915* (New York: Viking, 1971), pp. 212–213.

5. Quoted in Dorothy Norman, *Alfred Stieglitz: An American Seer* (New York: Random House, 1973), p. 240. Norman provides no source.

6. Peter Galassi, *Before Photography: Painting and the Invention of Photography* (New York: Museum of Modern Art, 1981), p. 17.

7. Stieglitz to Marius de Zayas, August 31, 1915, and September 2, 1915; in Marius de Zayas, *How, When, and Why Modern Art Came to New York,* ed. Francis M. Naumann (Cambridge: MIT Press, 1996), pp. 194, 197. (The emphases are Stieglitz's.) Responding to the first of these two letters from Stieglitz, de Zayas wrote: "I think I understand your point, but you must not over do it, that is why I have taken care to tell you everything we have done" (p. 195).

 While most scholars agree in seeing *291* and the Modern Gallery as a rather serious break with Stieglitz, I find at least one recent writer who takes a position closer to mine: Charles Brock, "Marius de Zayas, 1909–1915: A Commerce of Ideas," in Sarah Greenough, ed., *Modern Art and America: Alfred Stieglitz and His New York Galleries* (Washington, D.C.: National Gallery of Art, 2000), pp. 145–153.

8. Stieglitz to de Zayas, March 20, 1916, in de Zayas, *How, When, and Why,* p. 201. In this letter Stieglitz praises number 10–11, the penultimate issue, as "an otherwise perfect piece of work," the "otherwise" referring to a poor choice of paper, a problem for which he blames himself.

 Whether or not Stieglitz deserved some healthy criticism, his involvement with the everyday workings and finances of the magazine show more than the initial green light that much subsequent criticism has given him credit for. William Camfield is probably the early, still nuanced source for this generally held position, in his definitive book on Picabia: "Without

Stieglitz's approval, they [the new magazine and gallery] might not have materialized. But he had planned neither of them, and, in a respectful way, they were critical of him." In Camfield, *Francis Picabia: His Art, Life and Times* (Princeton: Princeton University Press, 1979), p. 75.

9. Reported by de Zayas, as cited in an exhibition catalogue, *History of an American: Alfred Stieglitz: "291" and After* (Philadelphia: Philadelphia Museum of Art, 1944), p. 7. I do not know the source for this quotation. After showing Stieglitz's photographs to Picasso, de Zayas wrote the photographer: "He came to the conclusion that you are the only one who has understood photography and understood and admired the 'steerage' to the point that I felt inclined to give it to him." De Zayas to Stieglitz, June 11, 1914, in de Zayas, *How, When, and Why,* p. 176.

10. De Zayas to Stieglitz, in de Zayas, *How, When, and Why,* p. 185. And, indeed, the war would kill Apollinaire, who was buried in the Père Lachaise cemetery on Armistice Day.

11. Admittedly, the generative metaphor is much clearer in this translation than in de Zayas's original French: "Il a marié l'homme avec la machine et il a obtenu des résultats positifs." De Zayas wrote that he was not responsible for the translation of his essay.

12. De Zayas to Stieglitz, August 13, 1915, in de Zayas, *How, When, and Why,* p. 187. The Picasso and Braque drawings, both of a violin, had been exhibited at 291 in 1914–1915. They can be seen in Greenough, *Modern Art and America,* pp. 200 and 201.

13. For an analysis that shows a much closer relationship of shapes than I do, see Willard Bohn, "Visualizing Women in *291,*" in Naomi Sawelson-Gorse, ed., *Women in Dada: Essays on Sex, Gender and Identity* (Cambridge: MIT Press, 1998), pp. 241–247 of his essay.

14. Here, if we thought de Zayas and Picabia had been working together, and that they were fond of cross-language puns, we could look to the painter's "crankcase."

 It is amusing to note that the American viewer-reader is confronted with an opposite gender problem from that of the viewers of Duchamp's famous *Nu* at the Armory Show. There, the art term "nu" had no gender, even if it could be assumed to refer to the female, which of course the viewers couldn't find in the painting. Here, primed by what appears to be de Zayas's misogyny, as well as his reiterated title, we miss that the central figure is necessarily male, as the feminine form *hurluberlue* was readily available. Bohn, in "Visualizing Women in *291,*" explicitly identifies *hurluberlu* with the woman and thus unmans the male kingpin around whom "Elle" circulates (p. 245).

15. De Zayas, [no title], *291,* no. 5–6 (July-August, 1915), [n.p.]. The text is in French, then translated. The original is a bit more blunt; in my first quotation, "American intellectuality" is not a "protective covering" but a condom.

16. Stieglitz, "291—A New Publication," *Camera Work,* no. 48 (October 1916); as cited in Dawn Ades, *Dada and Surrealism Reviewed* (London: Arts Council of Great Britain, 1978), p. 34. By this date *291* had ceased publication. All the more difficult, then, to think Stieglitz had felt wounded by the various manifestations at *291,* the more so when we find in this issue of *Camera Work*

the reprint of de Zayas's rather aggressive essay from number 5–6 in which he comments: "Stieglitz wanted to work this miracle. . . . He has failed."

17. Arthur Cohen, "The Typographical Revolution: Antecedents and Legacy of Dada Graphic Design," in Stephen Foster and Rudolf E. Kuenzli, eds., *Dada Spectrum: Dialectics of Revolt* (Iowa City: University of Iowa Press; Madison, Wisc.: Coda Press, 1979), p. 88.

 I've looked at this effect of typographic experimentation on various little magazines of this period in New York in my "dAdAmAgs," in Francis M. Naumann with Beth Venn, eds., *Making Mischief: Dada Invades New York* (New York: Whitney Museum of American Art, 1996), pp. 214–221, and I am using some of that work here.

18. There is a discussion of the American view of the corset, as seen from a French perspective, in Carole Boulbès, *Picabia, le saint masqué* (Paris: Jean-Michel Place, 1998), pp. 20–25.

19. *New York Call,* May 16, 1915; as cited in Francis M. Naumann, *Dada in New York* (New York: Abrams, 1994), p. 244 (n. 4). Naumann's introduction begins with a discussion of the corset, pp. 8–9.

20. *Rogue* 1, no. 1 (March 15, 1915): 18.

21. Dame Rogue [Louise Norton], "Très Décorseté," *Rogue* 3, no. 2 (November 1916): 7 [probably a misnumbered volume].

22. A fuller discussion of the French view of American women (by an American) may be found in Corn, *The Great American Thing,* pp. 57–60.

23. Mina Loy, "Three Moments in Paris: 1—One O'Clock at Night," *Rogue* 1, no. 4 (May 1, 1915): 10. The full poem may be found most conveniently in Mina Loy, *The Lost Lunar Baedecker: Poems,* ed. Roger Conover (New York: Farrar, Straus and Giroux, 1996), pp. 15–18.

24. Francis Picabia, in interview, "French Artists Spur On American Art," *New York Tribune,* 24 October 1915, sec. 4, p. 2. Quoted from K. G. Pontus Hultén, *The Machine as Seen at the End of the Mechanical Age* (New York: Museum of Modern Art, 1968), p. 83.

25. William Camfield, "The Machinist Style of Francis Picabia," *Art Bulletin,* no. 48 (September-December 1966), p. 315. The gun and target image has been sustained throughout subsequent scholarship and has taken on a life of its own, the gun supplied, for example, with an automatically repeating trigger that sets off an infinitely repeated "shot."

26. Marcel Duchamp, under the name of Marcel Douxami, in *Rongwrong* (one issue, 1917), [p. 1].

27. Francis Picabia, *Jésus-Christ Rastaquouère* (Paris: Au Sans Pareil, 1920), p. 24. "Our phallus ought to have eyes; if it did, we might believe for a moment that we had seen love up close" (my translation).

28. This horn is the Wondertone Mechanical Horn (1910, Moto Appurtenances Corp., N.Y.); it can be seen on permanent exhibit at the Ontario Science Museum, Ottawa.

29. William Camfield has found the original advertisement for the Haviland image, the "Wallace Portable Electric Lamp" (*Francis Picabia,* p. 84). Picabia's rendition is extremely faithful, his principal modification being the removal of the socket plug.

30. Wanda Corn usefully discusses the French views of American women, in *The Great American Thing* (pp. 56–60). On page 67 she reproduces the source (or a source) for the young American girl image, an advertisement for the Red Head Priming Plug, which Picabia has significantly simplified, notably removing the charming image of a smiling red-headed woman on the body of the plug. I feel Corn somewhat confuses the sexual imagery in finding the girl to be represented as "phallic," and performing a ballet on her skinny, hardly athletic electrode legs. She also finds our ingenue "ready to be plugged in" at either end (p. 66), whereas I see her far from that complaint. Finally, Corn considers "For-Ever" to be a known brand name, but I believe Picabia's switch on the well-known "Ever Ready" carries all his meaning.

31. Camfield, "The Machinist Style," has found a workable source for *De Zayas! De Zayas!* in a Delco starting and lighting system (after p. 316). But I expect many other, more schematic images of the period might supply more of the details than this one; my money is on the owner's manual for a Mercer, which Picabia owned in New York. I am intrigued by the gothic lettering on the battery: "Exide" together with "Battery" supply all but one of the letters Picabia cut out for the word "Ideal" collaged atop the original Stieglitz image, in which the letters *d* and *e* follow in the same snippet of paper.

32. In Xenophon's *Anabasis,* after a terrible sixteen-month retreat, the general's troops are elated to reach the Black Sea, in ancient times called the Euxine. Picabia is known to have relied on the pink pages, a list of foreign language phrases, in the *Petit Larousse* for various titles in this period; in this case he has started with "Thalassa! Thalassa!" ("The sea! The sea!"), words which inhabit the very name of his friend as it floats like a vision over the waves.

33. Konrad Cramer, in *Photographic Society of America Journal* (November 1947), p. 721; as reported in Norman, *Alfred Stieglitz,* p. 121.

34. I am referring to the print in the possession of the Metropolitan Museum of Art in New York, the Alfred Stieglitz Collection, 1949, reproduced in Corn, *The Great American Thing,* p. 22. In both the original print and the magazine cover, the word is, photographically, much too close to focus on, but I expect this did not concern Picabia, whether he knew it or not.

35. *La Pomme de Pin,* one number (St. Raphaël, France), February 25, 1922. The four pages of this publication may be found in Robert Motherwell, *The Dada Painters and Poets* (New York: Wittenborn, 1951), pp. 268–271. The original sentences read: "Notre tête est ronde pour permettre à la pensée de changer de direction," and "Il n'y a qu'une chose presque absolue[,] c'est le libre arbitre."

36. Francis Picabia to Stieglitz, letter of September 1919, in Alfred Stieglitz Archive, Beinecke Library, Yale University. "I think back on our life in New York, where you and I were really the only ones to sustain an ideal which did not change. Like that of our friends, with what *prodigious dexterity*—" (my translation).

37. Georgia O'Keeffe, letter, *MSS,* no. 4 (December 1922): 17. The curious inclusion of plumbers is reiterated at the end of her paragraph, and she may well be thinking of Duchamp's *Fountain:* she writes that she can return to Stieglitz's photographs as aesthetically and spiritually powerful, creating

the excitement aroused in her by "the Chinese, the Egyptians, Negro Art, Picasso, Henry Rousseau, Seurat, etcetera, even including modern plumbing—or a fine piece of machinery."

38. Stieglitz to Francis Picabia, on Anderson Galleries exhibition invitation, 1921. Fonds Jacques Doucet, Bibliothèque Ste.-Geneviève, Paris.

39. Sherwood Anderson, "Alfred Stieglitz," *MSS,* no. 4 (December 1922): 15. The circulation of this article was quite wide, as it had already appeared in the *New Republic,* October 22, 1922.

40. William Agee first wrote up interpretations for these machines, and other paintings and drawings that would be found at the time, in "Morton Livingston Schamberg: Color and the Evolution of His Painting," in his *Morton Livingston Schamberg: 1881–1918* (New York: Salander-O'Reilly Galleries, 1982). Agee updated these sources in "Morton Livingston Schamberg: Notes on the Sources of the Machine Images," *Dada/Surrealism,* no. 14 (1985): 66–80. On page 74 he reproduces the Acme-Champion Model A Book Stitcher.

41. Both versions of *Porch Shadows* were exhibited in *Paul Strand: The Range of Expression, 1914–1976* at the New York Public Library, 1982. The one I show is the one usually reproduced; the other should be in either *Paul Strand: On My Doorstep: A Portfolio of Eleven Original Photographs* (Millerton, N.Y.: Paul Strand Foundation, 1976), or *Paul Strand: The Formative Years, 1912–1917* (Millerton, N.Y.: Aperture, for the Paul Strand Foundation, 1982), which contains ten hand-pulled photogravures.

42. Fredric Jameson, "Beyond the Cave: Demystifying the Ideology of Modernism" [1975], in *The Syntax of History,* vol. 2 of his *The Ideologies of Theory: Essays, 1971–1986* (Minneapolis: University of Minnesota Press, 1988), p. 127.

43. Frank Lloyd Wright, "The Art and Craft of the Machine," as reprinted in Lewis Mumford, ed., *Roots of Contemporary American Architecture* (New York: Grove Press, 1959), pp. 178–179.

 In the twenties, less sanguine about the machine's use to produce indifferent duplicates, Wright anticipated Jameson: "Quantity production?—Yes. We have ten for one of everything that earlier ages or periods had. And it is worth so far as the quality of life in it goes, less than one-tenth of one similar thing in those earlier days. . . . Outside graceless utility, creative life as reflected in 'things' is dead." Frank Lloyd Wright, "In the Cause of Architecture: 1. The Architect and the Machine," *Architectural Record,* May 1927, reprinted in Frederick Gutheim, ed., *In the Cause of Architecture* (New York: Architectural Record Books, 1975), p. 132.

44. Wright was included in C. Matlack Price, "Secessionist Architecture in America," *Arts and Decoration* (December 1912), pp. 51–53.

45. I have looked at this topic at some length in my "Architecture of the Cubist Poem," in Eve Blau and Nancy J. Troy, eds., *Architecture and Cubism* (Cambridge: MIT Press), pp. 89–115.

46. As cited by James E. Breslin, *William Carlos Williams: An American Artist* (New York: Oxford University Press, 1970), pp. 33–34. The adjectives, famous in the history of imagism, are attributed jointly to Pound and T. E. Hulme.

47. Paul Mariani, *William Carlos Williams: A New World Naked* (New York: McGraw-Hill, 1981), p. 106.

48. William Carlos Williams, "Overture to a Dance of Locomotives," in *The Collected Poems*, ed. A. Walton Litz and Christopher MacGowan, vol. 1 (New York: New Directions, 1986), p. 146. "Overture" was first published in *Sour Grapes* (1921).

49. Williams, "Spouts," in *Collected Poems*, vol. 1, p. 169. Also first published in *Sour Grapes*.

50. Williams, "Drink," in *Collected Poems*, vol. 1, p. 53. "Drink" first appeared in *Others* for July 1916, an issue Williams edited.

51. Henry Adams, *The Education of Henry Adams* (New York: Random House, 1949), p. 499.

52. Stieglitz, quoted in Norman, *Alfred Stieglitz*, p. 76. Stieglitz was on his last trip to Europe, with his wife and child on a large and fashionable steamer.

53. Stieglitz, quoted in Evelyn Howard, "The Significance of Stieglitz for the Philosophy of Science," in Waldo Frank et al., eds., *America and Alfred Stieglitz: A Collective Portrait* (New York: Literary Guild, 1934), p. 199.

6 Days in April, Sweet and Cruel (1917)

1. Ezra Pound to Marianne Moore, in Ezra Pound, *Letters, 1907–1944*, ed. D. D. Paige (New York: Harcourt, Brace, 1950), p. 168.

2. Yvor Winters, review of Mina Loy, *Lunar Baedeker*, in *The Dial* (June 1926), p. 499.

3. The idea of a "marriage," potentially of more than minds, was first proposed by Roger Conover, in his introduction to Mina Loy, *The Last Lunar Baedeker*, ed. Conover (Highlands, N.C.: Jargon Society, 1982), p. xli.

4. Louise [Norton] Varèse, *Varèse: A Looking Glass Diary*, vol. I, 1883–1923 (New York: W. W. Norton, 1972), p. 126.

5. Ellin Mackay, "Why We Go to Cabarets," *New Yorker*, November 1925. See Ben Yagoda, *About Town: The New Yorker and the World It Made* (New York: Scribner, 2000), pp. 60–61. Baline soon changed his name to Irving Berlin.

6. Marie T. Keller, "Clara Tice, 'Queen of Greenwich Village,'" in Naomi Sawelson-Gorse, ed., *Women in Dada* (Cambridge: MIT Press, 1998), pp. 414ff.

7. Mina Loy, "Aphorisms on Futurism," in Loy, *The Last Lunar Baedeker*, p. 274. An indication of the interplay between the avant-garde magazines: this issue of *Camera Work* printed a short text from a play by Gertrude Stein about Marsden Hartley, then showing his work at 291; *Rogue* responded, in the April 1, 1915, issue that introduced Loy's poetry, with a parody play by the painter Charles Demuth, called *After Stein*.

8. Mina Loy, "Sketch of a Man on a Platform," *Rogue* 1, no. 2 (April 1, 1915): 12. Reprinted in Mina Loy, *The Lost Lunar Baedeker: Poems*, ed. Roger Conover (New York: Noonday Press, 1996), p. 19.

9. Dame Rogue [Louise Norton], "Philosophic Fashions: Keeping Our Wives at Home," *Rogue* 1, no. 2 (April 1, 1915): 17.

10. Loy, "Città Bapini," in *Last Lunar Baedeker*, p. 80.

11. William Carlos Williams, "Grotesque," in *Complete Poems,* ed. A. Walton Litz and Christopher MacGowan, vol. 1 (New York: New Directions, 1986), p. 49.

12. Paul Mariani, *William Carlos Williams: A New World Naked* (New York: McGraw-Hill, 1981), p. 102.

13. Loy, "Feminist Manifesto," in *Last Lunar Baedeker,* pp. 269–271.

14. Mina Loy, "Three Moments in Paris: Magazins du Louvre," *Rogue* 1, no. 2 (May 1, 1915): 11; reprinted in Loy, *Lost Lunar Baedeker,* pp. 17–18.

15. Marcel Duchamp, "The; Eye Test, Not a 'Nude Descending a Staircase,'" *Rogue* 3, no. 1 (October 1916): 2.

16. William Carlos Williams, "Prologue," 1918, to *Kora in Hell,* in Williams, *Imaginations,* ed. Webster Scott (New York: New Directions, 1970), p. 23.

17. Margaret Johns, "In the New Poetry," *New York Tribune,* July 25, 1915; cited in Carolyn Burke, *Becoming Modern: The Life of Mina Loy* (Berkeley: University of California Press, 1997), p. 197.

18. Winters, review of Loy, *Lunar Baedeker,* p. 496.

19. Williams, "Prologue" to *Kora in Hell,* p. 19.

20. Loy, Song IV, *Lost Lunar Baedeker,* pp. 54–55.

21. Williams, "The Ogre," in *Collected Poems,* vol. 1, p. 95.

22. Alfred Kreymborg, *Troubadour* (New York: Sagamore Press, 1957), p. 189.

23. Loy, "To You," in *Last Lunar Baedeker,* p. 89.

24. Williams, "Drink," in *Collected Poems,* vol. 1, p. 53.

25. Mina Loy, "Anglo-Mongrels and the Rose," in *Last Lunar Baedeker,* p. 131.

26. Loy, "Lions' Jaws," in *Lost Lunar Baedeker,* p. 48. Though Loy did not know Cravan at the time of the prewar Paris moment being described in this poem, his high jinks, in the company of Cendrars and the Delaunays at the Bal Bullier dance-hall, were well known among the "souvenirs" that the futurists are seen co-opting in this poem.

27. Kreymborg, *Troubadour,* p. 243.

28. Williams, "Prologue" to *Kora in Hell,* p. 23.

29. *Provincetown Plays,* 3rd series (New York: F. Shay, 1916). This last sentence suggests the play might bear some comparison to the later *Our Town* (1938) by Thornton Wilder, where the characters go, dronelike, through their small-town routines.

30. Cited by Roger Conover, introduction to Loy, *Last Lunar Baedeker,* p. xliii.

31. Loy, "Songs to Joannes" (no. 12), in *Lost Lunar Baedeker,* p. 57.

32. William Carlos Williams, *Kora in Hell* (1920), in *Imaginations,* p. 47.

33. Ibid., pp. 49–50. Parts of this passage from *Kora in Hell,* including text I don't quote here, bear a close resemblance to Eliot's "Prufrock" (first printed in *Poetry* in 1915), despite the change of point of view to that of the woman.

34. Loy, "Babies in Hospital," in *Lost Lunar Baedeker,* pp. 25–26.

35. Williams, *Al Que Quiere!* in *Collected Poems,* vol. 1, p. 107; there is yet another "Love Song" following, pp. 107–108.

36. Williams, "The Wanderer," in *Collected Poems,* vol. 1, p. 108. This poem was also revised for inclusion in the 1917 *Al Que Quiere!* An earlier version had appeared in the *Egoist* for March 1914. The poem meditates on the liberating influence exercised on Williams's poetic thinking by his paternal

grandmother; in a section on the Broadway crowds where he sees her as a presiding spirit, he rewrites the line "With bright lips and eyes of the street sort" as "With bright lips, and lewd Jew's eyes."

37. Loy, "Colossus," presented by Roger Conover, "Mina Loy's 'Colossus': Arthur Cravan Undressed," *Dada/Surrealism,* no. 14 (1985): 106.

38. The editor, Robert J. Coady, had at first hoped to join *The Soil* to *Others,* but Kreymborg and Williams had turned down his proposal, preferring to stick to poetry.

39. Arthur Cravan, [no title], *Soil* 1, no. 1 (December 1916): 36. No translation credit is given. Above this excerpt, which I print in full, were six lines from Whitman's "Crossing Brooklyn Ferry." The original of Cravan's poem, a much longer "Sifflet," was published in the first issue of his *Maintenant* (Paris, April 1912), in French like all of his work. The full text may be found in Arthur Cravan, *Maintenant,* ed. Bernard Delvaille (Paris: Eric Losfeld, 1957), pp. 17–19.

40. Cravan, [no title], *Soil* 1, no. 1 (December 1916): 4.

41. Robert J. Coady, "American Art," *Soil* 1, no. 1 (December 1916): 4.

42. In 1916, the Nick Carter serials were by various hands; the genre and character had been originated by John Coryell, in his sixties by now and an anarchist, friend to Emma Goldman, and recently director of the Ferrer School, an anarchist center frequented by the likes of Robert Henri, George Bellows, Man Ray, and Mike Gold. In the first issue of *The Soil,* "The Pursuit of the Lucky Clew" by "Nicholas Carter" is preceded by "The Dime Novel as Literature," by one Adam Hull Shirk (p. 39).

43. Robert J. Coady, "Toto," *Soil,* no. 1 (December 1916): 31.

44. Robert J. Coady, open letter to Mr. Jean Crotti, *Soil,* no. 1 (December 1916): 32. This letter, unannounced in the table of contents, also reproduces Crotti's famous wire sculpture of Marcel Duchamp.

45. Coady, "American Art," p. 4.

46. Henri-Pierre Roché, "The Blind Man," *Blind Man,* no. 1 (April 10, 1917): [1, 4].

47. Francis M. Naumann, *New York Dada, 1915–1923* (New York: Abrams, 1994), p. 176. This chapter of Naumann's book provides the most thorough essay on the show. However, an earlier, two-part version has much material for the scholar: Francis M. Naumann, "The Big Show: The First Exhibition of the Society of Independent Artists," part 1, *Artforum* 17 (February 1979): 34–39; and part 2 (April 1979): 49–53.

48. John Dos Passos, *The 42nd Parallel* (1930), in his *U.S.A.,* notes by Daniel Aaron and Townsend Ludington (New York: Library of America), p. 349.

49. John Reed, "Whose War," *Masses* (April 1917); as reprinted in William L. O'Neill, *Echoes of Revolt: The Masses, 1911–1917,* intro. Irving Howe, afterword by Max Eastman (Chicago: Quadrangle Books, 1966), pp. 286–287.

50. Frederick James Gregg, "A New Kind of Art Exhibition: Anybody Who Has Ever Painted a Picture, or Made a Sculpture, Can Show It—Without a Jury," *Vanity Fair,* May 1917, p. 47. Naumann, "The Big Show," part 2, passes in review the connections critics made between the show and the war effort (p. 52).

51. Leon Trotsky, quoted in Paul Avrich, *The Modern School Movement: Anarchism and Education in the United States* (Princeton: Princeton University Press, 1980), p. 374, n. 128.

52. Reed, "Whose War," p. 287.

53. William Carlos Williams, *Autobiography* (New York: Random House, 1951), p. 158.

54. Robert Payne, *The Life and Death of Trotsky* (New York: McGraw-Hill, 1977), p. 176.

55. Van Wyck Brooks, "The Culture of Industrialism," *Seven Arts* (April 1917): 663.

56. Ibid., pp. 656, 658.

57. Randolph Bourne, "The Puritan's Will to Power," *Seven Arts* (April 1917): 635.

58. Ibid., p. 637.

59. Brooks, "The Culture of Industrialism," p. 665.

60. For most of this list and other artists, see Clark S. Marlor, *The Society of Independent Artists: The Exhibition Record, 1917–1944* (Park Ridge, N.J.: Noyes Press, 1984). Two versions of the original catalogue can be found, one illustrated, the other not.

61. Henri-Pierre Roché, "The Blind Man," *Blind Man,* April 10, 1917, p. 4.

62. Henry McBride, "Opening of the Independents," *Sun,* April 15, 1917; as reprinted in his *The Flow of Art: Essays and Criticism,* intro. Daniel Catton Rich, essay by Lincoln Kirsten (New York: Atheneum, 1975), p. 123.

63. Henry McBride, "More on the Independents," *Sun,* May 13, 1917; reprinted in McBride, *The Flow of Art,* pp. 125–129.

64. H. Wayne Morgan, *New Muses: Art in American Culture, 1865–1920* (Norman: University of Oklahoma Press, 1978), p. 84.

65. Robert J. Coady, "The Indeps," *Soil* 1, no. 5 (July 1917): 210. This is the issue where Coady follows Cravan's model of demolishing the whole Paris Salon des Indépendants of 1912 in *Maintenant.*

66. Naumann, *New York Dada,* p. 180.

67. In *New York Dada,* Naumann, proposes the new attribution (p. 172); also see his pp. 127–128 on the Baroness. *God* was not in the Independents' show. For the Baroness, see Irene Gammel, *Baroness Elsa: Gender, Dada and Everyday Modernity, A Cultural Biography* (Cambridge: MIT Press, 2002).

68. Elsa von Freytag-Loringhoven, "The Modest Woman," *Little Review* 7, no. 2 (July-August 1920): 37–38.

69. See Barbara Buhler Lynes, "Georgia O'Keeffe, 1916 and 1917: My Own Tune," in Sarah Greenough, ed., *Modern Art and America: Alfred Stieglitz and His New York Galleries* (Washington, D.C.: National Gallery of Art, 2000), pp. 261–269.

70. Henry Tyrrell, "Esoteric Art at '291,'" *Christian Science Monitor,* May 4, 1917, p. 10; cited in Lynes, "Georgia O'Keeffe," p. 268.

71. These paintings, including the redundantly named *No. 24,* may be seen in recently discovered photographs of the O'Keeffe show as it was hung at 291, in Lynes, "Georgia O'Keeffe," pp. 266–267.

72. Ibid., p. 265.

73. Mina Loy, "Songs to Joannes," *Others* (April 1917): pp. 4–5. Reprinted in Mina Loy, *Lost Lunar Baedeker,* pp. 54–55.

74. Mina Loy, "Virgins Plus Curtains Minus Dots," *Rogue* (August 1915), as quoted from her *Lost Lunar Baedeker,* p. 21. I reproduce the interesting typography of this poem as it appears in *Rogue* and discuss the poem further in "dAdAmAgs," in Francis M. Naumann with Beth Venn, eds., *Making Mischief: Dada Invades New York* (New York: Whitney Museum of American Art, 1996), pp. 216–217.

75. Loy, "Brancusi's Golden Bird," in her *Lost Lunar Baedeker,* p. 79. On the complex origin of this poem, written in 1921, see Roger Conover's long note in this volume, pp. 198–199.

76. W. H. de B. Nelson, "Aesthetic Hysteria," *International Studio* 61, no. 244 (June 1917): 125; as cited in Naumann, *New York Dada,* p. 182.

77. Man Ray, interview with Arturo Schwarz, *Arts Magazine* 51, no. 9 (May 1977); as cited in Neil Baldwin, *Man Ray, American Artist* (New York: Clarkson N. Potter, 1988), pp. 58–59.

78. Williams, "Overture to a Dance of Locomotives," in *Collected Poems,* vol. 1, p. 146.

79. Marcel Duchamp, *Saltseller: The Writings of Marcel Duchamp,* ed. Michel Sanouillet and Elmer Peterson (New York: Oxford University Press, 1973), p. 32.

80. Unsigned, "Three Miles of Pictures at Independent Artists' Show," *New York Herald Tribune,* April 10, 1917, p. 5.

81. Marcel Duchamp to Suzanne Duchamp, April 11, 1917, as cited in William Camfield, "Marcel Duchamp's *Fountain:* Its History and Aesthetics in the Context of 1917," *Dada/Surrealism,* no. 16 (1987): 71–72. For the full text of this letter, and for others from Duchamp to his family, see Francis M. Naumann, ed., "Affectueusement, Marcel," *Archives of American Art Journal* 22, no. 4 (1982): 2–19.

82. Camfield, "Marcel Duchamp's *Fountain,*" p. 72.

83. Louise Norton, "Buddha of the Bathroom," *Blind Man,* no. 2 (May 1917): 5–6.

84. Marcel Duchamp, "I Propose to Strain the Laws of Physics," interview with Francis Roberts, *Artnews,* vol. 67, no. 8 (December 1968): 62.

85. Unsigned, "The Richard Mutt Case," *Blind Man,* no. 2 (May 1917): 5.

86. Stieglitz to Henry McBride, April 19, 1917, Archives of American Art, McBride papers; as cited by Camfield, "Marcel Duchamp's *Fountain,*" p. 91.

87. See Camfield, "Marcel Duchamp's *Fountain,*" p. 75 and note 39 for references to the O'Keeffe letter. And see, for example, Thierry de Duve, "Given the Richard Mutt Case," in de Duve, ed., *The Definitively Unfinished Marcel Duchamp* (Cambridge: MIT Press; Halifax: Nova Scotia College of Art and Design, 1991), pp. 213–215, where he refers to Duchamp's "diabolical" manipulations (and see the later roundtable discussion). The crucial letter to O'Keeffe, referred to by both de Duve and Camfield, is not available, and they did not actually see it. Camfield reports in his note that its publication was reserved for Jack Cowart, Juan Hamilton, and Sarah Greenough's *Georgia O'Keeffe: Art and Letters* (Washington, D.C.: National Gallery of Art, 1987), but it was not published in that volume.

88. Beatrice Wood, "Marcel" (excerpt from her *I Shock Myself*), *Dada/Surrealism,* no. 16 (1987): 14.

89. The main source for the evening is Gabrielle Buffet-Picabia, "Arthur Cravan and American Dada," in Robert Motherwell, ed., *The Dada Painters and Poets* (New York: Wittenborn, 1951), pp. 13–17. Note, however, that the original French of that text exhibits a certain number of differences, such as a greater vehemence on the part of his audience, the different identifications of the artist whose painting Cravan risks destroying (Sterner in Motherwell, Steichen in the French), and the additional scene of the French all lunching together at the Brevoort before the event and priming the boxer; see Buffet-Picabia's *Aires abstraites* (Geneva: Problèmes de L'Art, 1957), pp. 91–100.

90. Burkes's *Becoming Modern* is my main source for the poetry event (p. 230). She cites a review, "Poets in Spring Orgy of Verse and Not an Editor on the Job," *Globe and Commercial Advertiser,* April 19, 1917, p. 6. Poets reading, other than those I mention in my text, were Mary Austin, Arthur Giovanetti, and Allen Norton.

91. Williams, *Autobiography,* p. 136.

92. "Poets in Spring Orgy," as cited in Burke, *Becoming Modern,* p. 230.

93. Loy, "Songs to Joannes," in *Lost Lunar Baedeker,* section 12, p. 57, and section 15, p. 59.

94. Ibid., section 23, p. 62, and section 26, p. 63.

95. Williams, *Collected Poems,* vol. 1, p. 487n.

96. Williams, "Portrait of a Woman in Bed," in *Collected Poems,* p. 88.

97. See Williams on his "South" and "North" and the *Blind Man* in his "Prologue" to *Kora in Hell,* pp. 9–10.

98. Nevertheless, there is the probability of a closer connection here, as, before it was a publishing house, *Contact* was the name of a little magazine founded by Williams and McAlmon together, and they published Loy's poem "O Hell" and a short prose piece, "Summer Night in a Florentine Slum," in their first issue, *Contact,* no. 1 (December 1920).

99. Williams, *Autobiography,* pp. 174, 146.

100. Burke, *Becoming Modern,* pp. 262–265. Burke's version of Cravan's end is that of Williams, *Autobiography,* p. 141. She voices some doubts about whether Loy really returned to Mexico. There remains the good possibility that Cravan engineered his own disappearance. In 1946 Duchamp, in New York, wrote a legal document for Mina's benefit, certifying Cravan's death (Bibliothèque Jacques Doucet), but we cannot say he knew any more than we do. Roger Conover is still tracking him, in "The Secret Names of Arthur Cravan," *Arthur Cravan: poète et boxeur* (Paris: Terrain Vague and Galerie 1900–2000, 1992), pp. 25–37.

101. Loy, "The Widow's Jazz," in *Lost Lunar Baedeker,* p. 96. Written in 1927.

102. *Little Review* (May 1929), reprinted in Loy, *The Last Lunar Baedeker,* p. 328.

103. On this date, April 13, Beatrice Wood wrote in her diary: "See Stieglitz about 'Fountain.'" See Camfield, "Marcel Duchamp's *Fountain,"* p. 74.

104. Stieglitz, "My Dear Blind Man," *Blind Man,* no. 2 (May 1917): 15.

105. Stieglitz to Marcel Duchamp and Man Ray, April 17, 1921. Bibliothèque Jacques Doucet, Paris. Permission to quote from the Georgia O'Keeffe

Foundation. "Francis" is a mistake for Tzara, who signs the "authorization." I take "prod" to be an abbreviation for "prodigious."

106. Stieglitz to Francis Picabia, August 19, 1919. Bibliothèque Jacques Doucet. Permission to quote from the Georgia O'Keeffe Foundation.

107. Stieglitz to American Waste Paper Co., April 12, 1917; Beinecke Library, Yale University, Alfred Stieglitz, miscellaneous letters.

7 The Serial Portrait (1917–1935)

1. Stieglitz to Picabia, August 19, 1919. Bibliothèque Jacques Doucet. Permission to quote from the Georgia O'Keeffe Foundation.

2. Stieglitz to Francis Picabia, no date [1921]. Bibliothèque Jacques Doucet. Permission to quote from the Georgia O'Keeffe Foundation.

3. The dates represented by this exhibition are probably 1886 through 1920, as reported, for example, by Richard Whelan, *Alfred Stieglitz: A Biography* (New York: Little, Brown, 1995), p. 417, and Sarah Greenough, *Modern Art and America: Alfred Stieglitz and His New York Galleries* (Washington, D.C.: National Gallery of Art, 2000), p. 547. However, Sue Davidson Lowe, *Stieglitz: A Memoir/Biography* (New York: Farrar, Straus, Giroux, 1983), reports 1887 in her second appendix (p. 433), which suggests she has the catalogue in hand. The catalogue is listed in her bibliography, p. 420.

4. Henry McBride, "Photographs by Stieglitz," *New York Herald,* February 13, 1914; reprinted in his *The Flow of Art,* ed. Daniel Catton Rich (New York: Atheneum, 1975), p. 161.

5. McBride, *Flow of Art,* pp. 162, 163.

6. Quoted in Lowe, *Stieglitz,* p. 433. For a more detailed breakdown, see *Alfred Stieglitz: The Key Set: The Alfred Stieglitz Collection of Photographs,* ed. Sarah Greenough (Washington, D.C.: National Gallery of Art; New York: Abrams, 2002), vol. 2, p. 967.

7. Two of the Koeniger, or "Ellen," images appear in *Alfred Stieglitz: Photographs from the J. Paul Getty Museum* (Malibu, Calif.: J. Paul Getty Museum, 1995); these and two others are in John Szarkowski, *Alfred Stieglitz at Lake George* (New York: Museum of Modern Art, 1995). *The Key Set* has eleven, including those above, but not the beautiful one I reproduce, from the National Gallery of Canada.

 A lively roundtable discussion takes place in the Getty volume about the sensuality, vitality, and especially the daringly modern composition of the Koeniger images, with Emmet Gowin, Sarah Greenough, Charles Hagan, Weston Naef, and Szarkowski participating (pp. 120–124).

8. Quoted in Whelan, *Alfred Stieglitz,* p. 418. Lowe, *Stieglitz,* p. 241, attributes the "fears of censure" to a "dress rehearsal before family and friends." These, then, had seen all the nudes.

 One wonders if Stieglitz had gotten wind of Modigliani's first one-man show in 1917 at the Galerie Weil in Paris, where his notorious nude exposed in the gallery window, pubic hair prominent, had enraged the neighborhood and resulted in the police closing the exhibit. De Zayas's Modern Gallery had shown work by Modigliani in 1916, but none of the nudes.

9. Anne Middleton Wagner, *Three Artists (Three Women): Modernism and the Art of Hesse, Krasner, and O'Keeffe* (Berkeley: University of California Press, 1996), uses the same album as an index to Stieglitz's "demonstration." Her emphasis is not on the idea of a series—my narrative—but on the idea of Stieglitz portraying the diversity of O'Keeffe, her many selves: quite the contrary of a reductive portrait, "it evidently aims to describe a certain complexity as inherent in feminine identity," and "it was Stieglitz's great concept to treat the body as if it were a visual guide or index to the plurality of the female self" (pp. 88 and 89).

10. Reported in a 1986 interview with Benita Eisler, in Eisler's *O'Keeffe and Stieglitz: An American Romance* (New York: Doubleday, 1991), p. 167.

11. In this Metropolitan Museum album I am extrapolating on, O'Keeffe or her editor has indicated this photograph is from 1918, but I think not. This must have been taken during her second show, the one Stieglitz rehung in 1917 for her to see. Was O'Keeffe in 1978 fooled by the appearance of intimacy? The two were not intimate at all at that moment, in April 1917, though perhaps they could guess or, better yet, the photograph knew and could say more than they did!

12. Holland Cotter, "Washington's Lavish Art Buffet," *New York Times,* May 31, 2002, p. B35. Note that the reviewer is speaking not of this show or any other, but of the National Gallery of Art's *Key Set,* which inventories the more than 350 photographs of O'Keeffe in the Gallery's collection (not a catalogue raisonné, in fact). Certainly Stieglitz himself never expected anyone to slog through all these images at a sitting, not to mention that they are reproductions and not to scale.

13. Bram Dijsktra, *Georgia O'Keeffe and the Eros of Place* (Princeton: Princeton University Press, 1998), pp. 184–185. "Stieglitz's focus on O'Keeffe's torso was in virtually every detail analogous to Vanderpoel's pursuit of the evocative significance of line as a distillation of 'essential form'" (pp. 185–186).

14. This is one critical point of Mario Perniola's "Between Clothing and Nudity," in Michel Feher, Ramona Naddaff, and Nadia Tazi, eds., *Fragments for a History of the Human Body, Part 2* (New York: Zone/MIT Press, 1989), pp. 253–255. The idea of transit is his as well (the essay is from his book *Transiti*), though my use of it is elaborated in a somewhat different direction.

15. In the "master set" of Stieglitz photographs at the National Gallery of Art, Washington, D.C., this image is classified, under the title I give, as 1980.70.56.

16. In the master set, 1980.70.53. Eisler, *O'Keeffe and Stieglitz,* p. 190, must be describing this same image, as *Feet (1918),* with feet cropped at ankles, dangling from the top, and "squatting" implied by an undergarment. However, the image plays its role in a very dark and ugly drama for Eisler, who sees Stieglitz as plunging "to the heart of the forbidden" in the nude photographs; in this particular case, she claims he is fearfully exploring the "gnarled and misshapen toes from the vertical gash of her vagina" (p. 190).

17. Earlier called *Georgia O'Keeffe—A Portrait—Arms and Feet, 1918,* when I saw it in the master set, now entitled *Georgia O'Keeffe—Feet, 1918,* numbered 1980.70.57.

18. Mary Ann Caws, *The Surrealist Look: An Erotics of Encounter* (Cambridge: MIT Press, 1997), pp. 54, 56, 54.

19. At one time identified as *Georgia O'Keeffe—A Portrait with Road Map,* master set, 1980.70.328, the title has been corrected to simply *Georgia O'Keeffe.*

20. William Ewing, *The Body: Photographs of the Human Form* (San Francisco: Chronicle Books, 1994). Ewing further explores many of these headings, but in connection with specific images, in his catalogue for an exhibition at the Musée de L'Élysée, Lausanne, *The Century of the Body, 100 Photoworks, 1900–2000* (London: Thames and Hudson, 2000).

21. Wagner, *Three Artists,* p. 88.

22. Alexandra Arrowsmith and Thomas West, *Georgia O'Keeffe and Alfred Stieglitz: A Conversation in Painting and Photographs* (New York: HarperCollins/Callaway Editions; Washington, D.C.: Phillips Collection, 1992). The three essays are "Like Nature Itself" by Belinda Rathbone, "The Great American Thing" by Roger Shattuck, and "I Can't Sing So I Paint" by Elisabeth Hutton Turner.

 The operative quotation from O'Keeffe, which supplies the ammunition for the assault I am describing, is from her introduction to the album I have been using, Alfred Stieglitz, *Georgia O'Keeffe, a Portrait* (New York: Metropolitan Museum of Art, 1978), n.p.: "For me he was much more wonderful in his work than as a human being. . . . I could see his strengths and weaknesses." However, O'Keeffe was a bit subtler than she may seem there, writing between the two above sentences: "I believe it was the work that kept me with him—though I loved him as a human being." Beyond that, I find it very one-sided that no one considers O'Keeffe's statements odd, as reflections of herself rather than as unassailable evaluations of Stieglitz; what is she saying about herself, when she admits she could continue to live with a man for thirty years for his artwork rather than for his person?

23. The fascinating question of the wife as model is examined and illustrated in Arthur Ollman, *The Model Wife* (New York: Bulfinch [Little, Brown], 1999), the catalogue for an exhibition at the Museum of Photographic Arts, San Diego. Of those wives, though, only O'Keeffe was a painter, someone able to respond in kind.

24. Stieglitz, *Georgia O'Keeffe, a Portrait,* n.p. Wagner, in *Three Artists,* makes much of these "many lives" in her view of Stieglitz's portrait. She also takes a very different position from the critical one I have been summarizing, to give O'Keeffe powers equal to the photographer's in her portrayal: see her pp. 76–96.

25. Eisler, *O'Keeffe and Stieglitz,* p. 189. Anna C. Chave, "O'Keeffe and the Masculine Gaze," *Art in America* 78 (January 1990), is the writer who draws the parallel of Stieglitz's taking credit for O'Keeffe's career with his taking credit for her orgasms (p. 123). Dijkstra, *Georgia O'Keeffe,* after page 190, argues that the photographer withholds his bodily sexuality from a very threatening O'Keeffe (in Stieglitz's fantasy), within the context of what Dijkstra calls the period's "sexual dimorphism."

26. Chave, "O'Keeffe and the Masculine Gaze," mounts the case for this view beginning p. 120.

27. Stieglitz, *Georgia O'Keeffe, a Portrait,* n.p.

28. Quoted in a letter from Anita Pollitzer to O'Keeffe, January 1, 1916, in Anita Pollitzer, *A Woman on Paper: Georgia O'Keeffe* (New York: Touchstone/Simon & Schuster, 1988), p. 120.

29. O'Keeffe to Anita Pollitzer, January 4, 1916, in Pollitzer, *A Woman on Paper,* pp. 122, 121.

30. O'Keeffe to Stieglitz, January, 1916, in Pollitzer, *A Woman on Paper,* p. 123.

31. Laurie Lisle, *Portrait of an Artist: A Biography of Georgia O'Keeffe* (New York: Seaview Books, 1980), p. 73.

32. O'Keeffe to Elizabeth Stieglitz [spring 1918], in Whelan, *Alfred Stieglitz,* p. 396.

33. Reported in Lisle, *Portrait of an Artist,* p. 86; from Jean Evans, "Stieglitz—Always Battling and Retreating," *PM,* December 23, 1945.

34. O'Keeffe to Anita Pollitzer, June 20, 1917 [from Canyon, Texas], in Pollitzer, *A Woman on Paper,* p. 157.

35. Jeffrey Hogrefe, *Georgia O'Keeffe: The Life of a Legend* (New York: Bantam, 1992), argues that O'Keeffe's cantankerousness in Canyon was due to her suppressed homosexual rage, and to incest with her father and brother. Evidence for incest is that "victims of incest often wear loose-fitting clothing" (pp. 81–82). Both Hogrefe and Eisler, *O'Keeffe and Stieglitz,* describe as fact an erotic affair between O'Keeffe and Harris, but I find no evidence of it.

36. Stieglitz to Paul Strand, May 27, 1918, cited in Whelan, *Alfred Stieglitz,* p. 397.

37. Strand to Stieglitz, May 18, 1918, cited in Eisler, *O'Keeffe and Stieglitz,* pp. 172–173. This is a twenty-eight-page letter in which Strand outlines his conclusions about the whole situation in Waring, including his interest in Leah. Also to be noted, the previously quoted letter from Stieglitz to Strand is written later than this one; so it is despite remarks such as this, in which Strand cedes the place to Stieglitz, that the older man continues to insist O'Keeffe is *not* to be prevailed upon.

38. Eisler, *O'Keeffe and Stieglitz,* p. 172. The notorious combination was stated by Stieglitz to O'Keeffe directly, in a letter written six weeks earlier (March 31, 1918): "The Great Child pouring out some more of her Woman self on paper—purely—truly—unspoiled." In Pollitzer, *A Woman on Paper,* p. 159.

39. Ann Lee Morgan, ed., *Dear Stieglitz, Dear Dove* (Newark: University of Delaware Press; London: Associated University Presses, 1988), pp. 61, 62.

40. Pollitzer, *A Woman on Paper,* p. 202, reports Frieda's conversation with O'Keeffe in New Mexico: "'In her I always felt a detachment from the things that fritter away other peoples' minds. Hers seemed always very clear.'. . . . Georgia was always as she seemed that first day, 'beautiful and unmuddled.'"

41. Paul Strand to Stieglitz, May 30, 1918, cited in Eisler, *O'Keeffe and Stieglitz,* p. 177.

42. See Eisler, *O'Keeffe and Stieglitz,* pp. 165, 169. Influenza was feared, as an epidemic was coursing through the world in the last year of the war. Eisler feels the symptoms are not those of the flu. A local doctor thought O'Keeffe was as close to having TB "as anyone he had ever seen without being stricken." This pattern of obscure illness occurred again when O'Keeffe was unable to

leave a scene of constriction; in New York, the doctors were all in a quandary of interpretation before she began to spend her summers in New Mexico in 1929, against Stieglitz's wishes; once in the Southwest, she recovered immediately.

43. In this I am taking Stieglitz at his own word, as does Whelan, for example, *Alfred Stieglitz,* pp. 399–400. He dates the couple's sexual relations to a letter from Stieglitz to Dove dated August 15: "O'Keeffe and I are One in a real sense."

44. Maria Costantino, *Georgia O'Keeffe* (New York: Smithmark, 1995), p. 26. In 1919 Stieglitz arranged for two of her works to be shown at the Young Women's Hebrew Association Exhibition of Modern Art, and in 1922 he showed two more at the Municipal Building, Freehold, New Jersey: see "Chronology" in Jack Cowart, Juan Hamilton, and Sarah Greenough, *Georgia O'Keeffe: Art and Letters* (Washington, D.C.: National Gallery of Art, 1987), pp. 291–292.

45. While a match of O'Keeffe's agendas to mediums is far from neat, I think the case is quite strong enough for the purposes of my discussion; it is made carefully and in detail by Judith C. Walsh, "The Language of O'Keeffe's Materials: Charcoal, Watercolor, Pastel," in Ruth E. Fine and Barbara Buhler Lynes, with Elizabeth Glassman and Judith C. Walsh, *O'Keeffe on Paper* (Washington, D.C.: National Gallery of Art; Santa Fe: Georgia O'Keeffe Museum, 2000). Also see Barbara Lynes, "Inventions of Different Orders," in this same publication, pp. 44–54, on shifts into abstraction on paper, and back to objects, more often in oils.

46. Georgia O'Keeffe, *Georgia O'Keeffe* (New York: Viking, 1976), n.p. [facing plate 1].

47. Walsh, "The Language of O'Keeffe's Materials," p. 58. She also points out that O'Keeffe returned to charcoals at various later times when she started out anew.

48. Ibid., p. 77.

49. Barbara Butler Lynes, *O'Keeffe's O'Keeffes: The Artist's Collection* (New York: Thames and Hudson, 2001), p. 58.

50. O'Keeffe, *Georgia O'Keeffe,* n.p. [facing plate 88].

51. Ibid., n.p. [facing plate 51, *Shell and Old Shingle, VI,* 1926, oil]. The next in the series, number VII, is of a mountain out her window, a shape she says resembled the shingle, but we cannot recognize it from either reality or number VI.

52. Ibid., n.p. [facing plate 55].

53. Cited from Arthur Jerome Eddy in Ruth Fine and Elizabeth Glassman, "Thoughts without Words: O'Keeffe in Context,' in Fine and Lynes, *O'Keeffe on Paper,* p. 29. In an August 1915 letter to Pollitzer, O'Keeffe wrote, "I got Eddy a long time ago," and another letter shows she was rereading him for the talk she gave to her Canyon, Texas, school in January 1917; in Cowart, Hamilton, and Greenough, *Georgia O'Keeffe,* pp. 143, 159.

54. Fine and Glassman, "Thoughts without Words," p. 29. But by "their inner states," do Fine and Glassman mean those of the painters or of the shapes?

55. O'Keeffe, *Georgia O'Keeffe,* n.p. [facing plate 71].

56. I owe this idea and the word play to a French psychoanalyst: Victor N. Smirnoff, "Severin von Sacher-Masoch ou l'impossible identification," *Bulletin de l'Association Psychanalytique de France,* no. 4 (June 1968): 77. Is the hero of Sacher-Masoch's *Venus in Furs* being beaten by his wife in a filtered representation of the author's actual beatings, or is the story a philter designed to convince his real wife to treat him as the fictional wife does?

57. Gertrude Stein, *The Autobiography of Alice B. Toklas* (1933; New York: Random House/Vintage, 1990), p. 91.

58. "Say it, no ideas but in things" is a phrase that recurs a number of times in William Carlos Williams's epic poem *Paterson,* initially in an opening passage that revives a poem of 1926, "Paterson."

"Not Ideas about the Thing but the Thing Itself" is the last poem in Wallace Stevens, *The Collected Poems* (New York: Knopf, 1965), p. 534.

59. Wallace Stevens, "Angel Surrounded by Paysans," cited in epigraph to Stevens, *The Necessary Angel* (New York: Knopf, 1965).

60. O'Keeffe, *Georgia O'Keeffe,* n.p. [facing plate 5].

61. Unidentified to O'Keeffe, February 1912, in Pollitzer, *A Woman on Paper,* p. 101. In 1926 O'Keeffe was thirty-nine!

62. Sarah Greenough, "Georgia O'Keeffe, a Flight to the Spirit," in her *Modern Art and America: Alfred Stieglitz and His New York Galleries* (Washington, D.C.: National Gallery of Art, 2000), p. 448, where Stieglitz's photograph may be found, across from a plate of the painting.

63. O'Keeffe, *Georgia O'Keeffe,* n.p. [facing plate 74].

64. Stieglitz, "How I Came to Photograph Clouds," *Amateur Photographer and Photography,* no. 56 (1923): 255; reprinted in a number of places, notably *Stieglitz on Photography: His Selected Essays and Notes,* ed. Richard Whelan, preface and bibliography by Sarah Greenough (New York: Aperture, 2000), pp. 234–238.

65. Waldo Frank, "A Thought Hazarded," *MSS* (December 1922): 5. Cited in Whelan's note, p. 238 of *Stieglitz on Photography,* without Frank's italics for "*moulding.*" Also, the original has no comma between "atmosphere" and "suggestion," leaving the possibility that Frank meant something called "atmosphere suggestion."

66. See the notes to plates 36 and 40 in *Alfred Stieglitz: Photographs from the J. Paul Getty Museum,* pp. 76, 84.

67. Nadia Tazi, "Celestial Bodies: A Few Stops on the Way to Heaven," in Michel Feher, with Ramona Naddaff and Nadia Tazi, eds., *Fragments for a History of the Body, Part 2* (New York: Zone, 1989), p. 522. My argument below is prompted by Tazi's essay, but hers is written with quite a different purpose.

68. "Alfred Stieglitz: An Affirmation in Light," roundtable with Emmet Gowin, Sarah Greenough, Charles Hagen, Weston Naef, and John Szarkowski, in *Alfred Stieglitz: Photographs from the J. Paul Getty Museum,* p. 130–131.

69. Rosalind Krauss, "Stieglitz/*Equivalents,*" *October,* no. 11 (Winter 1979): 134–135.

70. Stieglitz to Hart Crane, December 10, 1923, in *Alfred Stieglitz, Photographs and Writings,* ed. Sarah Greenough and Juan Hamilton (Washington, D.C.: National Gallery of Art; New York: Callaway Editions, 1983), p. 203.

71. Georgia O'Keeffe, letter, *MSS* (December 1922): 17.

8 Down from the Clouds (1929–1935)

1. Rosalind Krauss, "Stieglitz/*Equivalents,*" *October,* no. 11 (Winter 1979): 140.

2. Daniell Cornell, in his *Alfred Stieglitz and the Equivalent: Reinventing the Nature of Photography* (New Haven: Yale University Art Gallery, 1999), discusses Stieglitz's photography in terms of "defamiliarization" as he reads it in Roman Jakobson's famous analysis of metaphor and metonymy. Defamiliarization, the making strange of art as opposed to a reassuring mimesis, was an effect that, for the Russian formalists, turned the viewer's attention to artfulness and self-reflexivity. In keeping with the general view of the Secession that I have been developing, I use the term to mean novel techniques that coax or prod the viewer further into the significance of the image.

3. Minor White, "Equivalence: The Perennial Trend," *PSA Journal* 29, no. 7 (1963), as cited on a Web site devoted to Thomas Merton's meeting Ansel Adams: <www.wam.umd.edu/mjhicky/stieglitz/equivalents.htm>.

4. An early painting by Hartley, *Deserted Farm* (1909), greatly resembles this photograph. It is in the Frederick R. Weisman Art Museum, University of Minnesota.

5. Wallace Stevens, "The Idea of Order at Key West," in Wallace Stevens, *The Collected Poems* (New York: Knopf, 1965), p. 129.

6. Rosalind Krauss, "Alfred Stieglitz's 'Equivalents,'" *Arts Magazine* 54, no. 6 (February 1980): 135.

7. Gerard Manley Hopkins, "Pied Beauty," in Richard Ellmann and Robert O'Clair, eds., *The Norton Anthology of Modern Poetry* (New York: Norton, 1973), p. 81.

8. In her article for *Arts Magazine,* Krauss has refashioned her essay in *October* on Stieglitz's *Equivalents* to deal with what she considers his work with the deepest, essential sense of symbolism as a principle of equivalence evolving out of the French literary movement. Though she has the greatest praise for the photographer's achievement in the cloud images, Krauss finds the deep sense of symbolism in its displacement of representation in favor of the sign: a "radical absence . . . of the world and its objects, subplanted by the presence of the sign," and "a level at which the object of interrogation is the very structure of the aesthetic sign" ("Alfred Stieglitz's 'Equivalents,'" p. 136).

Sarah Greenough, "How Stieglitz Came to Photograph Clouds," in Peter Walch and Thomas Barrow, eds., *Perspectives on Photography* (Albuquerque: University of New Mexico Press, 1986), traces the historical connections of the *Equivalents* to the French symbolist movement, while not neglecting Krauss's theoretical point (pp. 151–165). Both critics look at the writing going on in *Camera Work,* mainly by Benjamin De Casseres

and Sadaki Hartmann. While my interest is more psychological, within the confines of audience response (or reception theory), I find these essays especially valuable for showing that Stieglitz was not just aping simplistic interpretations of symbolism.

9. Nancy Newhall, *From Adams to Stieglitz: Pioneers of Modern Photography* (New York: Aperture, 1989), p. 107.

10. Ibid.

11. Ibid., p. 108.

12. Edmund Wilson, *The American Earthquake* (1958), as quoted by Sarah Greenough, "Alfred Stieglitz, Facilitator, Financier, and Father, Presents Seven Americans," in Greenough, ed., *Modern Art and America: Alfred Stieglitz and His New York Galleries* (Washington, D.C.: National Gallery of Art, 2000), p. 316.

13. Stieglitz, letter to Paul Rosenfeld, September 5, 1923, as reprinted in *Alfred Stieglitz, Photographs and Writings,* ed. Sarah Greenough and Juan Hamilton (Washington, D.C.: National Gallery of Art; New York: Callaway Editions, 1983), p. 212. The word in editorial brackets is the editors', and I agree the text cannot make sense without the addition. Stieglitz often dropped connective words in the heat of letter-writing. The letter is in response to Rosenfeld's position in his forthcoming book, *Port of New York.*

14. Greenough, "Alfred Stieglitz, Facilitator," pp. 316–318 in particular, provides greater detail. However, she credits Demuth with only one show after the *Seven Americans,* whereas a small exhibit of his closed the gallery, in April to May of 1929 (see her exhibition list, p. 549).

15. Dorothy Norman, *Alfred Stieglitz: An American Seer* (New York: Random House, 1973), p. 229.

16. Ibid., p. 227.

17. Marcia Brennan, *Painting Gender, Constructing Theory: The Alfred Stieglitz Circle and American Formalist Aesthetics* (Cambridge: MIT Press, 2001), pp. 117, 119.

18. Paul Rosenfeld, "American Painting," *Dial* 71 (December 1921): 665; as cited by Brennan, *Painting Gender,* p. 99.

19. Stieglitz to Stanton Macdonald-Wright, October 9, 1919; as cited in Norman, *Alfred Stieglitz,* pp. 136–137.

20. Paul Rosenfeld, *Port of New York: Essays on Fourteen American Moderns* (1924; Urbana: University of Illinois Press, 1961), p. 169; and Waldo Frank, "The Art of Arthur Dove," *New Republic* 45 (January 27, 1926): 269; both as cited in Brennan, *Painting Gender,* pp. 111, 112.

21. For a discussion of *Penetration* (1924), the origin of its title, and its position in the discussions of Dove's sexualized imagery in comparison to O'Keeffe's, see Debra Balken, "Continuities and Digressions in the Work of Arthur Dove from 1907 to 1933," in her *Arthur Dove: A Retrospective,* in collaboration with William Agee and Elizabeth Hutton Turner (Cambridge: MIT Press, 1997), pp. 28–29. The painting is reproduced on p. 53.

22. I am deriving this concept of a transitional arena from the psychoanalyst D. W. Winnicott's idea of the "transitional object." A child's favorite blan-

ket was Winnicott's key example of a magical entity that was not entirely exterior to nor interior to the child, but fully both.

Murray M. Schwartz, in an article that works to make literature such a privileged arena, quotes Winnicott: "'It is an area that is not challenged, because no claim is made on its behalf except that it shall exist as a resting-place for the individual engaged in the perpetual human task of keeping inner and outer reality separate yet interrelated.'" Schwartz, "Where Is Literature," in Peter L. Rudnytsky, ed., *Transitional Objects and Potential Spaces: Literary Uses of D. W. Winnicott* (New York: Columbia University Press, 1993), p. 58.

23. Arthur Dove to Stieglitz, February 1, 1932; as cited in Elizabeth Hutton Turner, "Going Home: Geneva, 1933–1938," in Balken, *Arthur Dove,* p. 106.

24. Lewis Mumford, "The Art Galleries: Surprise Party—Wit and Watercolors," *New Yorker,* May 5, 1934, p. 54; as cited in Turner, "Going Home," p. 101.

25. Turner, "Going Home," p. 105. See her pp. 104ff for a discussion of Dove's erudite mixing of mediums in the 1930s.

26. Henri Bergson, "An Extract from Bergson," *Camera Work,* no. 36 (October 1911): 20; as cited in Ann Lee Morgan, "The Art of Arthur Dove," in her *Arthur Dove, Life and Work: With a Catalogue Raisonné* (London: Associated University Presses; Newark, N.J.: University of Delaware Press, 1984), p. 46. Morgan discusses Bergson and Dove in her volume's next chapter, "Context and Theory," p. 79.

27. John Marin, undated manuscript reproduced in his *John Marin by John Marin,* ed. Cleve Gray (New York: Holt, Rinehart and Winston, 1977), p. 79.

28. Marin, undated manuscript, in *John Marin by John Marin,* p. 96.

29. Brennan, *Painting Gender,* p. 142. This is a phrase she credits to "Stieglitz and his critics," not to Rosenfeld alone.

30. Paul Rosenfeld, "Marsden Hartley," in his *Port of New York,* pp. 83, 98–100.

31. Wanda Corn, *The Great American Thing* (Berkeley: University of California, 1999), p. 239. On the other hand, in his "Charles Demuth: A Sympathetic Order," Charles Brock argues the opposite, that in Stieglitz's "long history of . . . support of displays of sexually provocative works of art," he finds no evidence of prejudice against homosexuality. In Greenough, ed., *Modern Art and America,* p. 373.

32. The source for this affair is William Carlos Williams, *Autobiography* (New York: Random House, 1951): "He told me how once he had made rather direct love to Djuna Barnes—offering her his excellent physical equipment for her favors. . . . He was one of the most frustrated men I knew" (pp. 172–173). Williams recounts what must have been Hartley's making a pass at him. But, "I too had to reject him. Everyone rejected him."

33. Townsend Ludington, *Marsden Hartley: The Biography of an American Artist* (Boston: Little, Brown, 1992), pp. 36–39. Ludington nevertheless assumes that Hartley had frequent random, clandestine sexual encounters with unknown men.

34. William Carlos Williams, "Beginnings: Marsden Hartley," in "Two Pieces," *Black Mountain Review* 7 (Autumn 1957): 166; as cited by Dickran Tashjian, *William Carlos Williams and the American Scene, 1920–1940* (New York: Whitney Museum of American Art, 1978), p. 51.

35. These letters are in the Beinecke Library, Yale University. An important segment is published in James T. Voorhies, ed., *My Dear Stieglitz: Letters of Marsden Hartley and Alfred Stieglitz, 1912–1915* (Columbia: University of South Carolina Press, 2002).

36. William Innes Homer, *Alfred Stieglitz and the American Avant-Garde* (Boston: New York Graphic Society, 1977), provides a good overview of Hartley's time in France and Germany (pp. 157–164 and 220–230). As Homer points out, Stieglitz's support did not end upon Hartley's return; he gave him a fourth show in 1916 and paid for his summer that year in Provincetown.

37. Norman, *Alfred Stieglitz,* quoting Stieglitz for the whole story, pp. 165–166.

38. Stieglitz to Hartley, February 5, 1929, as cited in Townsend Ludington, "Marsden Hartley, on Native Ground," in Greenough, *Modern Art and America,* p. 402.

39. Ibid., p. 412. Ludington answers the question: "It was, of course, recognition, money, and to be first violin at An American Place, something Stieglitz could not completely orchestrate."

40. Carol Troyen, "The 'Nativeness' of 'Primitive Things': Marsden Hartley's Late Work in Context," in Elizabeth Mankin Kornhauser, ed., *Marsden Hartley* (Hartford: Wadsworth Atheneum Museum of Art; New Haven: Yale University Press, 2002), p. 242. Troyen also describes the distress and the relief of both artist and photographer upon their parting ways.

41. The inevitable effect of Jonathan Weinberg's *Speaking for Vice: Homosexuality in the Art of Charles Demuth, Marsden Hartley and the First American Avant-Garde* (New Haven: Yale University Press, 1993) is to convey the idea that secret, gay communication is Hartley's first endeavor in his art, whereas I would see it as ancillary. For example, Weinberg (pp. 174–175) is critical of the exhibit catalogue *Marsden Hartley and Nova Scotia,* ed. Gerald Ferguson, with essays by Ronald Paulson and Gail R. Scott (Halifax, N.S.: Mount Saint Vincent University Art Gallery, 1987) for minimizing the role of homosexual attraction in Hartley's portrayal of the Mason family. But I think the editors were quite right to see Hartley as idealizing his relationship to these men of the sea.

42. Brennan, *Painting Gender,* gives a detailed description of *Tinseled Flowers,* without however referring to its eroticism (p. 162). The discussion by Kristina Wilson in Kornhauser, *Marsden Hartley,* is mainly technical (p. 301); however, her discussion of *Atlantic Window* highlights the sexuality of the flower, cites Rosenfeld, and sees Hartley trying to get past such "emotionalism," as he saw it (p. 300).

43. Andrea Gray, *Ansel Adams, An American Place, 1936* (Tucson: University of Arizona, Center for Creative Photography, 1982), p. 20. Most of my information about Adams's show at the Place is from this volume, the record of

a reconstruction of the show for a traveling exhibition. For a wider-ranging discussion of the relationship between Adams and Stieglitz, in the context of a traveling exhibition honoring Adams's centenary, see Sandra S. Phillips, "Adams and Stieglitz: A Friendship," *Art in America,* January 2005, pp. 62–71.

44. Ansel Adams to Beaumont Newhall, July 12, 1939, cited in Gray, *Ansel Adams,* p. 24.
45. Ansel Adams to Patricia English, November 21, 1936, cited in Gray, *Ansel Adams,* p. 24.
46. Ansel Adams to David Hunter McAlpin, February 3, 1941, in Gray, *Ansel Adams,* p. 33.
47. Ansel Adams to Stieglitz, May 27, 1940, in Gray, *Ansel Adams,* pp. 34–35.
48. Adams to McAlpin, October 2, 1946, in Gray, *Ansel Adams,* p. 33.
49. Peter Bacon Hales, *Silver Cities: The Photography of American Urbanization, 1839–1915* (Philadelphia: Temple University Press, 1984), p. 120.
50. Merrill Scheier, *The Skyscraper in American Art, 1890–1931* (New York: Da Capo Press; Ann Arbor: UMI Research Press, 1986), p. 43, and p. 262, n. 60.
51. Alan Trachtenberg, *Reading American Photographs: Images as History, Mathew Brady to Walker Evans* (New York: Hill and Wang, 1989), p. 217. In this chapter, "Camera Work/Social Work," Trachtenberg compares the work of Stieglitz and Hine in a much more detailed manner than my short comparison here.
52. See Paul Goldenberger, *The Skyscraper* (New York: Knopf, 1989), chapter 5, for a discussion of the "Drive for Height" in the thirties.
53. Dorothy Norman, *Encounters, a Memoir* (New York: Harcourt Brace Jovanovich, 1987), p. 91.
54. Hart Crane, "To Brooklyn Bridge," *The Bridge,* in Crane, *The Complete Poems and Selected Letters and Prose* (Garden City, N.Y.: Doubleday, 1966), p. 45.
55. Wright Morris, *Photographs and Words,* ed. and intro. James Alinder (Carmel, Calif.: Friends of Photography, 1982), p. 17.
56. O'Keeffe to Dorothy Brett, February 1932, as reprinted in Jack Cowart, Juan Hamilton, and Sarah Greenough, *Georgia O'Keeffe: Art and Letters* (Washington, D.C.: National Gallery of Art, 1987), p. 206.

9 Conclusion: The Secession's Unyielding Father

1. Marsden Hartley, *Somehow a Past,* ed. Susan Elizabeth Ryan (Cambridge, Mass.: MIT Press, 1997), pp. 62–64.
2. Alfred Stieglitz, "A Talk" [circa 1923], *Center for Creative Photography,* no. 1 (March 1976): 5.
3. Ibid., p. 8.
4. Janet Malcolm, review of *Diane Arbus: Revelations* and *Diane Arbus: Family Albums,* in *New York Review of Books,* January 15, 2004, p. 5. Malcolm raises the issue of Cartier-Bresson's large, later volumes, and speaks of looking at *Revelations* with "tired eyes."

Index

Note: Authors of secondary works are included in this index, but not the titles of their articles or monographs, which may be found in the notes, beginning page 319. Only period journals and newspapers are indexed.